The Sourcebook of Contemporary Jewelry Design

Natalio Martín Arroyo

The Sourcebook of Contemporary Jewelry Design

Natalio Martín Arroyo

HARPER
DESIGN

An Imprint of HarperCollins Publishers

First Edition:
Published by **maomao** publications in 2012
Via Laietana, 32, 4th fl., of. 92
08003 Barcelona, Spain
Tel.: +34 93 268 80 88
Fax: +34 93 317 42 08
www.maomaopublications.com

English language edition first published in 2012 by:
Harper Design
An Imprint of HarperCollins*Publishers*,
10 East 53rd Street
New York, NY 10022
Tel.: (212) 207-7000
Fax: (212) 207-7654
harperdesign@harpercollins.com
www.harpercollins.com

Distributed throughout the world by:
HarperCollins*Publishers*
10 East 53rd Street
New York, NY 10022
Fax: (212) 207-7654

Publisher:
Paco Asensio

Editorial Coordination:
Cristian Campos

Editor and texts:
Natalio Martín Arroyo

Translation:
Cillero & Motta

Art Direction:
Emma Termes Parera

Library of Congress Control Number: 2011942174

ISBN: 978-0-06-210503-5

Printed in Spain

First Printing, 2012

CONTENTS

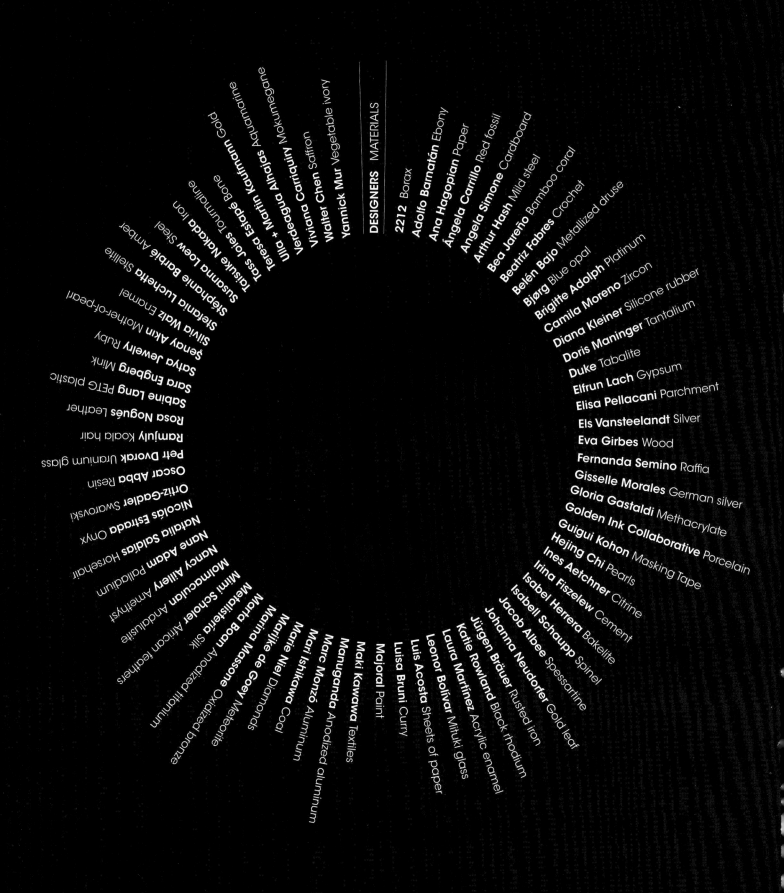

DESIGNERS · MATERIALS

Designer	Material
2212	Borax
Adolfo Barnatán	Ebony
Ana Hagopian	Paper
Ángela Carrillo	Red fossil
Angela Simone	Cardboard
Arthur Hash	Mild steel
Bea Jareño	Bamboo coral
Beatriz Fabres	Crochet
Belén Bajo	Metallized druse
Bjørg	Blue opal
Brigitte Adolph	Platinum
Camila Moreno	Zircon
Diana Kleiner	Silicone rubber
Doris Maninger	Tantalium
Duke	Tabalite
Elfrun Lach	Gypsum
Elisa Pellacani	Parchment
Els Vansteelandt	Silver
Eva Girbes	Wood
Fernanda Semino	Raffia
Gisselle Morales	German silver
Gloria Gastaldi	Methacrylate
Golden Ink Collaborative	Porcelain
Guigui Kohon	Masking Tape
Hejing Chi	Pearls
Ines Aetchner	Citrine
Irina Fiszelew	Cement
Isabel Herrera	Bakelite
Isabell Schaupp	Spessartine
Jacob Albee	Gold leaf
Johanna Neudorfer	Rusted iron
Jürgen Bräuer	Black rhodium
Katie Rowland	Acrylic enamel
Laura Martinez	Mituki glass
Leonor Bolivar	Sheets of paper
Luis Acosta	Curry
Luisa Bruni	Paint
Majoral	Textiles
Maki Kawawa	
Manuganda	Anodized aluminum
Marc Monzó	Aluminum
Mari Ishikawa	Coal
Marie Niel	Diamonds
Marije de Goey	Meteorite
Marina Massone	Oxidized bronze
Marta Boan	Anodized titanium
Metallistería	Silk
Mimi Scholer	African feathers
Molmacuan	Andalusite
Nancy Aillery	Amethyst
Nane Adam	Palladium
Natalia Saldías	Horsehair
Nicolás Estrada	Onyx
Ortiz-Gadler	Swarovski
Oscar Abba	Resin
Petr Dvorak	Uranium glass
Ramjuly	Koala hair
Rosa Nogués	Leather
Sabine Lang	PETG plastic
Sara Engberg	Mink
Satya Jewelry	Ruby
Şenay Akin	Mother-of-pearl
Silvia Walz	Enamel
Stefania Lucchetta	Steilite
Stéphanie Barbié	Amber
Susanna Loew	Steel
Taisuke Nakada	Iron
Teresa Estape	Bone
Tass Joies	Tourmaline
Ulhî + Atholas	Aquamarine
Verdugo Langblue	Nokungagane
Viviana Carrillo	Saffron
Walter Chen	Vegetable ivory
Yannick Mur	
Marina Kaufmann	Gold

Contemporary jewelry.
A new universe has evolved!

If the return of Ophiuchus, the new sign of the western zodiac, changed our view of the universe of stars, technological progress, trends, consumerism and social habits have made jewelry undergo an even bigger change—if that is possible—within just a few decades than all the uproar caused by the new star among those that follow horoscopes. However, in the same way that the sign of Ophiuchus was already present in the original Babylonian zodiac and is now back as a revival, contemporary jewelry design uses and reinvents shapes, techniques and styles that are steeped in centuries of gold and silverwork. It was precisely the Babylonians and the Assyrians, or Sumerians, that developed jewels of extraordinary beauty some 3,000 years before Christ, which we can see from the magnificent treasures found in the excavations of their ancient cities. Contemporary jewelry is unquestionably the result of thousands of years of history and research, whose creators still use metals and precious stones, without ceasing to renovate, reinvent, and experiment with materials, techniques, and concepts.

In this book you will find everythig, from elements used by Palaeolithic man as a jewel to reinforce his personality: woods, feathers, skins, etc.; techniques such as the Japanese *Mokumegane* to fuse metals, quilling paper and its applications to jewelry; to time-worn methods of reproduction, such as lost wax, or the most revolutionary methods of rendering design and printing pieces in 3D.

Over fifty International jewelry designers have shared their latest creations in the pages of this book. It is incredible to see that if we choose just one material used by each of them, we discover a surprising list of different materials, which gives us an idea of the huge potential and countless possibilities to be found in contemporary jewelry today. A mandala that represents an unusual cosmos, a new creative UNIVERSE.

Concepts and line drawing in contemporary jewelry

Introduction to technical drawing

Eugen Steier

The idea behind this book is to show the many ways in which jewelers use drawing as a tool in their craft. Naturally, there are many different drawing techniques and methods, but in this section we will focus on the basics of technical drawing so that you have a foundation to build on.

This step-by-step introduction starts with simple geometric shapes and well-known forms of perspective. You will learn how to draw volumes, how to manage light and shadow, and how to use color to translate different materials. Each step includes clear verbal and visual instructions, as well as useful tips to avoid basic mistakes.

There are many different drawing tools and materials, which can be confusing. A good way to start is to choose the right paper. There is a seemingly infinite array of sizes, colors, textures, and weights (thicknesses), but to begin with, a simple sheet of ordinary, A4 white paper will suffice. Paper color and texture may come into play further along the line, as in the case of extremely detailed watercolor renderings or looser, more impressionistic pastel drawings, for example. We illustrate one way in which special paper's color and texture may be used to better effect in the section about illustrating pearls.

Now, you will have to stick to adapted tools. This depends on the kind of drawing you wish to achieve, but, as a general rule, wet or powdery substances (such as paints and loose pigments) are better suited for heavier paper, as they will create waves or rub off ordinary paper. Shops are full of attractive, specialized tools (and so-called improvements are invented regularly), but in this case we have stuck to basics, and you will only need the following:

Pens and Pencils

- Several softhead pencils (from 4B to HB). For clear lines and for shading.
- Artists' color pencils. Their high pigment content yields bright color while allowing for sharp lines as well as shading. You will need several shades of grey to depict silver, and shades of yellow and brown to depict gold.
- White gel pen. Very useful for drawing in highlights.

Tools

- Regular eraser. For erasing mistakes along sharp edges, and obtaining a clean result.
- Kneaded eraser. For absorbing excess graphite or pigment on top of your drawing, and softening your lines or shading. Simply press or gently rub on the drawing where necessary. To avoid re-depositing pigment with the next use, knead eraser until all pigment is absorbed.
- Pencil sharpener.
- Light sandpaper to (gently!) scratch out faults you cannot get rid of with either eraser. For sharpening or creating a flat surface along the tip of your pencil, in the case of shading in particular.
- Compass, for drawing circles and reporting angles.
- Circle and elliptical template, for drawing circles, ovals, and their diameters.
- Several drawing triangles or a protractor, for measuring angles.
- Ruler.
- Drawing board. Not mandatory, but a very comfortable option.

Basic perspective and light

For our first example we have chosen a basic ring, which consists of a square element and a round element. You are going to learn how to go from a circle to an oval band, and then from a square to a cube. We will illustrate a simple numbering technique to draw shadow and light, and a trick that gives the drawing a shiny, finished look.

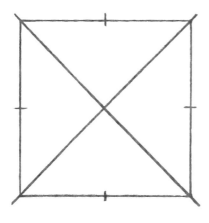

First, draw a square, and mark the mid-section of each side. Then draw two lines diagonally across, which indicate the center of the form.

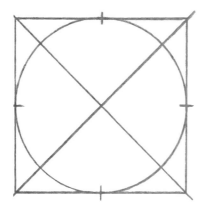

Carefully position the compass point at the intersection of the two diagonals, and draw a circle that touches the mid-section mark of each side of the square.

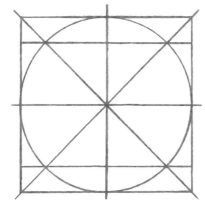

Draw two vertical lines that go through both points where the circle meets the diagonals. These lines will help you to draw the oval.

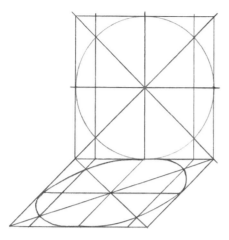

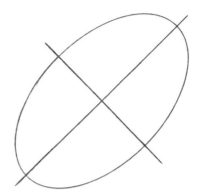

To draw an oval, which is a circle in projection, use the cavalier perspective. Extend each vertical line in the drawing at an angle of 45°, thus obtaining two planes. These lines suffer a 2/3 reduction because of the inclination of the axis. This trick, called foreshortening, gives a more realistic sensation to the drawing.

Once you have a good understanding of basic shapes and how they relate to each other, use a template ruler as a shortcut. Choose an oval, and draw it at an angle of 45°. Mark its horizontal and vertical axis.

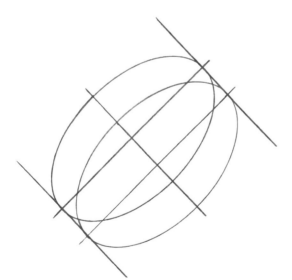

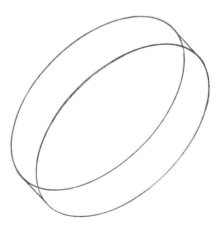

Use the same oval and draw it a second time at the same angle, at ten millimeters distance from the first. Connect the upper and the lower edges with a line.

Erase all straight lines from the drawing, and you get the oval with its volume. Use a combination of pen (to draw the ovals) and pencil (to draw the lines) to simplify this process.

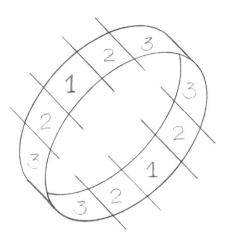

Thanks to a three-tone scale (1 = white, 2 = grey, 3 = black), you can create a simple code to draw shadows and lights, adding dimension and definition to the drawing. Tip: pick one light source for the piece. In the case of this ring, it comes from the upper left.

Trace four parallel lines at the same angle as the oval's horizontal axis. Tone 1 is in the middle, tone 3 is in the outer parts, and tone 2 makes the connection between them.

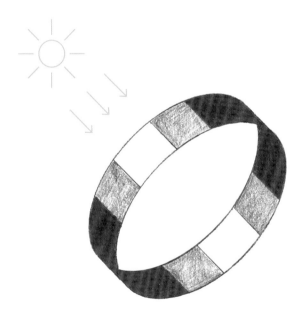

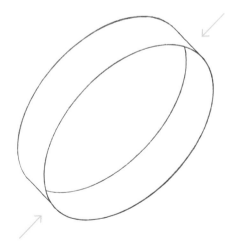

Fill in the shades according to the tone numbers (see scale above). This simplification allows you to envision basic light and shadow.

The oval band looks transparent until you erase the top arch of the inside of the band, thus indicating that one goes in front of the other.

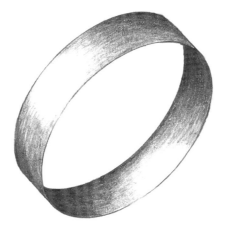

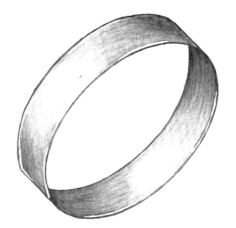

For a realistic shadow, softly blend the tones into each other. A trick to achieve a more realistic effect: the darkest shadow of the underside of the band is slightly darker than on the topside.

To make the oval look shinier (in the case of a polished ring), use a white gel pen or pencil to create strong black and white contrast. Draw thin lines along the border of the darkest sections of your oval.

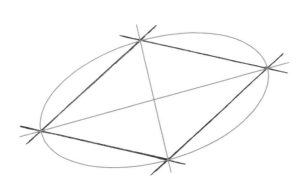

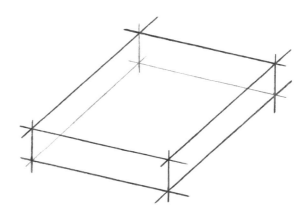

To draw a square in perspective, start with a rhomboid: opposite angles must be of equal size. To do this, draw an oval, mark its horizontal and vertical axis, and connect the four dots.

In a process similar than with the oval, add volume by drawing same-length vertical lines from each corner. Connect the four dots, and you obtain a second rhomboid of the same proportions.

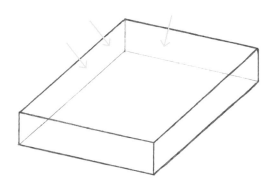

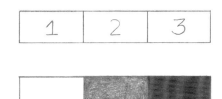

As with the oval, your rhomboid looks transparent until you erase the "underneath" lines. By doing so, you achieve the effect of perspective.

Using the same three-tone scale as you did with the oval, you will see how light and shadow are distributed on a cube.

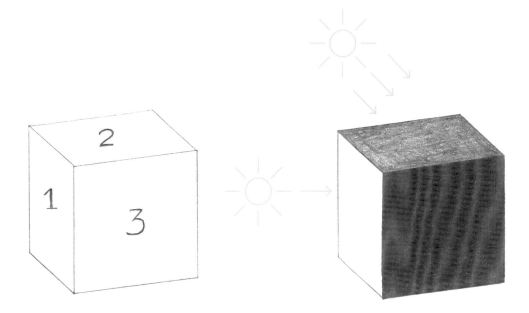

As with the oval, the light comes from the left side: tone 1. Tone 2 on top, and tone 3 in front, the area less exposed to light.

Fill in the tones referring to the numbers. This exercise allows you to envision basic light and shade distribution on a three-dimensional parallelogram.

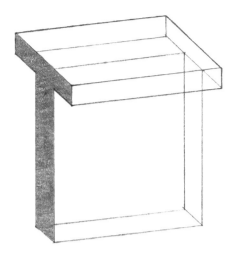

Now combine both lessons to draw a silver ring with a rectangular decorative element. Place the rectangle on top of a frame for the circle, making sure they are aligned along the center, forming a "T" shape from the side. The frames determine the proportions of each element.

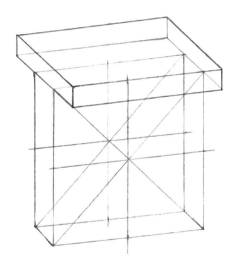

In order to draw the ring itself in perspective, draw the frame's front and back horizontal and vertical axis.

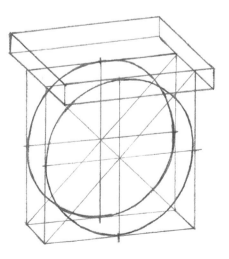

The two circles that you draw have to go through the crossing points of the vertical and horizontal axis with the lining of each square.

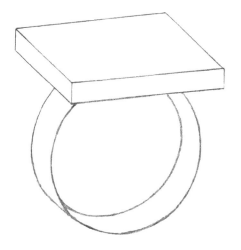

Erase the circle's frame, and you are left with the three-dimensional form of the ring. This drawing serves as a basis for the next two steps.

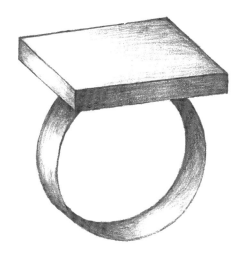

In order to draw the shadows on the ring, remember how you set the shadows on the oval and the cube. In this example, the light comes from the left side.

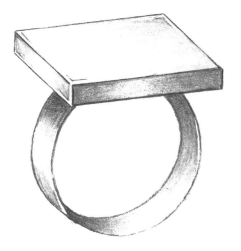

This being a polished ring, you can make it look shinier with a white gel pen. Draw thin lines on each border, where the shadows are the darkest. Highlights always go on the darkest points of the drawing.

Silver and cabochon stone

In this example you can use variations of the first exercise, and add a cabochon-shaped gemstone. The square shape is the ring itself, and the round shape is the decorative element (bezel and stone). You will learn how to draw a silver ring and a colored, cabochon gemstone.

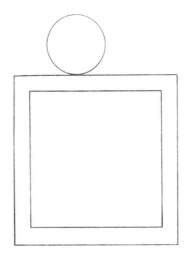

First, draw a square inside another: the distance between either square indicates the thickness of the ring. The circle placed on the square represents the stone and its position.

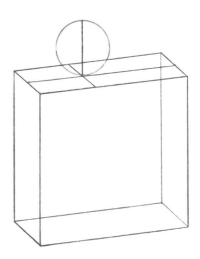

Imagine the placement of the round element on top of the square ring. The vertical line indicates the base of the bezel.

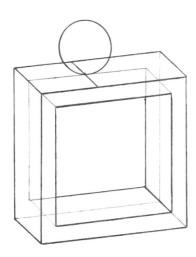

Draw the correct shape of the ring by using the cavalier perspective—drawing lines jutting out at a 45° angle from each corner. The length of the lines determines the width of the ring.

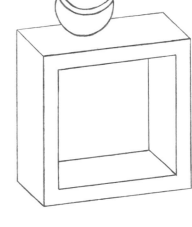

Erase the unnecessary lines and indicate the edge of the bezel by drawing a curved line that follows the rounded shape of the stone. The thickness of the bezel is indicated by a ledge on the outsides of the stone. Draw a rounded, triangular highlight where the light hits the stone.

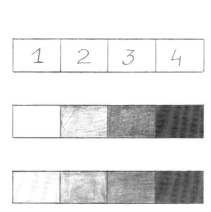

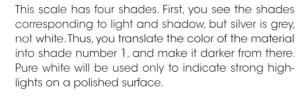

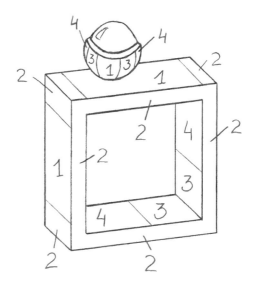

This scale has four shades. First, you see the shades corresponding to light and shadow, but silver is grey, not white. Thus, you translate the color of the material into shade number 1, and make it darker from there. Pure white will be used only to indicate strong highlights on a polished surface.

Divide the light and shade in the same manner you did earlier, light coming from the top left-hand side.

Fill in the different shades referring to the scale numbers. Try to blend the shades softly into one another. The gemstone highlight remains white.

Use grey pencils to indicate the material (silver). Soften the graphite shadows where necessary, and indicate form with shades of a grey pencil instead. For the gemstone (see page 20), use a blue pencil to replace graphite shadows with shades of blue. Use a gel pen for highlights on metal.

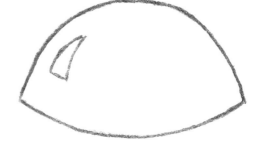

First, draw an outline of the gem's shape with a pencil. We are focusing on the classical cabochon cut, which is smooth and rounded.

All gems reflect light. A simple and effective way to indicate light is to draw a small rounded triangle where it hits the stone. Here, light is shining from the left.

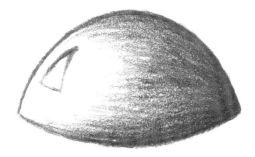

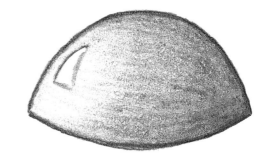

A black and white image may help you to visualize the shading. Because light comes from the left, the right side must be dark. The highlighted triangle is always white.

In this case the stone is blue. Follow the same shading pattern as with the graphite pencil. The highlighted triangle is always white, but its outline is blue.

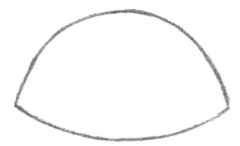

Some cabochon-cut gems have a star-shaped highlight. First, draw the outline of the gem.

The rules for the highlight are the same as with the normal cabochon gem, but move it slightly to the right in order to have space to draw its star shape. The axis of the star is rounded to follow the surface of the stone.

A black and white image may help you to visualize the shading. Because light comes from the left, the right side must be dark. The highlighted star is always white.

In this case the stone is orange. Follow the same shading pattern as with the graphite pencil. The highlighted star is always white, but its outline is orange.

Gold and facetted stone

The ring we draw now is made of gold. It has a more complex shape, and includes a facetted gemstone. You will learn which colors you can use to draw gold, and how to draw polished versus matte surfaces. You will also see how to draw a faceted gemstone in color and learn how to set its highlights.

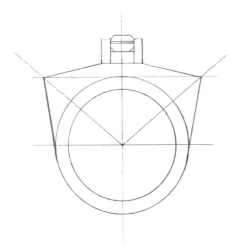

Draw the side view of the ring in two dimensions to determine its proportions. Use a compass to draw the circles and a ruler to draw the axis and all other lines of the ring.

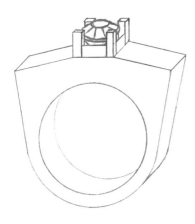

Draw the ring in three dimensions using the cavalier perspective. Remember how you drew ovals when you draw the small gemstone inside the ring.

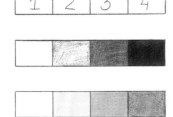

Use a scale of four shades to draw gold: one white, and three yellows. Number 4 is close to brown and it represents the darkest shades in the drawing.

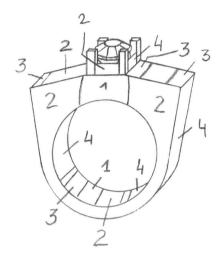

Divide your drawing in parts as shown in the example. It will help you to set the right color at the right place to make the drawing look good.

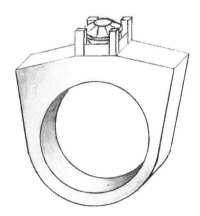

This is how to draw a matte golden surface. The different shades of yellow are mixed softly with each other. There are no hard lines.

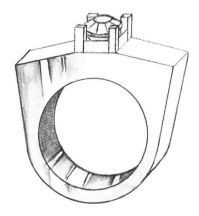

Here you see how to draw a polished golden surface. The colors are separated with hard lines of number 4. The lightest color is always set next to the darkest.

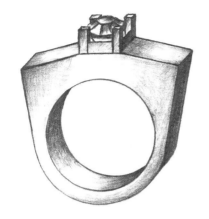

To help you with the shading, imagine it in black and white. In this case, the surface is made matte.

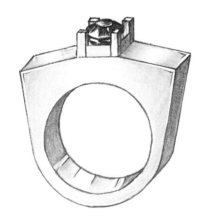

Here is a finished drawing of a matte golden ring. As you can see in this example, even matte rings usually have a polished inner surface for comfort.

When drawing the gemstone, first draw an outline of the faceted gemstone from the side. In spite of the visual division in top and bottom, the direction of the light will determine the shading.

To draw a gemstone in three dimensions and in perspective, follow the example. Facets may be simplified. The lines have to be very clean. Rows of facets are usually the same size all around the stone.

Imagine a vertical axis along the gemstone. If the light comes from the left, the right half will be darker. Draw it in black and white. One high-lighted facet remains completely white.

Choose a color you like to draw the gemstone, and replace shades of grey with shades of that color. Remember the vertical axis, and leave one facet and the top left of the stone white.

Complex curves

This example shows you how to draw a ring that has different curves. First, imagine a side-cut of the ring in two dimensions, then frame the volume within a three dimensional parallelogram to help determine the correct perspective. You will also learn how to draw polished curved surfaces.

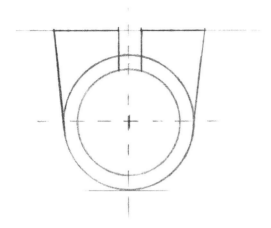

Use a compass and a ruler to draw the simplified form of the ring from profile. The horizontal and vertical axis will help you to achieve symmetry.

Erasing unnecessary lines will take you from a flat, geometrical vision to a simple, side view of the ring that also indicates basic volume.

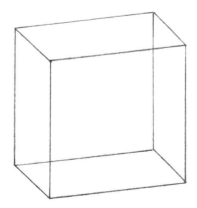

Construct a parallelogram whose height and widest measurements are the same as the ring. The cavalier perspective gives you guidelines to draw the rest of the ring in proper perspective.

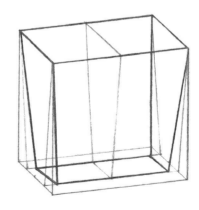

Using the frame, reduce the proportions of the parallelogram to follow the narrowing at the bottom of the ring.

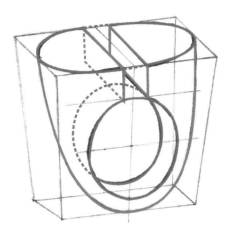

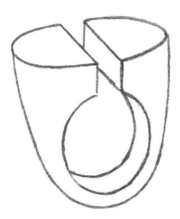

The shape looks complex, but focus on the basic geometry: one large, flat oval at the top (cut in two), two rectangles facing each other at the cut, the circle of the finger part of the ring, and an arc following its curve. Remember how you drew these elements in perspective in previous examples.

Erase unnecessary lines. The form that is left serves as a template for the upcoming steps.

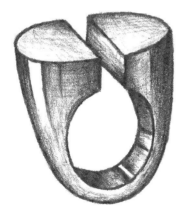

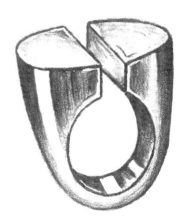

Using a pencil, fill in the basic shadows as shown, and remember that shine and highlight always go next to the darkest shade. In this case, the light source is more diffuse, which allows for subtler definition of the rounded shapes.

Use grey pencils to draw the silver surface of the polished ring. The gel pen highlights add shine.

Butterfly clasp and duplicate drawings

In this exercise you will learn how to draw earrings. These are yellow gold, with a white gold accent. Enlarged drawing exercises of a basic pin and butterfly mechanism will allow you to understand their construction, and you will see how to make sure both earrings are identical.

Draw the rectangular form of the earring in the front view. Mark the spot where the pin will be placed with a vertical and a horizontal line.

Now draw the earring in cavalier perspective. The length of the lines indicates the thickness of the earring.

Draw the earring from the side, including the pin in its correct position, and a profile view of the butterfly. You will see how to draw these parts in detail over the next pages.

To illustrate the pin of the earring in detail, draw the basic rectangular form, and mark the butterfly slots with two pairs of horizontal lines.

Draw little inward curves to indicate the slots. The upper corners must also be curved as the tip of the pin is always rounded.

First, use a pencil to draw the shadows on the pin. Since the light is coming from the left side, the left side stays clear and the right side dark. The slots are slightly shaded on the top right.

As the pin is made of gold, use yellow and brown pencils to draw the corresponding shadows.

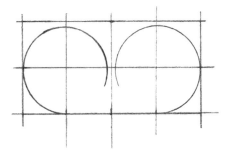

Start with constructing a frame. Divide it vertically into four equal parts, and mark the horizontal axis. Use a compass to draw two incomplete circles. Their center is one millimeter outside the 2nd and 4th lines. This is the profile cut of the butterfly.

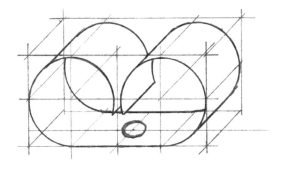

Use the cavalier perspective to draw a three-dimensional frame as deep as the butterfly is wide. Extend all lines of the butterfly at a 45° angle as shown in the example. Place the oval indicating the pin hole at the center of the bottom of the frame.

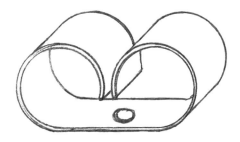

Erase all unnecessary lines. Draw a parallel line to the profile cut of the butterfly and an additional curve inside the pin-hole oval, in order to indicate the thickness of the metal.

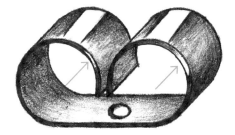

The butterfly is made of gold and has a polished surface. In order to draw the highlights, use black lines next to white ones. Note the highlight on the profile cut of the butterfly.

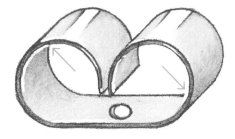

Use yellow and brown pencils to draw the golden butterfly. White gel pen highlights interrupt the outline of the butterfly where one section of metal comes in front of the other. This enhances perspective.

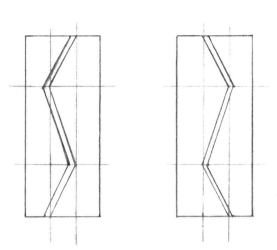

If you have to draw two identical, mirrored pieces, draw them frontally and on the same level first. Use the same measurements for both drawings.

Erase all unnecessary lines, and add perspective to the earrings. Draw them on different levels if you want to make your illustration more dynamic.

Use your pencils to draw shadows following the same rules as on page 15. The shadows look the same on both because the light comes from the same direction.

Use yellow and brown pencils for the yellow gold, and a grey pencil to emphasize the zigzag white gold accent.

Combination exercise

The earrings you are going to draw now have a more complex geometrical form, and two different types of stones, which you will learn how to draw at the end of the exercise—diamonds seen from above, and a pyramidal-color gemstone. You will also see how to draw an earring hook mechanism.

Draw a frontal two-dimensional view of one earring. In the upper part, put three little circles to represent the diamonds. The lower triangle represents the gemstone.

Draw the earring in cavalier perspective. Focus on the basic geometry: the volume is determined by three squares of different sizes sitting one above the other, the bottom one finishing in a point. Use the vertical axis that goes along the center of the squares as a guideline.

Erase all unnecessary lines and you will obtain a clear, three-dimensional form. This form serves as a template for the next steps.

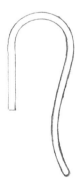

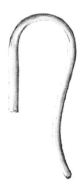

One of the most popular mechanisms for an earring is the hook. Here is an outline of a classic hook. There are many variations, but they always follow the same basic shape.

Since the hook always follows the same basic shape, the shading is similar for all variations. As this hook is made of gold, use yellow and brown pencils to draw the shadows.

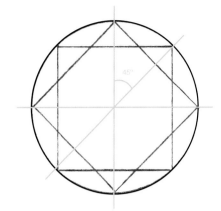

On this page you will learn how to draw a frontal view of a classic brilliant diamond shape. Choose the diameter you need, and draw a circle with a compass.

Draw two squares at a 45° angle from each other inside the circle. Use their diagonals to help you with this, and then erase them. You obtain sixteen triangles that represent the facets of the diamond.

Imagine a diagonal line like you see in the drawing. All the inside triangles on the left side are highlighted, and all the inside triangles on the right are shaded.

Conversely, all the outside triangles on the left are shaded, and all the outside triangles on the right are highlighted. By inverting the white and black accents, the reflections look quite realistic.

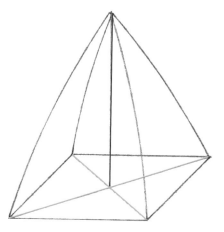

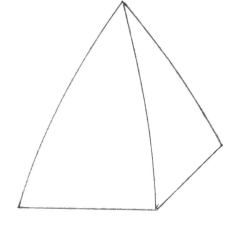

This example shows you how to draw a color gemstone in the shape of a pyramid. Draw a square and determine its center using its diagonals. To determine the top of the pyramid, draw a vertical line of the appropriate length rising from the center. If the pyramid is normal, use a ruler to connect the corners of the square to the top. If the pyramid is rounded, use an oval template ruler to draw these lines.

Erase all unnecessary lines, and you obtain a three-dimensional view of the gemstone.

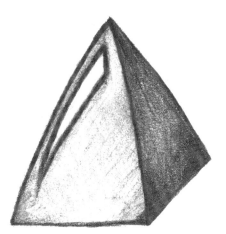

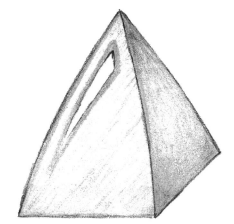

Use pencils to draw the shadows. On the front facet, draw a rounded triangular highlight that follows the curve of the stone's surface. This triangle remains white.

Choose a color for your gemstone, in this case, green. Light comes from the left side. The reflection stays white, but is outlined in green.

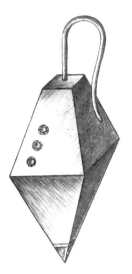

Combine the form of the earring with the drawing of the hook. Place it in the center of the top square. Draw diagonals if you need help to be more precise and erase them afterwards. This drawing serves as a template for the next steps.

Draw the shadows with a pencil,—light coming in from the left side. The diamonds are theoretically the same as on page 33, but in this case they are so small that you may simplify them.

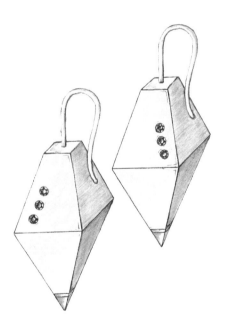

Draw both earrings in color. They are mirror images of each other. Use the gel pen to give a brilliant touch to the drawing.

Pearls

Next, you will learn how to draw pearls. In this case we used Grey Fumée Canson 160 g/m² paper. Color and paper weight are very useful when drawing pearls, because the texture of the paper gives you a softer touch to the drawing. You can use white pencils, gel pens, and color pencils. The texture of this paper also gives a softer touch to the drawing.

Choose the diameter you need for the pearl, and draw a circle with a white pencil. Use a compass or a circle template to do so.

On the upper left side of the pearl we draw a circle with a white pencil. This represents the reflection of the main light source. A smaller circle represents the reflection of ambient light.

The center of the pearl always looks darker, whatever its color. In this case, it is white. White pearls are usually drawn with grey colors.

This is a complete drawing of a white pearl: dark grey core, lighter shade of grey along the edge, and big and small reflections. The left outline is highlighted, while the right outline is in the shade. This adds definition to the edge of the pearl.

Use grey pencils for a white pearl. The core must be a little bit darker. Draw the left border with a white gel pen and the right with a black one.

To draw a grey pearl, use dark grey and black pencils. The right outline of the pearl is drawn in black to give it more definition. Only the light reflection is white.

For a pink pearl we need both a white and a pink pencil. Draw the core in pink. Use a white pencil for the right side, and the white gel pen for the left.

For a green pearl, use green and black pencils. Use green for the core, and draw the outer parts in dark grey. Outline the pearl with black.

Chains

On the next two pages a couple of gold chain variations are presented. Chains are a series of objects connected with each other, usually in the form of a series of metal rings passing through one another. This means that drawing a section of a chain is usually enough to get your idea across.

First, draw a pattern of the chain in pencil. Draw transparent links in order to help determine which part will be visible and which will not.

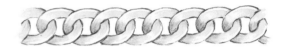

Erase the hidden part of each element of the chain. Use brown and yellow pencils to draw the shadows. Shadows go to the back part of the metal; highlights show the front part.

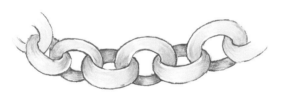

This chain has thick oval links. The front sections of the oval are drawn bigger than back sections to emphasize perspective. Use a gel pen for highlights.

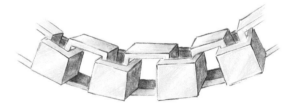

This chain consists of cubic links. Each link is drawn in perspective and shaded as in the first exercises.

Brooch mechanisms

In the next examples you will see a selection of brooch mechanisms. There are a lot of different types, but these are four classical examples. The first two are simple and very well known mechanisms. The last two are more technical, and thus more difficult to draw. The real trick to drawing these mechanisms is in understanding how they work.

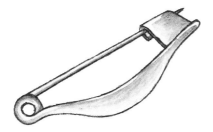

This mechanism is made of one forged piece of metal. It is often made in materials like copper, silver or even iron. Here it is drawn in gold.

This mechanism is made of two parts and a pin. The pin is fitted through the top section of the right part, which is a tube, and folded closed. Both its ends are held in place by the notches on the left part.

This mechanism swivels open and closed to maintain the pin in place. Here is a frontal view, open.

Here you can see the same mechanism drawn in perspective. The central section of the mechanism has been swivelled shut around the tip of the pin.

In this mechanism, the inside tube is pulled back to allow the pin to enter the outside tube, and then pushed back around the pin. Technically speaking, this is one of the most complicated mechanisms.

Clasps

Over the next couple of pages, you will see different types of clasps. The first three are simple, well-known mechanisms. The last two have concealed mechanisms and are usually used to close strings of pearls—they are often carefully hand-made by classically-trained goldsmiths.

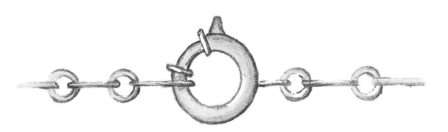

This most popular, and very classic, clasp is usually combined with simple, thin chains. It is opened and closed easily, and is very secure.

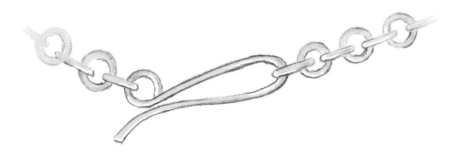

This clasp can be easily made with a pair of pliers. The curves may vary, but the basic circle-and-hook form always remains.

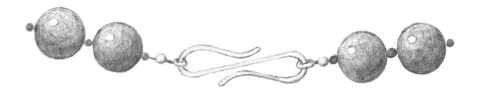

The symmetrical "S" shaped clasp is often combined with glass pearls or other heavy beads. It is very resistant and also very easy to handle.

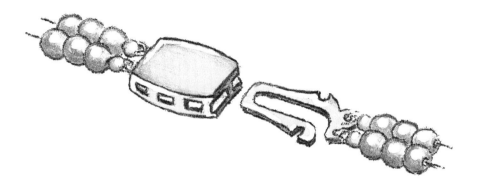

This clasp is often used for rows of pearls because it can vary in size. The hook is inserted flat into a slot on the side, and pushed back into the locking position.

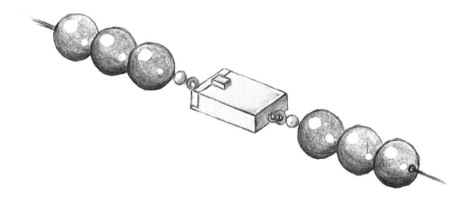

This clasp also has a concealed locking mechanism. From the outside however, it looks like a simple box with a button.

Cuts and color

In this final section, we will review the different types of gemstones (cabochon, square, and brilliant cuts) followed by an example of each in the setting, or bezel, usually associated with it.

Here you see an example of a color gemstone with a cabochon cut. This drawing shows a close-up of a classical cabochon setting, and its proper shading.

When you draw a square, facetted gemstone, it is important to concentrate on the reflections. It is important to remember, a gemstone without well-set reflections often looks unnatural. A gemstone with a square cut is often set in a box-like setting.

Here is a close-up of a classically cut blue stone, in a classical, solitary setting. The setting seen here is often used for big-facetted color gemstones. Its shape allows the light to illuminate almost every facet of the gemstone.

Last but not least, this is an example of a pavé setting, which can be used on flat or curved surfaces.

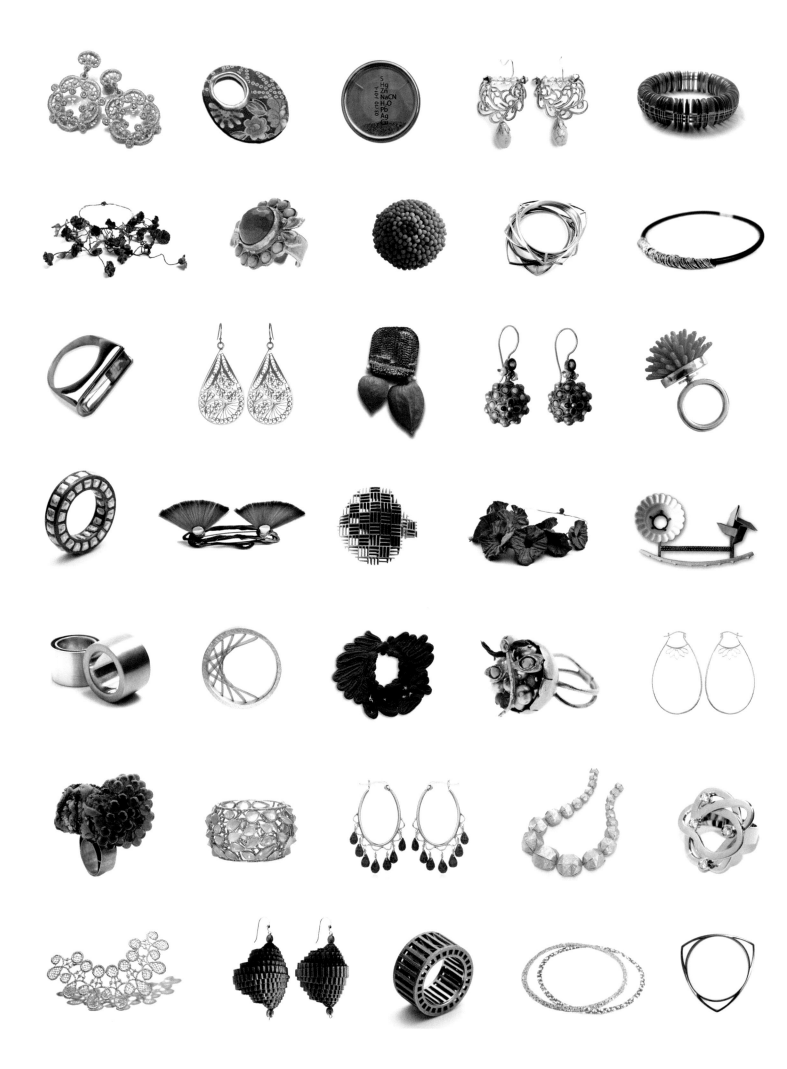

Contemporary jewelry designers

2212

www.2212.com.ar

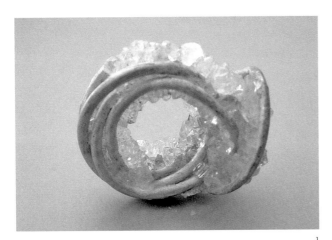

1

Today, Alejandra is the Argentine designer behind the firm 2212. But twenty years ago, she was a practicing psychologist. In 2002, attracted by the techniques involved and her need for creative expression, she began to train in jewelry design, and it quickly became her life's work. Most of her pieces are crafted in silver, because of the quality, color, and range of possibilities offered by this material. (Her firm takes its name from the boiling point of silver in degrees Celsius.) Her use of silver combined with copper, oxidized alpaca, and other materials imbue Alejandra's exquisite designs with style and taste.

If you didn't specialize in jewelry, what would you do?
I painted for many years, so that would be one possibility. Another career that I would have liked to have had, (apart from my earlier one in psychology) is biology.

Describe your work space in three words.
My second home.

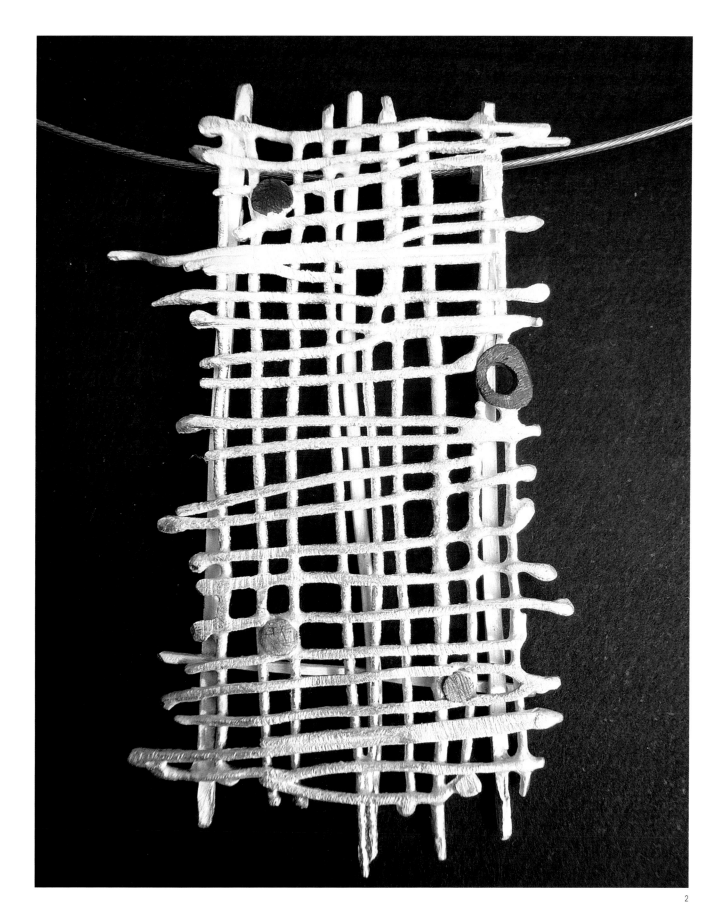

1. Ring
Silver 925 and borax crystals

2. Pendant
Controlled fire, silver 925,
bronze, and copper

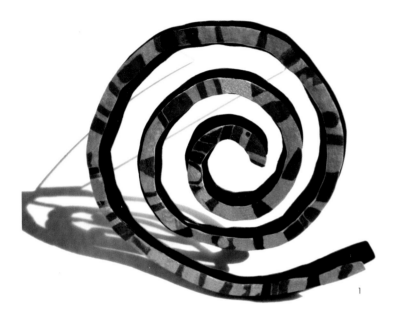

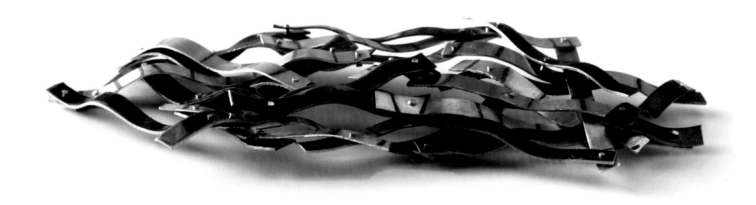

1. Brooch
Silver 925 with copper fusion,
bronze, and German silver
mounted on antiqued black
German silver

2-3. Brooch
Surgical steel, silver 925 with
copper fusion

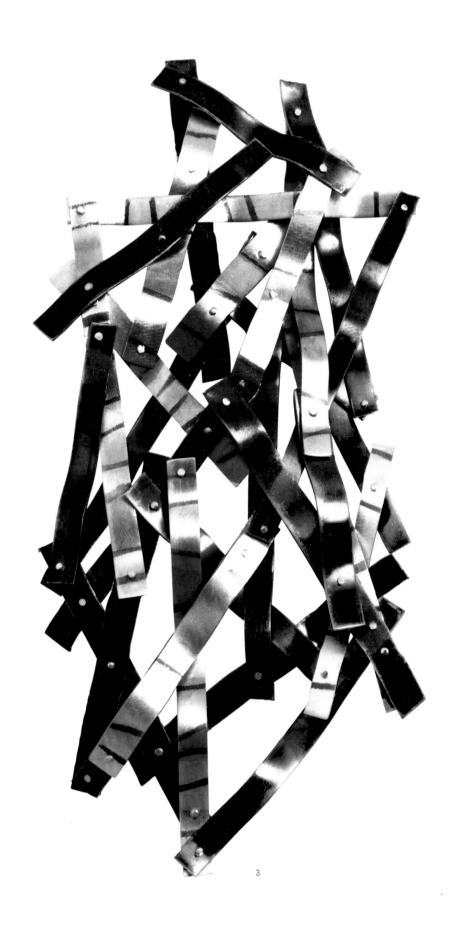

3

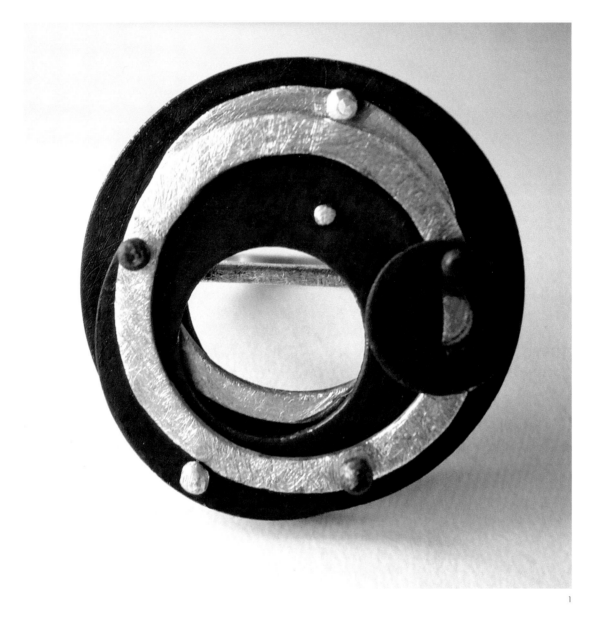

1

1. Ring
Silver 925 and antiqued
black copper with rivets

2. Ring
Silver 925 and copper
with rivets

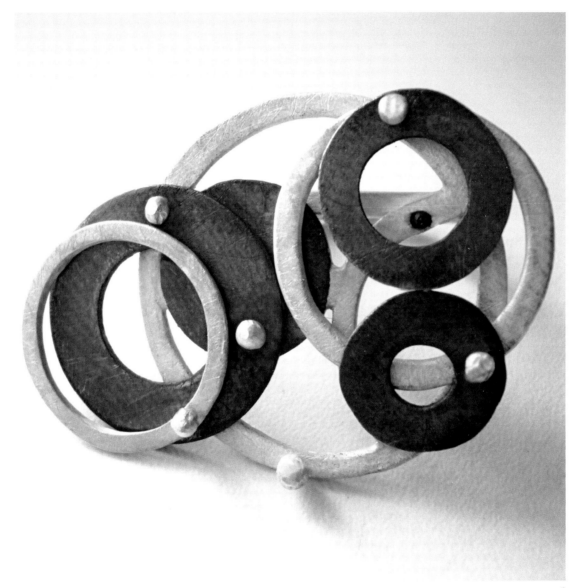

2

51

Adolfo Barnatán

www.adolfobarnatan.es

Adolfo Barnatán was born in Paris in 1951. Shortly thereafter, his family moved to Buenos Aires; as a teenager they moved again to Madrid, where he studied art and interior design. His early exhibitions were actually drawings, and it was not until the mid-1970s that he took an interest in volume and started to experiment with sculpture. In 1997, Barnatán began to produce his *Joyas de artista* ("artist's jewelry"), and since then he has continued designing jewelry, experimenting with ebony, obsidian, and gold. His work is characterized by sleek lines and striking contours.

If you could work with only one material, what would it be?
As a jeweler, I would choose gold, always in a matte format, and in its three colors. But as a sculptor, which is what I am, I would choose stone since this is the material that excites me the most and stirs me into action.

Describe your work space in three words?
Very light, spacious, and tidy.

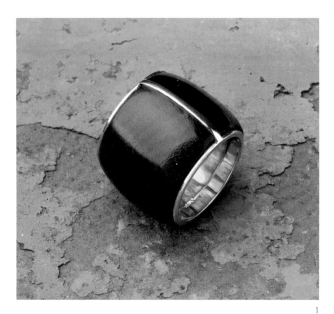

1

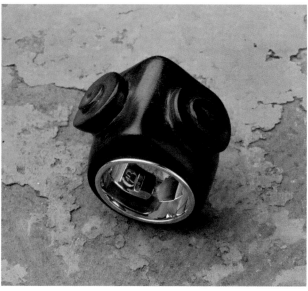

2

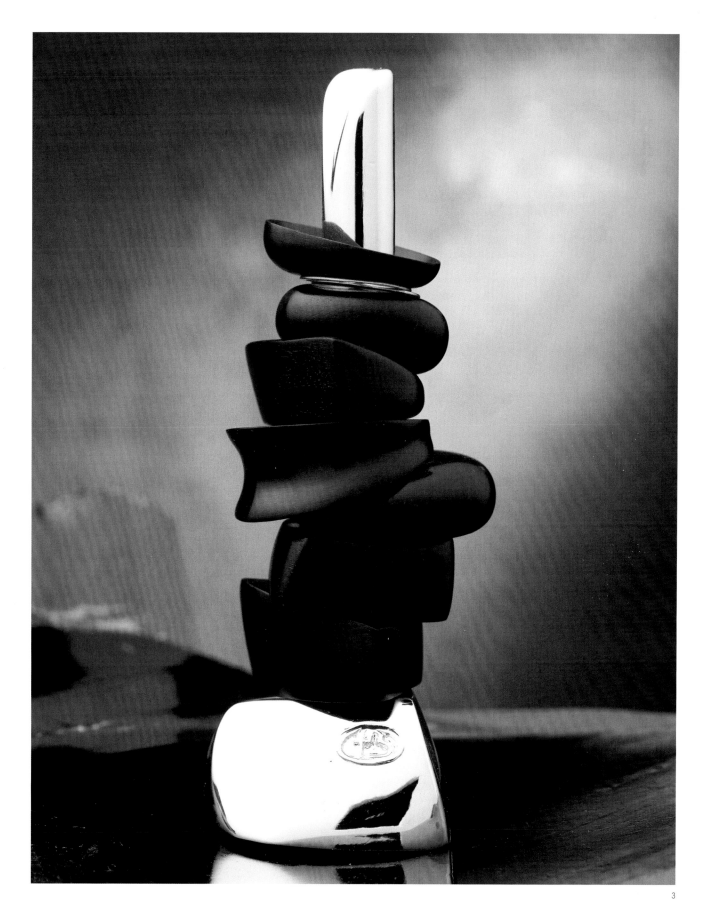

3

1. *Cylinder with line* ring
Ebony and 18-karat gold

2. *Constelado V* ring
Ebony and 18-karat gold

3. Bronze abacus with seven rings
Bronze with gold plating and ebony ring
with 18-karat gold

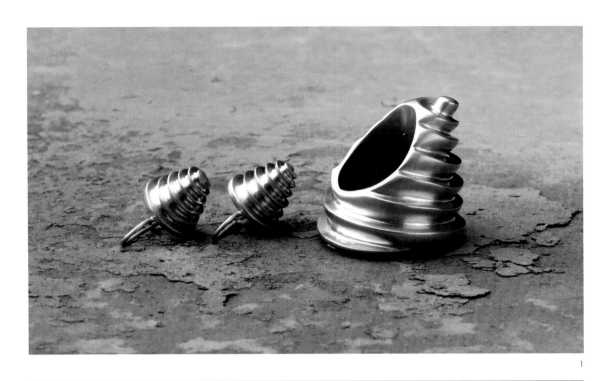

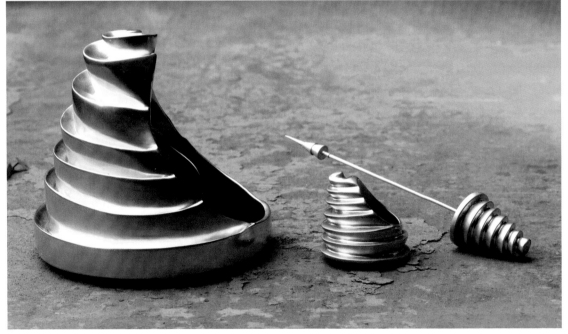

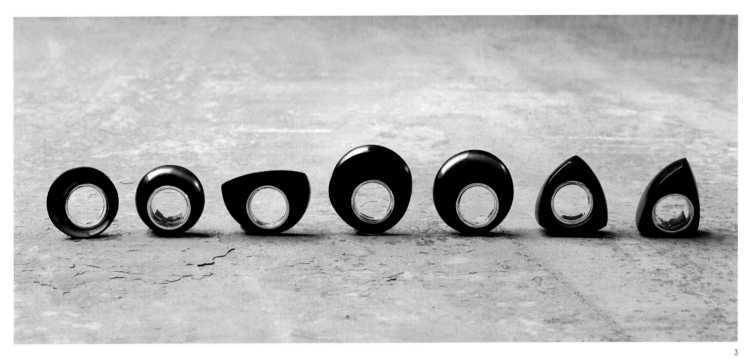

3

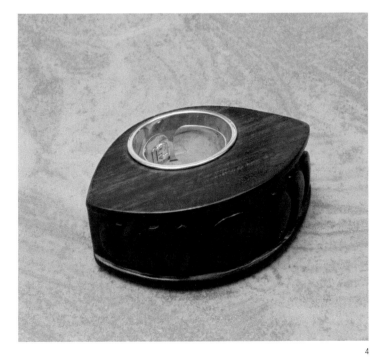

4

5

1. *Campana* collection
White gold ring and earrings

2. *Campana* collection
Red gold bangle, ring,
and grass spot

3. *Seven ebony* rings
Ebony and 18-karat gold

4. *Siete lunas* ring
Ebony and 18-karat gold

5. *Unicornio* ring
Ebony and 18-karat gold

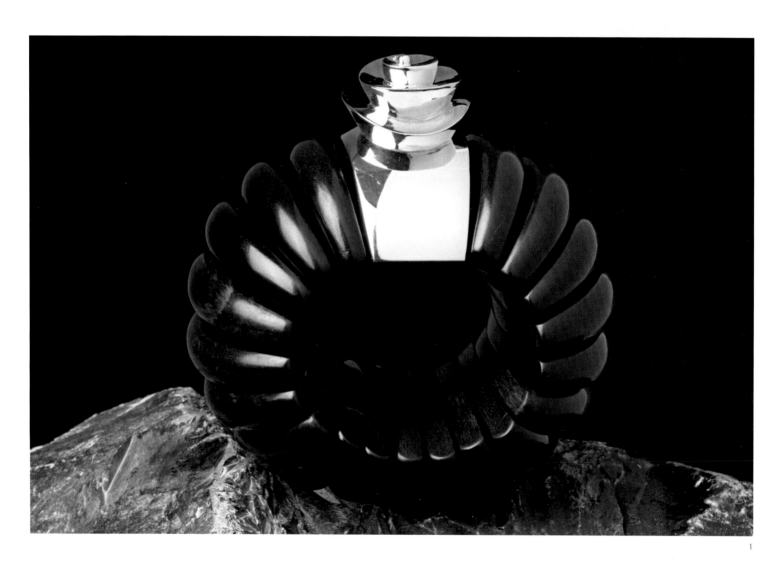

1. *Unicornio* bangle
Ebony and polished
18-karat gold

2. *Ebony* abacus with seven rings
Red gold, 18-karat yellow gold,
and ebony

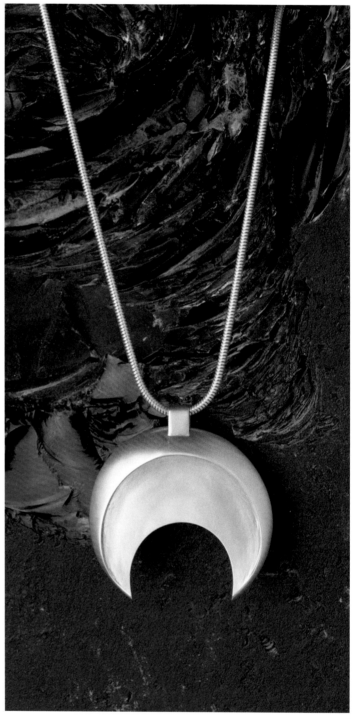

1. **Double ring**
White gold

2. *Luna nocturna con brillantes* **pendant**
18-karat gold and fine diamonds

3. *Luna descendente* **pendant**
18-karat gold

4. *Sol bandas* **pendant**
18-karat gold

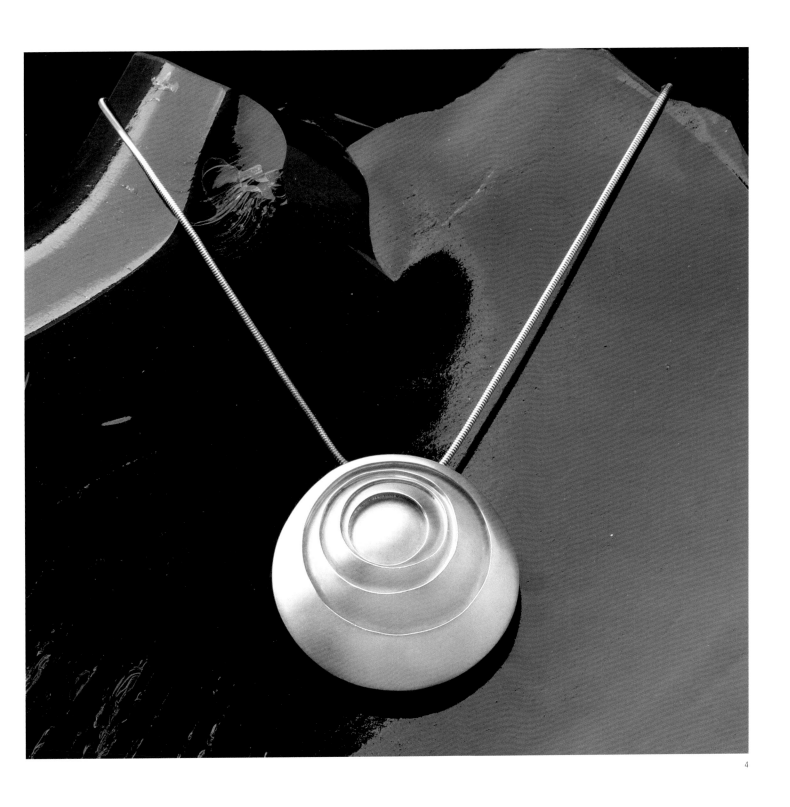

Ana Hagopian

www.anahagopian.com

Ana Hagopian was born in Buenos Aires and now lives in Spain. She studied fine art and interior design at the University of Buenos Aires. After spending several years traveling in Asia, Africa, and South America, she started to work with paper, almost by accident. Her paper creations reflect Hagopian's ongoing contemplation of nature, organic forms, colors, shades, and textures. Her pieces are light and ethereal, like flowers and leaves. To her, the use of paper is a form of provocation: the example of how a humble, accessible material can be turned into a piece of jewelry. Her work has been shown in solo and group exhibitions in Europe, Japan, and the United States.

If you didn't specialize in jewelry, what would you be?
An interior designer or anything related to the care and preservation of animals.

If you could work with only one material, what would it be?
The one I have chosen: paper.

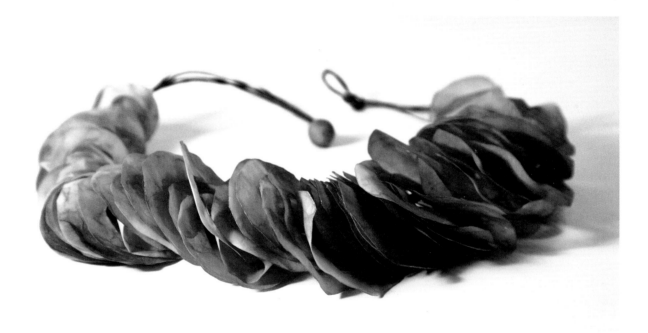

1

2

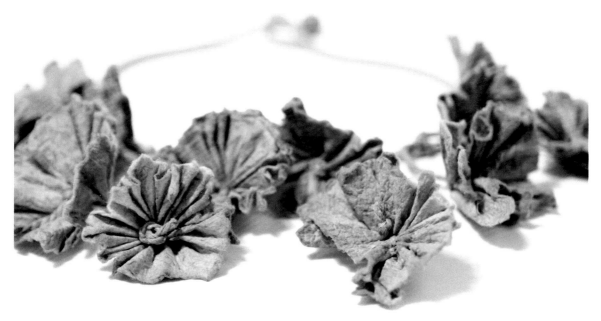

3

1. *Seaweed* necklace
Paper

2. *Air* necklace
Paper

3. *Grapevine* necklace
Paper

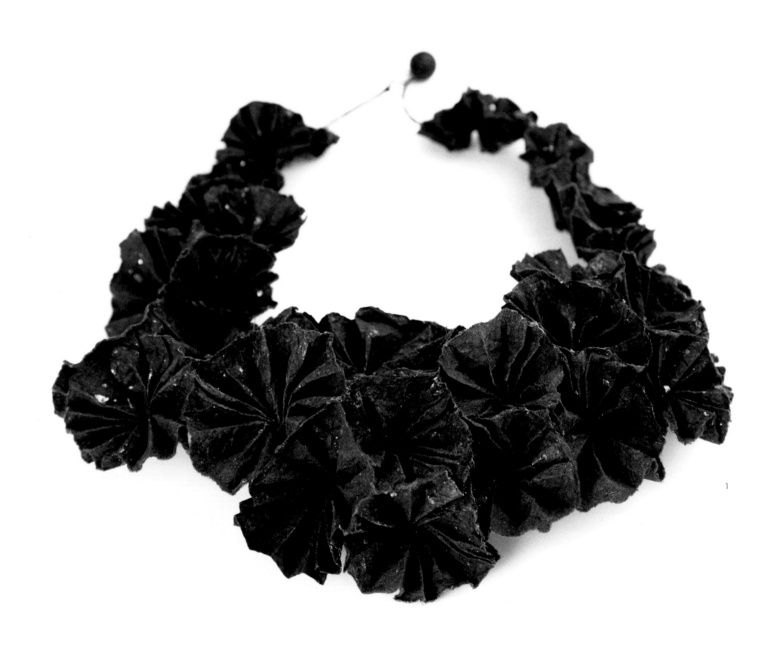

1. *Fossil* necklace
Paper

2. *Camellia* necklace
Paper

3. *Anemona Red* necklace
Paper

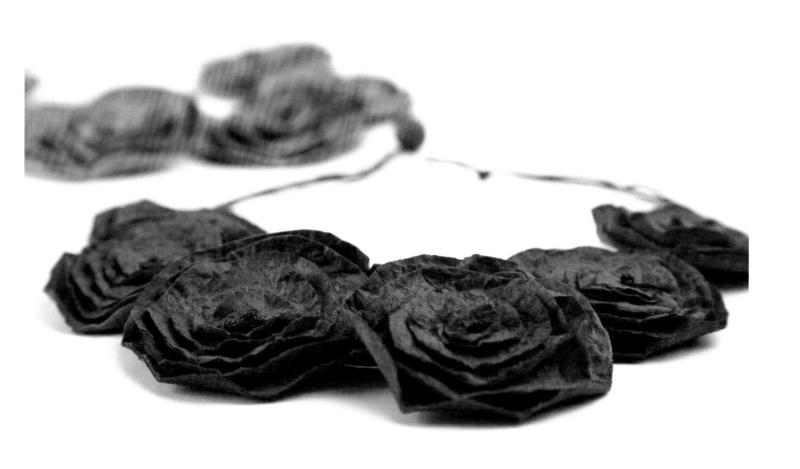

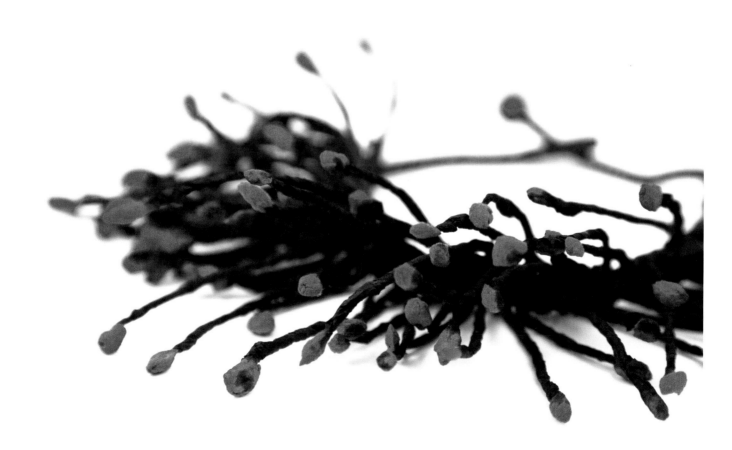

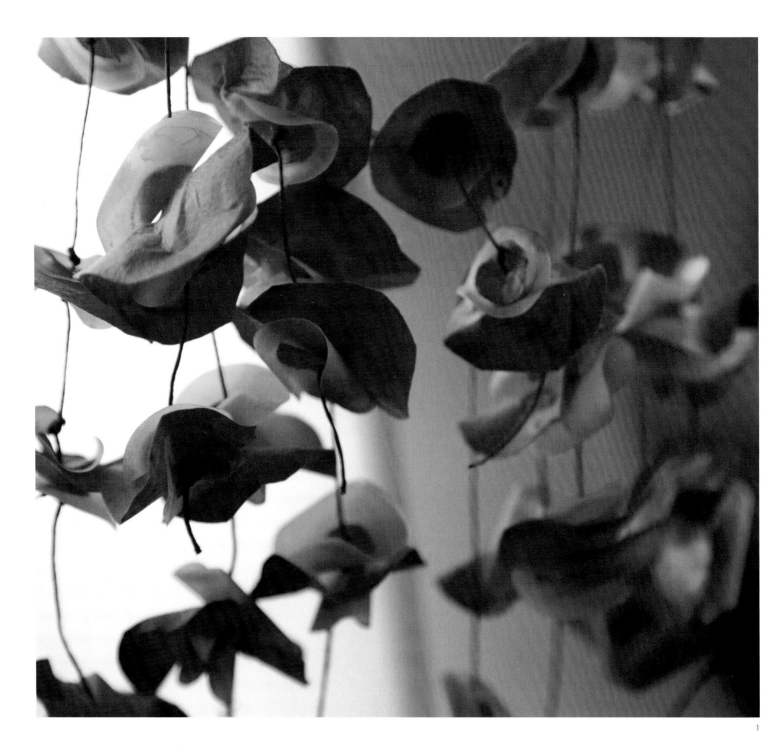

1. *Fresia* necklace
Paper

2-3. *Amarillis* necklace
Paper

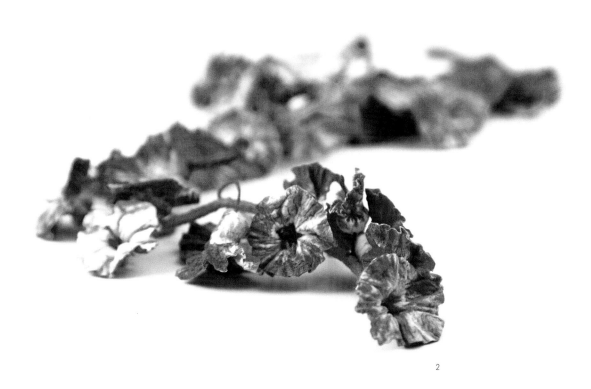

2

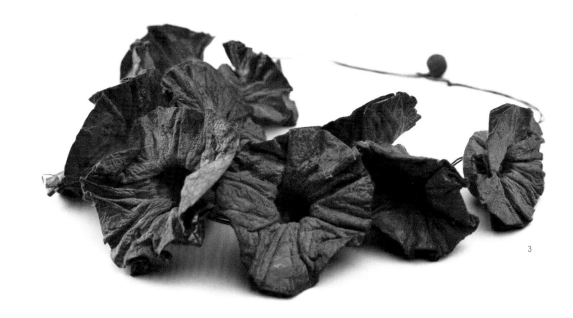

3

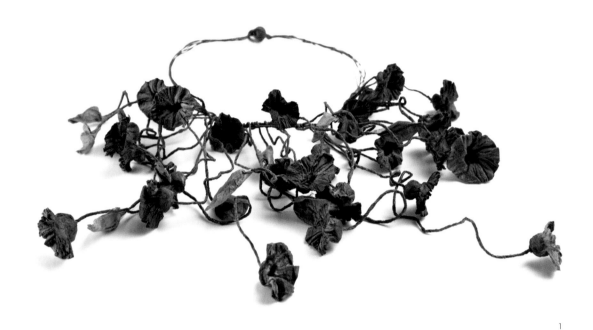

1

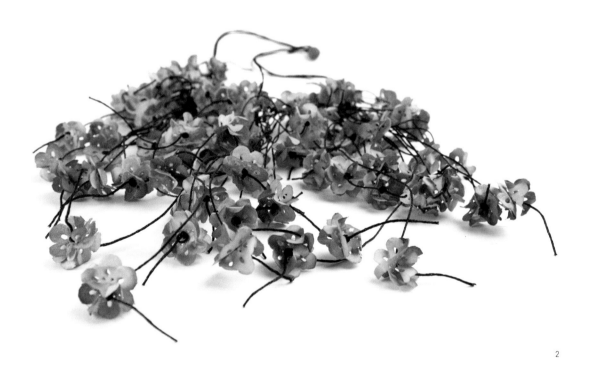

2

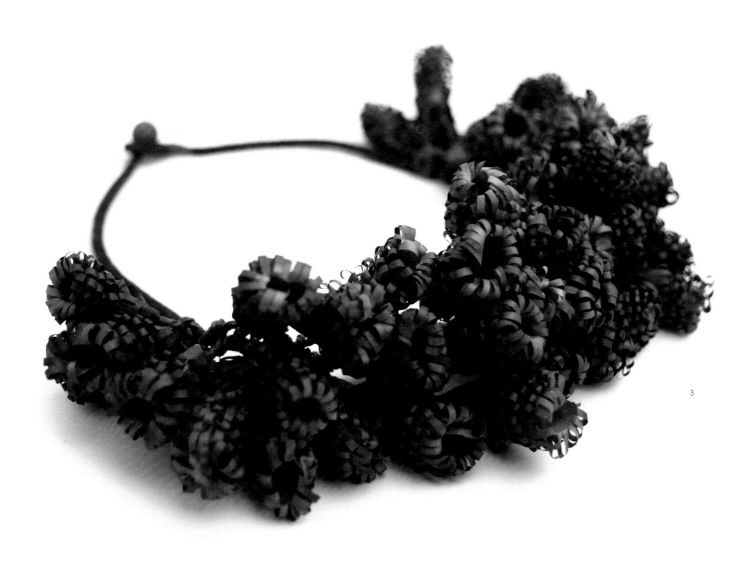

3

1. *Campanula* necklace
Paper

2. *Cherry blossoms* necklace
Paper

3. *Raspberry* necklace
Paper

Ángela Carrillo

angelacarrillojoyas.blogspot.com

Industrial designer Ángela Carrillo studied at the Jorge Tadeo Lozano University in Bogotá, Colombia, where she specialized in jewelry. There she developed a style defined by plasticity, color, textures, techniques, and experimention with combinations of materials. Her pieces are strongly influenced by natural objects and her love for the handmade. Carrillo's work has been shown at a number of international exhibitions in Colombia and Europe.

If you could work with only one material, what would it be? Gold. The nobility of this metal and its possible variations are really wonderful. Throughout my relationship with this material, it has taught me some very important concepts, including precision, respect, and the value of each element.

If your work involved contemporary music, what style of music would it be? Acid jazz with a bit of Lounge. Acidjazz has highly structured, harmonious elements; a constant search for new, idiosyncratic forms of expression; and an attitude that is fresh, contemporary, and upbeat. Lounge brings a hint of sobriety and a suggestion of soft, cool, refined rhythms.

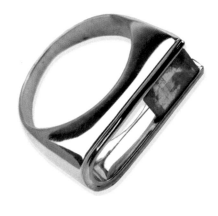

1

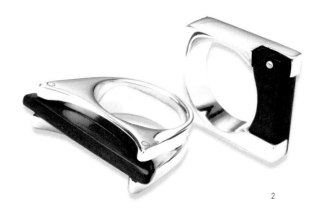

2

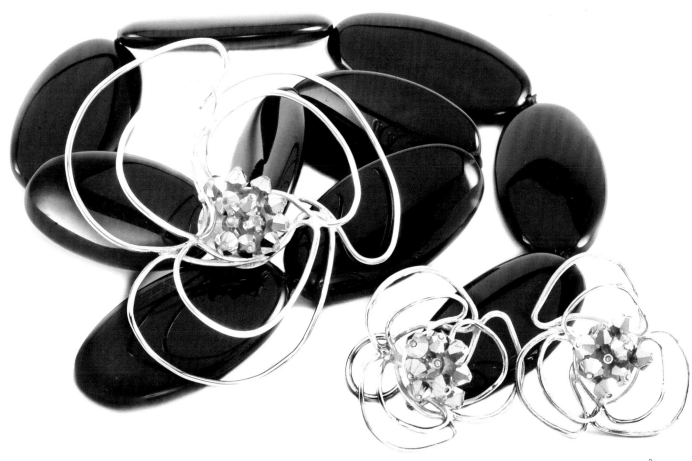

3

1. *Emerald green dimension* ring
18-karat yellow gold, 18-karat white gold, and emerald, casting and reinforced setting

2. *Orient* and *Zigzag* rings
Silver 925 and satine, casting or lost wax, reinforced setting

3. *Vie en rose* necklace
Silver 925, onyx, and Swarovski crystals, mounting

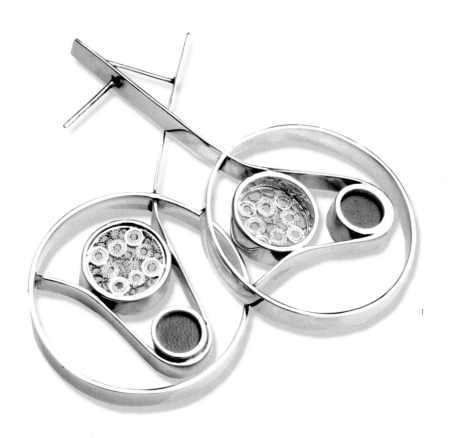

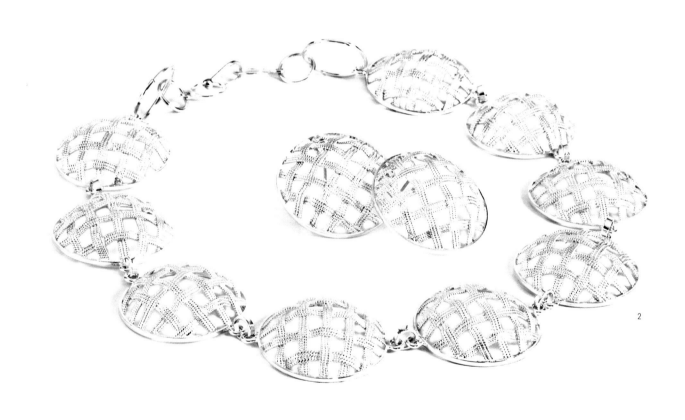

2

1. *Wave* earrings
Silver 950 and leather,
mounting and filigree

2. *Taffeta* necklace
Silver 950, filigree

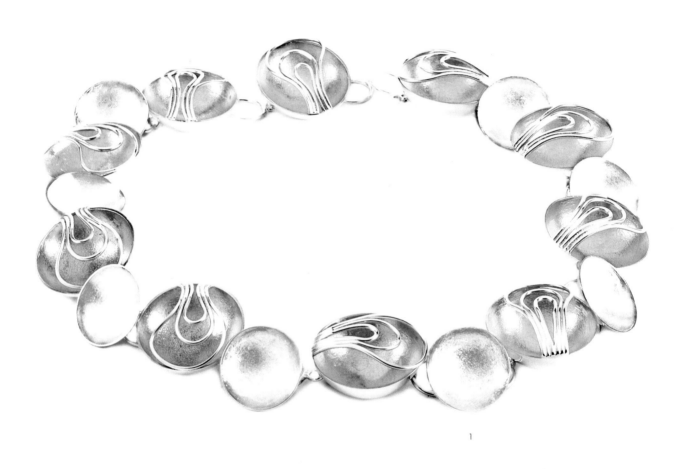

1

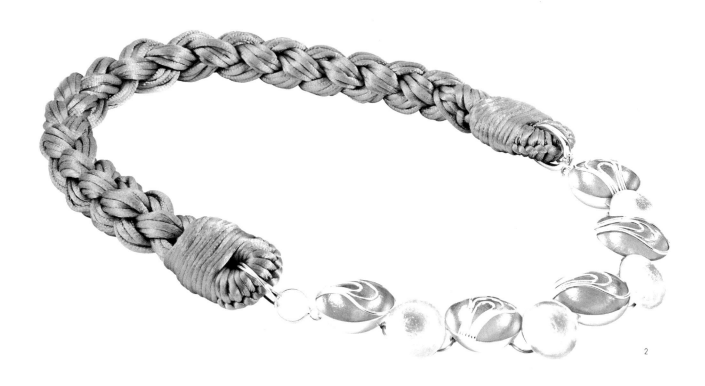

2

1. *My shell bi* short necklace
Silver 950 with 18-karat gold
plating, mounting

2. *My shell* silk long necklace
Silver 950 with 18-karat gold
plating and handwoven silk cord,
mounting

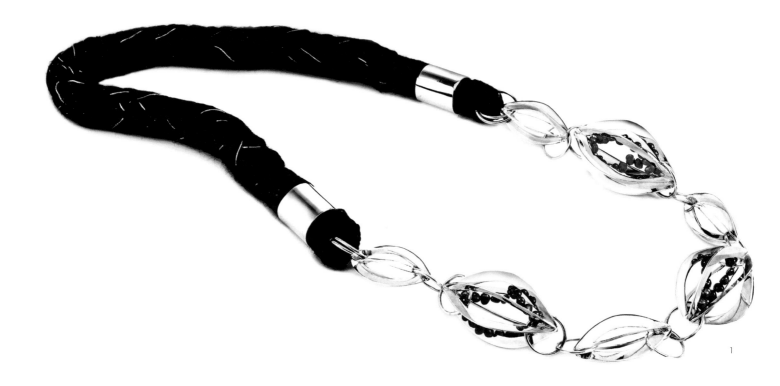

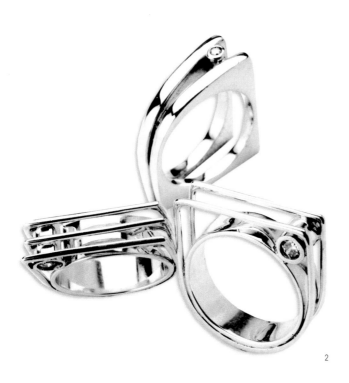

1. *Tropical fruit* necklace
Silver 925, cultured pearls, and handwoven
silk cord, mounting

2. *Sydney & Calatrava* rings
Silver 925 and zircon, mounting

3. *Amores con sentidos* necklace
Silver 950 and red fossil, mounting

4. *Aqua* rings
Silver 925 and acrylic, mounting

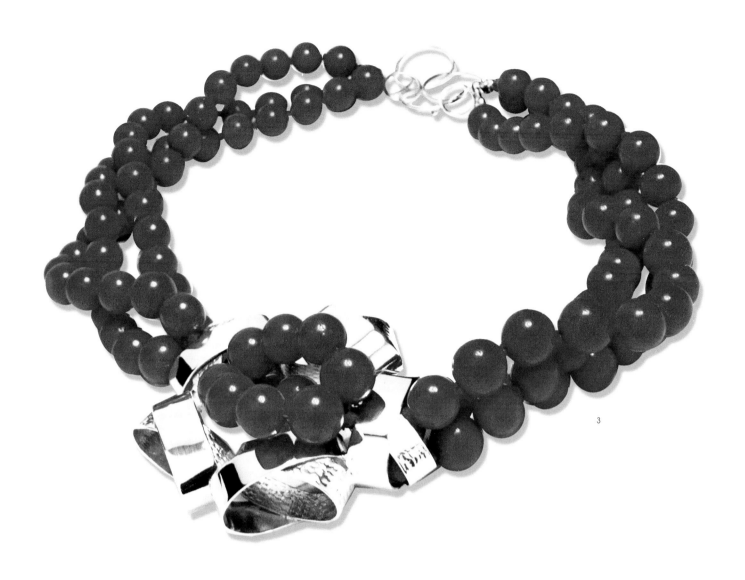

3

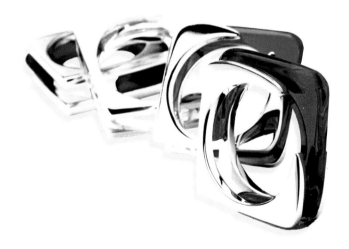

4

Angela Simone

www.angelasimone.it

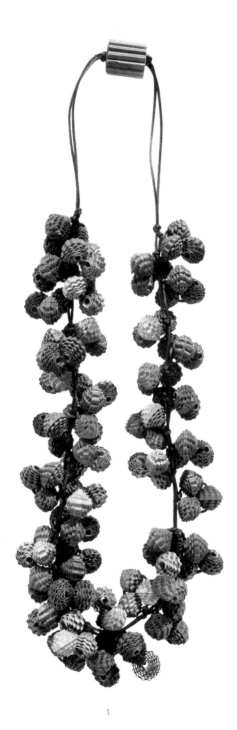

1

Angela Simone was born in Albenga, Italy, in 1963. She moved to Milan at the age of 20 to study advertising and graphic design at the European Institute of Design. Three years later, she began to work for fashion and beauty magazines, while cultivating her passion for paper as an art form. By using paper with a range of textures—such as *suminagashi* (marbled paper) or *quilling* (rolling or coiling paper)—in her jewelry designs, she is able to connect the two dimensions of paper with the three dimensions of jewelry. Simone has taken part in major jewelry shows and seminars, and her jewelry has appeared in magazines such as *Elle*, *Glamour*, and *Vanity Fair*.

If you didn't specialize in jewelry, what would you be?
I am very eclectic. My real profession is graphic design, but I find all types of creative work interesting.

If you could work with only one material, what would it be?
My dream is to get to know and work with all types of materials: ceramics, wool, iron, glass…. I need my own Aladdin's lamp!

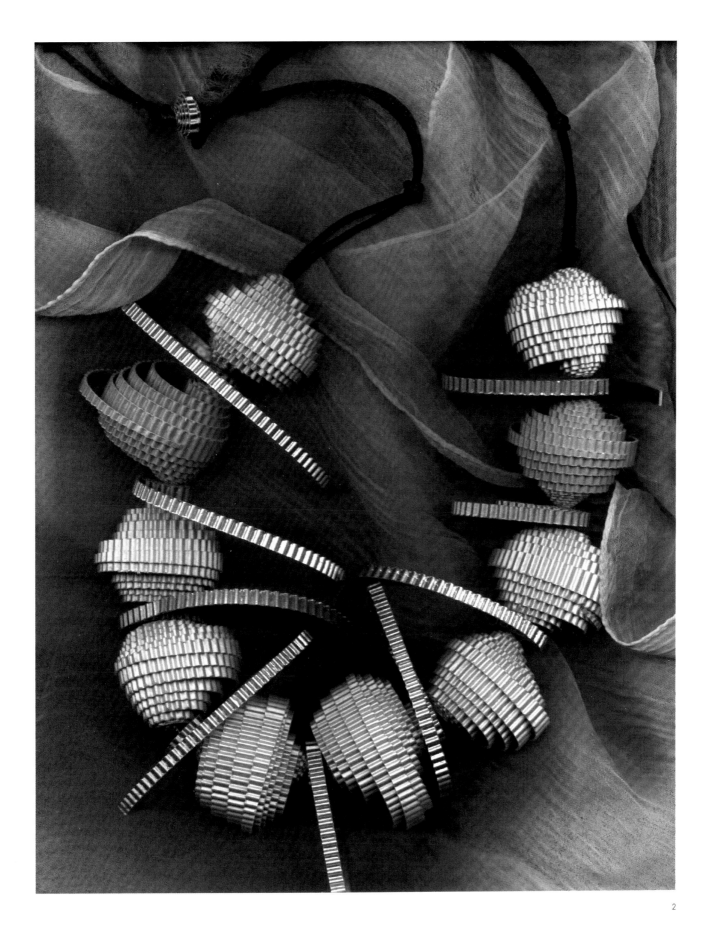

1. *Corallo* necklace

Orange/white corrugated
cardboard and silk thread,
quilling technique

2. *Pianeti* necklace

Silver corrugated cardboard
and silk thread, quilling
technique

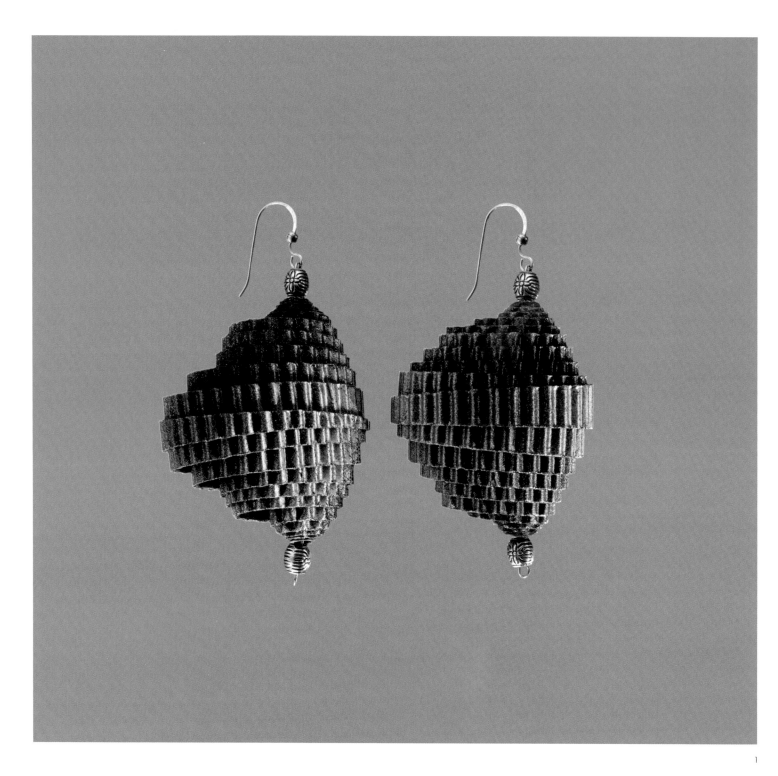

1. *Srotolat* earrings
Blue/black corrugated
cardboard, silver, and silk
thread, quilling technique

2. *Conchiglie* necklace
White corrugated cardboard,
silk thread, and white rice pa-
per balls, quilling technique

3. *Srotolata* necklace
Blue/black corrugated card-
board, silver, and silk thread,
quilling technique

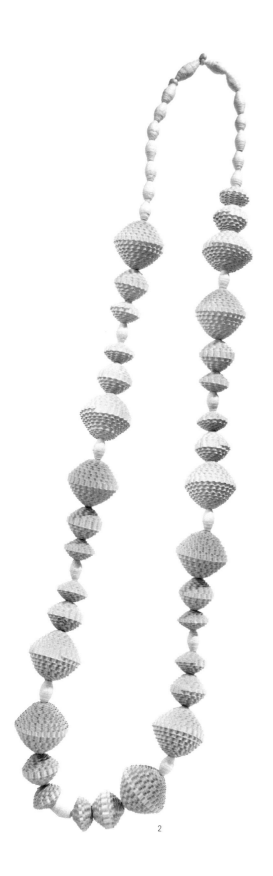

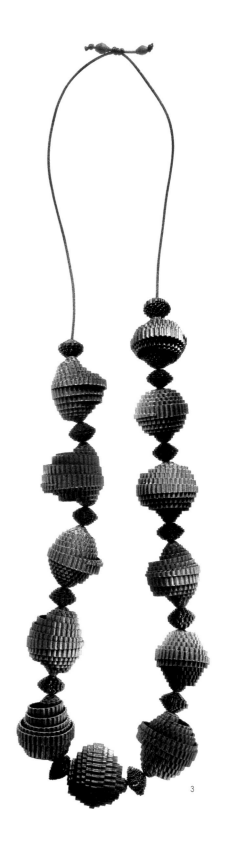

2

3

79

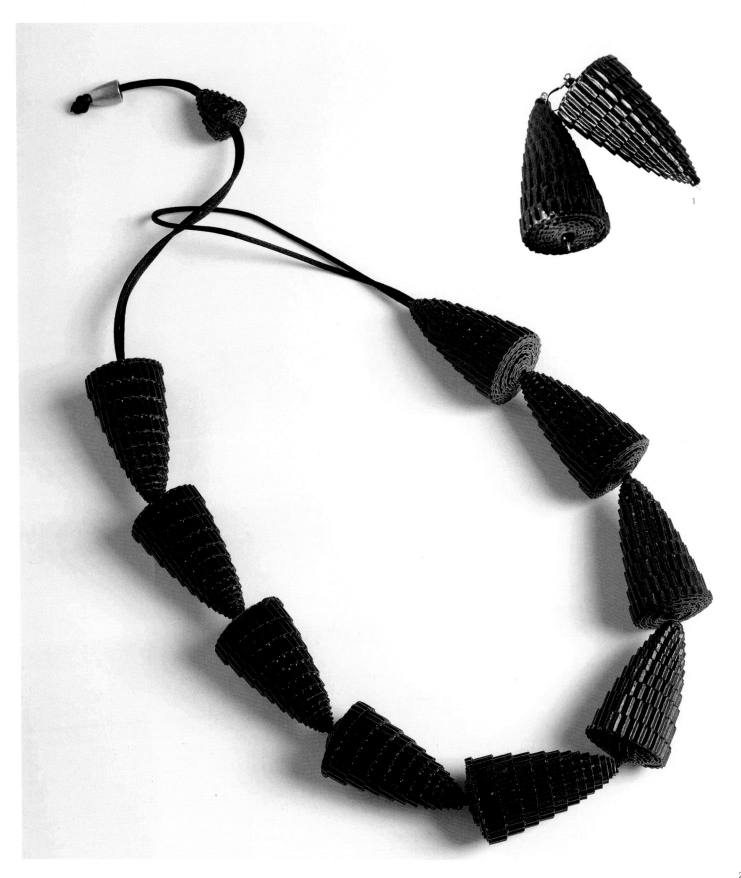

1. Cone-shaped earrings
Black corrugated cardbord,
quilling technique

2. *A ritmo regolare* **necklace**
Black corrugated cardbord,
quilling technique

3. *Fiori* **necklace**
White/black/gray corrugated
cardboard and black rice
paper balls

1

2

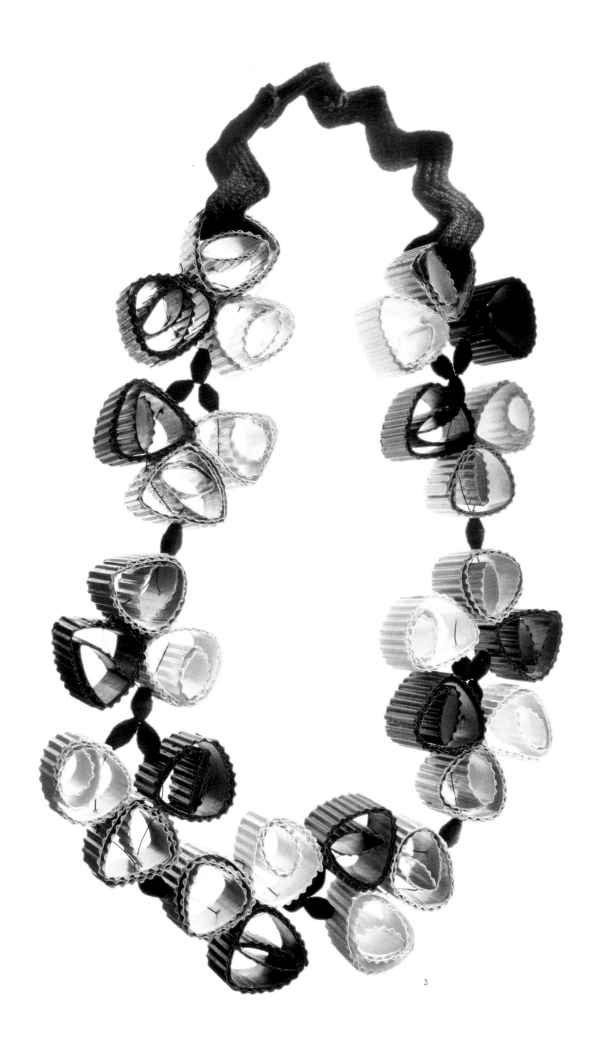

3

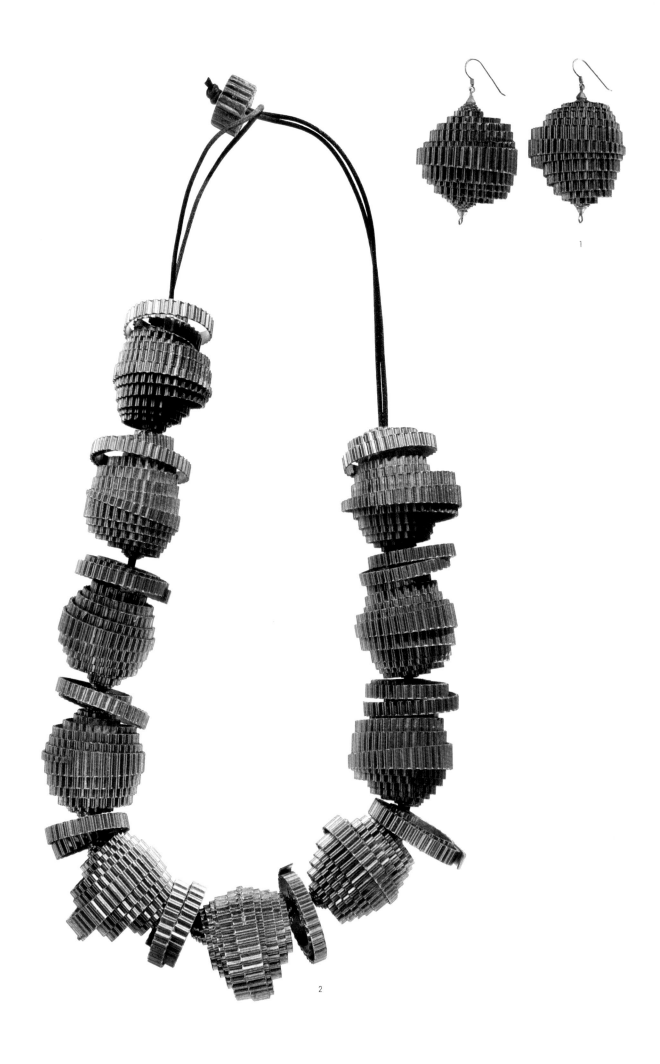

82

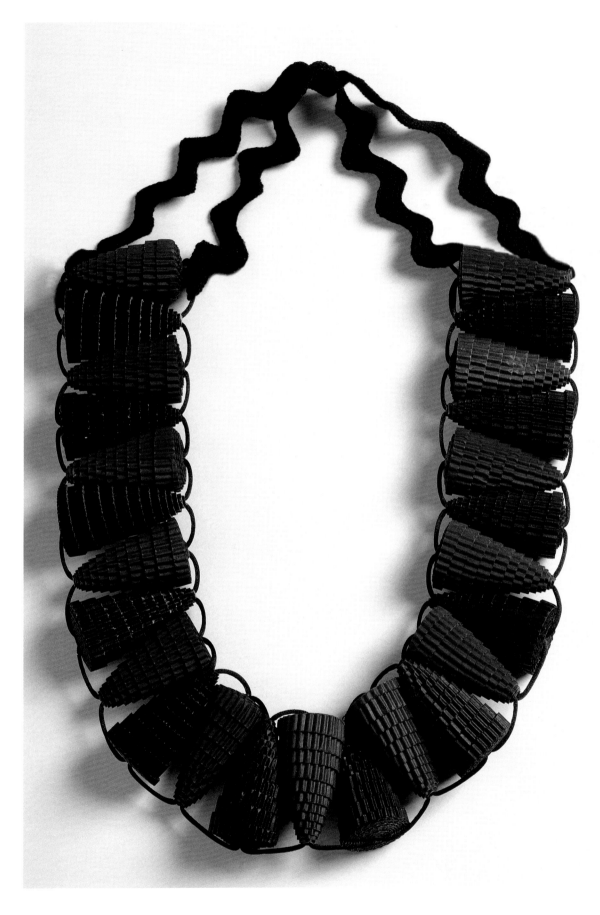

3

1. *Srotolati* earrings
Golden corrugated cardbord,
quilling technique

2. *Gold pianeti* necklace
Golden corrugated cardboard
and silk thread, quilling
technique

3. *Afro* necklace
Black corrugated cardboard,
quilling technique

Arthur Hash

www.arthurhash.com

Arthur Hash was born in 1976 in Panama and currently lives in Richmond, Virginia. He graduated from Virginia Commonwealth University with a degree in fine art in 2002 and received his master's degree in jewelry design and gold and silversmithing from the University of Indiana in 2005. His pieces are intelligent and fun, combining the latest techniques in laser cutting and three-dimensional design with traditional jewelry-making techniques. His work has been included in many exhibitions and public and private collections in the United States. Hash has taught at several institutions, and is currently a professor in the Metal Program at New York State University in New Paltz.

If you didn't specialize in jewelry, what would you be?
An industrial designer.

Describe your work space in three words.
Fluidity, creation, spontaneity.

1. *Mancha de café* brooch
Steel and enamel

1

2

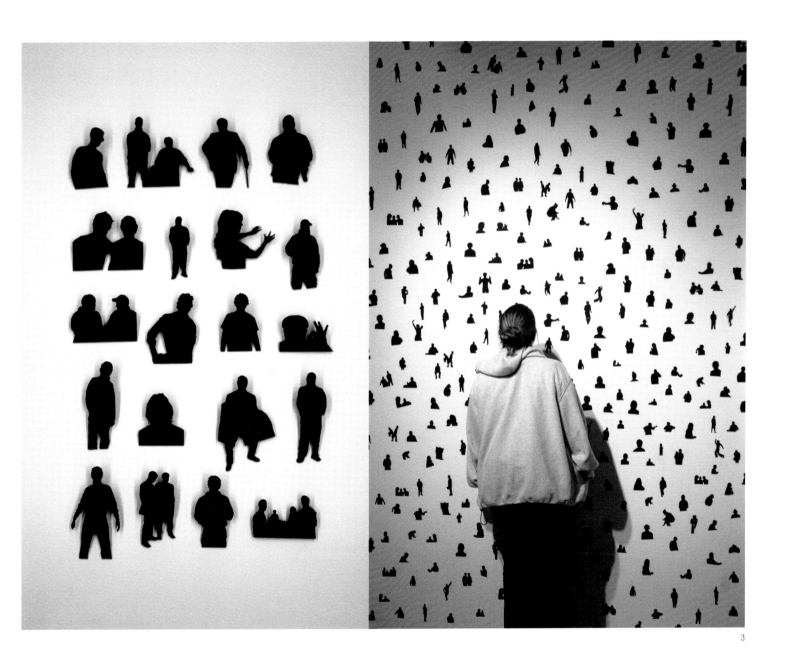

1-3. *Silhouettes* pins
Mild steel and paint; process
and development of the
collection, created by Arthur
Hash and converted into an
installation

1

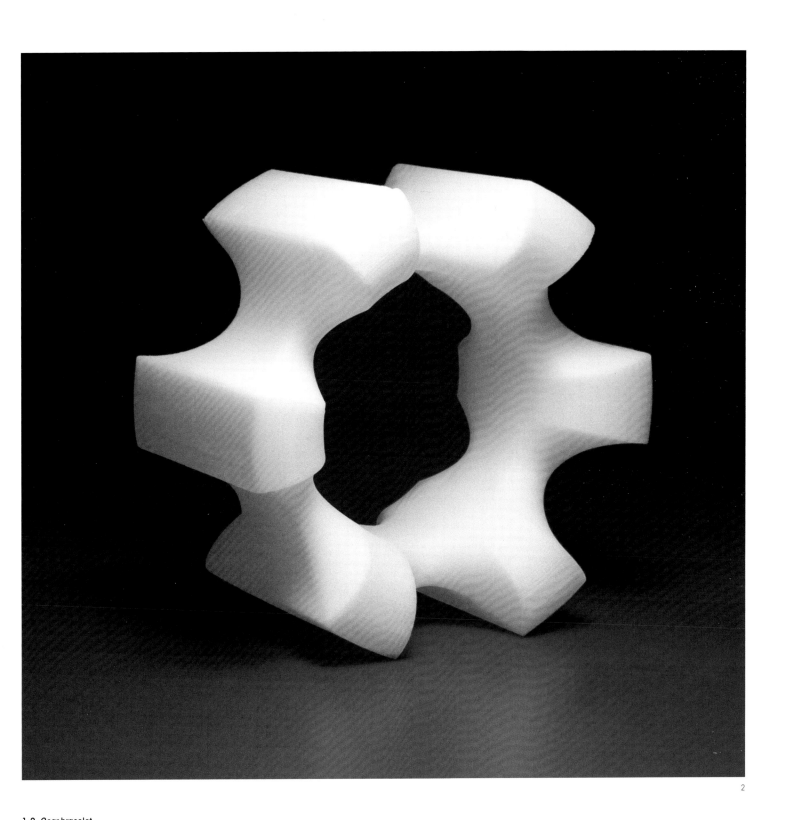

1-2. *Gear* bracelet

ABS plastic, designed with
Rhino Render and printed on
a Dimension SST 3D printer

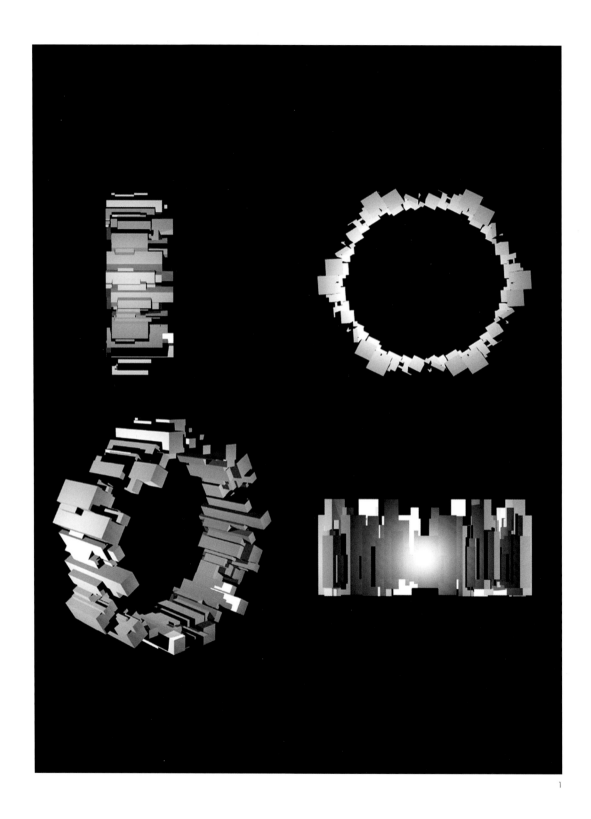

1

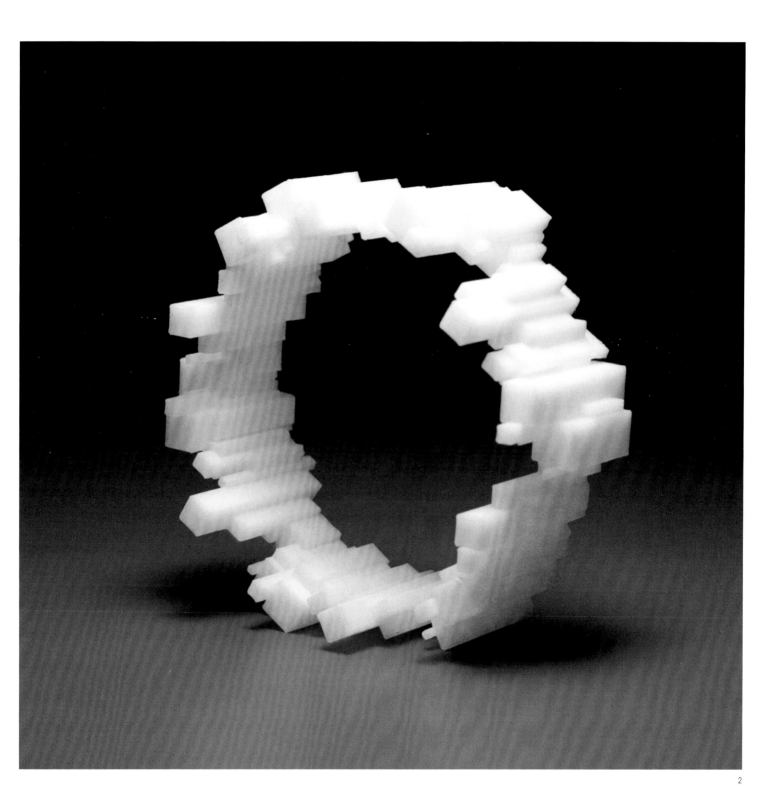

1-2. *Cityscape* **bracelet**
ABS plastic, designed with
Rhino Render and printed on
a Dimension SST 3D printer

Bea Jareño

www.beajarenojewellery.com

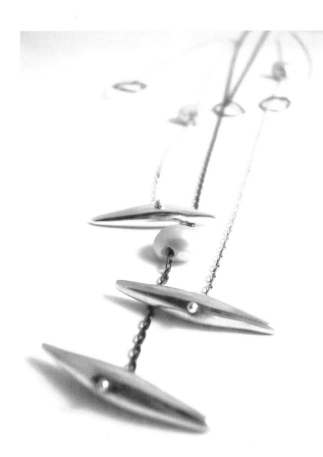

1

Born in Madrid, Bea Jareño graduated with first-class honors in jewelry design from London's Kensington and Chelsea College in 2004. She subsequently established her studio in the Hatton Gardens section of London. Her work draws heavily from African culture, and the porcupine is a recurring symbol. Her pieces, which have a simple look, explore the contrast between metals such as red and yellow gold, oxidized silver, polished silver, and other materials, along with hand-made finishes, textiles, and touches of color from precious gems and pearls.

If your work involved contemporary music, what style would it be?
Alternative rock.

Describe your work space in three words.
My workplace represents happiness, creativity, and freedom.

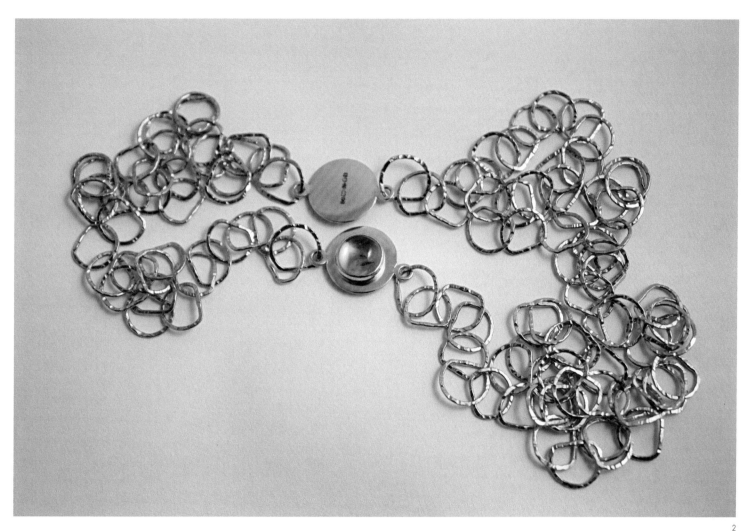

1. *Pearl* necklaces
Group of three, with two
finishes: oxidized silver and
polished silver, thin chain
with porcupine clasp, and
freshwater pearls

2. Necklace
Silver with 24-karat gold
plating, with green peridot
gemstone (olivine),
handmade textured links

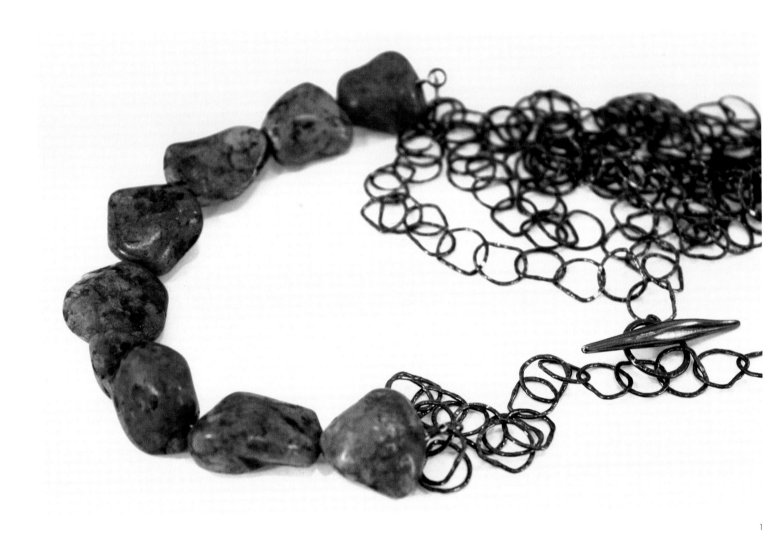

1. *Afiok* necklace
Coral and oxidized silver
links, sponge coral dyed red
with porcupine clasp, made
by hand and texturized

2. *Afiok* necklace
Bamboo coral dyed red and
pink, oxidized silver links,
made by hand and texturized

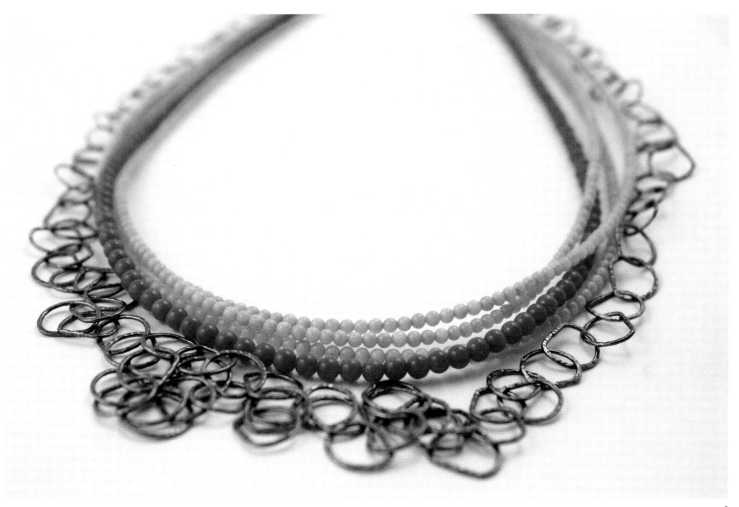

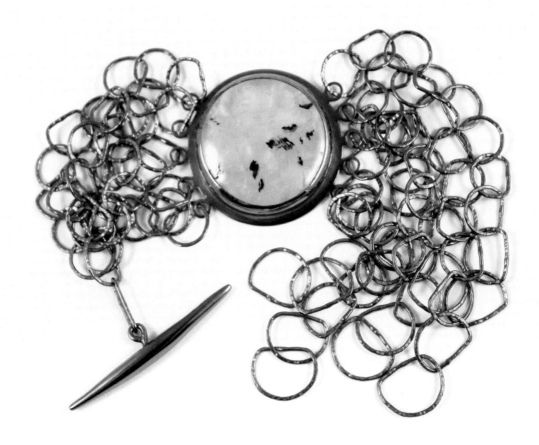

1

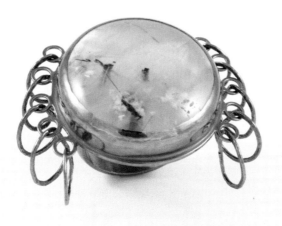

2

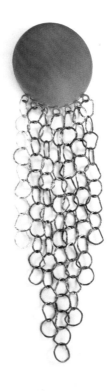

1. *Afiok* **bracelet**
Oxidized silver and porcupine
clasp, pyrite cabochon stone
mounted on silver disc with
multiple handmade links

2. *Afiok* **ring**
Pyrite cabochon stone
mounted on oxidized
silver disc, with texturized
handmade links

3. *Brooch of the desert*
Silver disc with handmade
links of oxidized silver and
24-karat yellow gold

4. *Afiok*
Pyrite stone with oxidized
silver links, made by hand
with texture

3

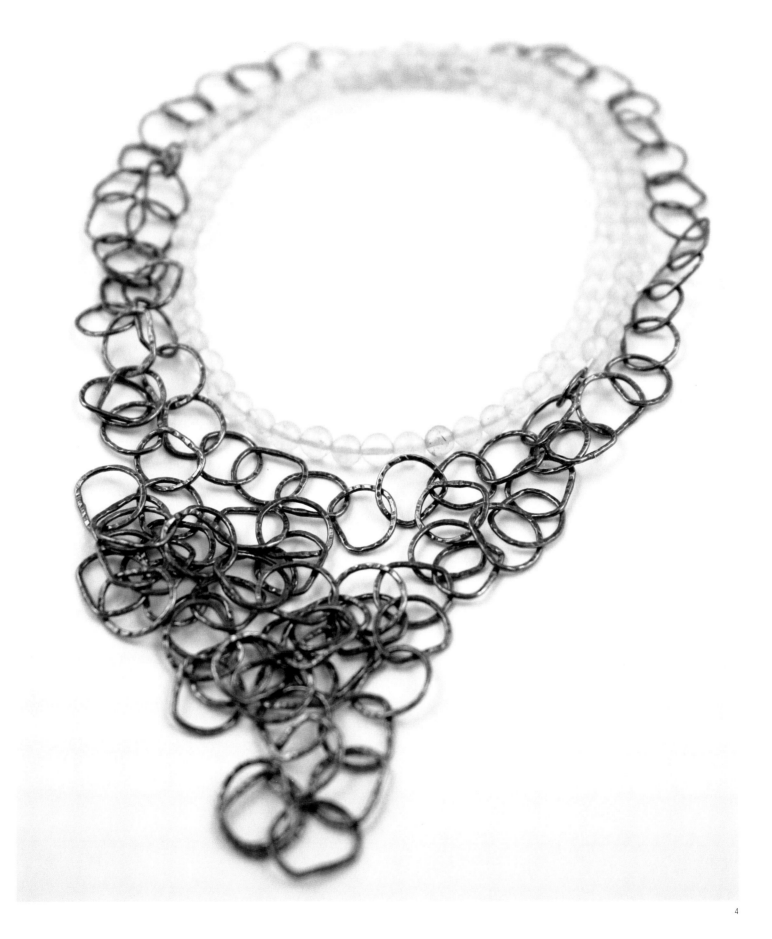

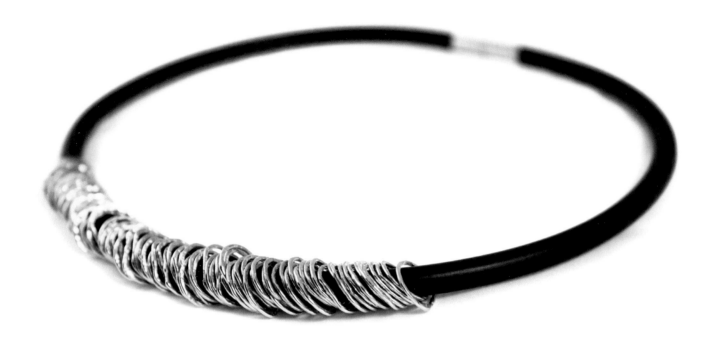

1

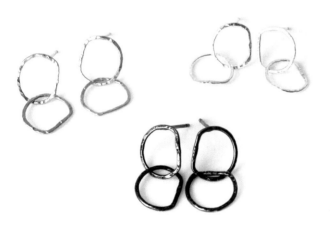

2

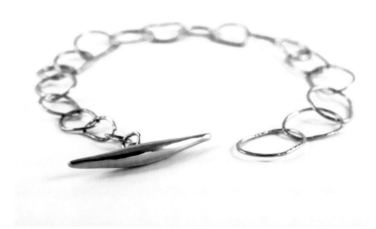

3

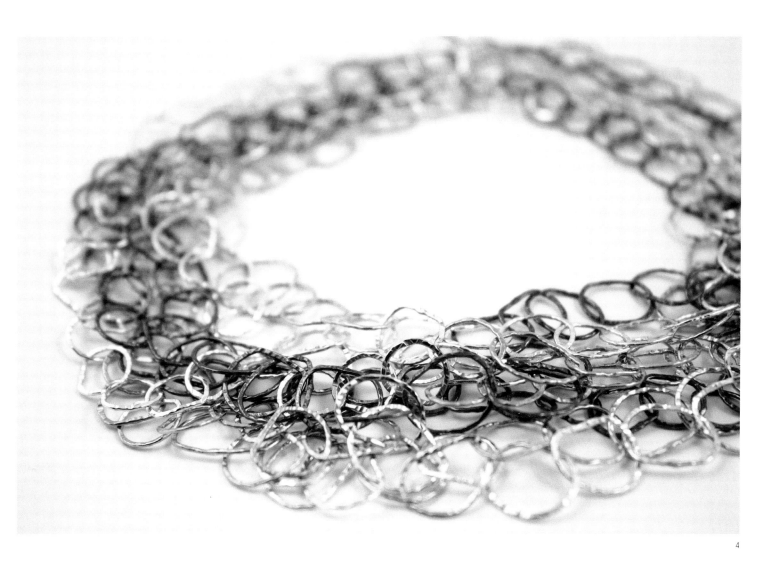

4

1. Necklace
Silver with 24-karat yellow gold plating and black rubber with handmade links

2. *Afiok* earrings
Silver with 24-karat gold plating, oxidized silver and polished silver, links made by hand with texture

3. Bracelet
Silver with 24-karat yellow gold plating and porcupine clasp, links made by hand with texture

4. Double-strand necklace
Oxidized silver, polished silver, 9-karat yellow gold plating, and porcupine clasp

Beatriz Fabres

www.beatrizfabres.com

Born in Chile, Beatriz Fabres arrived in Florence in 2004, where she studied jewelry and jewelry design at Le Arti Orafe Jewelry School. After graduating, she moved to Naples, a city with a long jewelry-making tradition; she spent three years there working on her own and for other jewelers. In 2010, she moved again, this time to Barcelona, where she opened up her own workshop and boutique.

If you didn't specialize in jewelry, what would you be?
I would like to have at least three children, work at home, tend a garden, and be a better cook with each passing day.

If you could work with only one material, what would it be?
Platinum. Of all the precious metals, it is the rarest, the purest, the most resilient, and the most interesting. It is also the most difficult metal to work with. To understand platinum, you need to know something about its history and discover the different meanings that have been attributed to it over time.

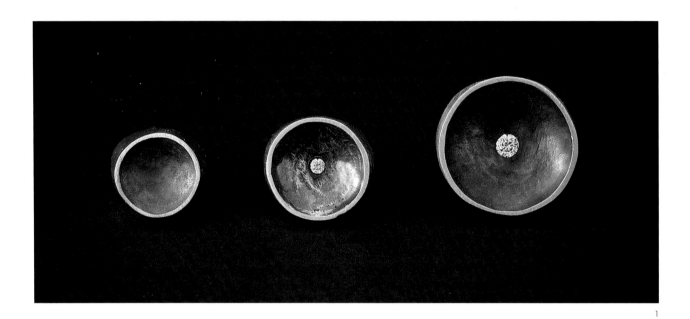

1

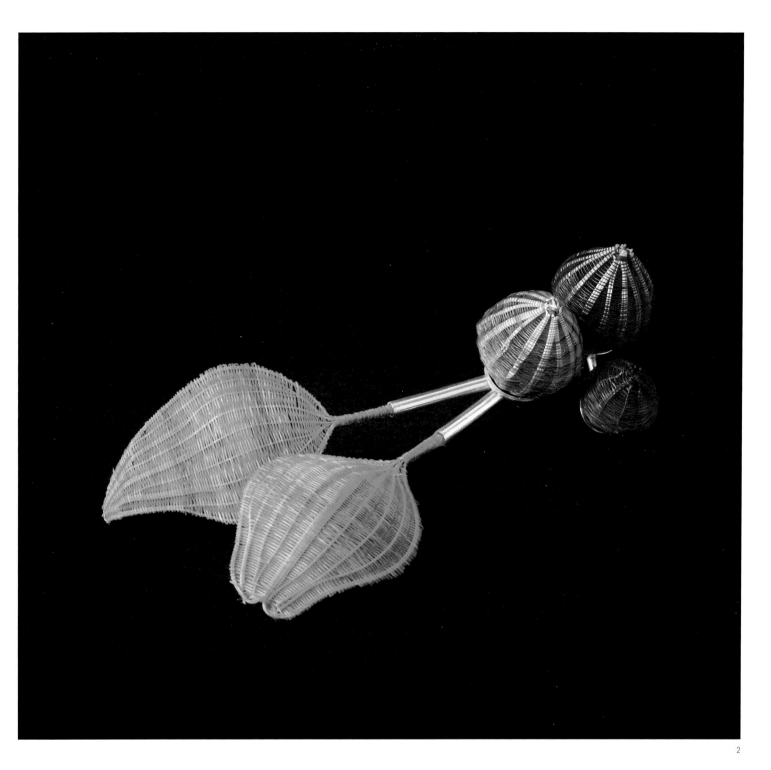

1. Rings
Large and medium-sized
silver and oxidized silver
rings with diamonds

2. Brooch
Silver and horsehair, woven
and dyed by hand

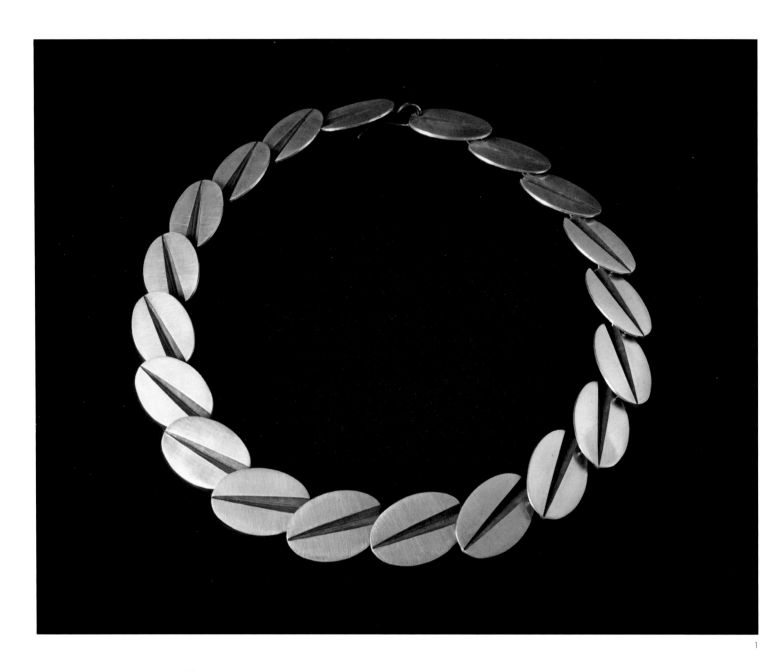

1. Necklace
Silver and oxidized silver

2. Necklace
Long silver

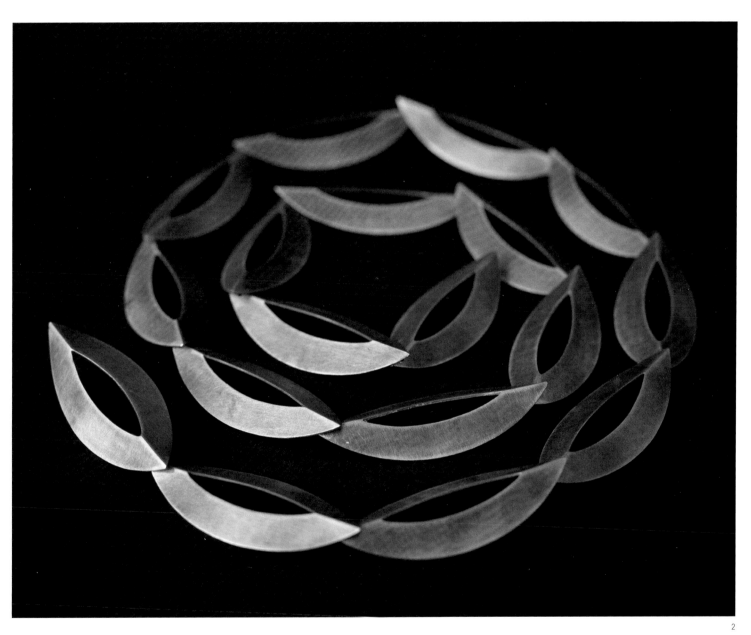

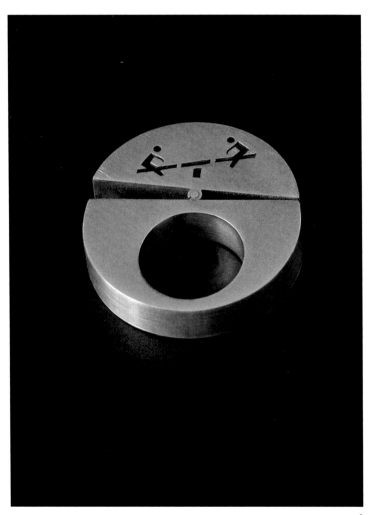

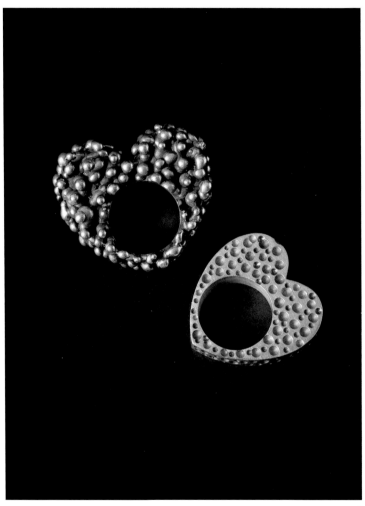

1

2

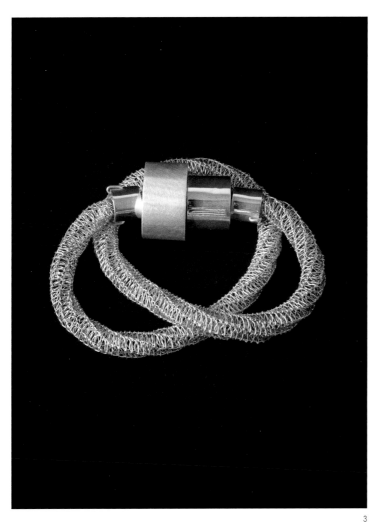

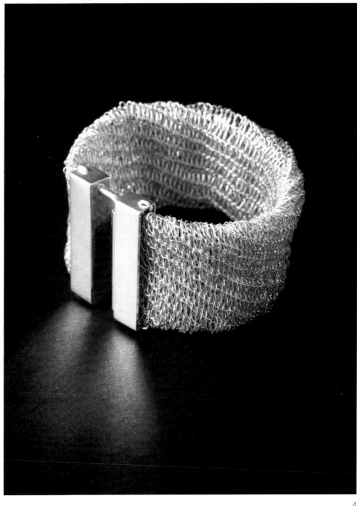

3

4

1. Ring
Silver, handmade cutout
figure

2. Rings
Heart rings manufaclured
using lost wax technique

3. Necklace
Silver necklace, crocheted
by hand

4. Bracelet
Silver, crocheted by hand

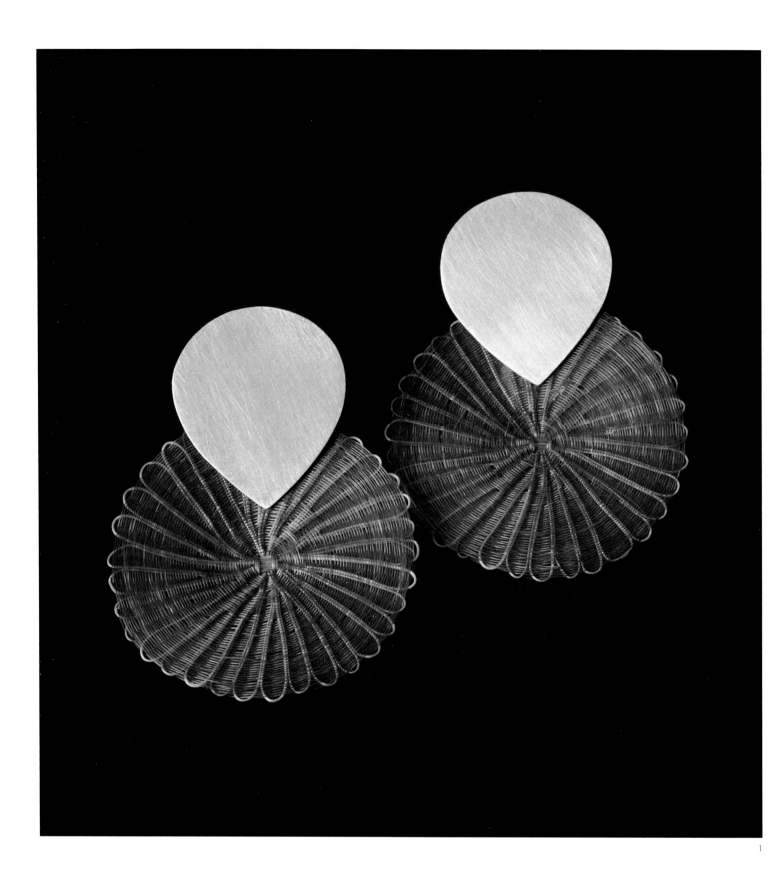

1. Earrings
Silver and horsehair,
woven and dyed by hand

2. Bracelet
Silver and metacrylate
bracelet, with figures
cut out by hand

Belén Bajo

www.belenbajo.com

1

The Spanish jewelry designer Belén Bajo studied fine art at Complutense University in Madrid. Soon she began to give classes in jewelry design at the School for Jewelry Studies in Madrid and work with Barín, the jewelry distributor; this experience taught her about sales and marketing before she went on to create her own collections. Her approach to jewelry is animated by her passion for industrial design and art, and by her fascination with nature, from which she appropriates the shapes and forms she finds seductive. In 1996, she presented her collection at the Feria Iberjoya in Madrid, where she has continued to be a regular contributor.

If you didn't specialize in jewelry, what would you be?
An interior designer, a furniture designer, or a window dresser.

If your work involved contemporary music, what style of music would it be?
Soul, for sure.

1. Ring

Mosaic of onyx and white
agate

2. Pendant

Mosaic of onyx and white
agate

1. Ring
Onyx, white, and green agate

2. Ring
Green agate

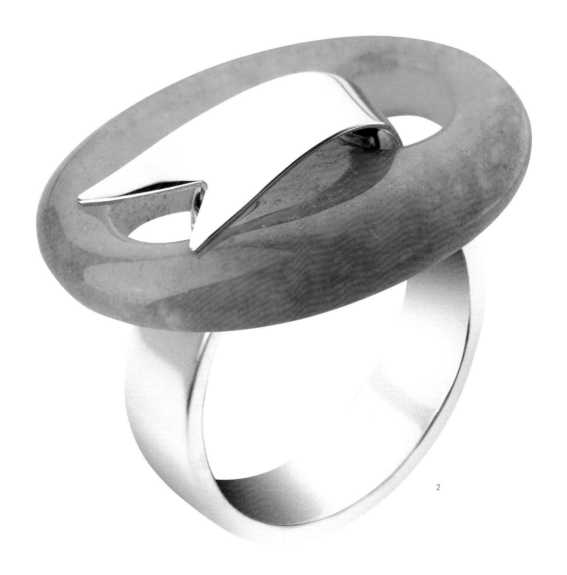

2

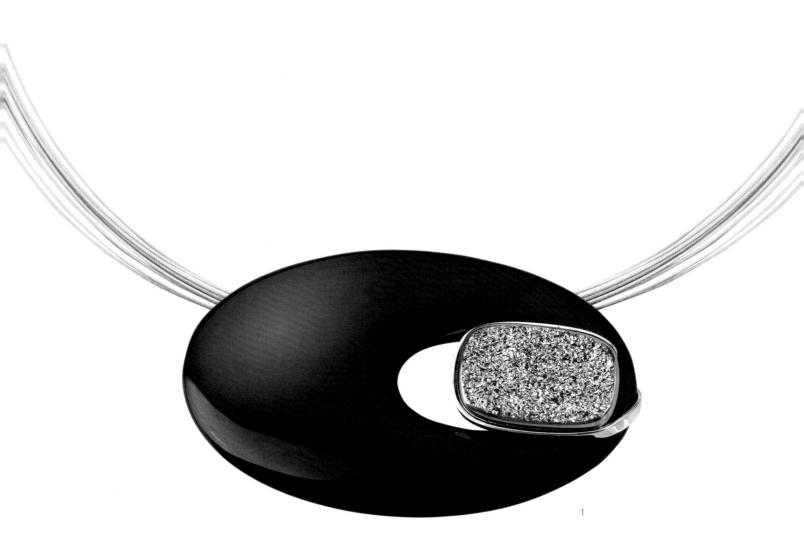

1

1. Pendant

Onyx and metallicized agate
in titanium

2. Ring

Onyx and metallicized druze
in titanium

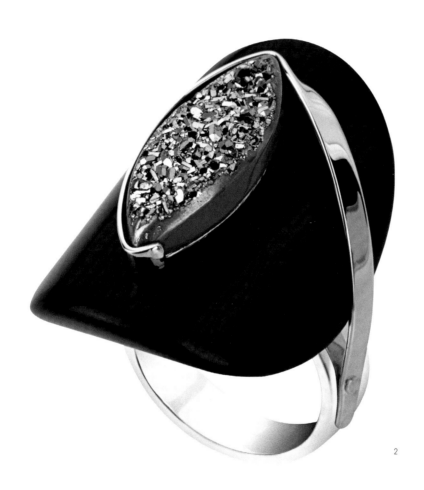

2

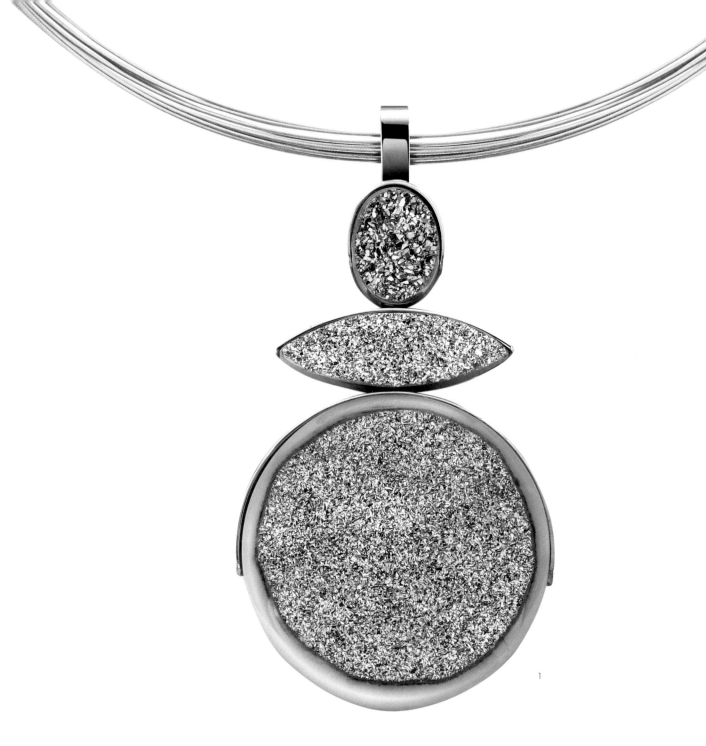

1. Pendant
Metallicized druze in
titanium and metallicized
druze in gold

2. Ring
Black druze, metallicized
druze in titanium and in
9-karat gold

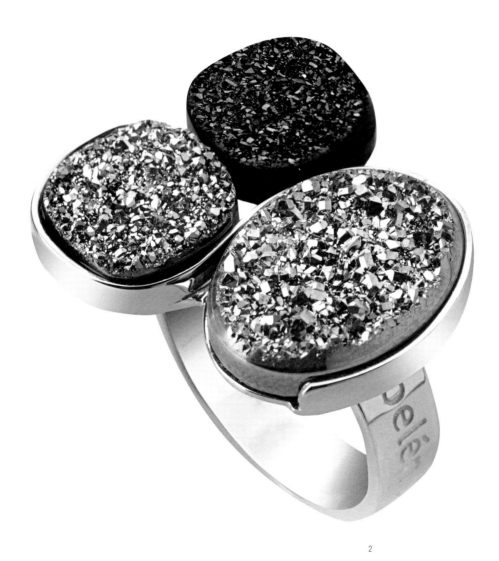

2

Bjørg

www.bjorgshop.com

Bjørg Nordli-Mathisen was born in Norway in 1966. At the age of 17, she moved to Oslo and studied for a year at an art college before taking a year off to travel and work in the fashion world. It was then that she fell in love with design and dressmaking and bought herself a sewing machine. Soon she launched her own clothing line, which was shown in Norway, Germany, and Japan. She then moved to Copenhagen and opened a boutique and studio, where she designed and produced children's wear, jewelry, and textiles for the home. In 2001, she moved to India with her family, where she lived for three years and developed her own style of innovative, pure, and elegant jewelry. Her first clients were Liberty and Harvey Nichols, and by 2004, the firm Bjørg was born. Today, her collections are found in more than twenty countries around the world.

If you didn't specialize in jewelry, what would you be?
I would be an inventor.

Describe your work space in three words.
Inspiration and organized chaos.

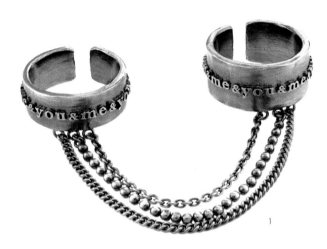

1

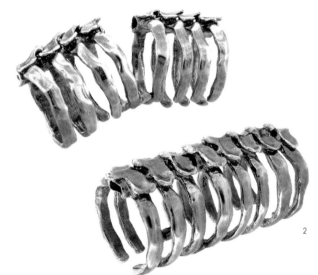

2

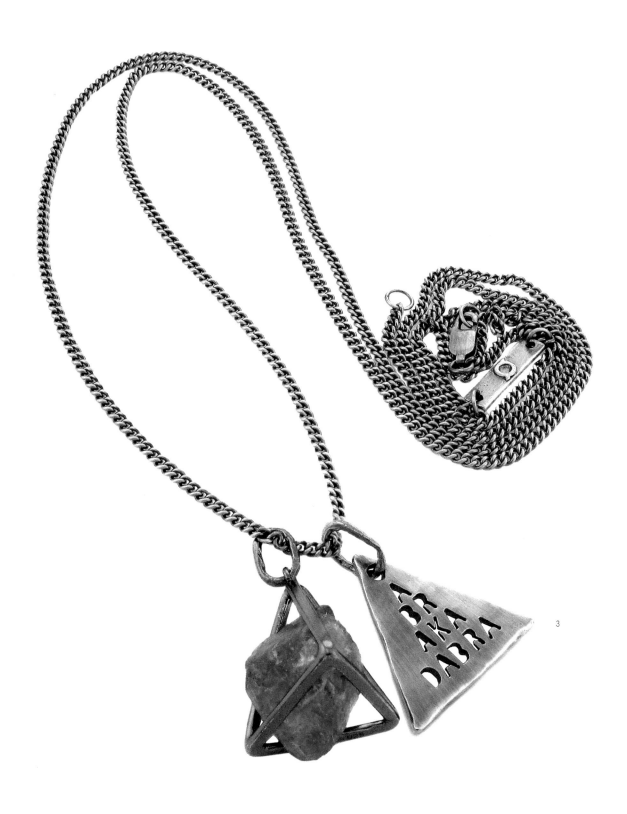

1. *You & me* ring
Silver ring with chains

2. *Columna vertebral* ring
Articulated silver

3. *Abrakadabra* necklace
Silver with green quartz

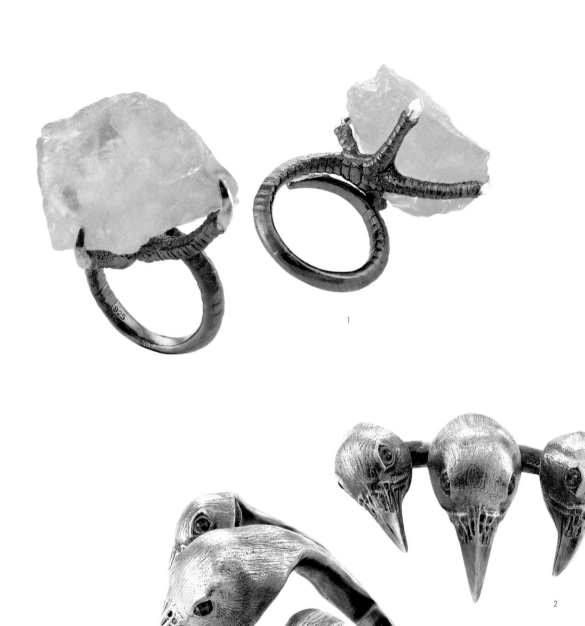

1

2

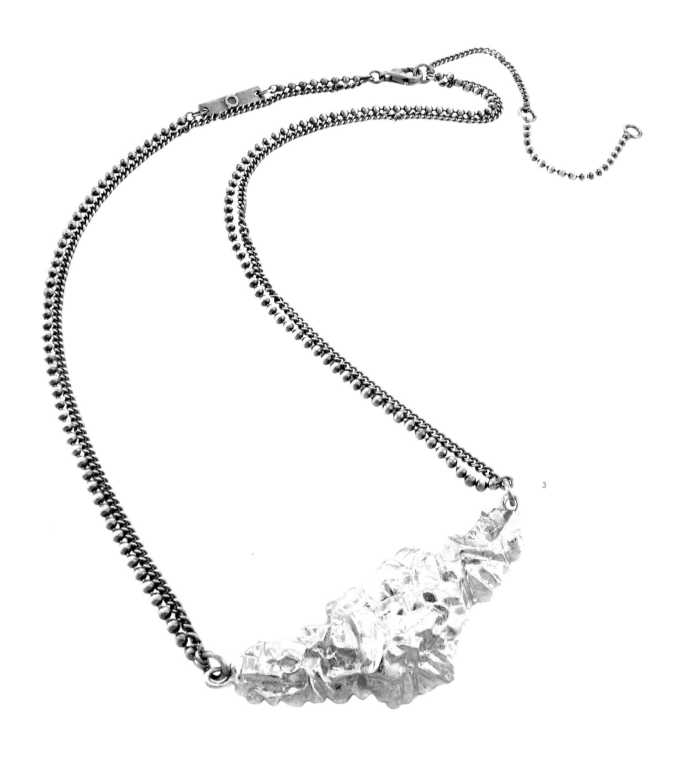

3

1. Ring
Bird's claw and pink quartz

2. *Forest* series ring
Silver

3. *Cluster* necklace
Silver and gold

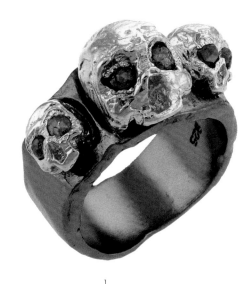

1

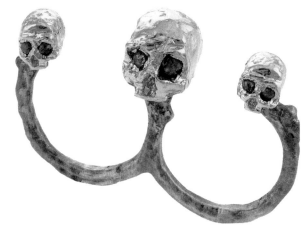

3

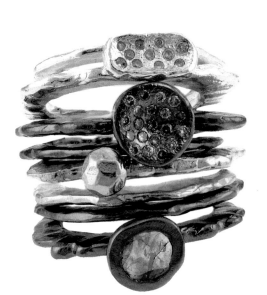

2

1. Ring
Silver with gold-plated
skulls and six *rosecut*
diamonds incrusted

2. Ring
Silver with gold-plated skulls
with six *rosecut* diamonds
incrusted

3. Rings
18-karat gold-plated silver
and German silver with
incrustations

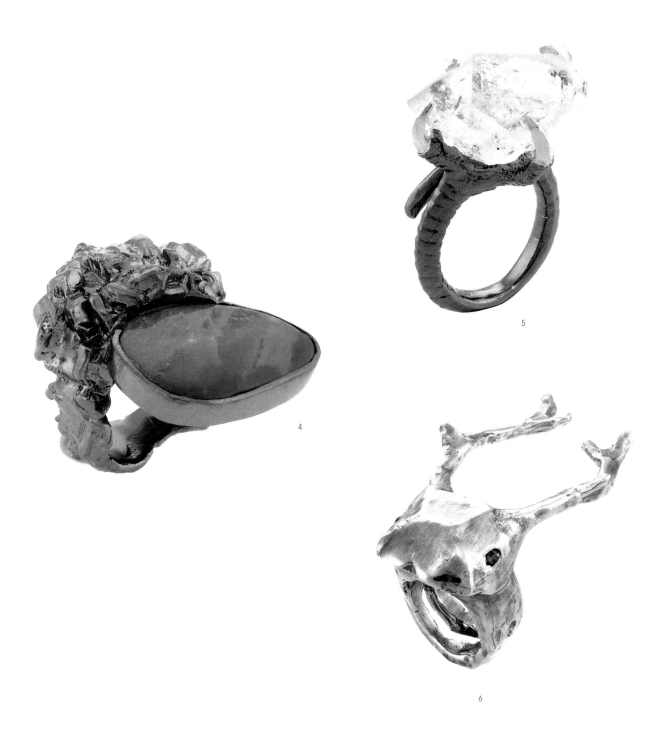

4. Ring
Silver with blue/black opal

5. Ring
Bird's claw and white quartz

6. Ring
Solid silver stag beetle

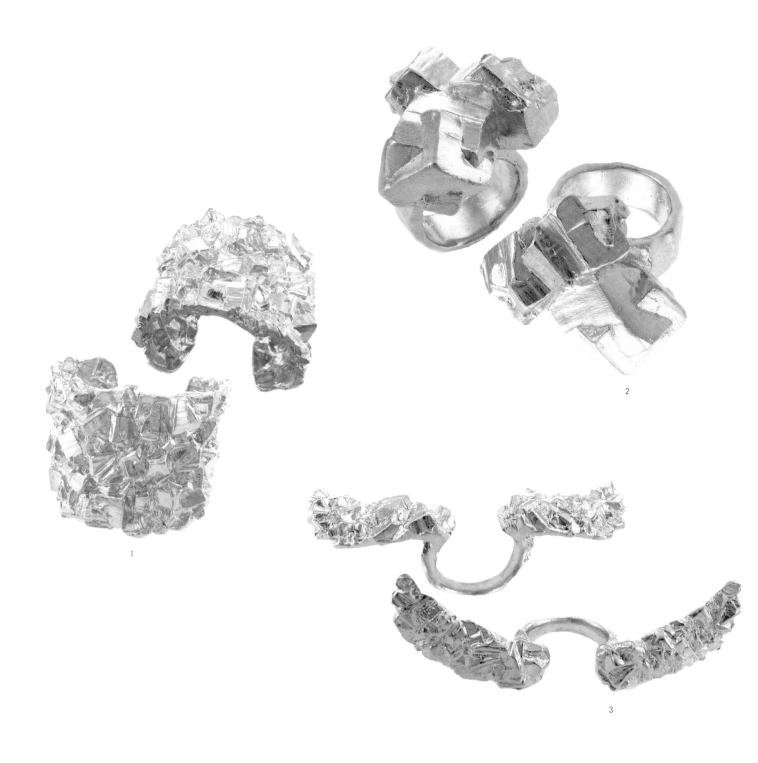

1. *Cube pyrite* ring
Silver with 18-karat yellow
gold plating

2. *Big cluster* ring
Silver with 18-karat yellow
gold plating

3. *Cluster wing* ring
Silver with 18-karat yellow
gold plating

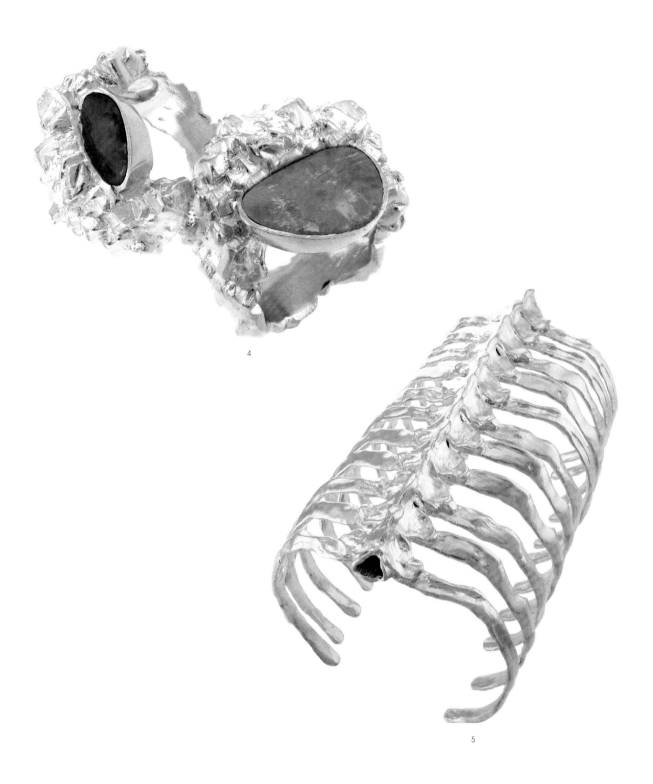

4

5

4. Rings
Silver rings with yellow gold
plating and blue/black opal

5. *Columna vertebral* bangle
Yellow gold

Brigitte Adolph

www.brigitte-adolph.de

Jewelry designer Brigitte Adolph was born in Fulda, Germany, in 1975. Hailing from two generations of jewelers, she studied jewelry design in Copenhagen, and in Pforzheim, Germany. After becoming a goldsmith, she refined her skills working in Stockholm for the royal jeweler to the Swedish Crown. In 2005, she set up her own studio in Karlsruhe, in southwest Germany. Adolph's work has been honored with a number of national and international prizes, including the 2009 Jewelry Award at the International Jewelry Fair in Munich, and the Red Dot Design Award, one of the most important design awards in the world. Among her most striking pieces are those in her *Spitzen-Schmuck* collection, which are handmade and have the appearance of delicate lace, and her Loop necklaces, a contemporary interpretation of the traditional pearl necklace.

If you didn't specialize in jewelry, what would you like to do?
I have to create things with my hands. It's a real passion. I would probably have been a costume designer. And I'd be working with lace.

If your work involved contemporary music, what style would it be?
An opera. In my work I look for well-balanced composition. Opera is special—it isn't vulnurable to fleeting trends. I often name my work after an opera, as I did with the *Pique Dame* ring, invoking Tchaikovsky's grandeur.

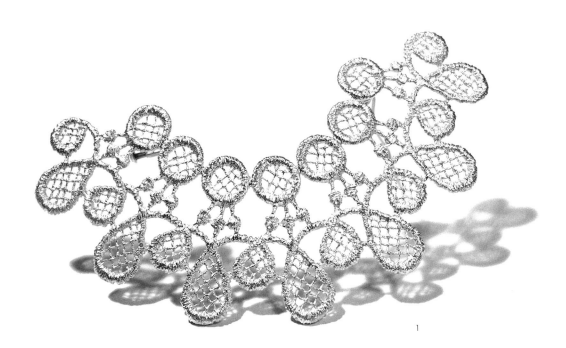

1

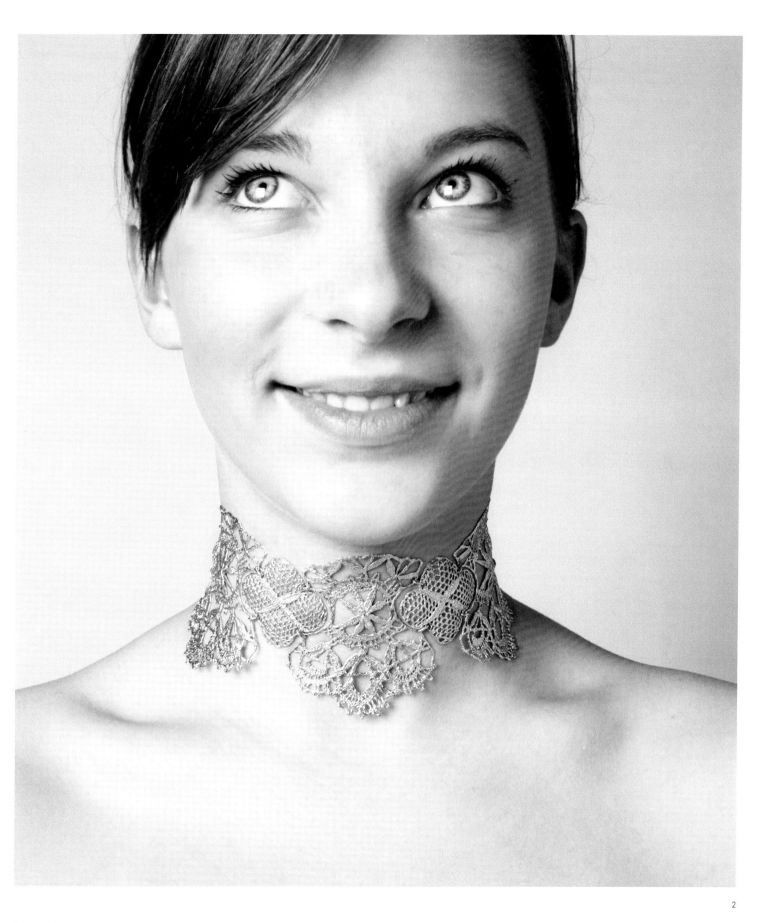

1. *Chandelier* brooch
Silver 925

2. *Venezia* necklace
Platinum 950

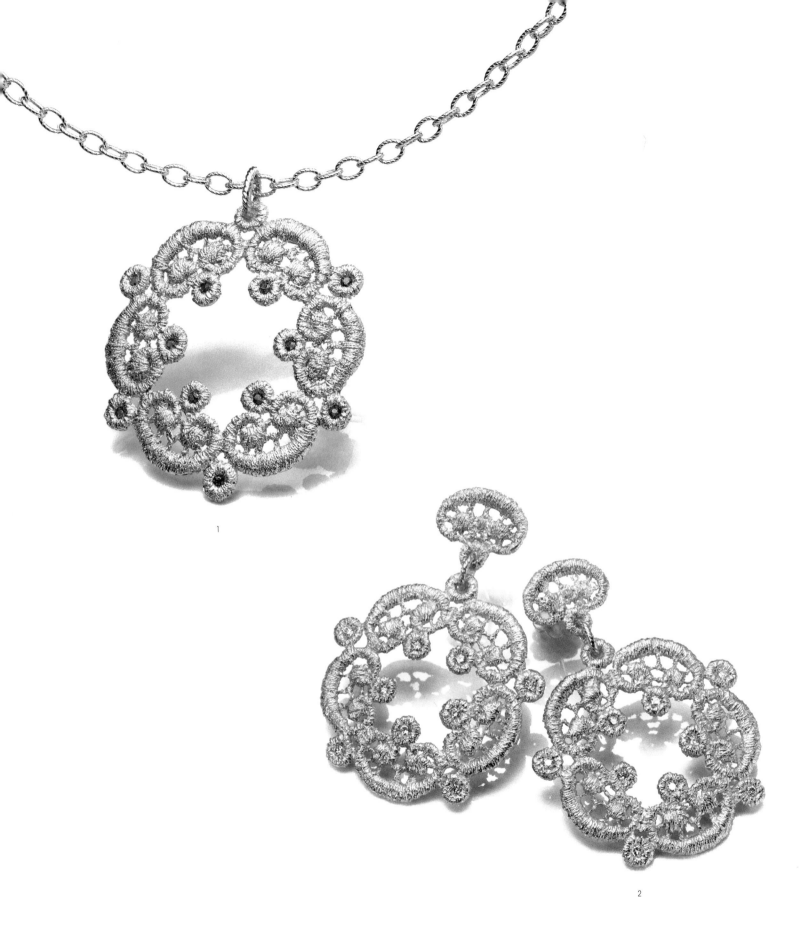

1

2

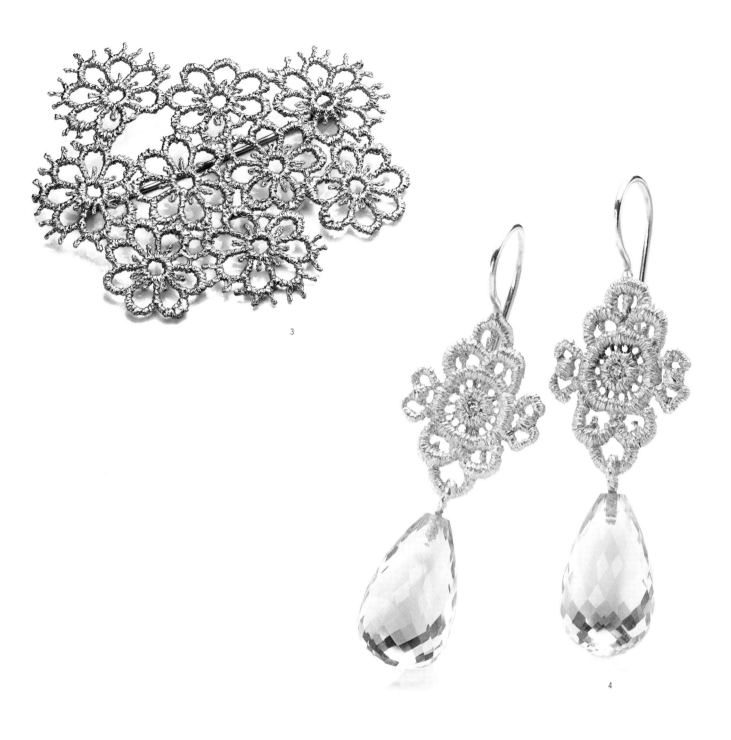

3

4

1. *Aridane* necklace
Yellow gold 750 and rubies

2. *Aridane* earrings
Yellow gold 750 and
18 champagne-colored
diamonds

3. *Schmuckkörbchen* brooch
Yellow gold

4. *Mona Lisa* earrings
Yellow gold 750 and faceted
teardrops made of citrine
quartz

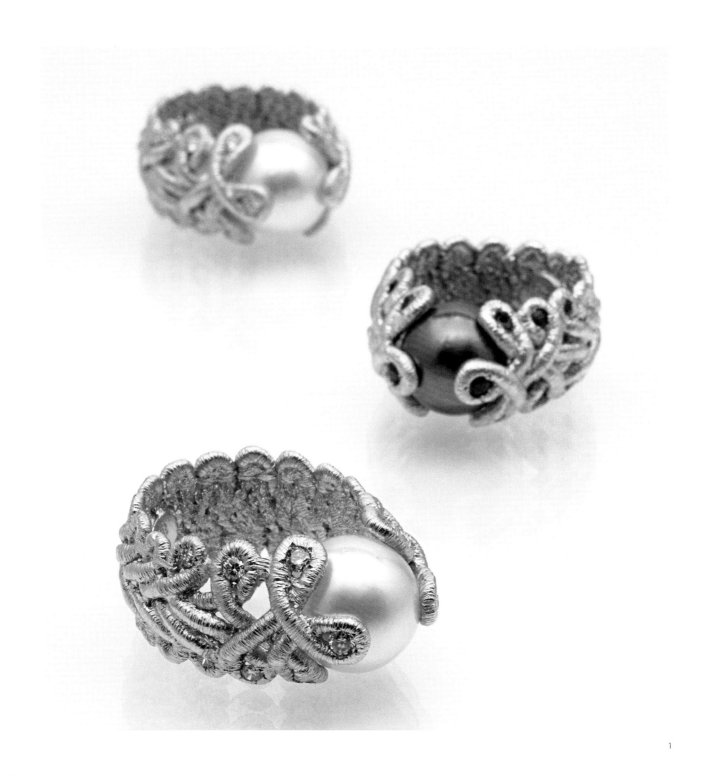

1

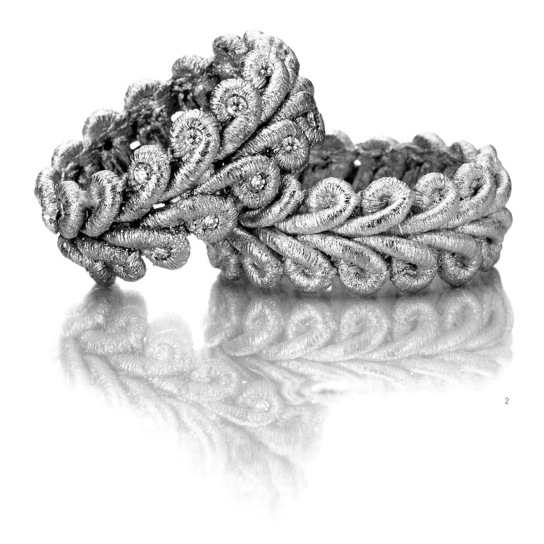

2

1. *Pique dame* rings
Silver, black rhodium, yellow
gold, pearls, diamonds, and
rubies

2. *Bordure* rings
Silver, yellow gold, and
diamonds

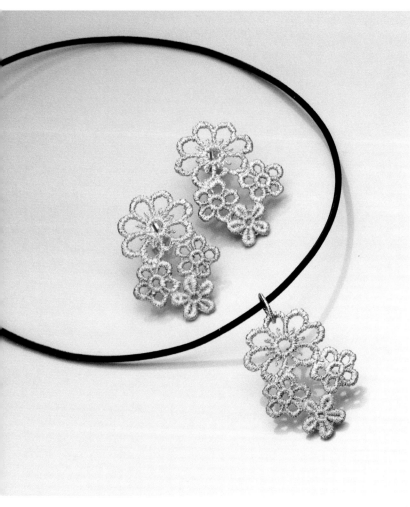

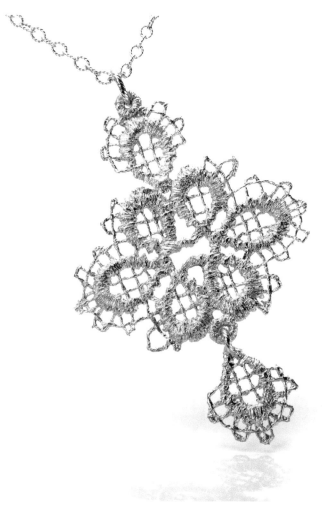

1

2

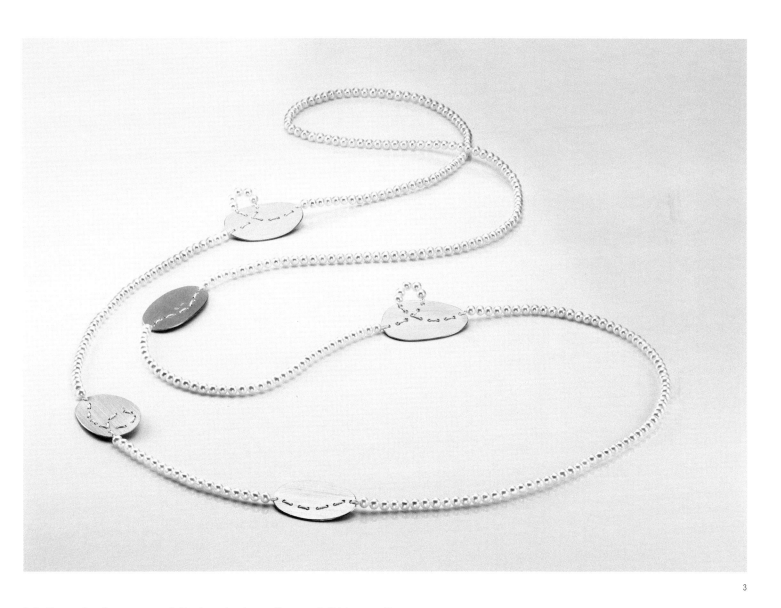

3

1. Necklace and earrings
Yellow gold

2. *Merchants daughter* necklace
Yellow gold

3. *Halsketten* necklace
Gold-plated silver 925, freshwater
pearls, and silk cord

Camila Moreno

www.coroflot.com/be_u

Camila Moreno discovered her passion for jewelry while studying industrial design at Javeriana University in Bogotá, Colombia, and then specializing in this field in Jewelry Design at the European Institute of Design in Milan. Her jewelry is conceptual: her pieces take their meaning from their color and shape, and from the technique used to make them. Moreno's creativity allows her to transform virtually any shape or material into a piece of jewelry.

If you didn't specialize in jewelry, what would you do?
I like to think of myself as a designer specializing in jewelry, so if I didn't create jewelry, I would be doing research on design management, innovation, and sustainability—topics that are very interesting and applicable across fields Otherwise, I would be working with craft communities, since handmade crafts are really incredible and require a great deal of skill and technical expertise.

If you could work with only one material, what would it be?
Silver, because it can be given color, shape, and different textures. It is elegant, but at the same time it can also be used on an everyday basis. A great deal can be said with it through subtle design.

1

2

3

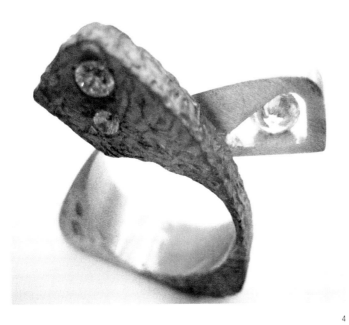

4

5

1. *Amor/love* rings
Layered rings in silver 925 which say "*love*" when put together

2. *Dreams and desires* earrings
Earrings in silver 925 with paper texture

3. *Sea* ring
Open ring in silver 925

4. *Botero* ring
Satin silver, reticulated gold-plated silver, and white zircon

5. Ring
Double-sided silver 925 openwork: one side has a bright silver finish and the other is plated in gold with a satin finish

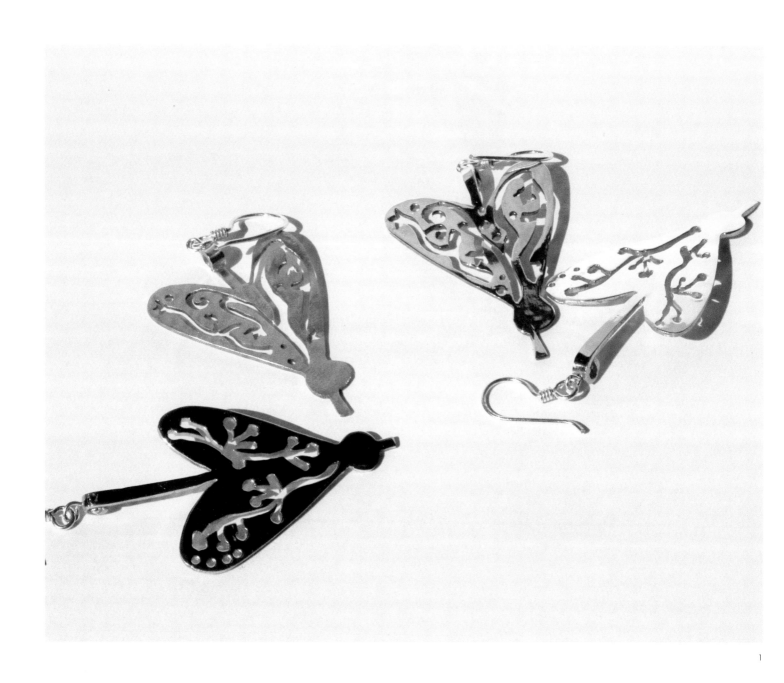

1

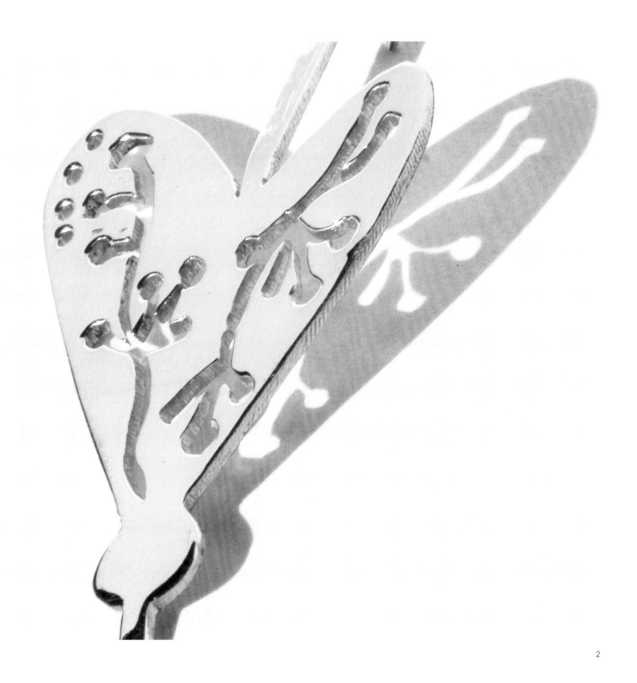

2

1-2. *Butterfly*
with nature **earrings**
Double-sided silver 925
openwork; one side has a
bright silver finish and the
other is plated in gold with a
satin finish

Diana Kleiner

www.dianakleiner.com

Born in Rosario, Argentina, Diana Kleiner has two fine arts degrees and a teaching qualification from the National University of Rosario. She has also taken postgraduate courses in etching and screen printing at the State University of New York and the University of Barcelona, and her work shows her mastery of these techniques. She invokes cultural references from the writings of Freud and Borges to the shapes and patterns of pre-Colombian cultures. Her jewelry has been shown in museums and galleries in Argentina, Spain, and the United States. In 2010, the Argentine Academy of Fine Art included her work as part of its permanent collection.

If you didn't specialize in jewelry, what would you be?
If I wasn't interested in jewelry, I would be what I am: an artist.

Describe your work space in three words.
My workspace is spacious, light, and dynamic.

1

1. *Hombres de arena*
necklaces and earrings
Sterling silver, articulated,
engraved pieces, and
silicone rubber cords

2. *Hombres de arena*
necklaces and earrings
Sterling silver and silicone
rubber cords

1. *Hombre nuevo* sketch

2. *Hombre nuevo* necklaces,
earrings, cufflinks, and keyring
Engraved, enamel silver in colors,
and silicone rubber cords

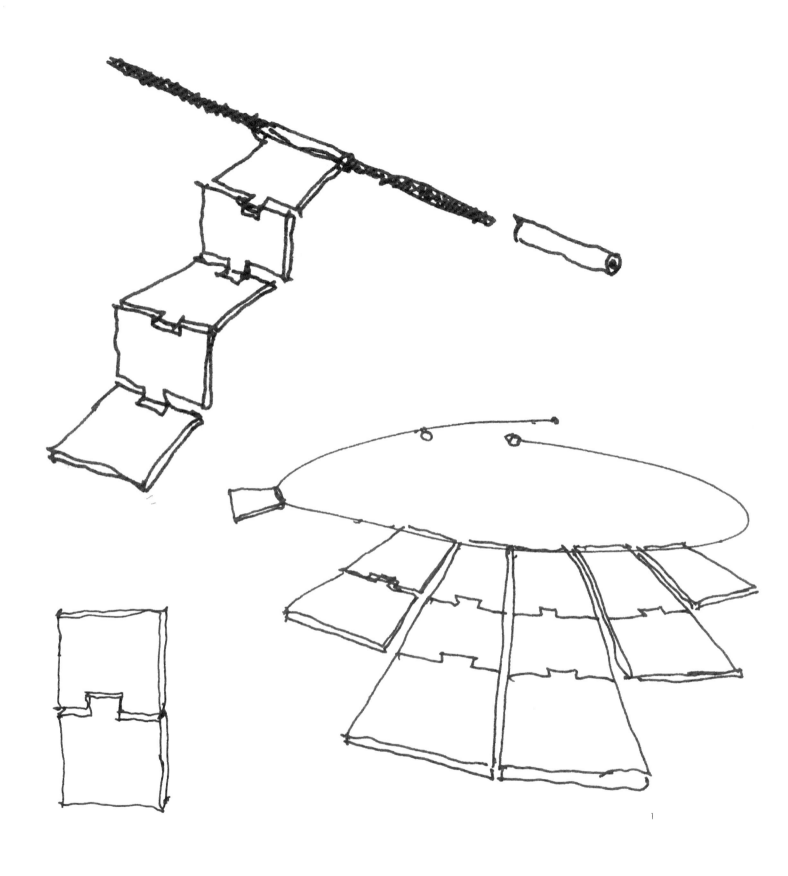

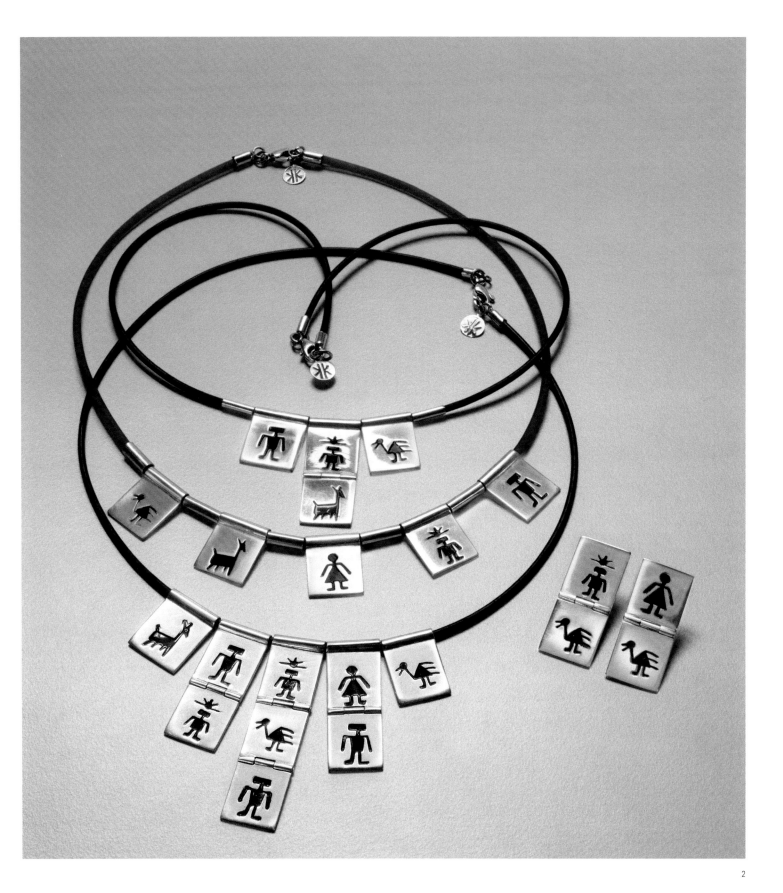

1. Sketches and studies of the articulated pieces

2. *Hombre nuevo* necklaces and earrings
Engraved, enamel silver in black, and silicone rubber cords

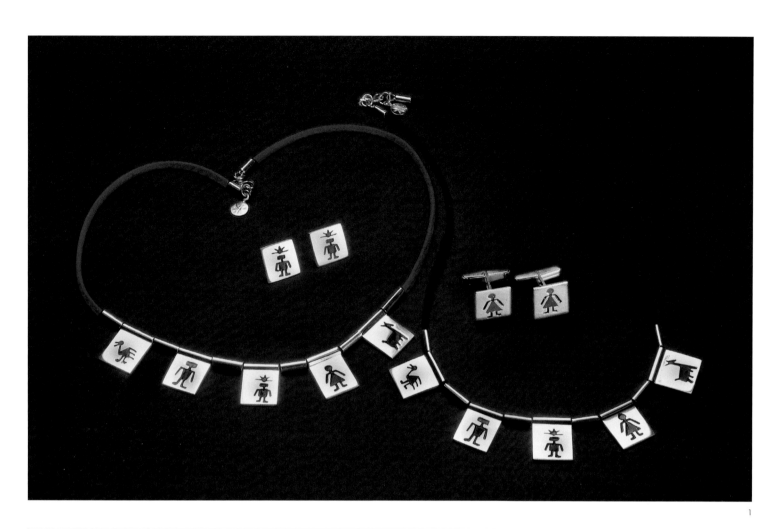

1

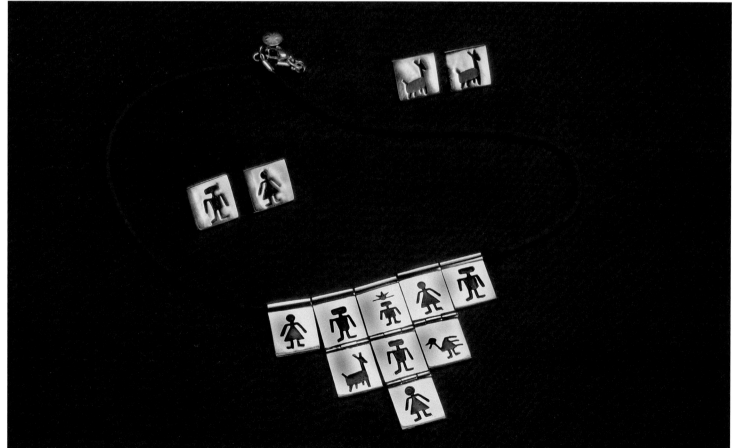

2

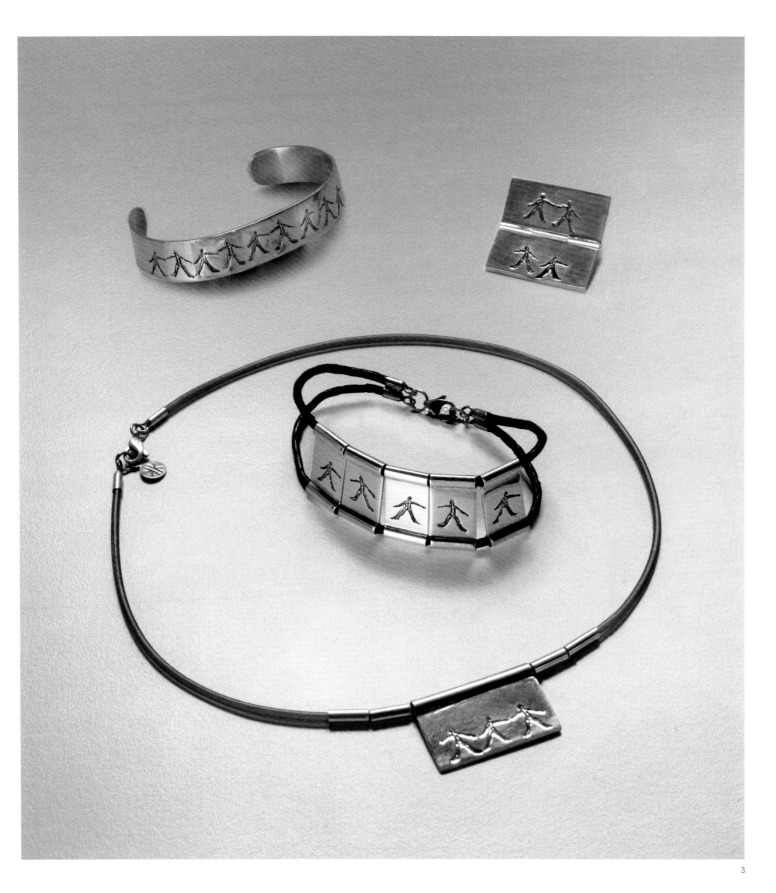

1-2. *Hombre nuevo*
necklaces and earrings
Engraved, enamel silver in
colors, and silicone rubber
cords

3. *Hombres de arena*
necklaces and earrings
Engraved silver and silicone
rubber cords

Doris Maninger

www.alchimia.it/english/staff/
doris_maninger.htm

Doris Maninger was born in Graz, Austria, in 1958, but has lived in Florence for many years. In 1977, she recieved a degree in comparative linguistics from the University of Graz. Later, she won a scholarship to study ceramics and fine arts at Saddleback College in Mission Viejo, California. This experience led her to enroll at the Academy of Fine Arts in Vienna. In 1985, she moved to Italy to study restoration techniques at the Department of Cultural Heritage in Cosenza. In the early nineties, Maninger entered Le Arti Orafe Jewelry School in Florence. She has staged group and solo exhibitions across Europe and Asia, and lectures and gives workshops around the world. She has also been involved with many international shows, both developing the concept and acting as curator.

If you could only work with one material, what would it be?
I would work with fabrics.

If your work involved contemporary music, what style of music would it be?
Free jazz.

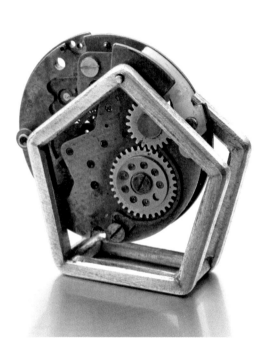

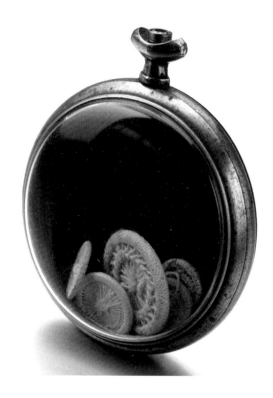

1

2

144

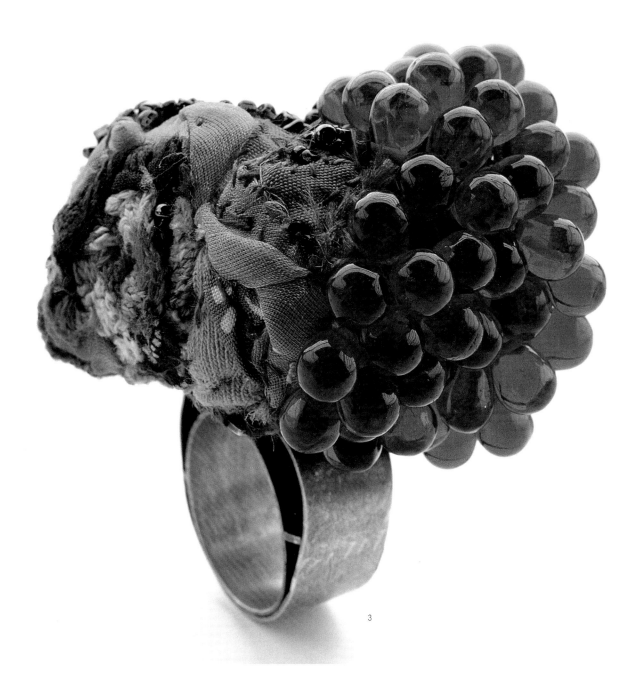

3

1. *Not really time* brooch
Silver, gold, and ruby

2. Brooch
Watch housing, buttons, gold,
garnet, and diamond

3. *Caviar* ring
Silver, textile, and beads

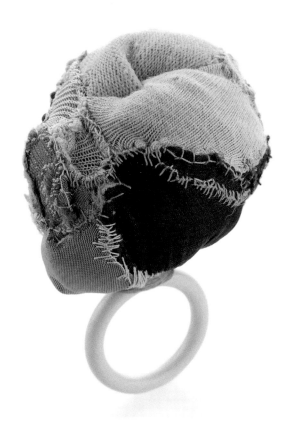

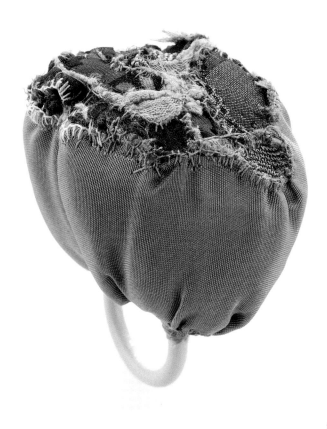

1

2

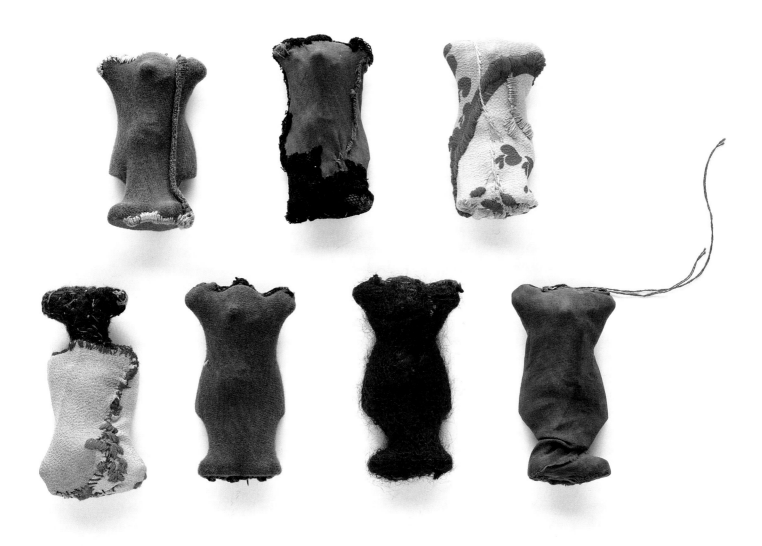

3

1-2. *Incuro* rings
Silver and textiles

3. *Spirits* brooch
Plastic and textiles

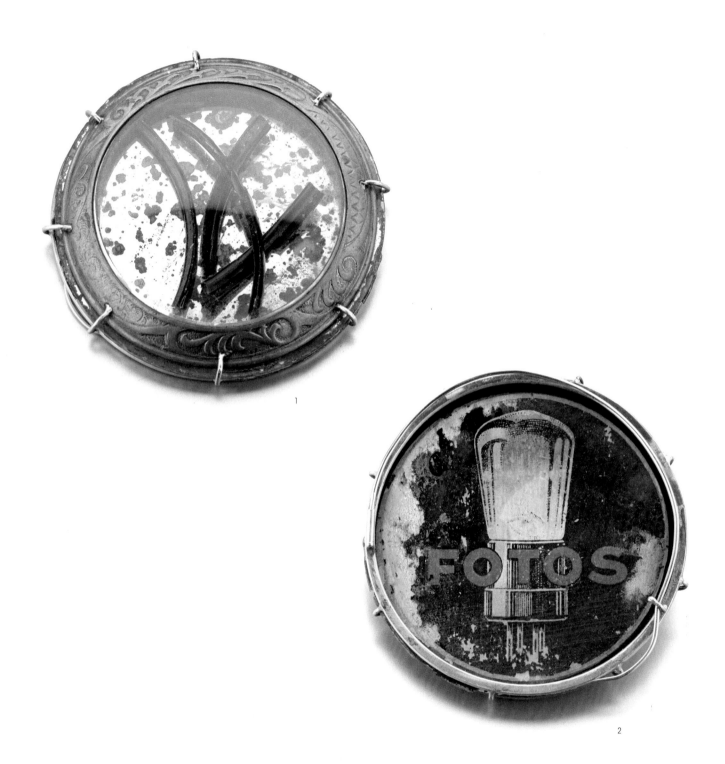

1. *Memories 1* pendant
Watch housing, gold, mirror,
and plastic

2. *Memories 1* pendant
Watch housing, gold, mirror,
and plastic

3. *Un Fiore nell'Occhiello* brooch
Textiles and resin

4. *Undecent* brooch
Textiles, resin and beads

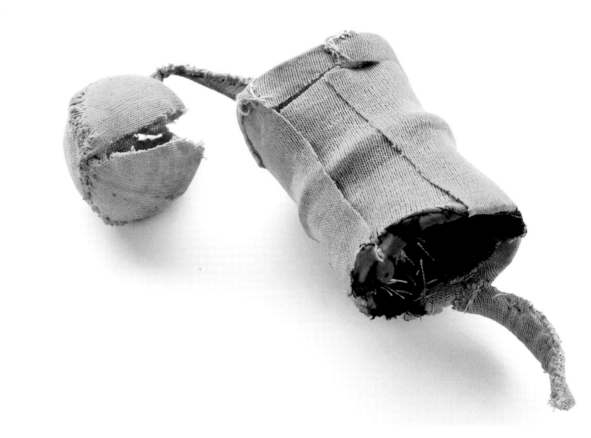

3

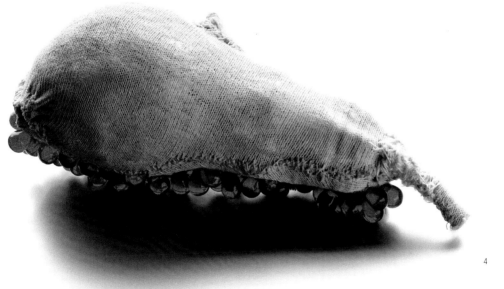

4

149

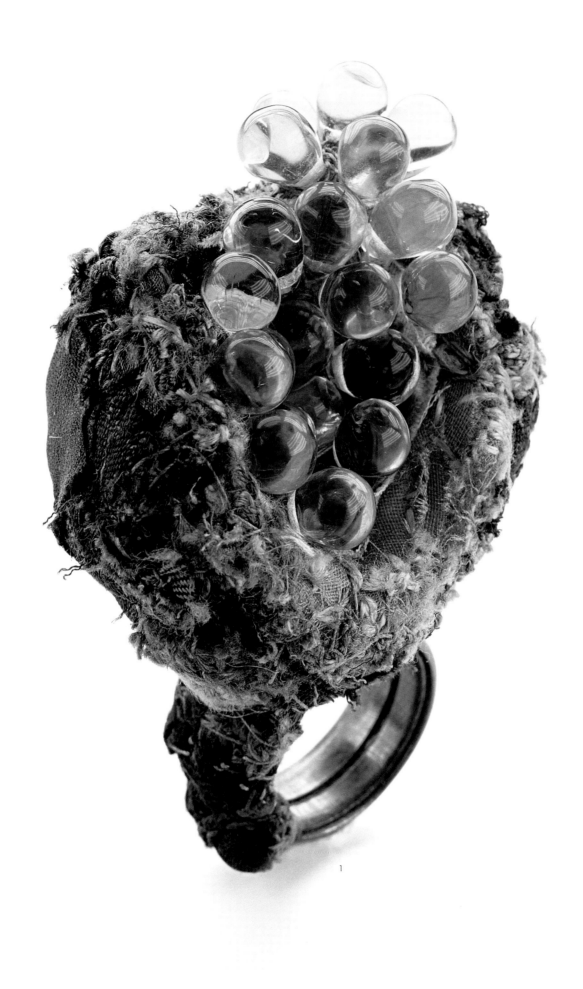

1

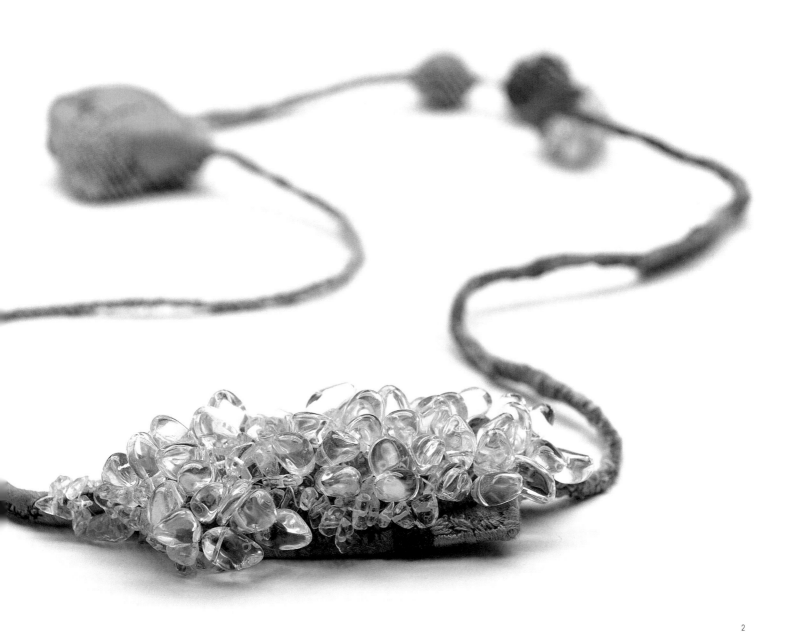

1. *Ring with tears* ring
Tantalum, fabric, and beads

2. *Underwater* necklace
Lead, fabric, and beads

Gaetano Del Duca

www.dukedesign.it

Gaetano Del Duca is an Italian freelance designer living and working in Florence. After spending his childhood in Germany, he enrolled at the Institute of Art in Florence, where he studied the various techniques used to make artistic jewelry. He subsequently graduated from the Higher Institute for Artistic Industries in Florence and worked in the city's jewelry workshops and also for various graphic design companies. His range of experience—which also includes industrial design, furniture design, packaging, and technical illustration–complements his career as a jewelry designer. His work has been recognized with several international awards.

If your work involved contemporary music, what style of music would it be?
Rap and Hip-hop.

Describe your work space in three words.
Small, cozy, organized.

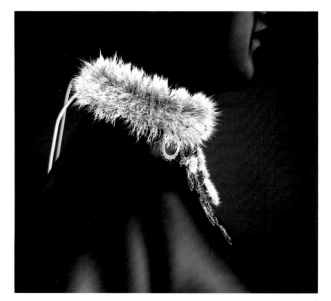

1

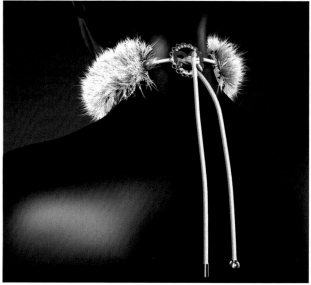

2

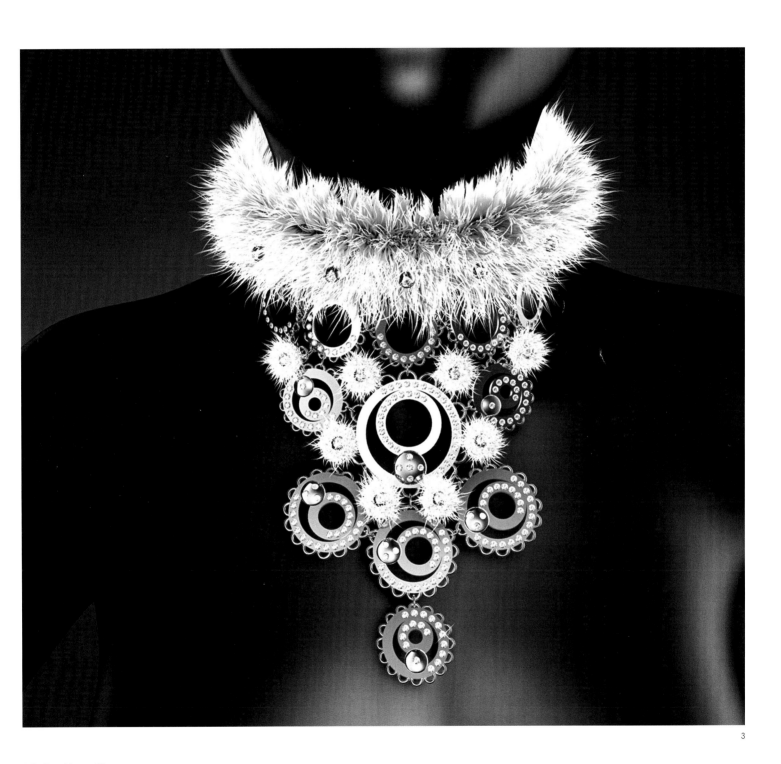

3

1-3. *Cherubino* necklace
White gold, steel, silver, synthetic fur, and 230 brilliant cut diamonds; International HRD Diamond Jewelry Award *A night at the opera* (2007)

1

2

1-2. *Ice flowers* necklace
and sketch
White gold and brilliant cut
diamonds

3-4. *Ice flowers* earrings
and ring
White gold and brilliant cut
diamonds

3

4

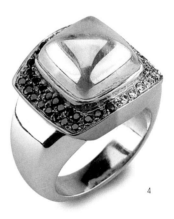

1

3

2

4

1-2. Necklace and sketch
White gold and diamonds

**3-4. *Space light* ring
and sketch**
White gold, black diamonds,
diamonds, and tavalite

**5-6. *Tin Tin* bracelet
and sketch**
Silver, gold-plated silver, steel,
enamel, and 441 brilliant cut
diamonds

5

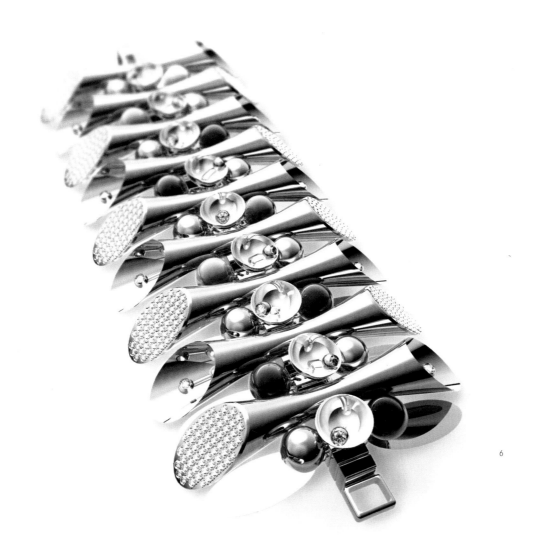

6

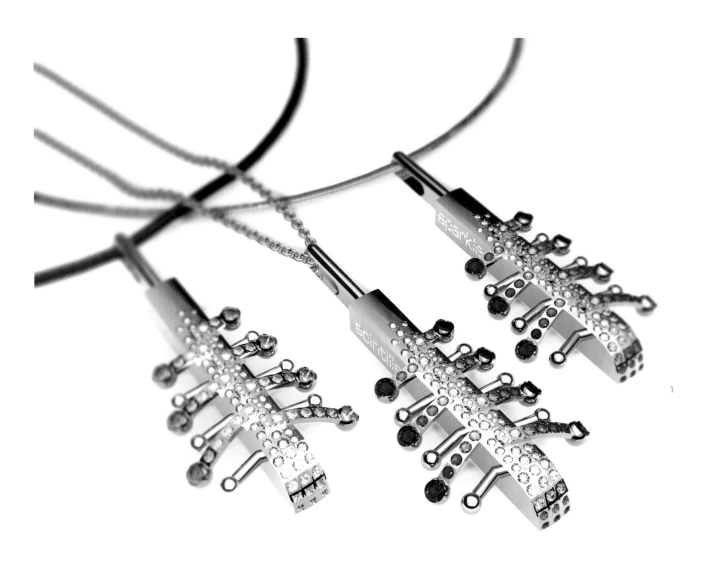

1-2. *Scintille* pendants and rings
White gold, rose gold, yellow gold,
diamonds, and semi-precious
stones; Goldsign Vogue Gioiello
International Design Award finalist

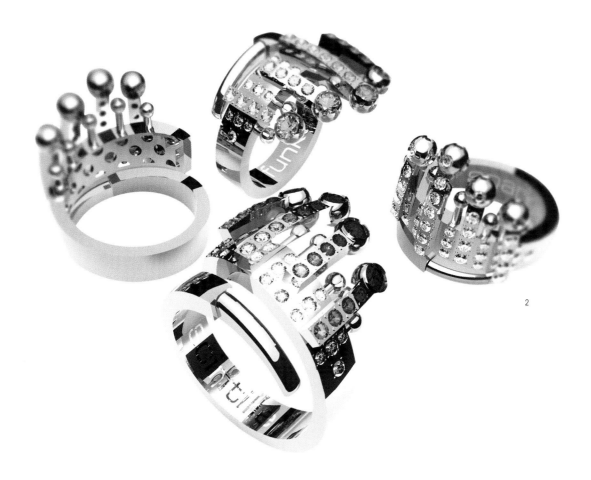

2

Elfrun Lach

www.piecesofeight.com.au

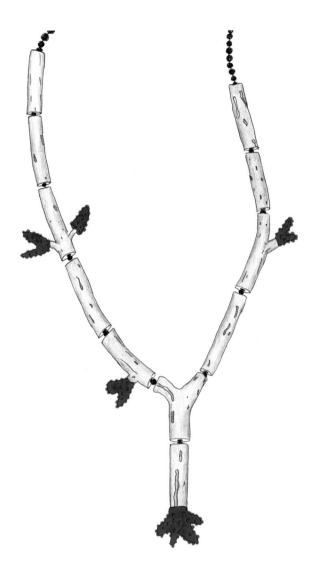

Elfrun Lach completed her degree in fine art and gold and silversmithing at the Royal Melbourne Institute of Technology in 2004, and then went on to receive a master's degree in art. She has shown her jewelry since 2001 at exhibitions and venues including the SOFA (Sculpture Objects and Functional Art) exhibitions in New York and Chicago, Charon Kransen Arts in New York, Jewellery Topos at the Galerie Marzee in the Netherlands, and as part of *Beyond metal: contemporary Australian jewelry and holloware*, which toured India, Malaysia, and Singapore in 2007. Her work is included in private collections in Australia, Canada, France, Germany, Japan, and the United States.

If you could work with only one material, what would it be?
Coral. Coral is one of the earliest materials used for human adornment, but over time the difficulty of obtaining it has led it to be replaced by other materials, including bone, glass, wood, porcelain, and plastic.

1

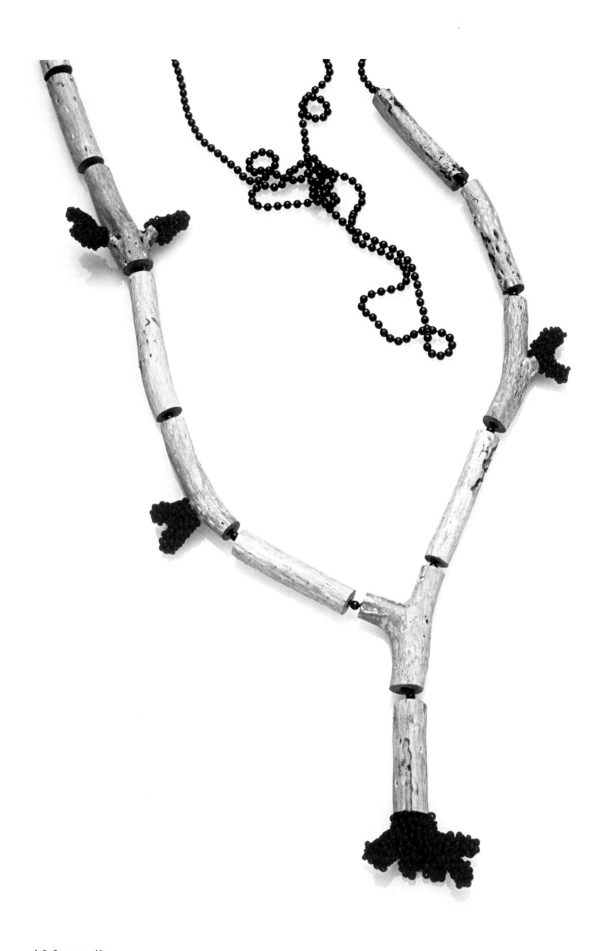

2

1-2. *Sprung* necklace
Natural twigs, gypsum, bee's
wax, felt, glass beads, cotton
thread, and oxidized silver

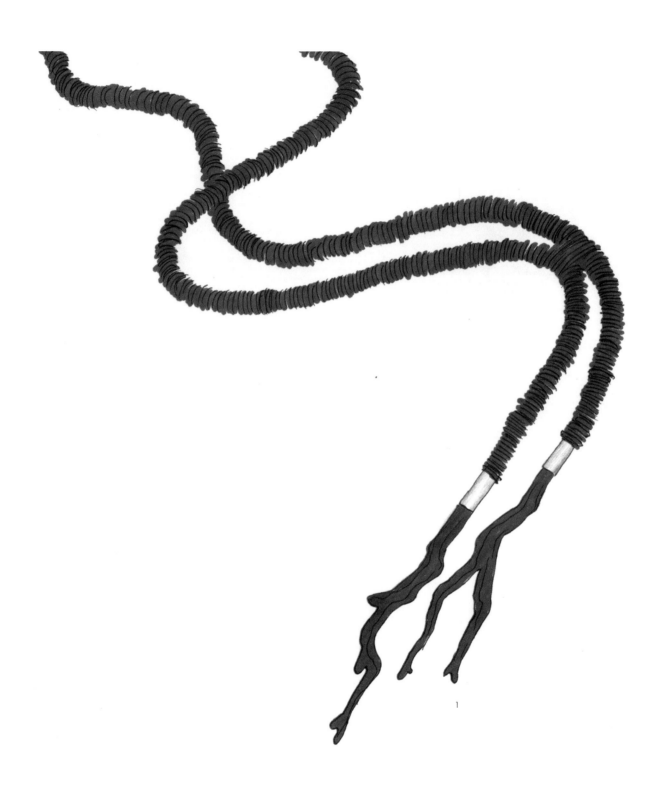

1-2. *Corallium rubrum* necklace
Branches of natural red coral
and polypropylene

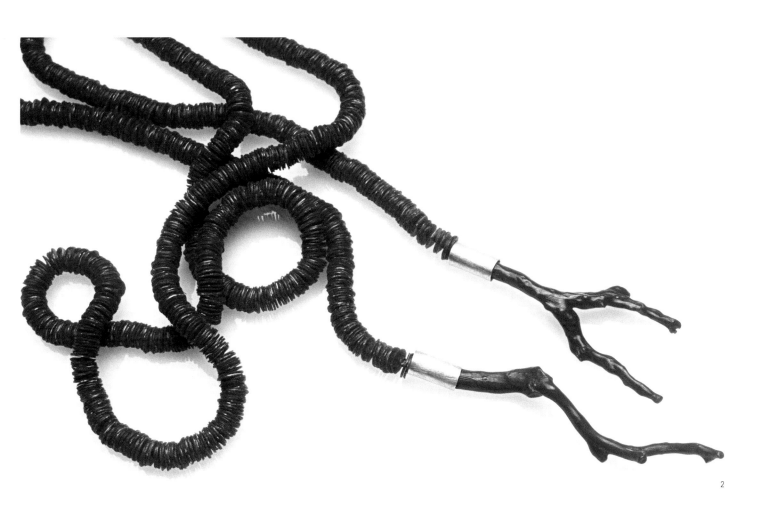

2

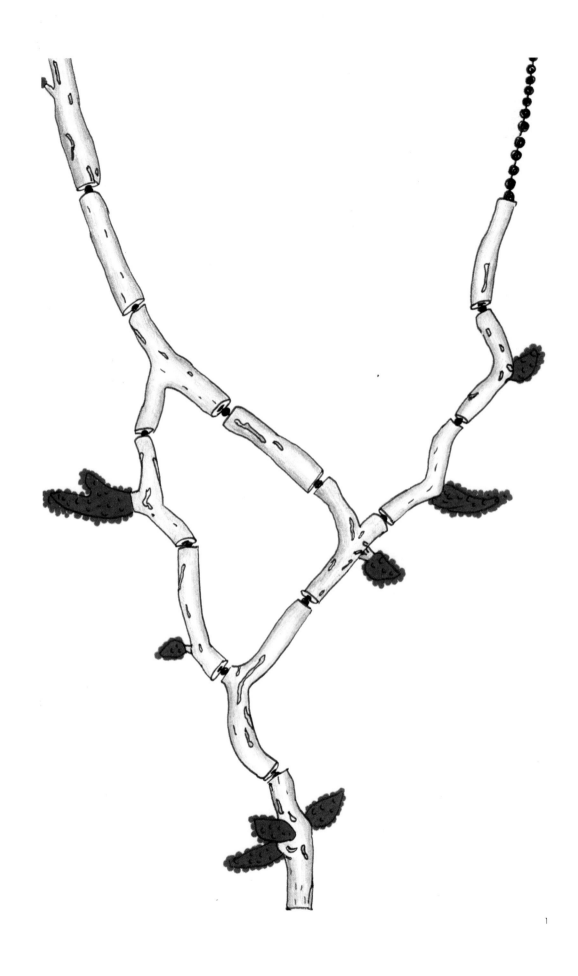

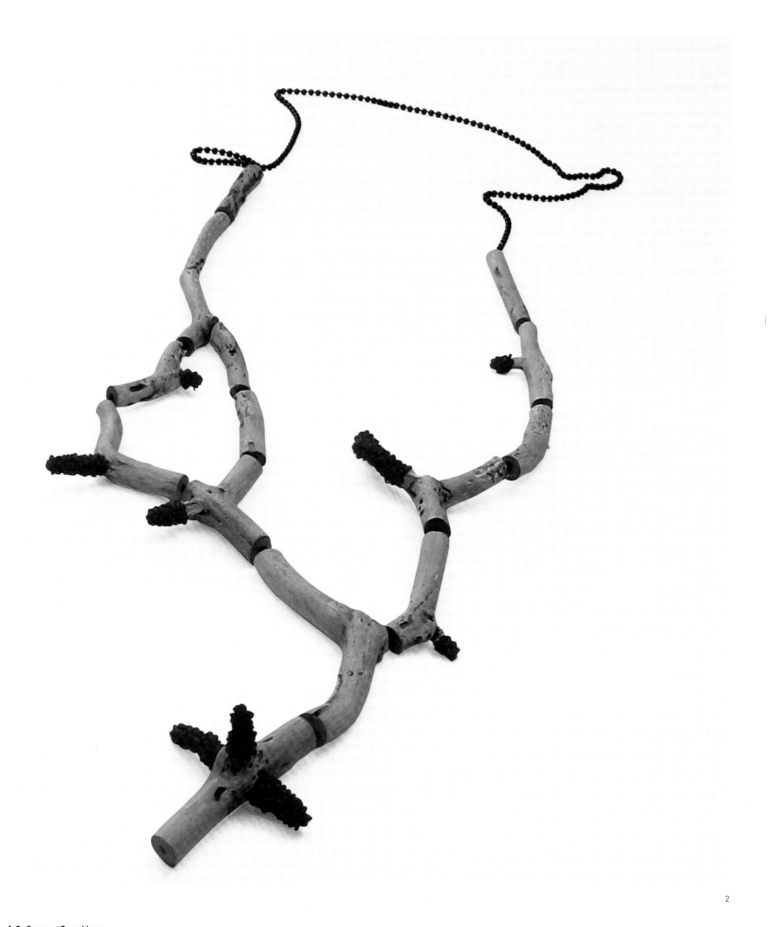

1-2. *Sprung* #2 **necklace**
Natural twigs, gypsum, bee's
wax, felt, glass beads, cotton
thread, and oxidized silver

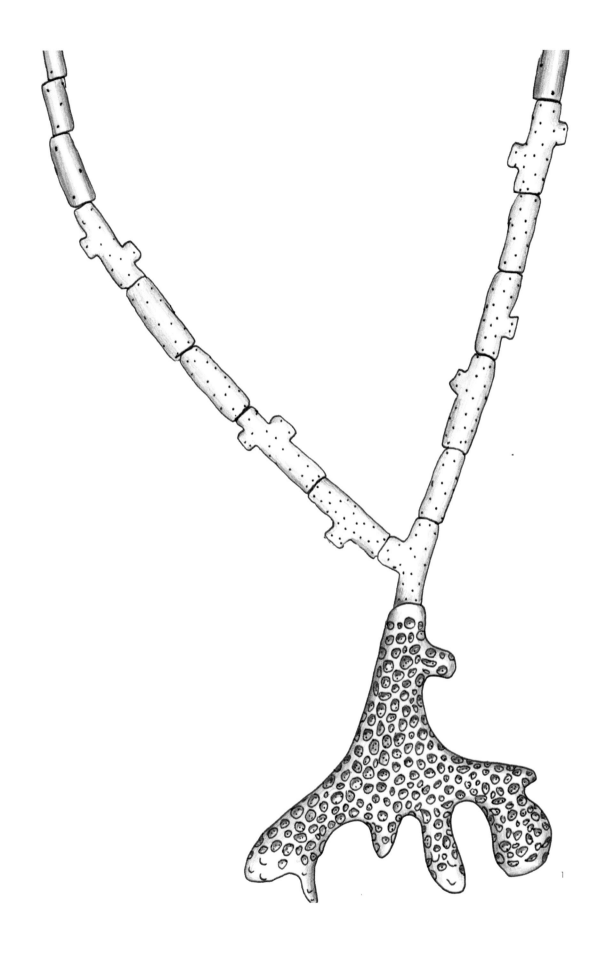

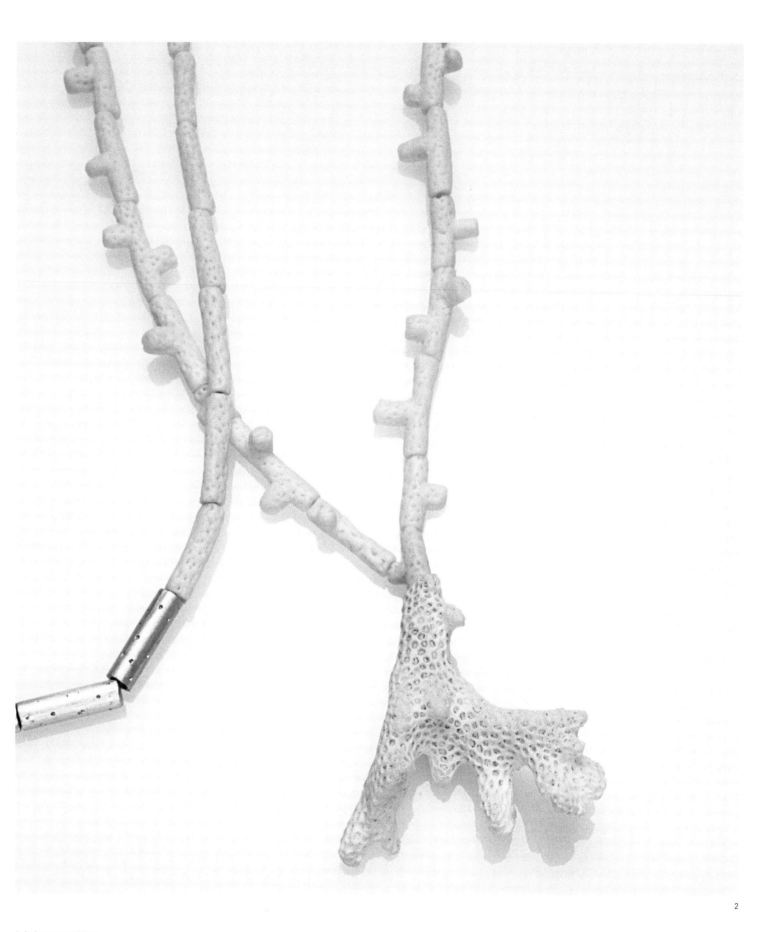

1-2. *Broome* **necklace**
White coral, porcelain, and
sterling silver

Elisa Pellacani

www.ilde.info

1

Elisa Pellacani was born in Reggio Emilia, Italy, in 1976. She studied art history at the University of Parma and completed her training in Artistic Editing at the International School of Graphic Arts in Venice and in illustration at the Escola Massana in Barcelona. Drawing on her skills as a photographer, illustrator, and editor, she creates jewelery that is in effect three-dimentional, wearable art. She is also very active in Barcelona's bookbinding community: she founded the Association of Book Artists (ILDE), coordinates Barcelona's International Art Book Fair, and teaches the craft at numerous institutions.

If your work involved contemporary music, what style of music would it be?
If I were a musician, I would be interested in jazz and experimental music.

Describe your work space in three words.
My study is my world. It is the warehouse, refuge, and bookshop of my dreams.

1. *Orlando innamorato* necklace
Silver and enamel

2. *Camminare per l'aria* brooch
Silver, gold, stones, and enamel;
dedicated to the writer
Silvio D'Arzo

2

1

2

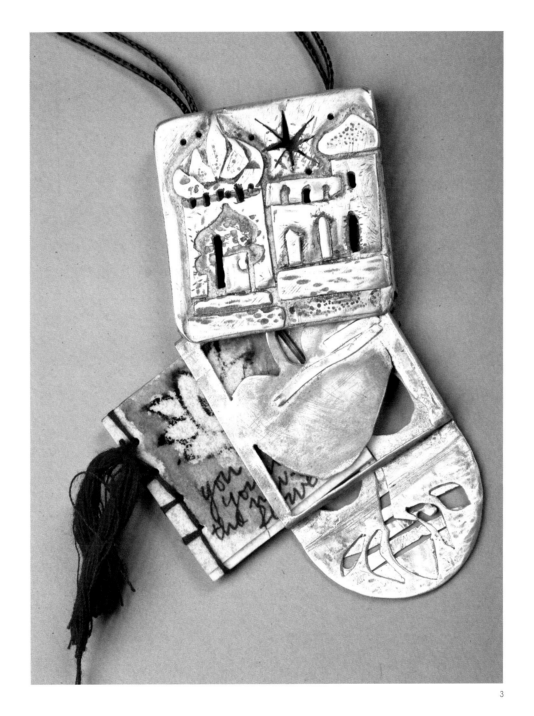

3

1-2. *Peligroso* book-brooch

Silver, gold, paper, and red ink

3. *Oriental travel log* book-pendant

Silver, gold, parchment, Indian ink,
and Japanese binding

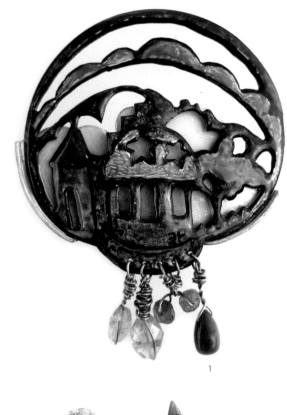

1

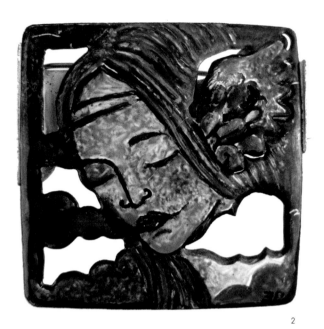

2

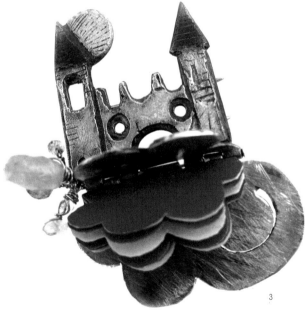

3

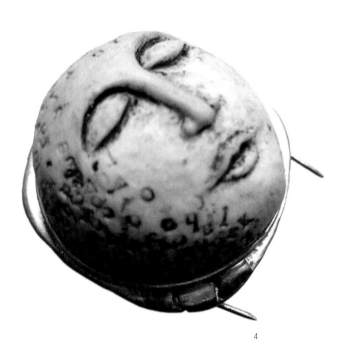

4

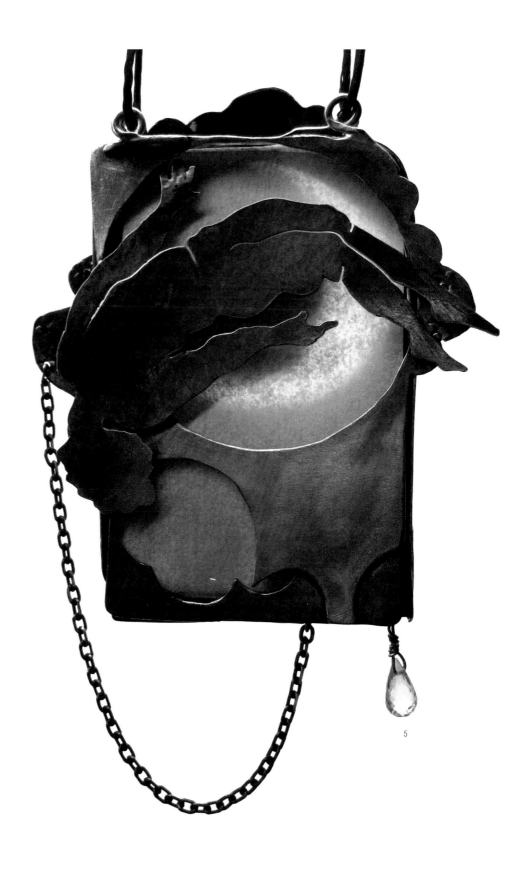

5

1. *Oriental travel log* book-pendant
Silver, gold, parchment, Indian ink,
Japanese binding

2. *Angelica* brooch
Silver and enamel

3. *Castillo* book-brooch
Silver, origami paper, and stones

4. *Paredes de estrellas* brooch
Porcelain, silver, and gold

5. *Camminare per l'aria* book-pendant
Copper, silver, stone, parchment,
and waxed thread; dedicated
to the writer Silvio D'Arzo

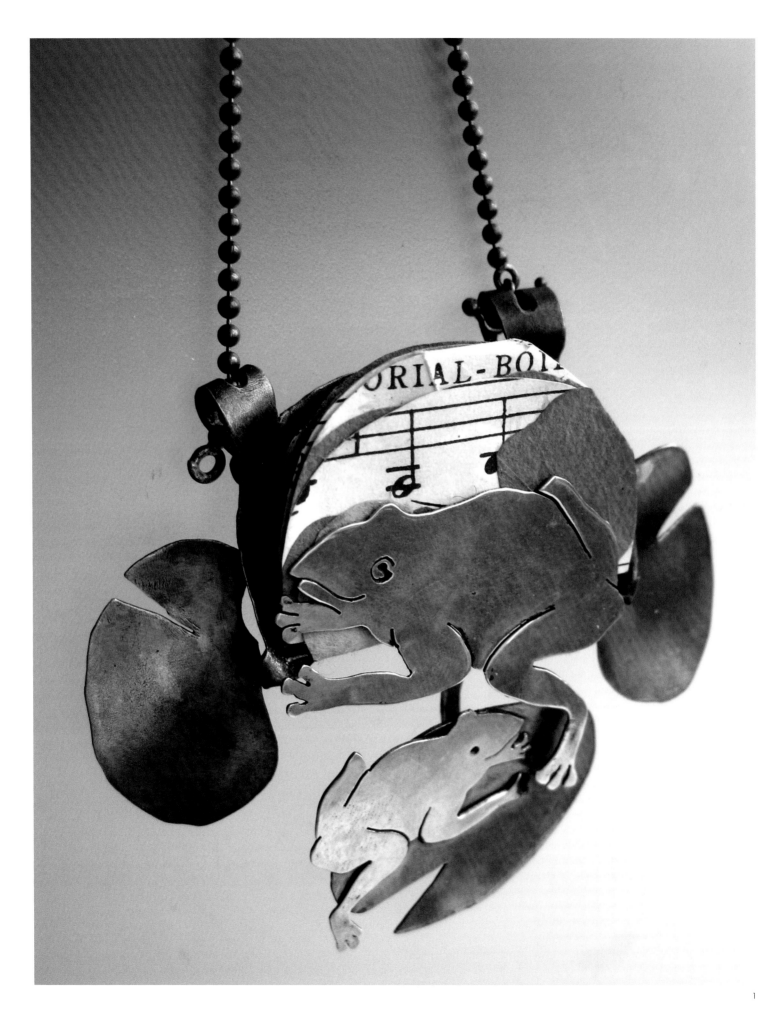

1

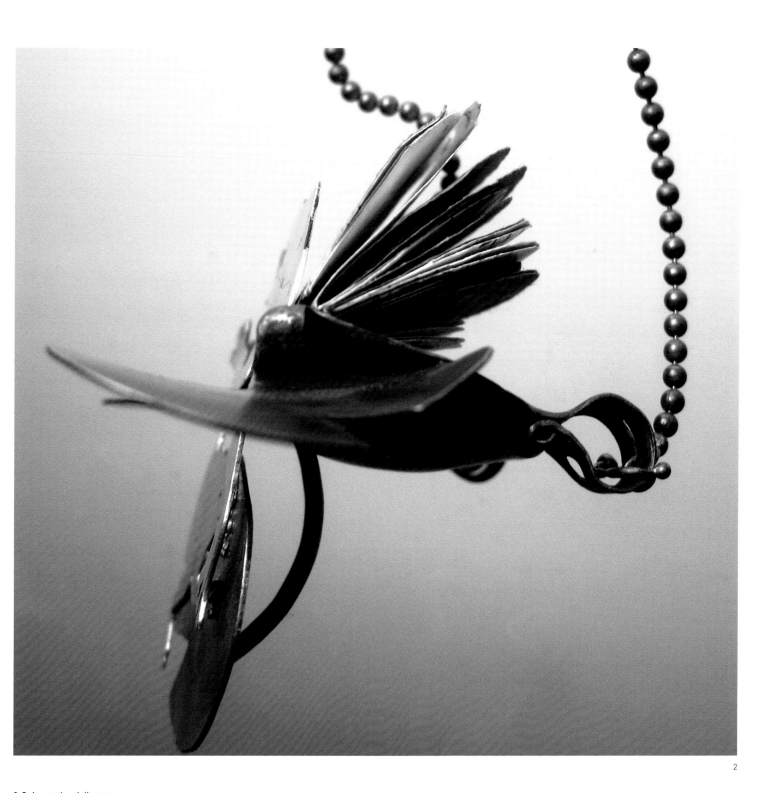

1-2. *La musica delle rane*
book-pendant
Silver, copper, paper with
music score, and twine
binding; closed on the left,
open on the right

2

Els Vansteelandt

www.elsvansteelandt.be

Jewelry designer Els Vansteelandt was born in Brussels in 1961. She began her career as a goldsmith in 1997, designing both jewelry and art objects. Her work has received international acclaim, and has been exhibited in museums and galleries throughout Europe. Design Flanders, an institution from Belgium which promotes designers and stimulates companies and the public to use design, has recognized her work since 2001 and included it in the "World Best Design Exchange" that took place as part of the 2007 Design Korea exhibition in Seoul. She has also been selected twice for the German Silver Triennial. Following a number of successful projects with Modo Brux-elles and the boutique White Hotel, Vansteelandt opened a studio in the center of Brussels to serve as her own meeting place and creative laboratory. Her work is included in several permanent art collections.

If you didn't specialize in jewelry, what would you be? Being a surgeon would seem to me to be an exciting alternative.

Describe your work space in three words. A laboratory for creation and meditation.

1

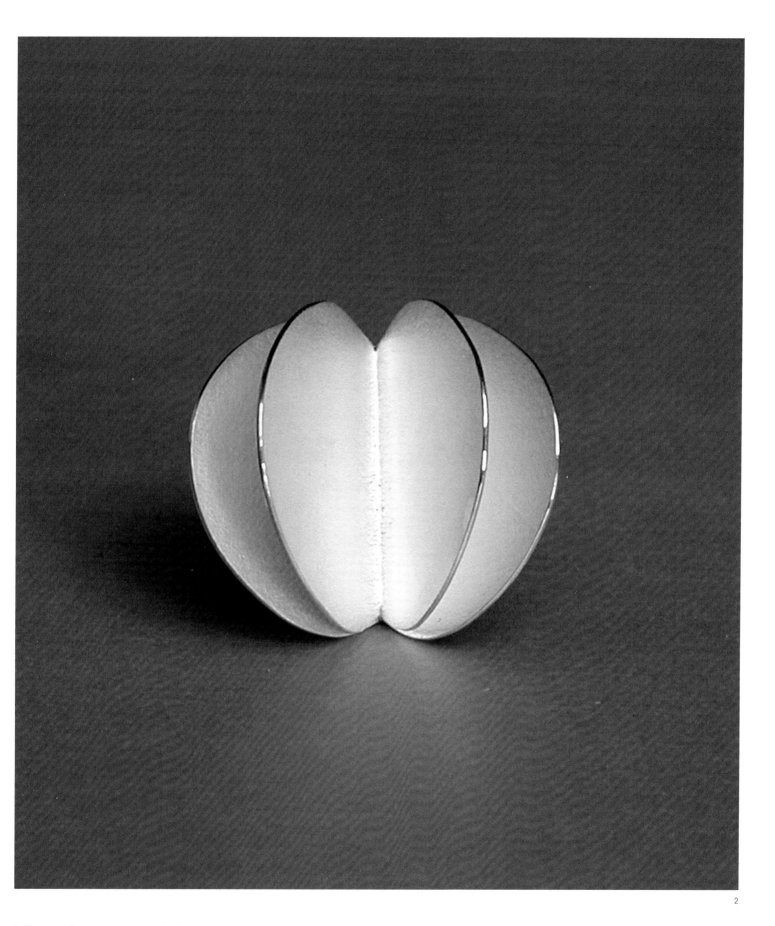

1. *Heart work* rings
Silver 925

2. *Euphrasy* brooch
Silver 9350

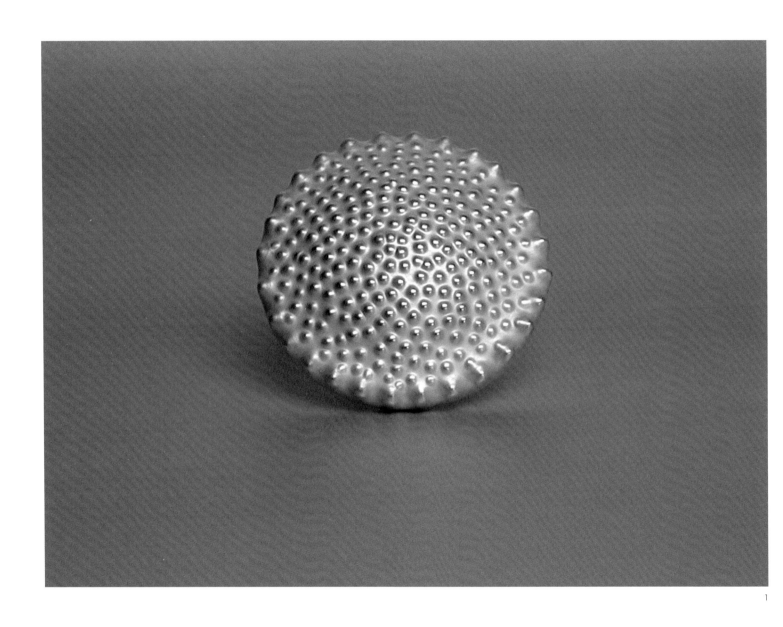

1

178

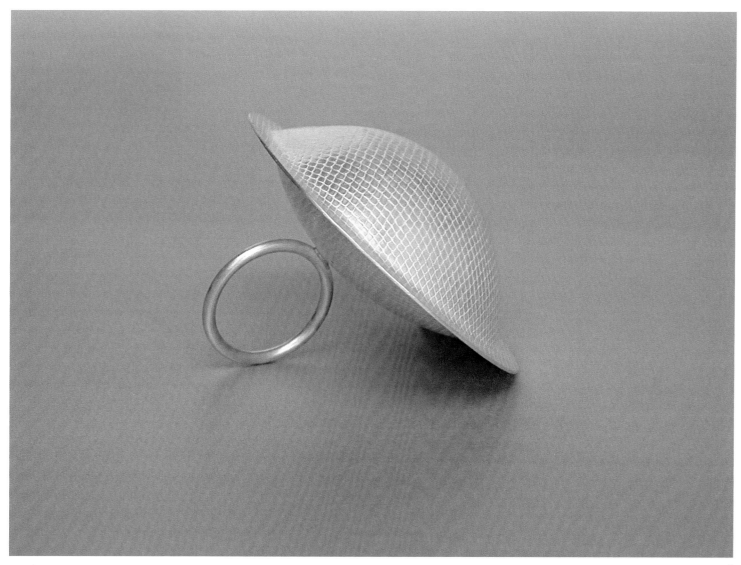

1. *Budding beauty* brooch
Silver 935

2. *Spaced-out* ring
Silver 935

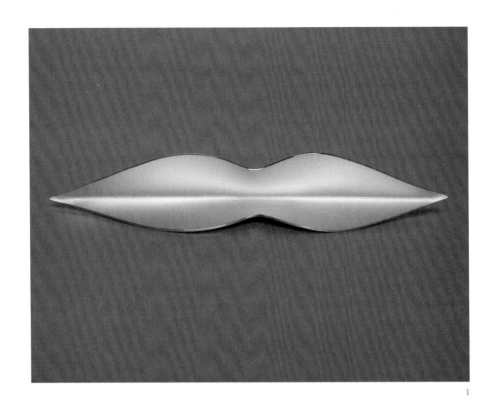

1

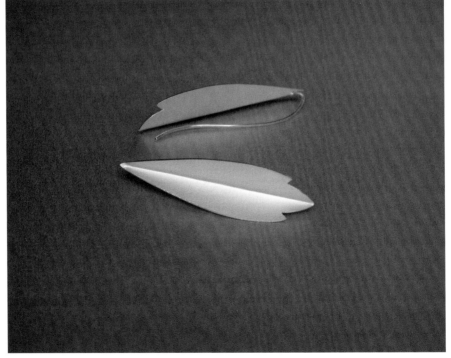

2

180

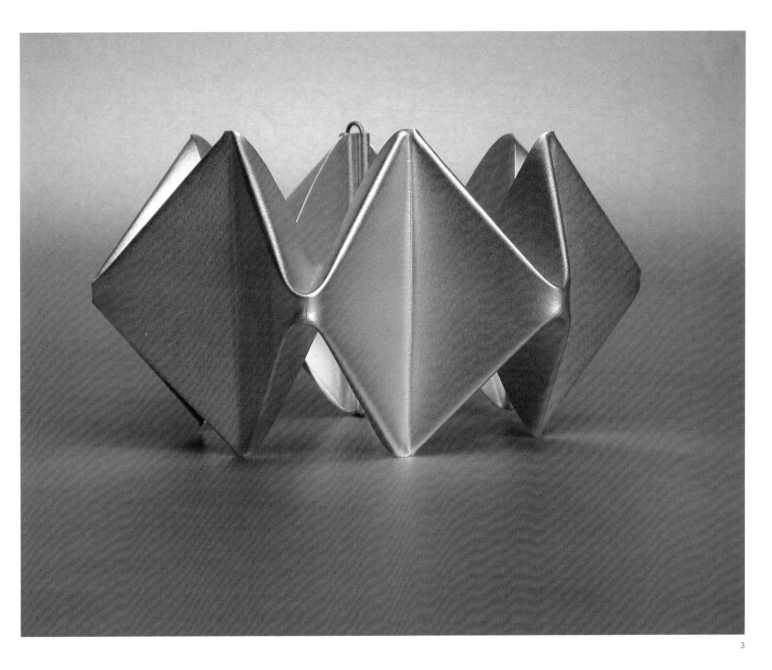

3

1. *Labiate* brooch
Silver 935

2. *Grow on* earrings
Silver 925

3. *Inside out* bracelet
Silver 999

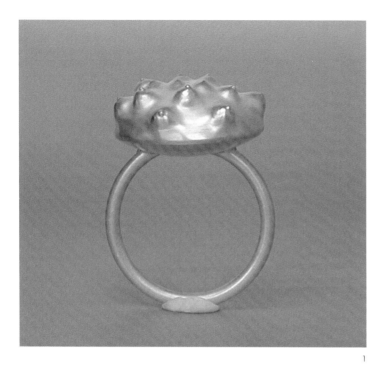

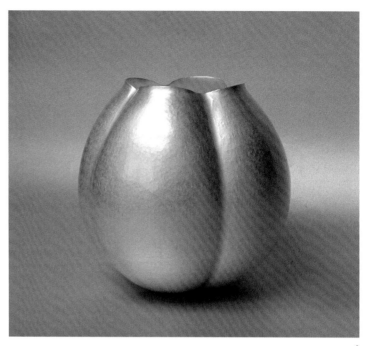

1

2

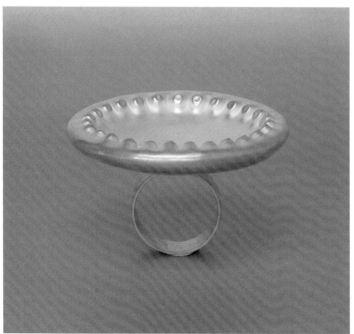

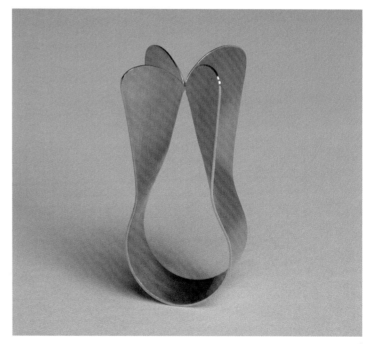

3

4

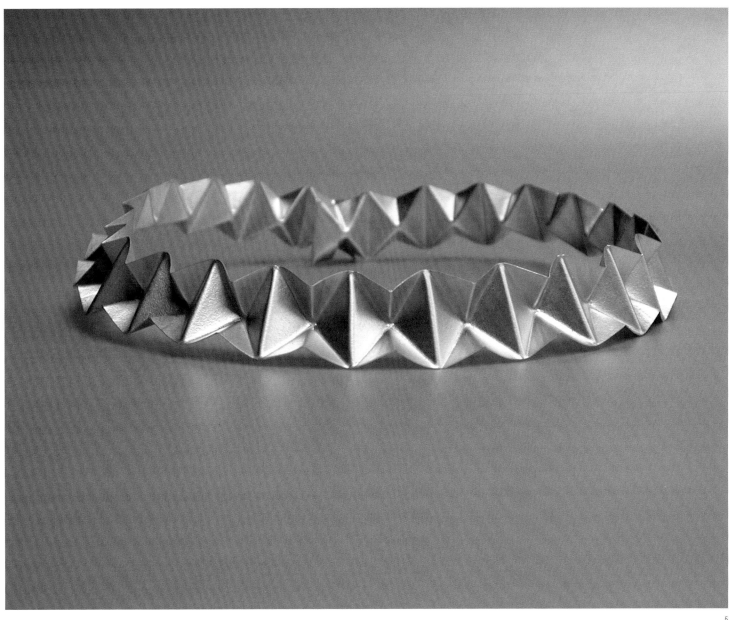

5

1. *Untouchable* ring
Silver 935

2. *Papaverous* container
Silver 925

3. *Alchemilla* ring
Silver 935

4. *Let's fly* ring
22-karat gold

5. *Praalband* necklace
Silver 925

Eva Girbes

joyart-esana.blogspot.com

1

Eva Girbes was born in Granada but moved to Barcelona, where she trained at the School of Arts and Trades of Barcelona and the Escuela Massana. She studied Berber jewelry with Karim Oukid, and took courses in smelting and ceramic pastes at the Taller Perill. She has been involved with the *Sensational jewelry* project coordinated by Silvia Walz. She frequently draws upon the warmth of materials such as wood, silver, and German silver in her pieces, and highlights the contrasts between solid and hollow shapes, and volume and flatness. She always links her pieces to a particular celebrity, which she uses to infuse the object with personality.

If you were not involved in jewelry, what would you do?
I imagine I would be a sculptor. Even though I ended up in jewelry, I started my training at the Escuela Massana in sculpture. I was impressed by jewlery's scale. But conceptually, I do not think there is a clear dividing line between the two art forms.

Describe your work space in three words.
Harmonious, full, and chaotically tidy.

1-2. *Lo duradero y lo efímero* brooches
Silver, German silver, and wood

2

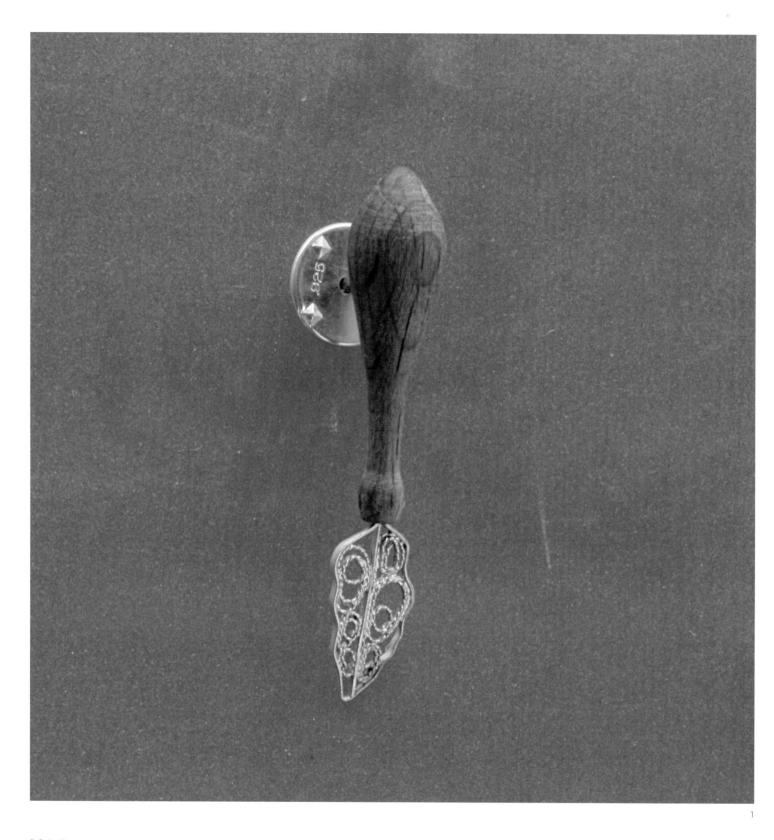

1-2. *Lo ligero*
y lo pesado pins
Wood and silver

1

1. *Lo ligero y lo pesado* pin
Wood and silver

2. *Señora encuentros* and
Señor pérdida brooches
Silver, enameled copper,
miscellaneous found plastics,
and buttons

188

Fernanda Semino

semino.fernanda@gmail.com

1

Fernanda Semino was born in Rosario, Argentina, in 1979. Her taste for art and exquisite style was evident from an early age. She went on to earn degrees in fine art and in graphic design and illustration, and to train in goldsmithing and metalwork. She continues to incorporate new techniques for jewelry and textiles. Semino has worked as a graphic designer for various companies and as a teacher at Taller Fabric, an art workshop in Málaga, Spain. Her pieces, which combine her passion for jewelery and textile art, have been featured in a number of group and individual exhibitions in Rosario and Buenos Aires.

If you didn't specialize in jewelry, what would you like to do?
If I didn't specialize in jewelry, I would like to be a singer, but I know I don't have the stage presence it requires.

If your work involved contemporary music, what style of music would it be?
I think my work would be classified as some kind of alternative genre, like Regina Spektor or Björk.

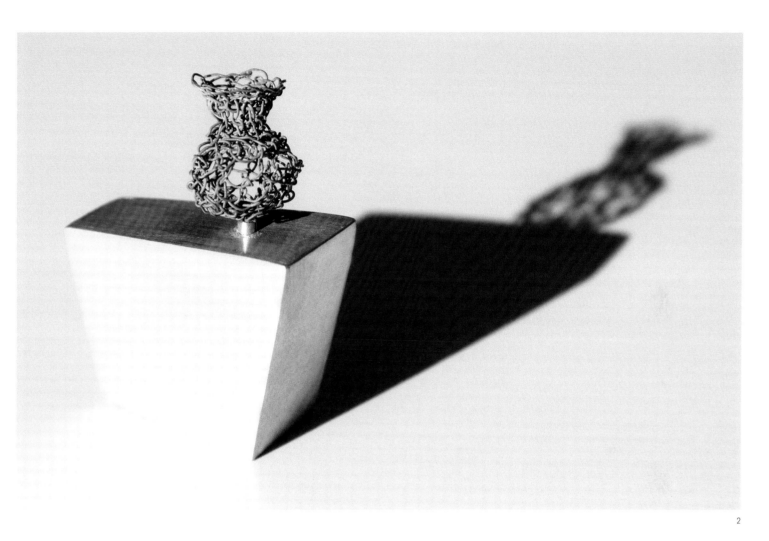

1. *Rectangular textile* ring
Silver 950 with patina and
Japanese cloth

2. *Woven bowl* brooch
Silver 950 and silver thread
with patina

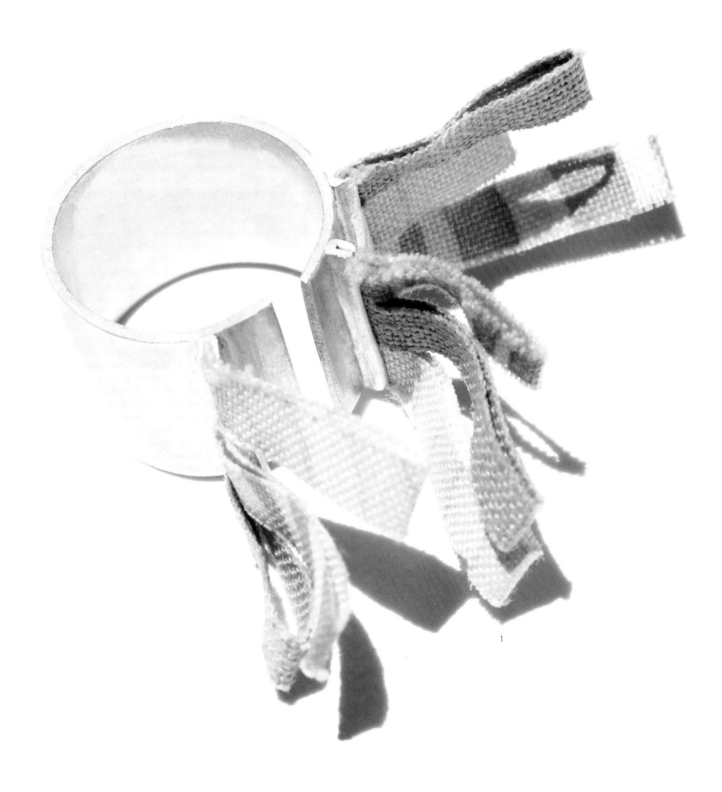

1. **Ring**
Silver 950 and Japanese
cloth

2. *Oriental* **earrings**
Silver 950 and Japanese
cloth

3. **Ring**
Silver 950 and Japanese
cloth

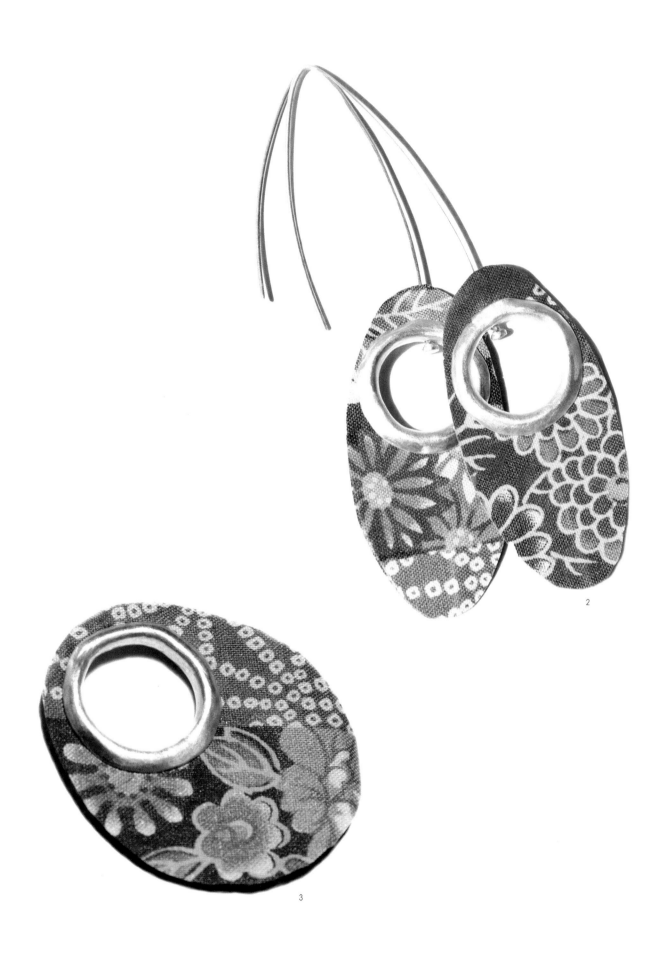

2

3

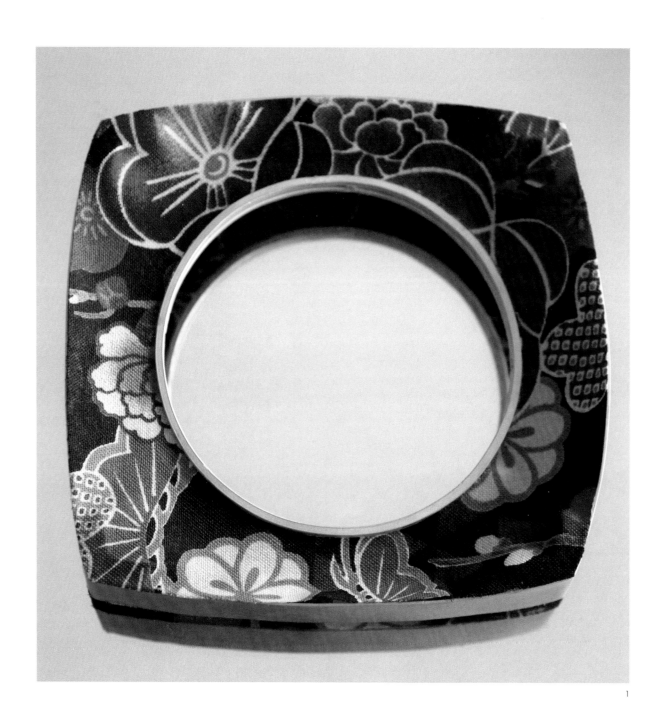

2

1-2. *Oriental* **bracelets**
Silver 950 and
Japanese cloth

1. *Black raffia* **bracelet**
Silver 970 and handwoven
raffia

2. **Bracelet**
Reticulated silver 950

197

Giselle Morales

gissellemorales.blogspot.com

1

Giselle Morales was born in the Dominican Republic in 1982. She received her training in art, sculpture, and jewelry in Santo Domingo, New York, Finland, and Barcelona, where she studied at the Escola Massana. Her work has been included in exhibitions and shows in Europe, Santo Domingo, and the United States. Her work is based on her urge to share her experiences through symbolic forms with a hidden message of time and movement.

If you didn't specialize in jewelry, what would you be?
A Buddhist.

Describe your work space in three words.
Light, movement, freedom.

2

3

1-4. *Lo efímero y lo
duradero* **brooches**
Copper, silver, fired enamels,
paint, resin, and thread

4

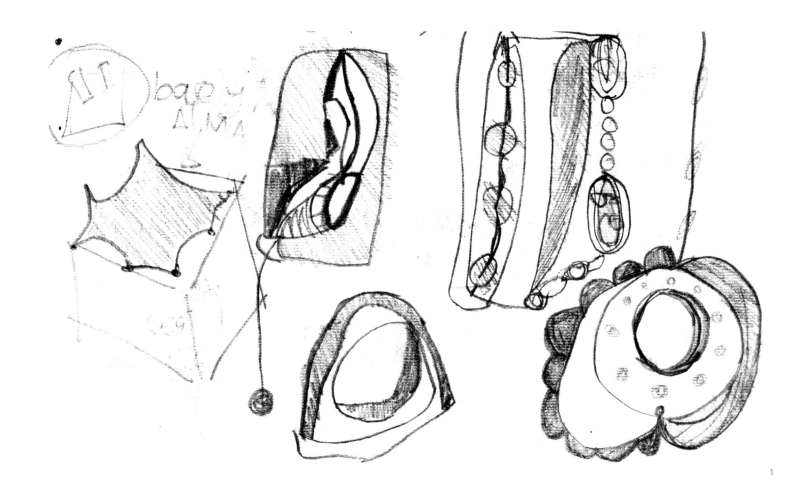

1. *Lo ligero y lo pesado* sketches

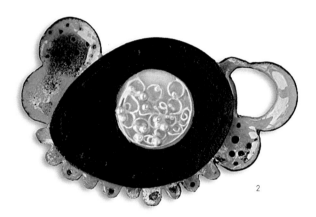

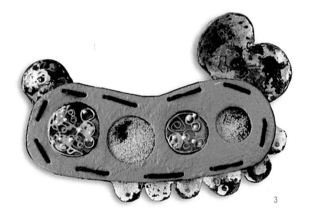

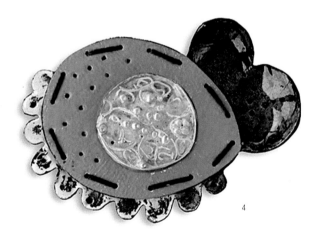

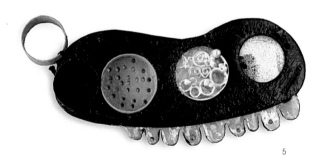

2-5. *Lo ligero y lo pesado* brooches
Copper, silver, fired enamels, paint,
filigree, and resin

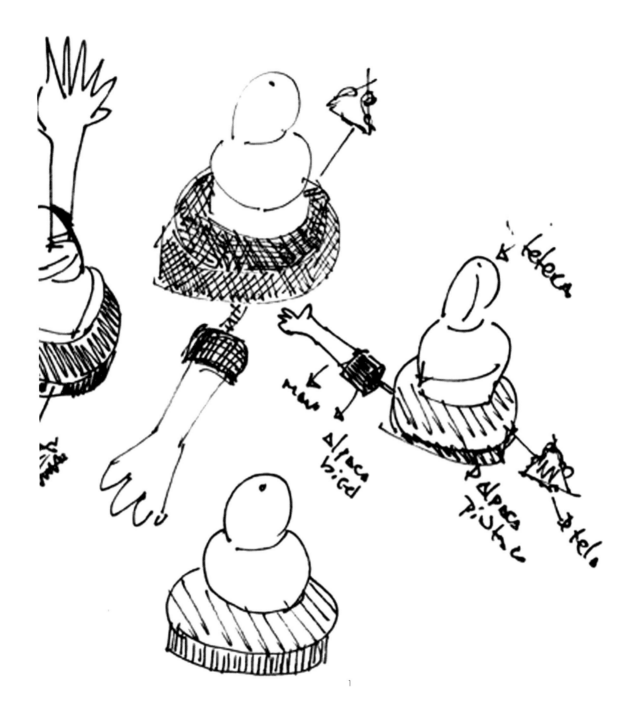

1. *Lo peligroso* brooch sketches

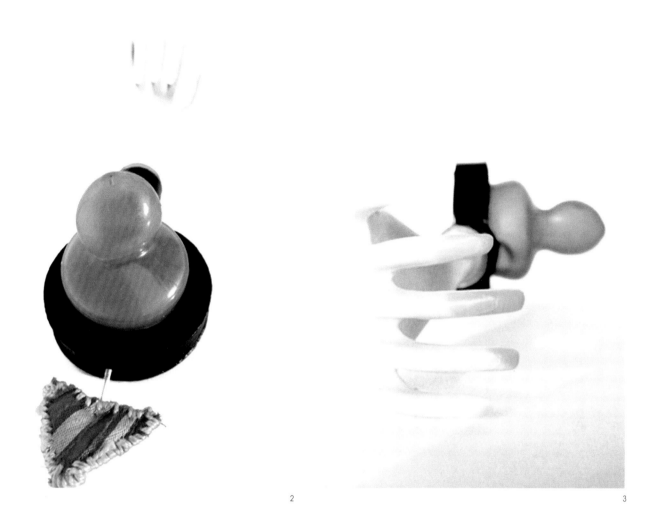

2

3

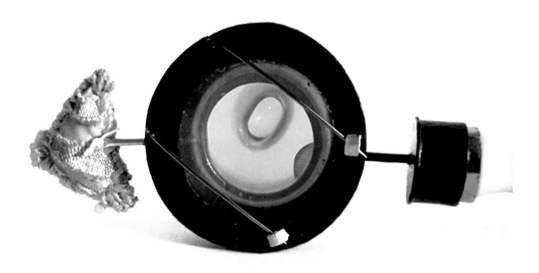

4

2-4. *Lo peligroso* brooch
Silver, plastic, German silver,
textile, and latex

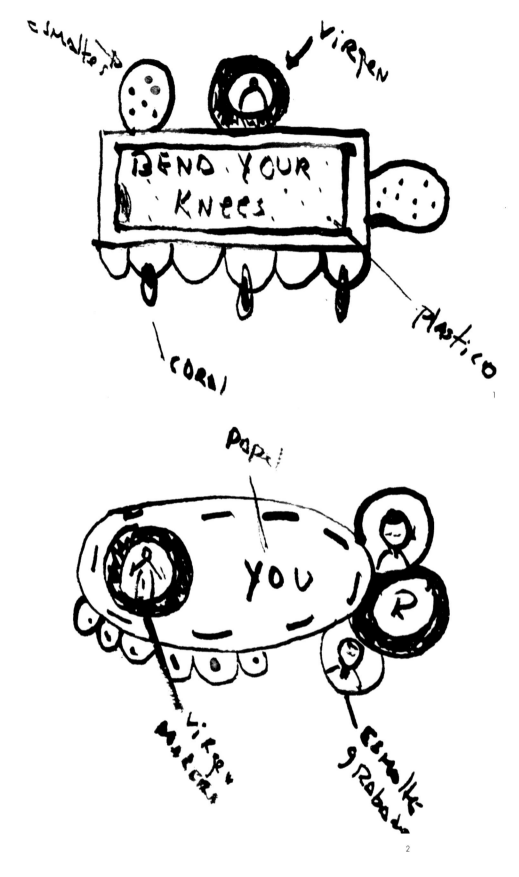

1-2. *Bend your knees* and
Your brooches sketches

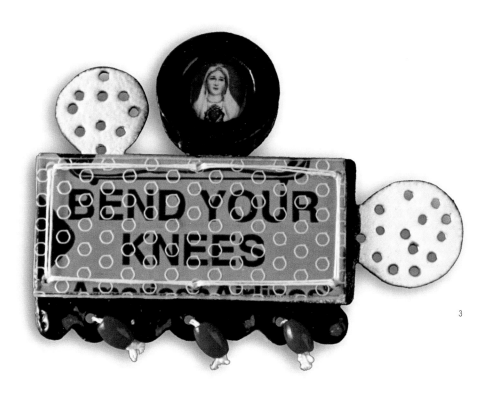

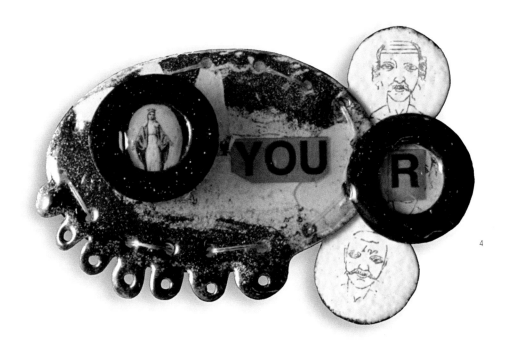

3. *Bend your knees* brooch
Copper, silver, fired enamels,
paper, resin, and wood

4. *Your* brooch
Copper, silver, fired enamels,
paper, resin, and wood

Gloria Gastaldi

gloriagastaldi.blogspot.com

Jewelry designer Gloria Gastaldi was born in 1965 in Cordoba, Argentina. In 1988 she obtained a master's degree in ceramics from the School of Fine Arts Líbero Pierini of Rio Cuarto in Argentina. During the following years her ceramic pieces began to be shown in many group exhibitions. In 1991, she studied design and jewelry making with designer Iza Guimares in Brazil, and the following year took part in a gold and silversmithing workshop at the Rómulo Raggio Museum of Art in Buenos Aires. She would later run a workshop on design and jewelry making in her hometown, as well as teach gold and silversmithing at the Technical Institute. Her original collections have been featured in numerous solo and group exhibitions. Her pieces are characterized by the fusion of different materials, with playful, dynamic results.

If you didn't specialize in jewelry, what would you be?
A chef.

If your work involved contemporary music, what style of music would it be?
Electronic.

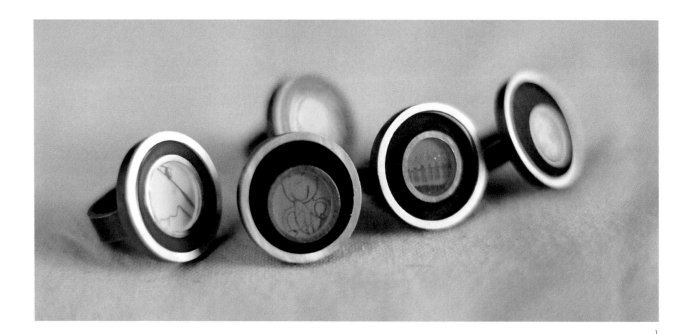

1

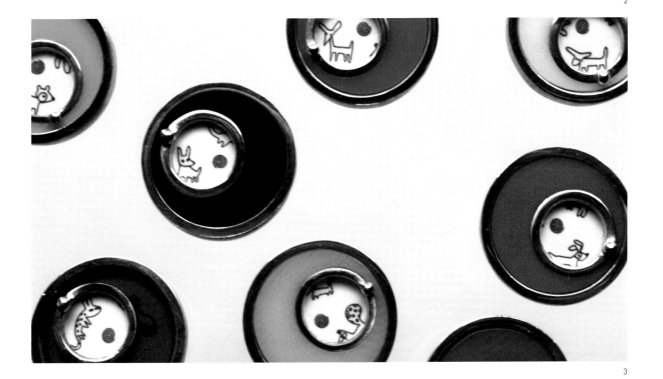

1. *Pop flúor* rings
Silver 925 and metacrylate

2-3. *Móviles* rings
Silver 925 and metacrylate;
the pieces have an internal
system that enables the
metacrylate piece to rotate to
show different images

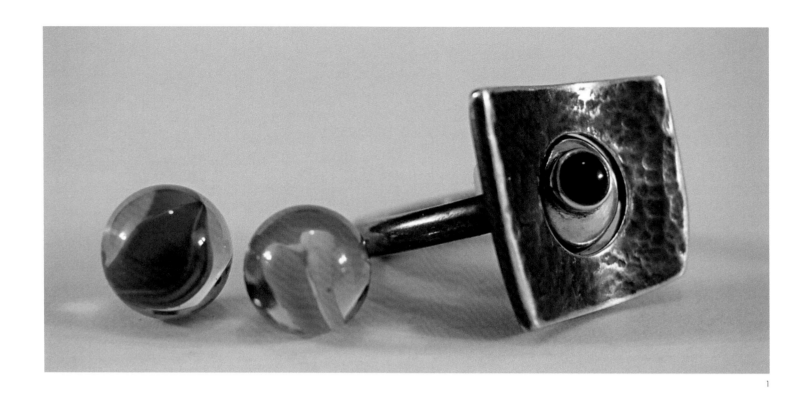

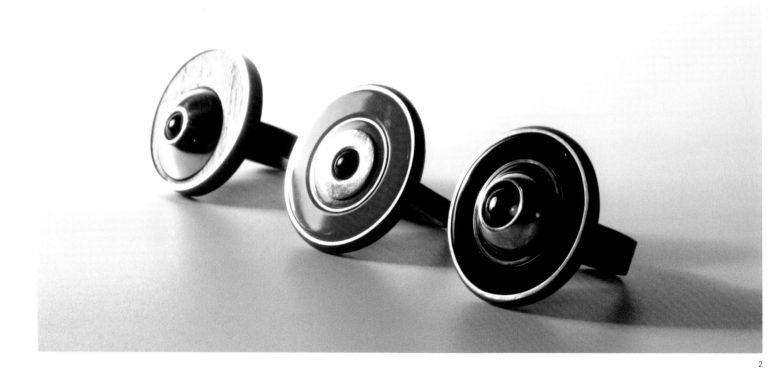

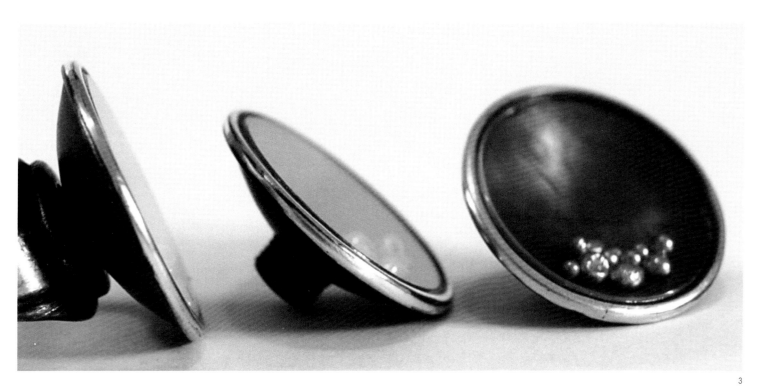

3

4

1. *Elementos* ring
Silver 925, metacrylate,
and stone

2. *Pop* rings
Silver 925, metacrylate,
and stones

3. *Elementos* rings
Silver 925, watch glass,
gold, and copper; this piece
is composed of a threaded
system enabling the bowls of
the beads in different metals
to be changed

4. *Elementos* ring
Silver 925 and marbles;
this piece is composed of
an anchorage system that
enablins the elements
to be changed

1-2. *Canícas* rings
Silver 925, marbles, and
metacrylate; composed of
a series of interchangeable
pieces, making it possible
to modify the ring

Golden Ink Collaborative

www.goldenink.com.au

Golden Ink is a collaborative effort between two Australian artists, jeweler Katherine Wheeler and printer Abby Seymour. They met at the Royal Melbourne Institute of Technology, where Seymour was studying printing and Wheeler fine art and gold- and silversmithing. Once they began their collaboration, they faced the challenge of finding the medium that would best allow them to combine their talents. After some trial and error, they settled on ceramics, which has allowed them to move in new and exciting directions. Having received significant media attention and building a strong customer base, Goldenlink opened their online store in 2011.

If you didn't specialize in jewelry, what would you be?
Wheeler: A marine biologist.

If you could work with only one material, what would it be?
Wheeler: Sterling silver.
Golden Ink: Porcelain.

If your work involved contemporary music, what style of music would it be?
Golden Ink: Indie rock.

1

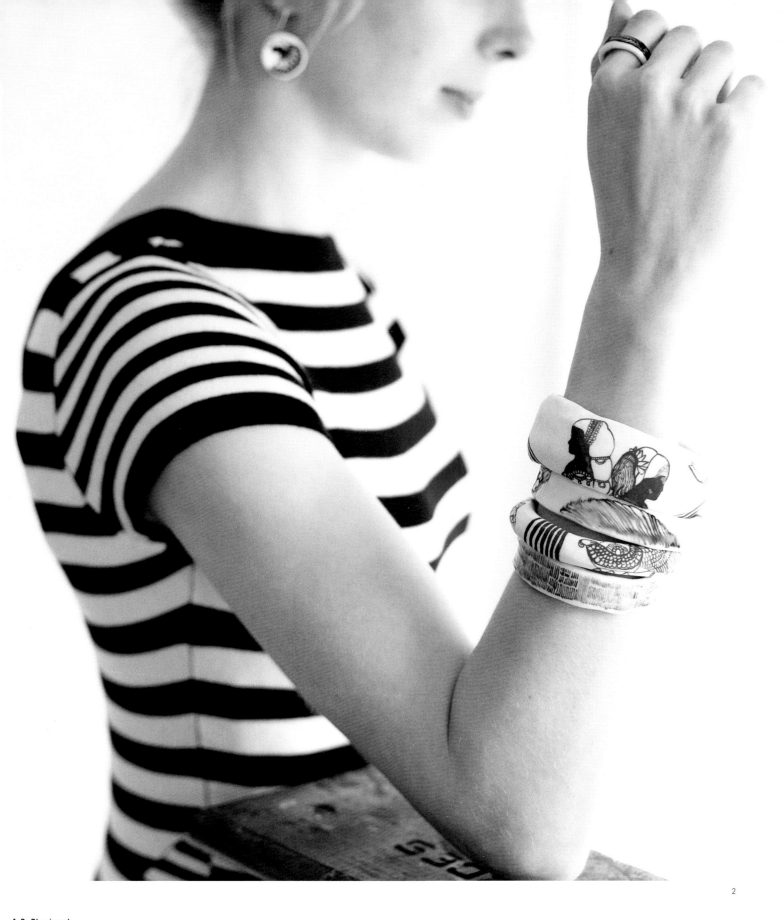

1-2. *Blue* **jewels**
Enamel rings and bracelets,
with illustrations of feminine
profiles and handpainted
geometric and organic
patterns on handmade
ceramic pieces

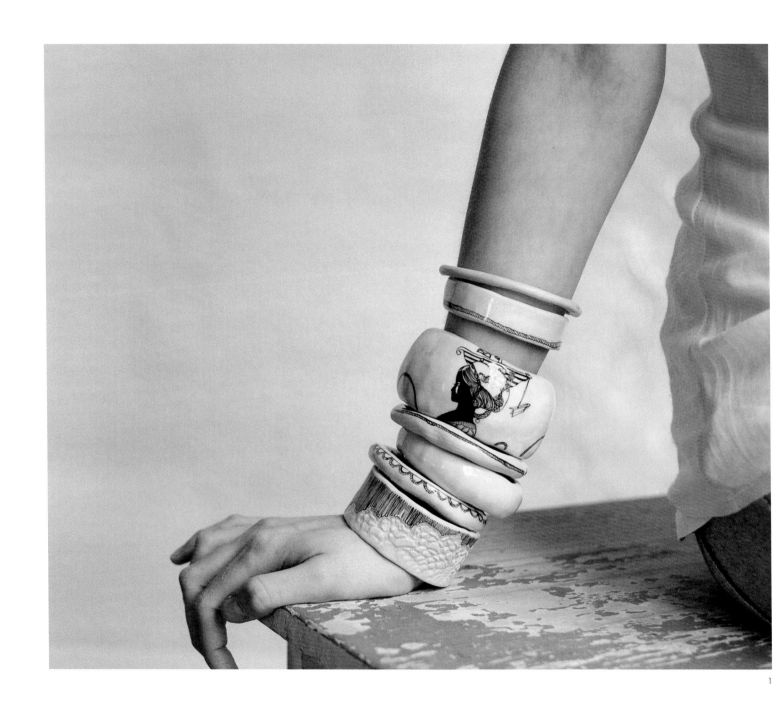

1-2. *Rose pale* jewels
Enamel rings and bracelets,
with illustrations of feminine
profiles and handpainted
geometric and organic
patterns on handmade
ceramic pieces

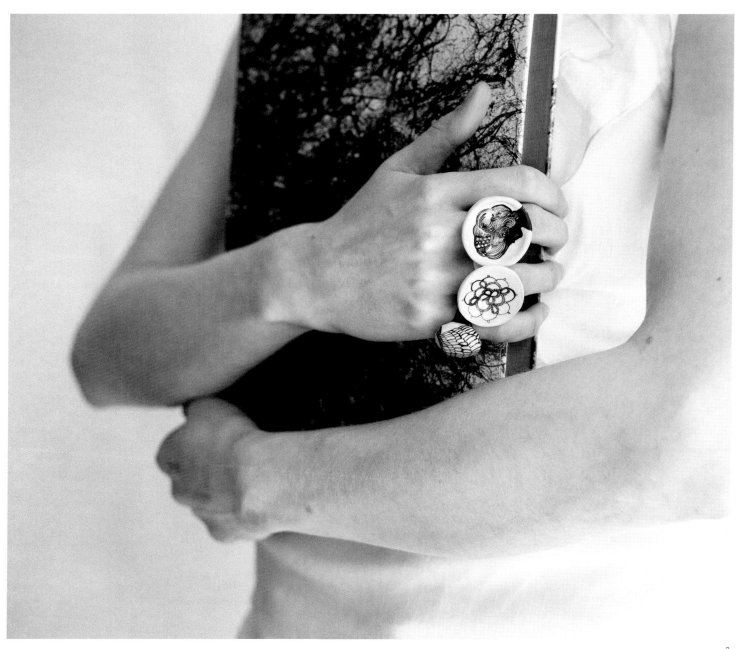

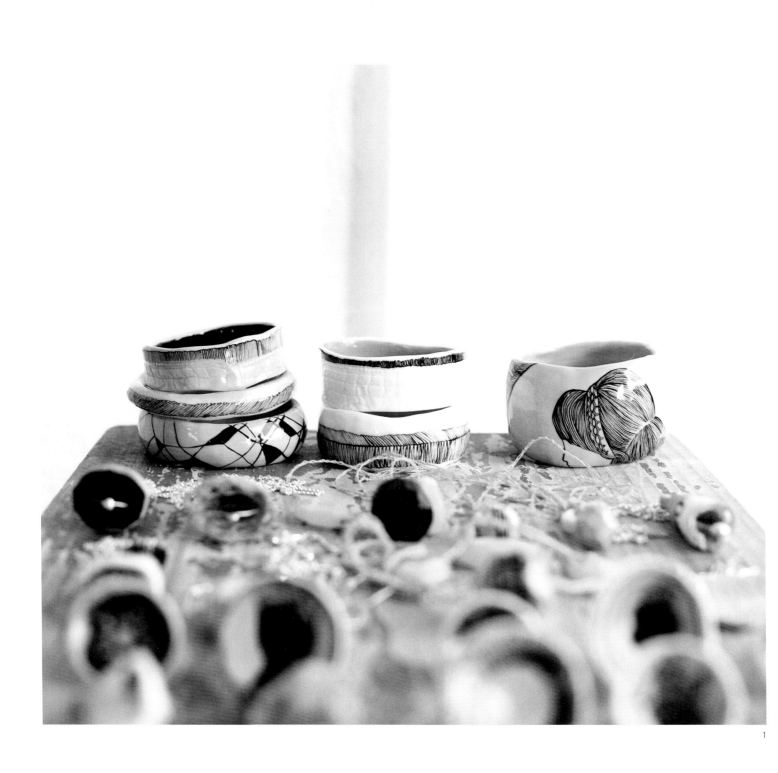

1

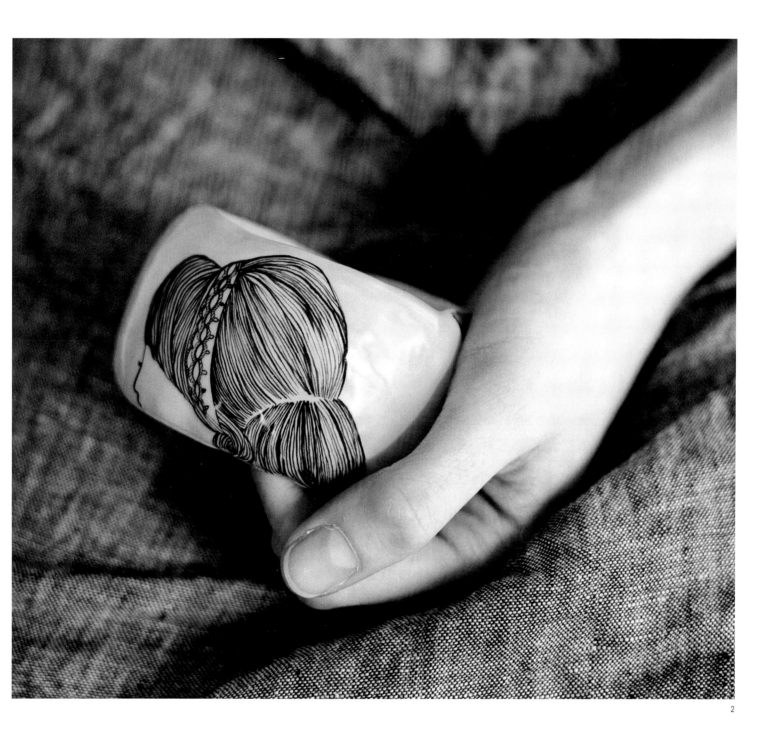

1-2. *Golden yellow* **jewels**
Enamel rings and bracelets,
with illustrations of feminine
profiles and handpainted
geometric and organic
patterns on handmade
ceramic pieces

Guigui Kohon

www.guiguikohon.com

1

The Argentine artist Guigui Kohon was born in 1969 and graduated from the School of Architecture and Urban Planning at the University of Buenos Aires in 1993. Three years later she moved to Barcelona, where she lived for twelve years and studied jewelry at the Escola Massana. In 2001, she won the Marshall Prize, awarded by the Lower Silesia Assembly and KGHM Metale, a Polish metals company. In 2002, she was awarded a research grant from the Escola Massana. In 2008 Cohon returned to Argentina, where she established an art clinic with Fabiana Barreda and an open pilot project with Sergio Bazán at Galería Isidro Miranda. She is a cofounding member of Peidereina (the Association of Artistic Jewelry in Argentina), and has shown her work throughout Europe and the Americas. In 2010 she published *100/100 Basuradejoyería* ("jewelry waste") a limited-edition book inspired by a photograph of an open pit mine, which included a signed and numbered brooch.

If you could only work with one material, what would it be?
Words.

Describe your work space in three words.
Home, chaos, things.

S
Hg
Zn
NaCN
H₂O
Pb
Ag
Cu

03 /10 J-01-L

2

1. *Smokescreen* brooch
Transparent and printed tape

2. *Y se necesita tanto para
tan poco* brooch
Silver and glass receptacle
with silver dust/waste
material from designer's
workshop

1-2. Brooch
Silver printed fabric with
photo and acrylic receptacle
with silver waste material
from the designer's workshop

1

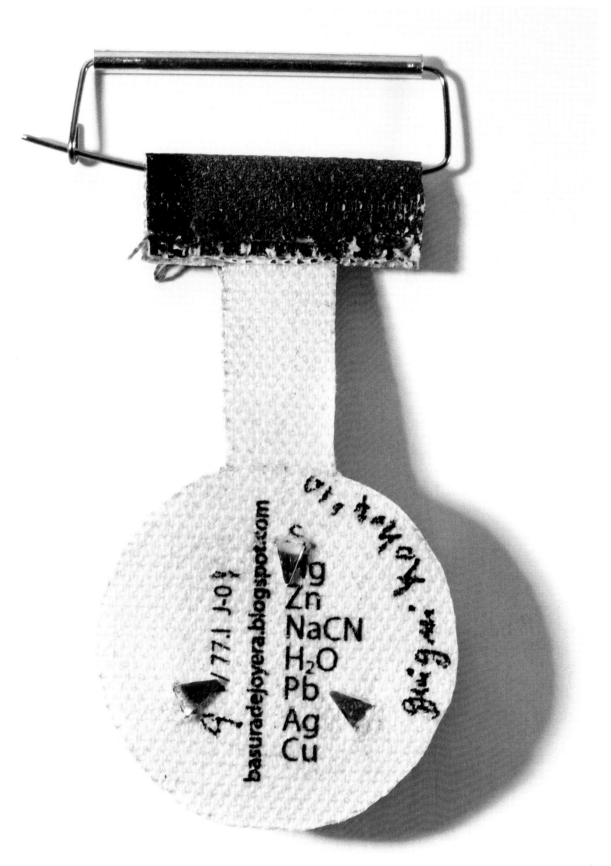

basuradejoyera.blogspot.com
tot / 1.77 / 4
g
Zn
NaCN
H₂O
Pb
Ag
Cu

221

1 2 3

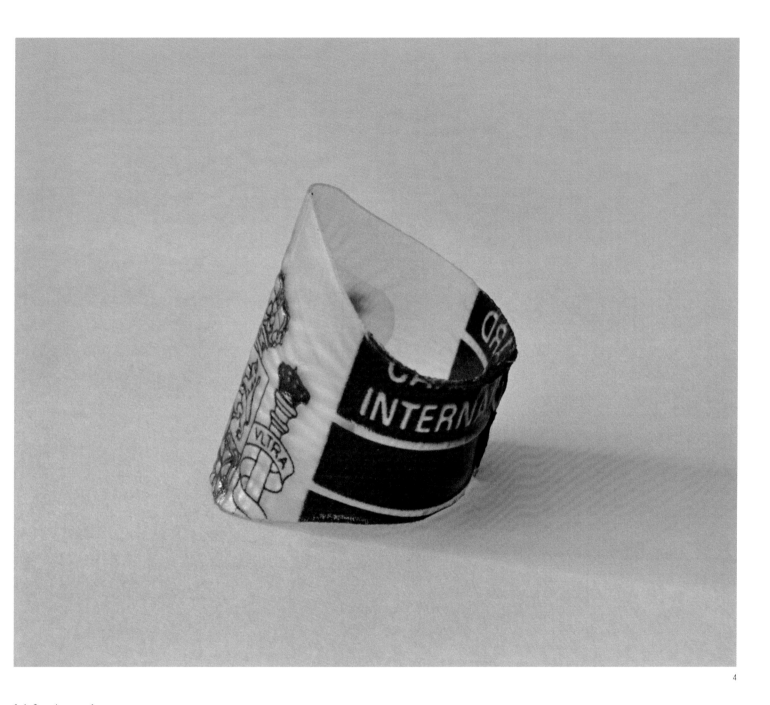

1-4. *Open in case of
emergency* rings
Waste material

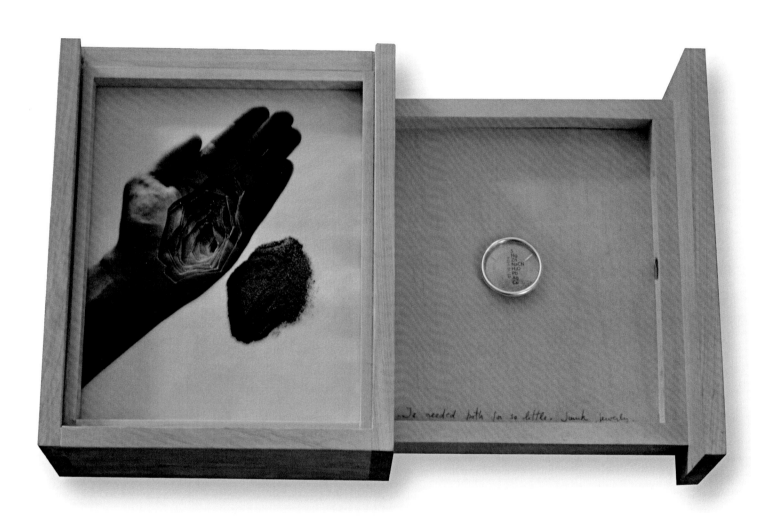

1

1. *Y se necesita tanto para
tan poco* brooch
Silver, glass container with
silver waste material from
the designer's workshop,
and wooden box with
printed paper

2. *Smokescreen* bracelet
Adhesive paper

Hejing Chi

New website coming soon

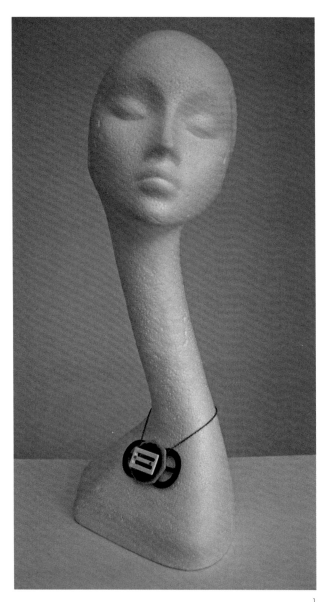

1

Hejing Chi studied fashion design and surface textiles for fashion at the London College of Fashion. After graduating, Hejing worked for various fashion houses before realizing that her true calling was in jewerly. Partnering with a friend, she created bags, belts, jewelry, and other fashion accessories. Although the line gradually grew in popularity and was sold in London's Covent Garden and on Carnaby Street, the venture came to an end when her partner left the United Kingdom. After a hiatus and some soul-searching, Hejing finally returned to the jewelry scene, establishing her own firm in 2009. Bold, original, and creative, Chi draws her inspiration from vintage and everyday objects.

If you didn't specialize in jewelry, what would you be?
A zookeeper!

If you could work with only one material, what would it be?
That's something that changes each day. I choose whatever comes into my mind at any given moment.

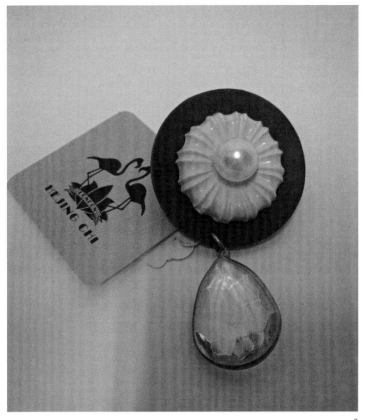

2

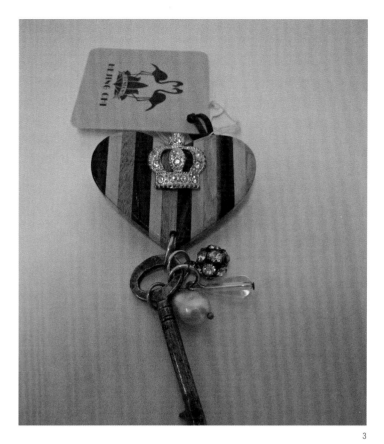

3

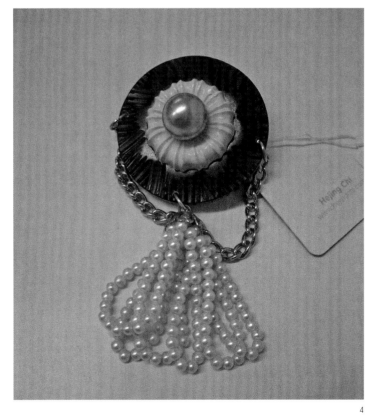

4

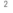

5

1. Necklace

Vintage bakelite

2. Brooch

Old buttons made of celluloid, cultured pearls, and artificial glass teardrop

3. Brooch

Old piece made of wood, with button tiara made of vintage diamonds, diamond bead, and key

4. Brooch

Old dark brown button, white celluloid button, cultured pearl, chain of vintage minipearls, and old golden chain

5. Brooch

Old piece made of wood, flower-shaped celluloid button, old corrugated wooden pieces, and white celluloid beads

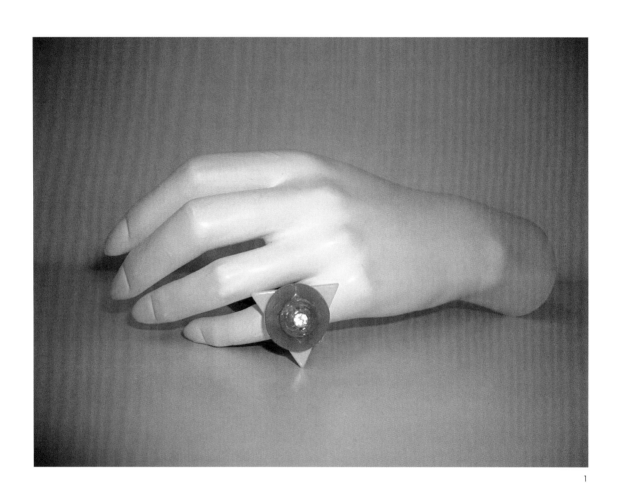

1

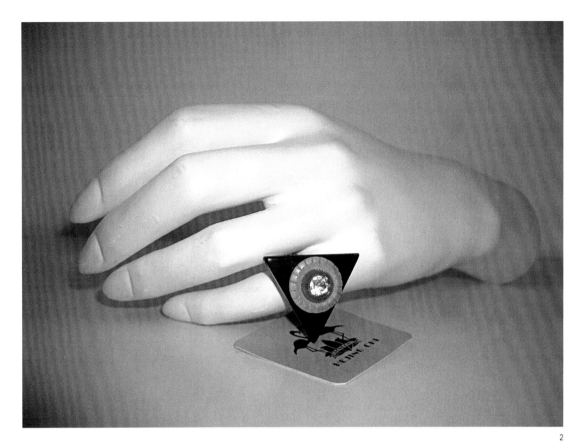

2

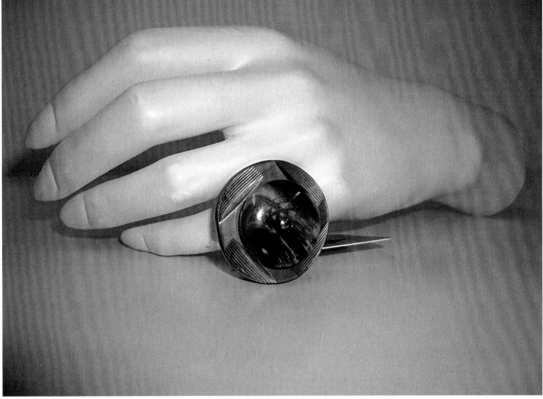

3

1. Ring
Old bakelite and celluloid
buttons

2-3. Rings
Old bakelite and celluloid
buttons, diamond, and silver

1. Necklace
Old golden chain and
vintage red plastic flowers

2. Necklace
Old cultured pearls and
vintage bakelite buttons

3. Necklace
Old chain and old wooden
handpainted pieces

1

2

3

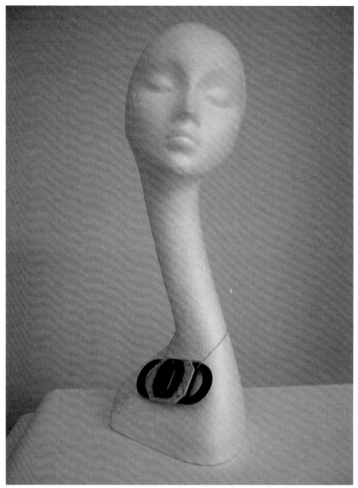

4. Necklace
Old golden chain, old key,
and vintage charms

5. Necklace
Old golden chain and vintage
bakelite buttons

6. Necklace
Old chain and used plastic
beads

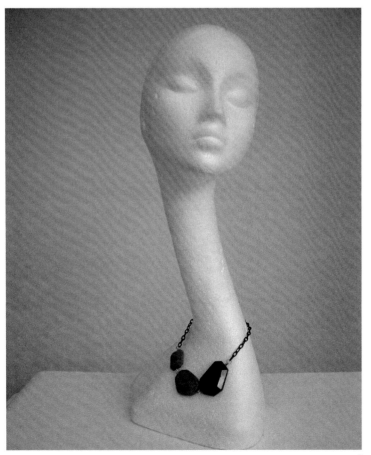

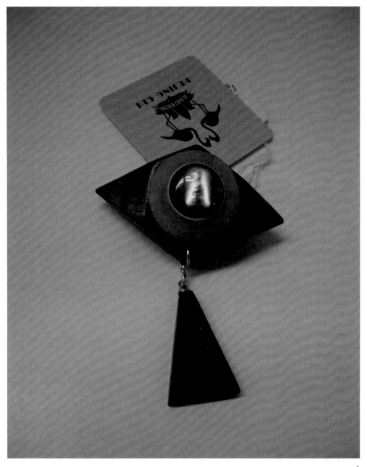

1

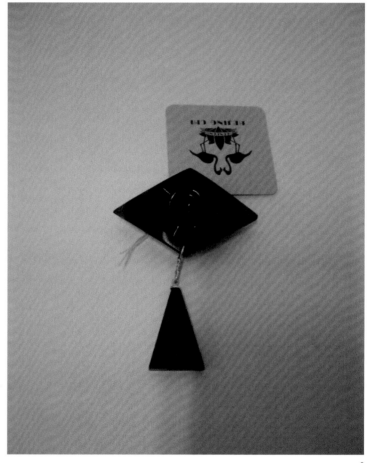

2

1. Brooch
Old layered wood and
vintage buttons

2. Brooch
Old layered wood and
vintage plastic flower

3. Earrings
Vintage plastic pieces and
golden chain

4. Earrings
Vintage plastic bow and
old bead

3

4

Ines Aechtner

www.ines-aechtner.de

Ines Aechtner was born in 1960 in Osnabrück, Germany. After high school, she trained as a gold and silversmith, and then spent time working in the south of Spain. In 1992, she designed the official jewerly for documenta, the three-month-long international art exhibition held every five years in Kassel, Germany. She has taken part in every documenta since then, and has also been included in a number of exhibitions. Her pieces stand out for their simple, clear-cut lines and their careful selection and combination of materials and finishes.

If you didn't specialize in jewelry, what would you be?
I would like to be a photographer.

If you could work with only one material, what would it be?
Platinum.

Describe your work space in three words.
Creative, *zeitgeist*, significant.

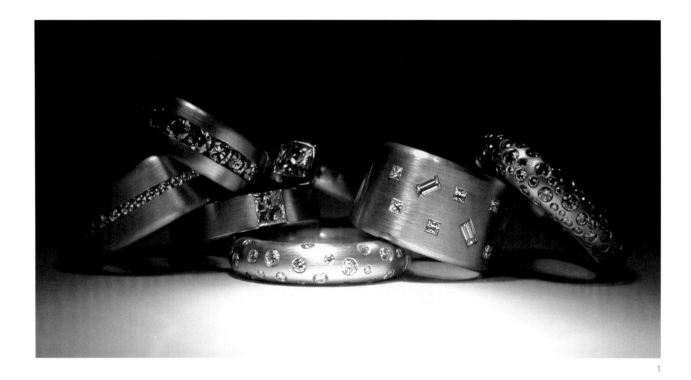

1

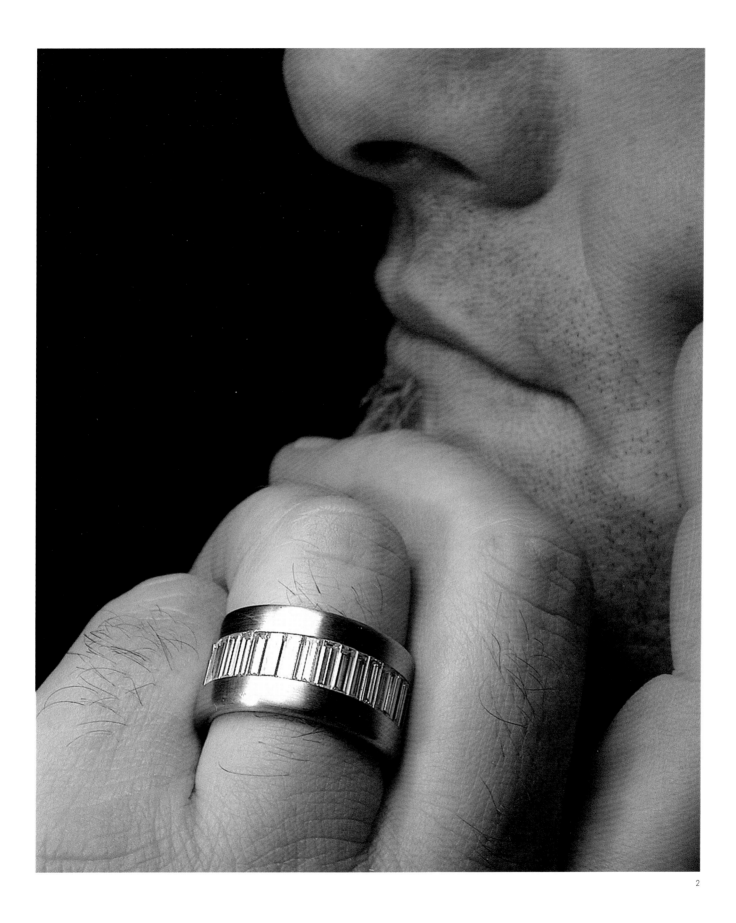

1. Rings
Various metals and precious
stones

2. Ring
Baguette diamonds in
18-karat white gold

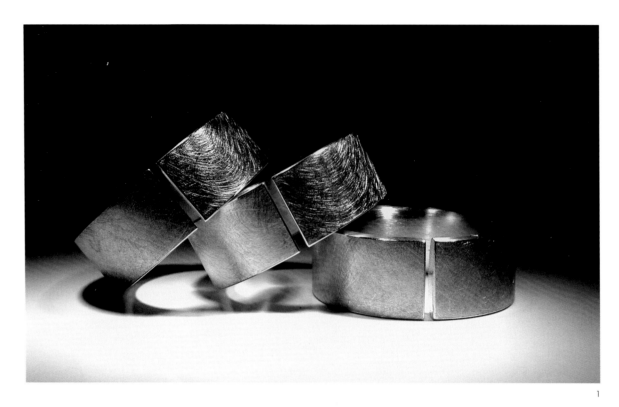

1

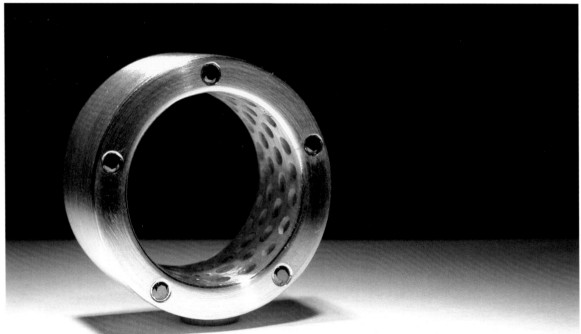

2

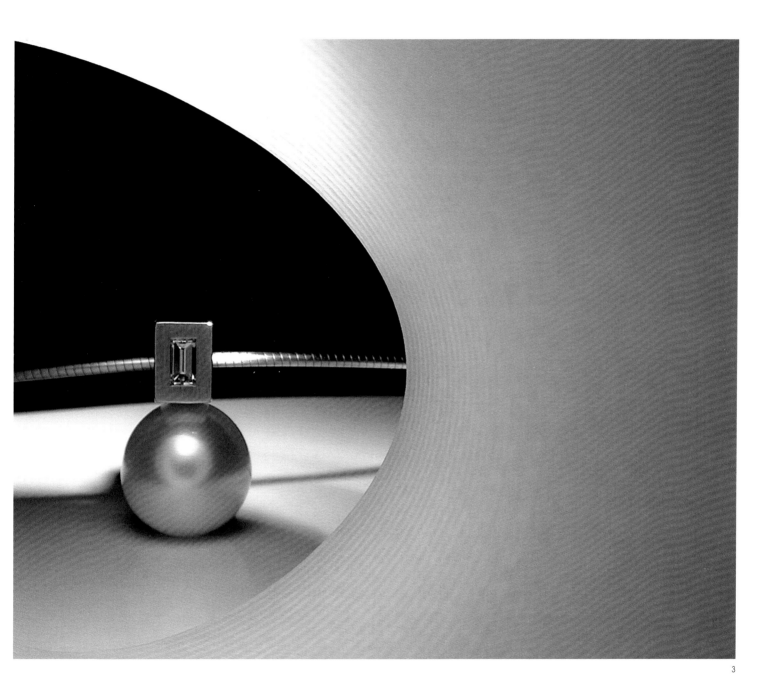

3

1. *Tri colore* set of rings
Silver plated in red, white, and yellow gold

2. Ring
Silver, 18-karat yellow gold and black diamonds

3. Necklace
South Sea or Australian pearl, 18-karat white gold, and emerald-cut diamond

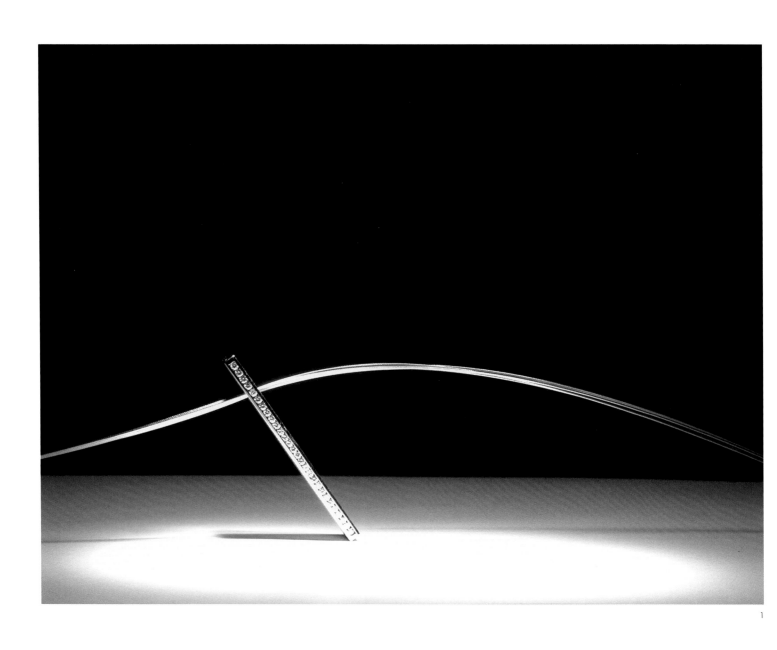

1. Pendant
18-kilate white gold with Top
Wesselton diamonds

2. Bangle
Silver

1. Ring
950-Palladium with brown
diamonds

2. Pendant
220-karat citrine quartz and
18-karat white gold

Irina Fiszelew

www.irinafiszelew.com.ar

1

Irina Fiszelew was born in Buenos Aires in 1970. Her restlessness led her to study a range of artistic disciplines: graphic design, music, and stage and opera design. Finally, it was at the Municipal School of Jewelry in Buenos Aires that she found her true calling, and what has led to a prolific career. In 2004, her *Juegometría* project won her a design fellowship from the Buenos Aires Culture Fund. In her work, which combines metal with other materials, Fiszelew creates a language of expression that she then uses to develop broad-based thematic collections. Her work has been featured in numerous solo and group shows in Buenos Aires.

If you didn't specialize in jewelry, what would you be?
I think I would be a psychoanalyst. I find the search made by each of us for an existential meaning in our lives to be really interesting and exciting.

Describe your work space in three words.
My workspace is intimate, light, and tidy.

2

3

1-3. *Alicia* series pins
Laminated paper, silver 925

1. Microkosmos series
necklace, ring, and pin
Paper maché, silver 925

2. Microkosmos series ring
and pin
Paper maché, silver 925

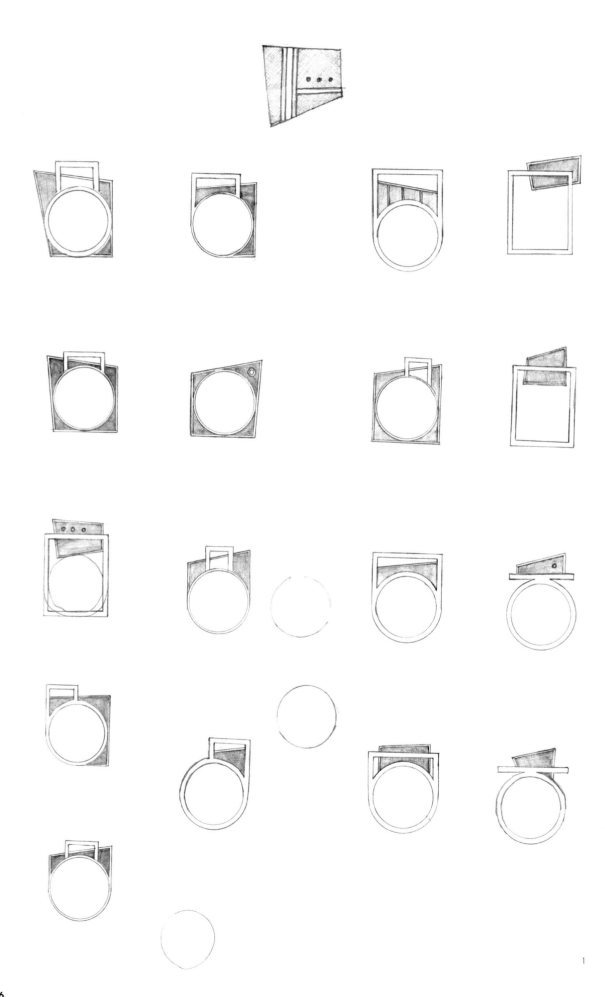

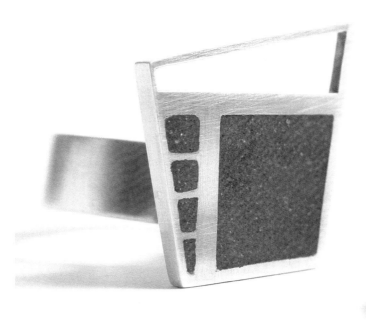
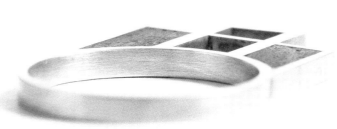

1. *Urbana* series sketches

2. *Urbana* series rings
Silver 925 and cement

Isabel Herrera

www.cambur.net

Isabel Herrera was born in Venezuela. She began her jewerly studies in Mexico City in 2002, while working as an actress. Two years later, she moved to Barcelona to study at the Escuela Massana and elsewhere, and became involved with Silvia Walz's *Sensational jewelry* project. Herrera's work has been shown at galleries in Barcelona, Rome, and Caracas. Her workshop, El Lavadero, located in an old public bathhouse in Barcelona's Raval neighborhood, is the site of numerous group and individual projects. Her deeply textured pieces invoke her Venezuelan roots; memories and feelings are expressed through her attention to detail.

If you didn't specialize in jewelry, what would you be?
I would still be an actress.

If you could only work with one material, what would it be?
Emotions.

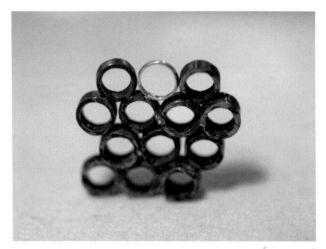

1

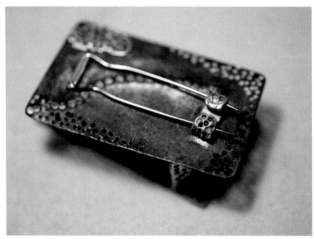

2

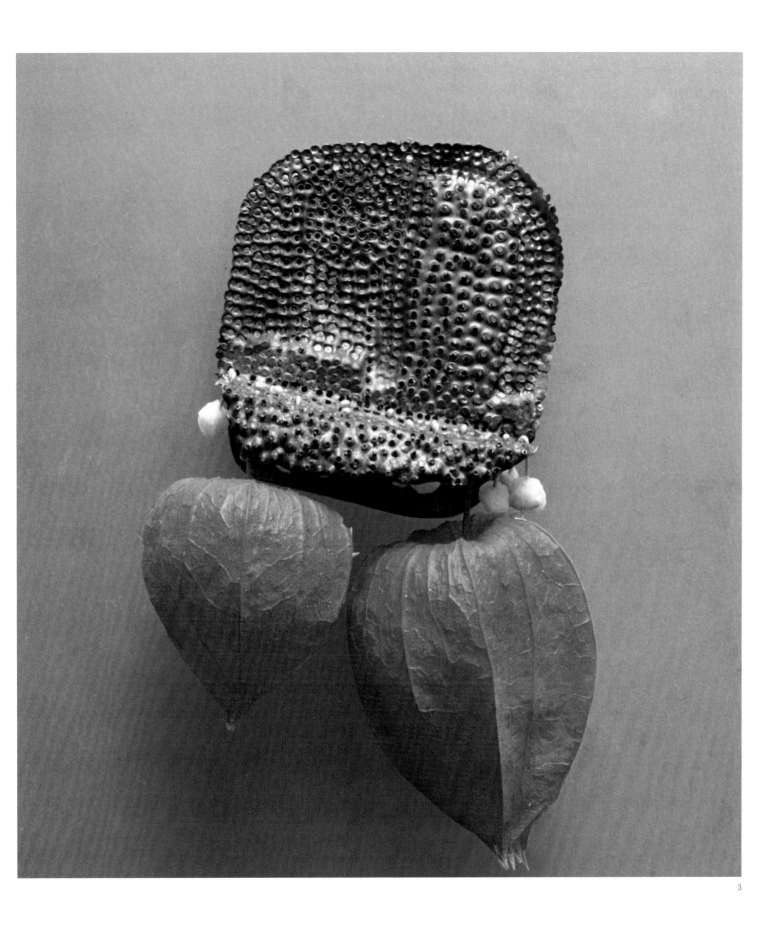

3

1. *Similitud* brooch
Iron and gold plus magnet

2. *SW* brooch
Iron

3. *Pura vida* brooch
Iron, paper, silver, and flowers

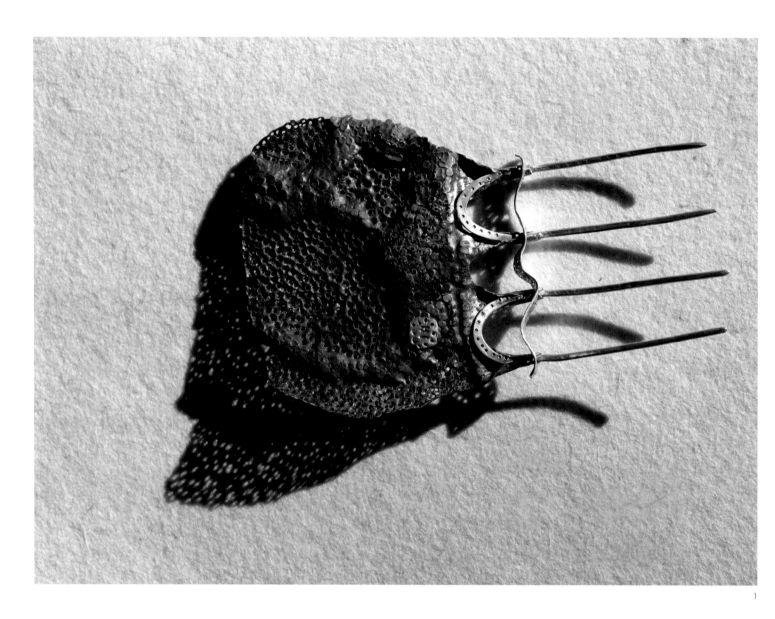

1. *Shadows* **ornamental comb**
Iron and silver

2. *Mundo interno* **brooch**
Iron, silver, and gold

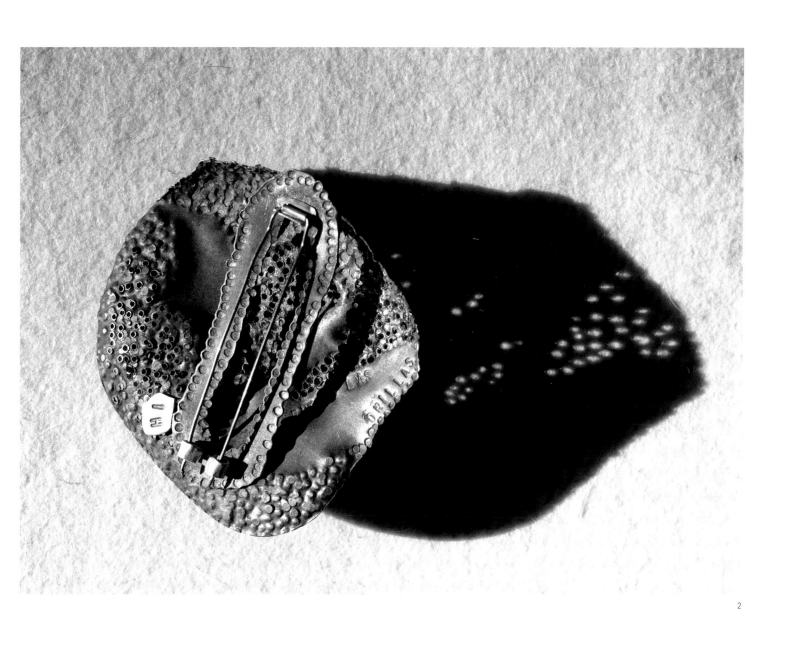

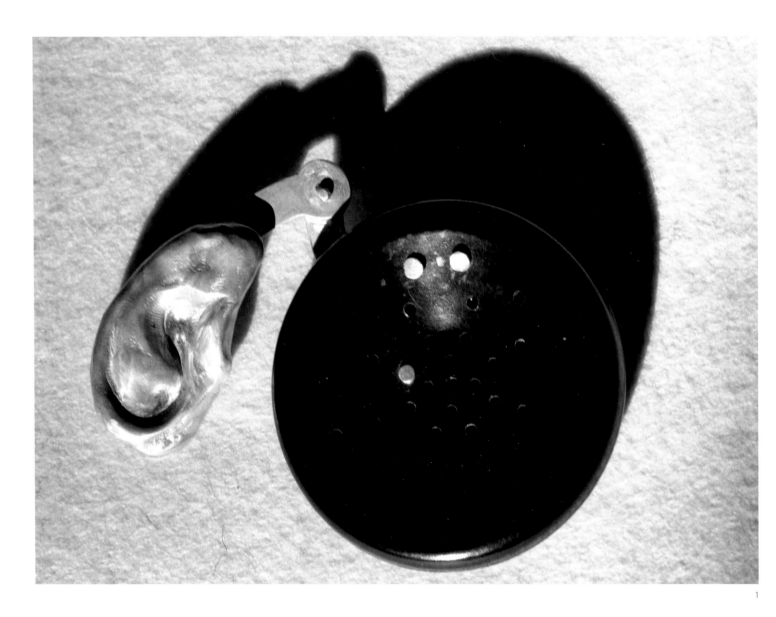

1

1. *Susurro* brooch

Silver, bakelite, paper, and textile

2. *Entra y encuentra* brooch-pendant

Blue brass, iron, silver, and gold

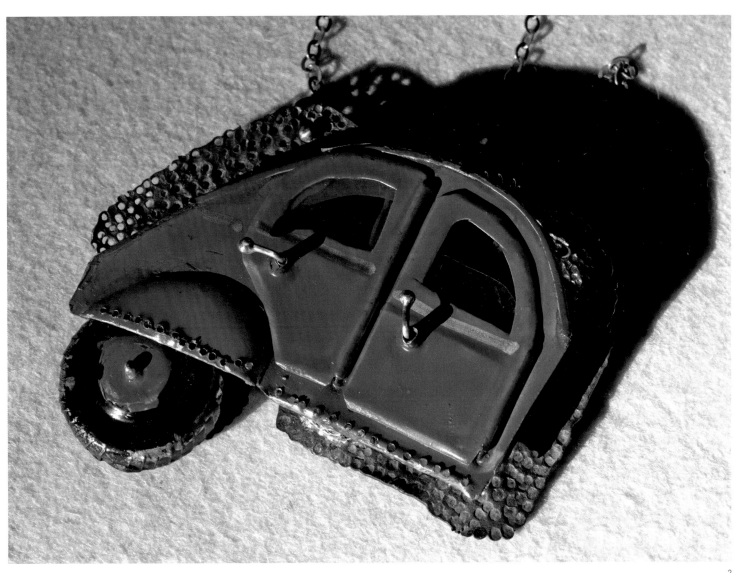

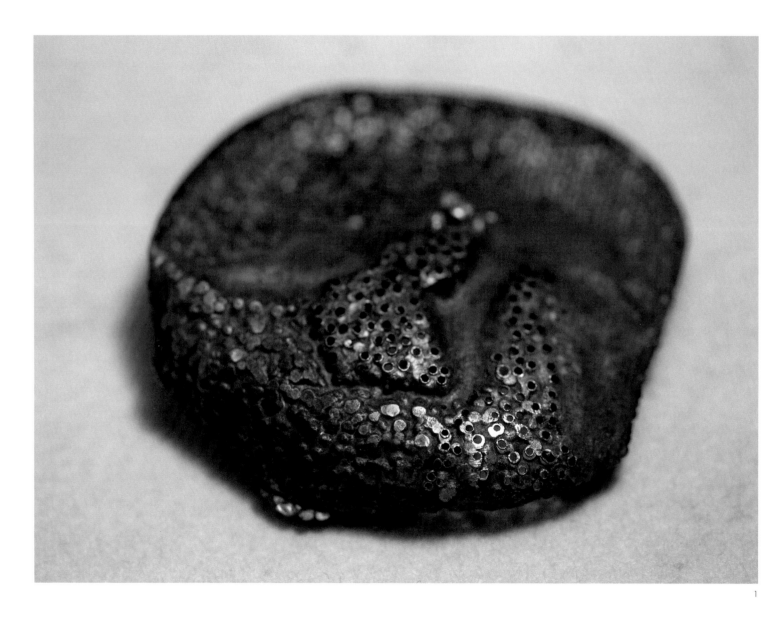

1. *Mundo externo* brooch
Iron, silver, and gold

2. *Corazón real* brooch
Copper, silver, and red acrylic

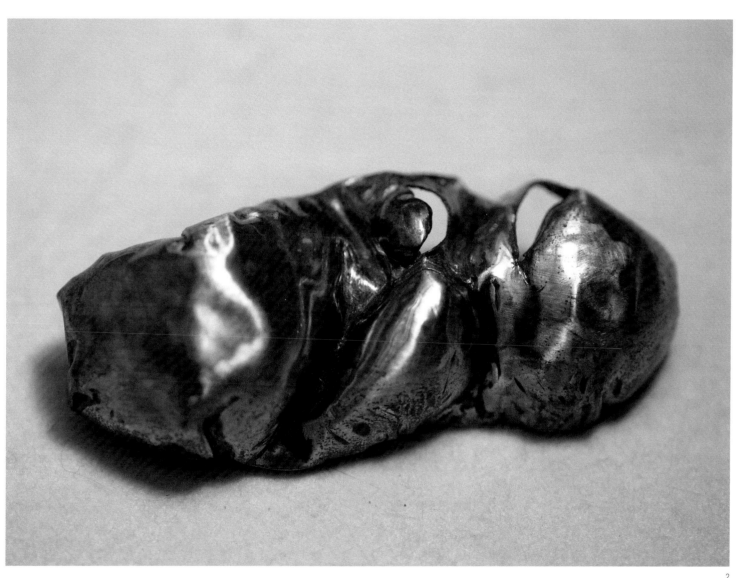

Isabell Schaupp

www.isabell-schaupp.de

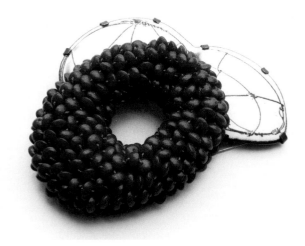

Isabell Schaupp was born in Augsburg, Germany, in 1969. For several years, she worked as an apprentice carpenter. Before establishing herself in the world of jewlery, Schaupp had a varied career, first as an apprentice carpenter, and then after a period of extensive travel and of study at the Hildesheim University of Applied Sciences and Arts in Germany, as a nurse. Her pieces mix traditional materials and techniques to produce new forms and associations, and is easily identified by its minimalist color pallete of white, black, and red. Her work has been included in exhibitions in Europe, Japan, and the United States. Her prizes include the Innovation Award at the Munich Inhorgenta and the Grassi Prize from the Slavik Gallery in Vienna, both of which were won in 2008.

If you didn't specialize in jewelry, what would you be?
A doctor flying in a Cessna, a biologist, or a hundred and one other things.

1

If you could work with only one material, what would it be?
It would have to be a magic material that could change at my beck and call, because I can't imagine myself working with the same material my whole life! But if you want me to commit myself, I'd probably choose wood.

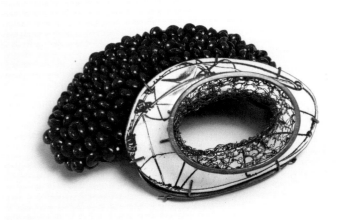

2

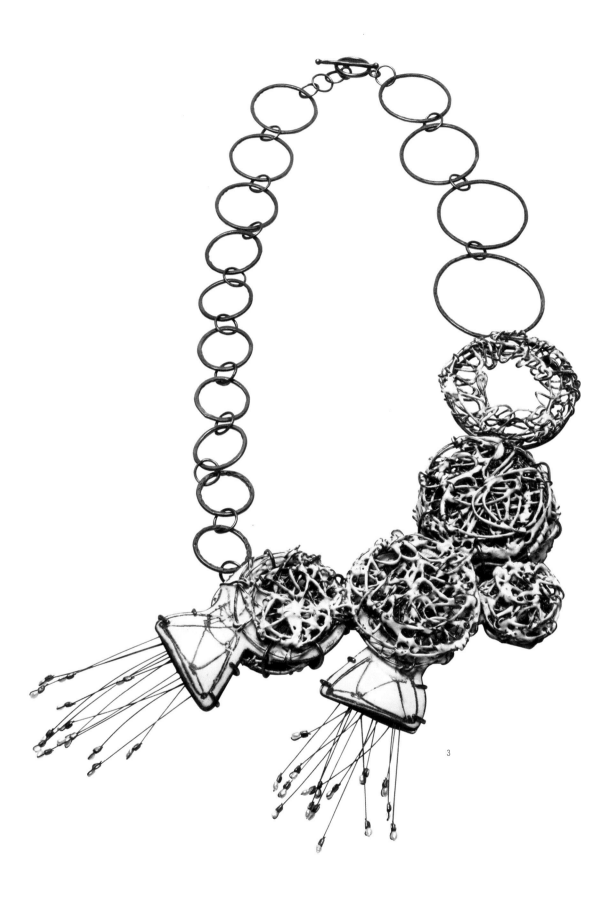

3

1. *The friendly listener* brooch
Silver, copper, enamel, photo, coral, and fabric

2. *Shell mouth* brooch
Silver, copper, enamel, photo, coral, and fabric

3. *30 days II* necklace
Silver, steel, copper, enamel, photo, and pearls

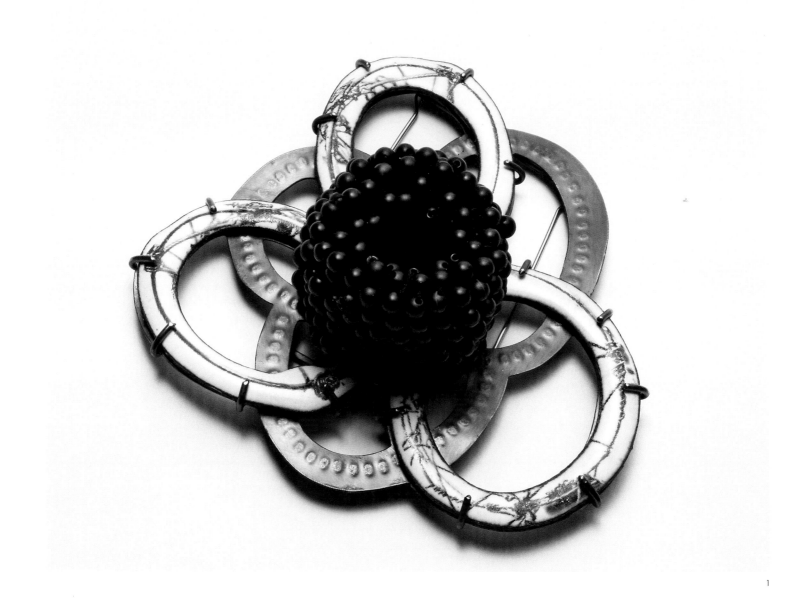

1

1. *Flower with bead funnel* brooch

Silver, copper, enamel, photo, onyx, and fabric

2. *The listener* brooch

Silver, copper, enamel, photo, spinel, and fabric

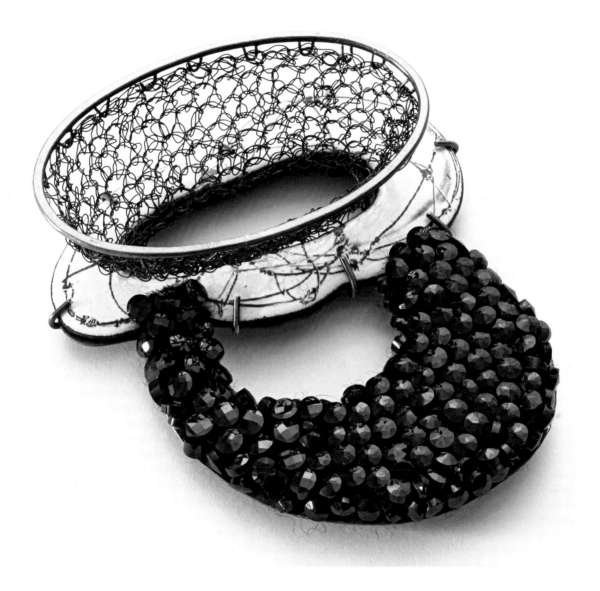

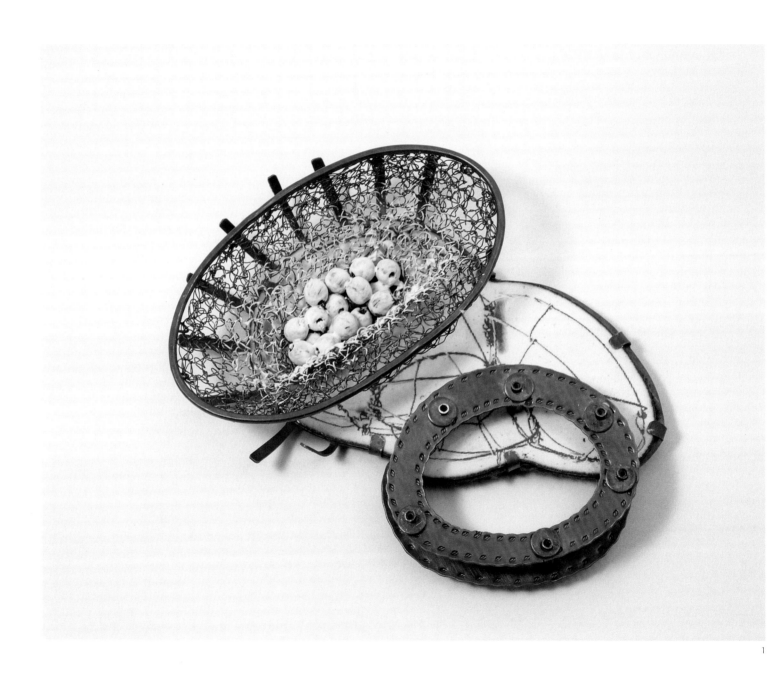

1. *Big Mouth* brooch
Silver, copper, enamel, photo, wood, acrylic, and textile

2. *Cactus* brooch
Silver, copper, enamel, photo, coral, and fabric

3. *Month 8* brooch
Iron, copper, enamel, photo, silver, and plastics

4. *Month 5* brooch
Iron, copper, enamel, photo, and silver

5. *Month 41* brooch, 2010
Silver, copper, enamel and photo

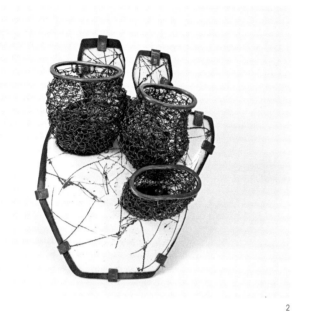

2

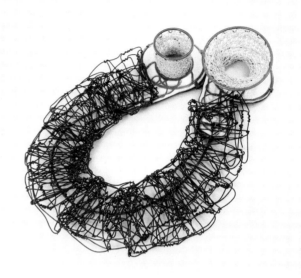

3

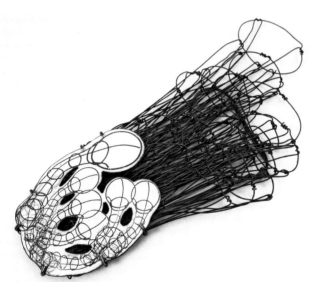

4

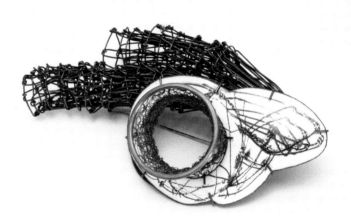

5

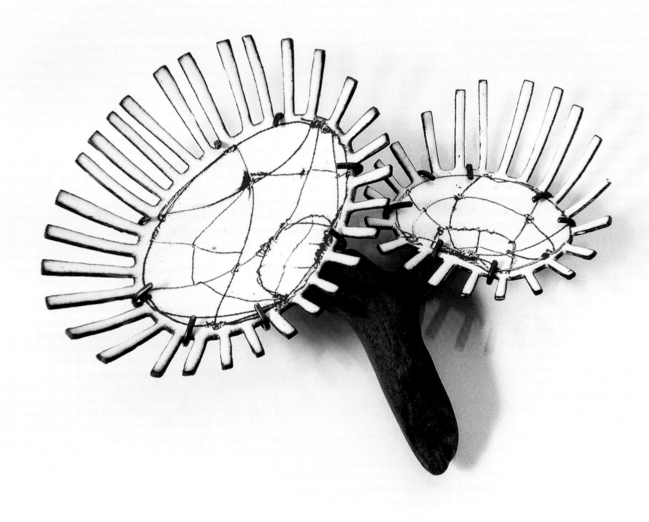

1. *Ray flower* **brooch**

Copper, enamel, photo, wood,
and silver

2. *Month 6* **brooch**

Iron, copper, enamel, photo,
white agate, and silver

1

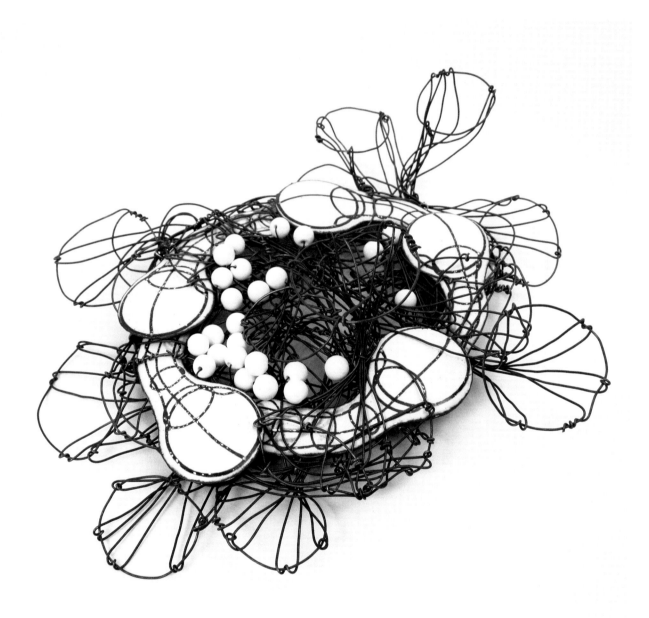

Jacob Albee

www.jacobalbee.com

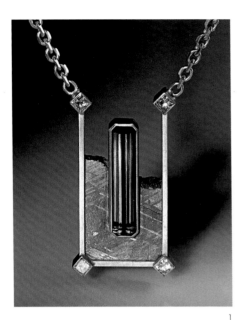

1

Jacob Albee was born in 1976 and raised in Strafford, Vermont. He now lives in Burlington with his wife and business partner, Kristin, and their son, Axel. For Albee, a successful piece of jewelry is one that you don't want to take off, that invokes the past but looks to the future. His work has been featured in numerous galleries in the United States, and his awards include the 2009 American Craft Council Award of Excellence, the 2008 NICHE Award (in the Gold With Stones category), and *AmericanStyle* magazine's 2008 list of the *Top Ten Emerging Artists*.

If you didn't specialize in jewelry, what would you be?
If I weren't interested in jewelry, I would be a biologist or a masked crusader.

If your work involved contemporary music, what style of music would it be?
I associate my work with the music of Tom Waits, which is a difficult genre to classify.

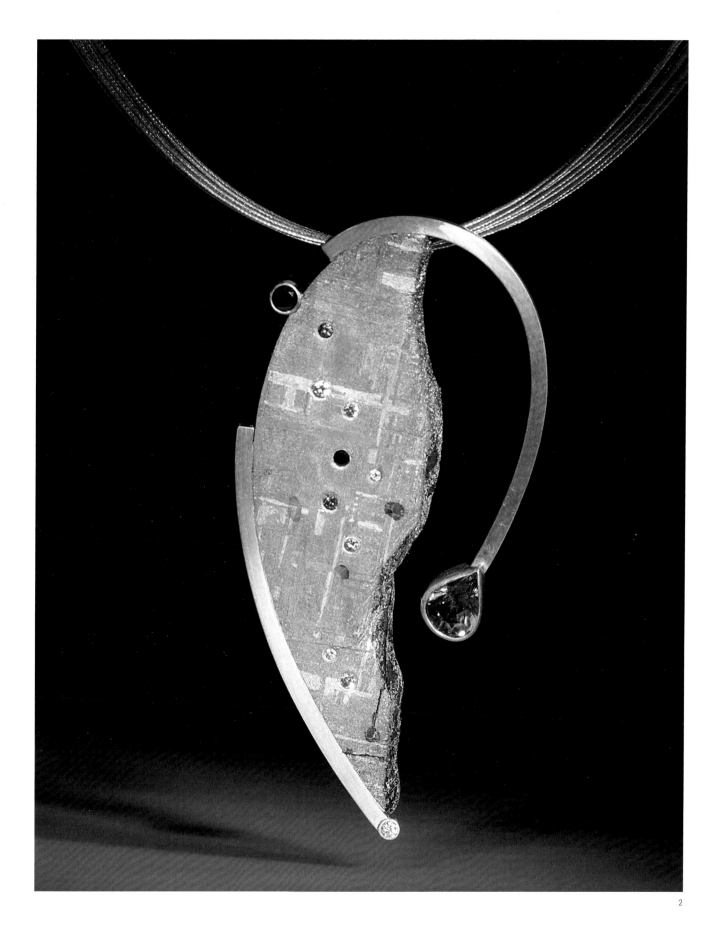

1. *Obelisk* **necklace**
Indicolite tourmaline, 22, 18
and 14-karat gold, Gibeon
meteorite, and diamonds

2. *Ficus* **pendant**
18-karat gold, Gibeon
meteorite, colored, white
and black diamonds, and
tsavorite garnet

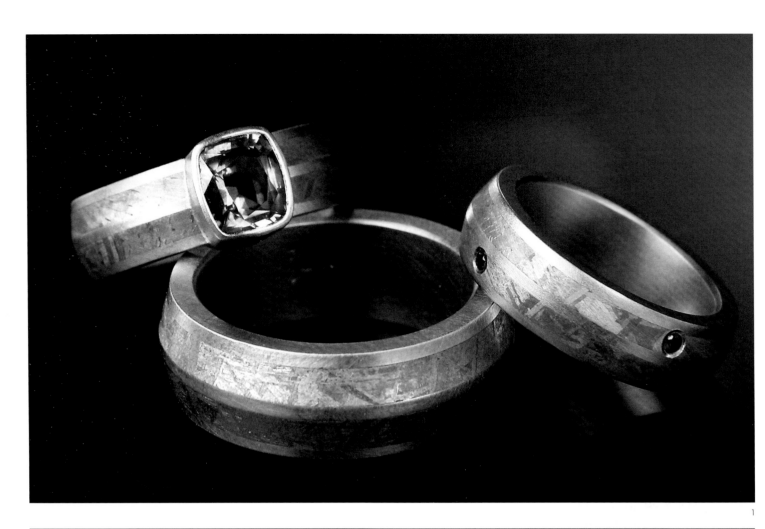

1

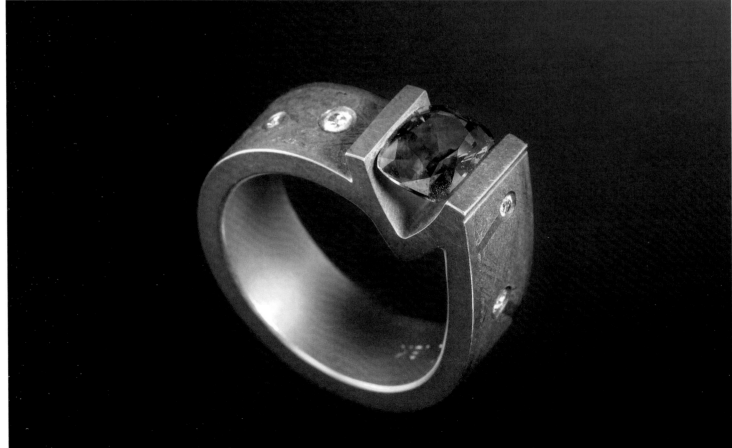

2

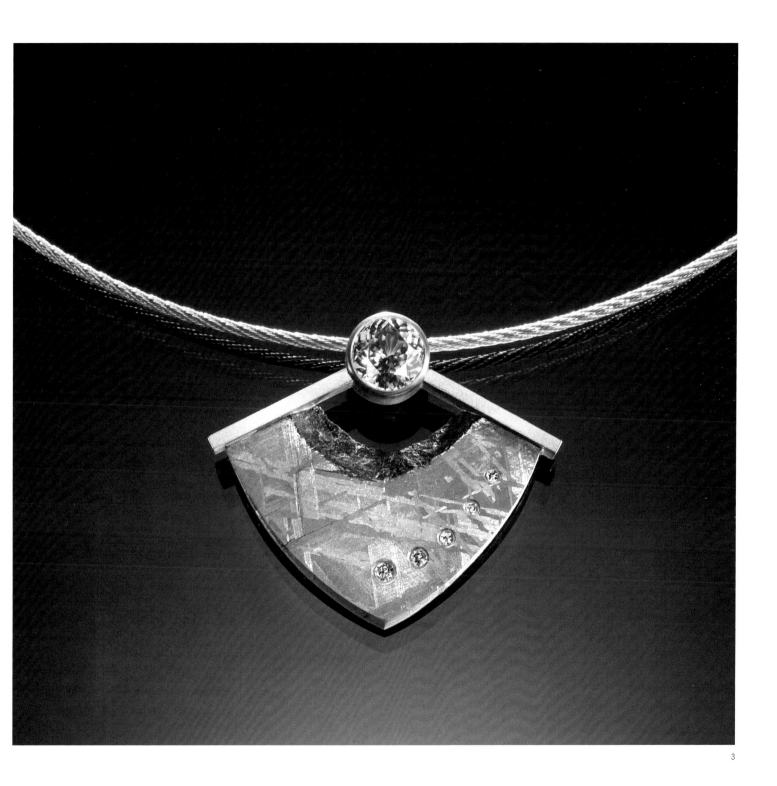

3

1. *Meteorite ridge* rings
Meteorite and 18-karat gold
with precious stones.

2. *Sapphire* ring
Meteorite and 18-karat gold
with sapphire

3. *Champagne* pendant
Gibeon meteriorite, Tanzanian
zirconium, 18-karat gold, and
champagne diamonds

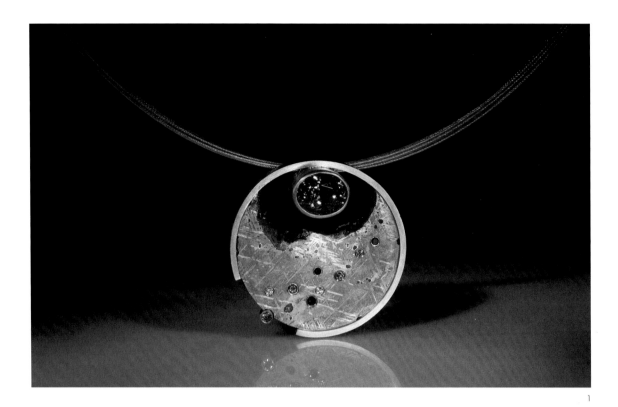

1

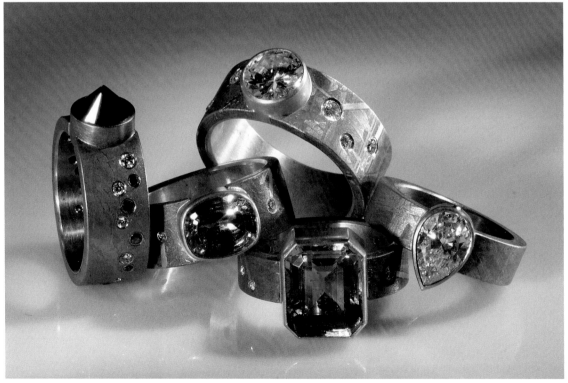

2

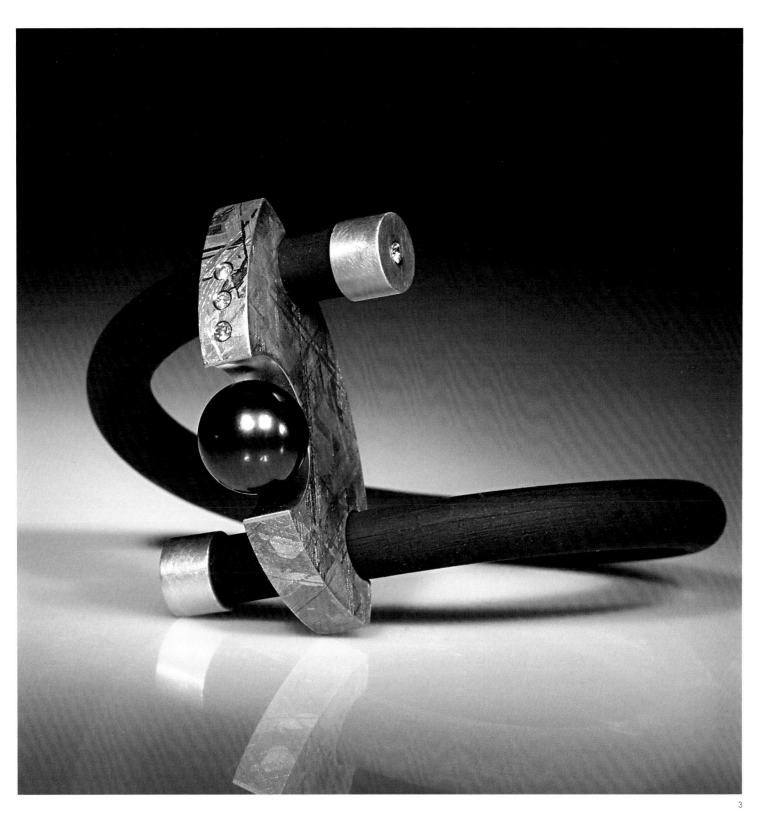

3

1. *Blue moon* pendant
White, black and champagne diamonds, Gibeon meteorite, blue zirconium, and 18-karat gold

2. *Meteorite* rings
Meteorite, 24 and 18-karat gold, and colored gems

3. *Artemis* bracelet
Gibeon meteorite, 18-karat gold, Tahitian pearl, white and yellow diamonds, and rubber; adjustable and reversible

269

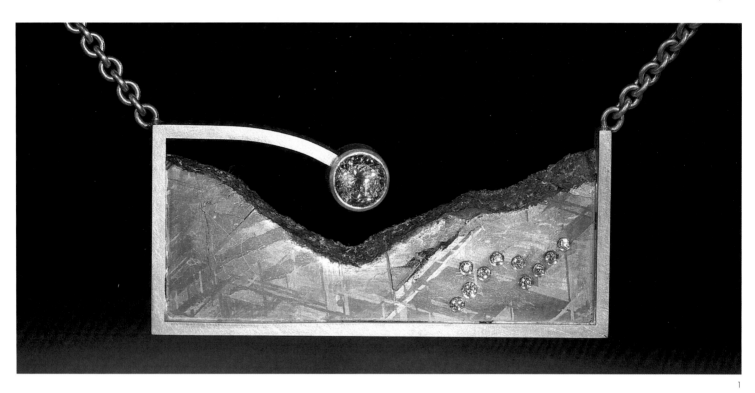

1

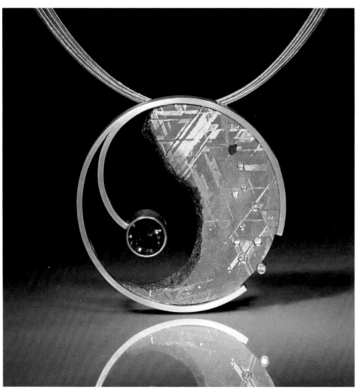

2

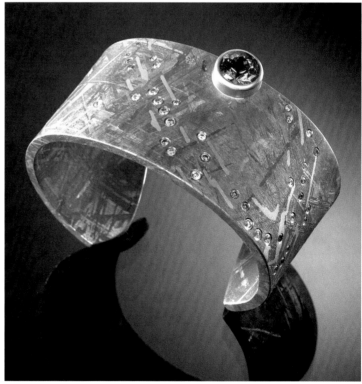

3

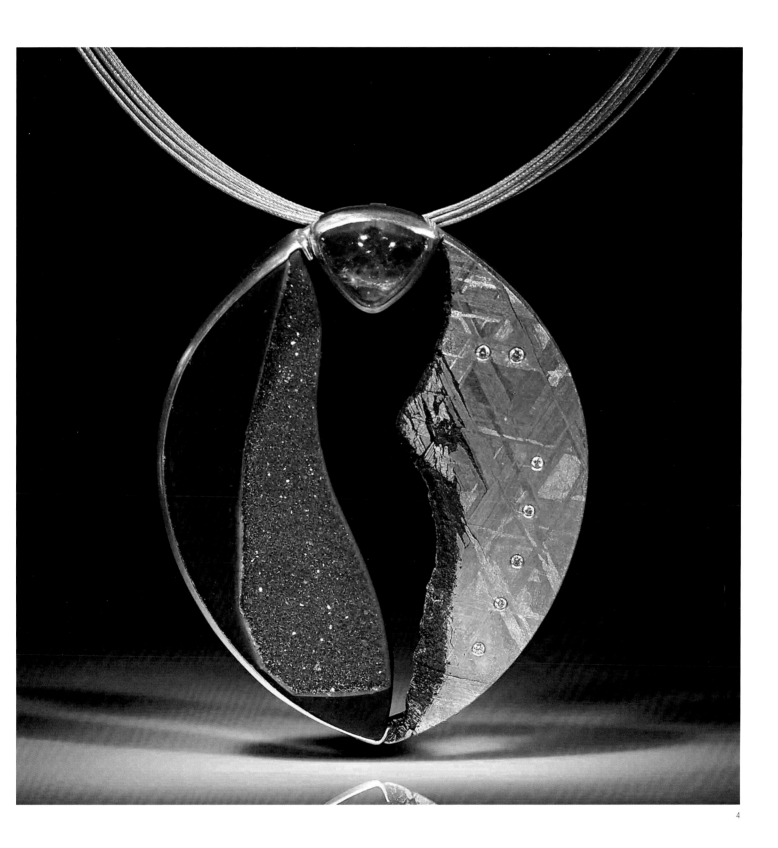

4

1. *Dawn* necklace
Gibeon meteorite with
diamonds, spessartine
garnet, and 18-karat gold

2. *Tao* pendant
Gibeon meteorite, rodhalite
garnet, yellow diamonds, and
rubber

3. *Galileo* bracelet
Gibeon meteorite with
rubelite tourmaline, colored
diamonds, and 18 and
24-karat gold

4. *Eclipse* pendant
18-karat gold, meteoric iron,
diamonds, onyx druze, and
spessartine garnet

Johanna Neudorfer

www.joyn-jewels.com

Johanna Neudorfer was born in 1981 in Vienna. She explored a wide range of the arts, including painting, fashion design, photography, and screen printing, before she discovered the craft of jewelry in Florence, where she was drawn to metals and precious stones, and the possibility of highlighting and augmenting human beauty. After apprenticing with Italian jewelers, Johanna moved to Barcelona, where she continued her training at the Industrial College and elsewhere, focusing on the creative embellishment of jewelry. An exchange program with the Hiko Mizumo College of Jewelry in Tokyo allowed her to learn the traditional Japanese techniques that influence her most recent pieces. Her creations constantly play with duality and emit a natural and functionally minimalist look.

If you didn't specialize in jewelry, what would you be?
I would be painting on the largest canvases I could find.

Describe your work space in three words.
Light, sea, functionality.

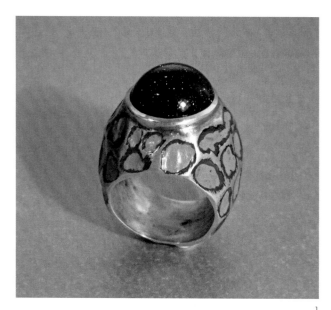

1

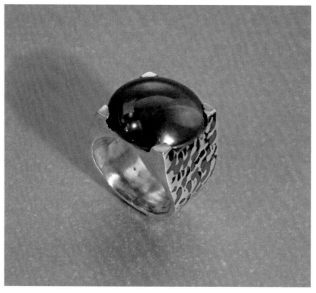

2

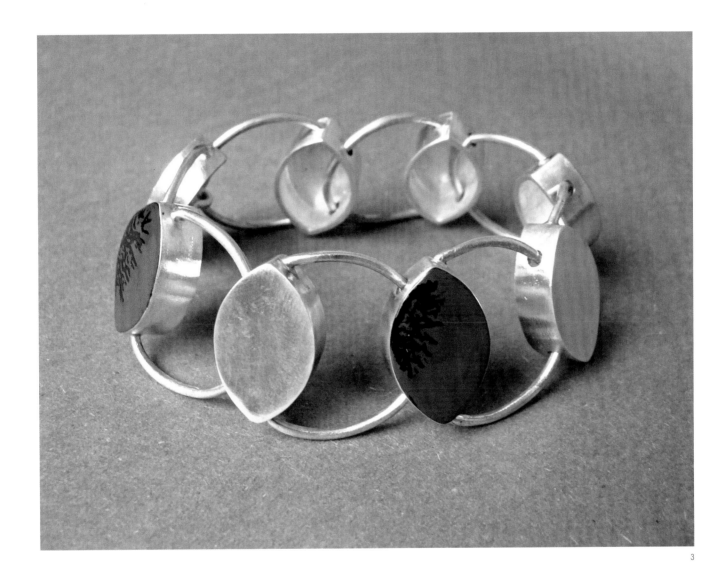

1. *Borders 1* ring
Silver 925, Japanese
lacquer, and chrysolite cut
in cabochon

2. *Borders* ring
Silver 925, Japanese
lacquer, and hematite cut in
cabochon, melting of wax,
lacquered

3. *Eclipse* bracelet
Silver 925 and Japanese
lacquer, constructed,
lacquered in layers

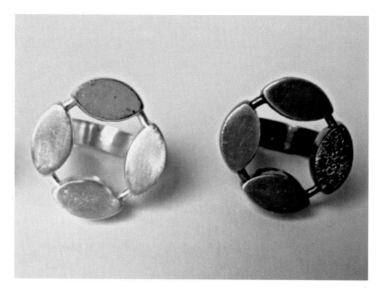

1. *Eclipse* rings
Silver 925, Japanese lacquer
and goldleaf, constructed,
hand engraved, lacquered
in layers

2. *Borders* brooches
Silver 925, Japanese lacquer,
pearls, and piano wire, eaten
into by acid, lacquered in
layers, riveted

3. *Eclipse* earrings
Silver 925, Japanese lacquer,
constructed, lacquered
in layers

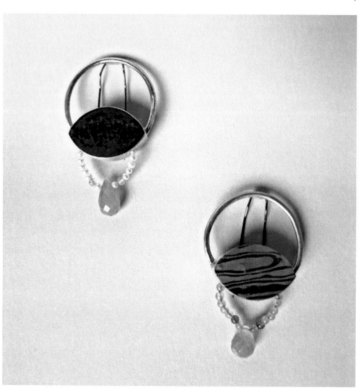

2

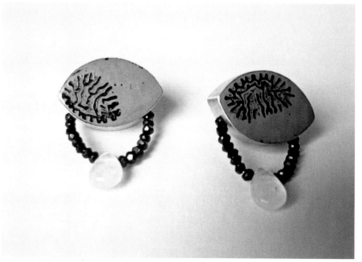

3

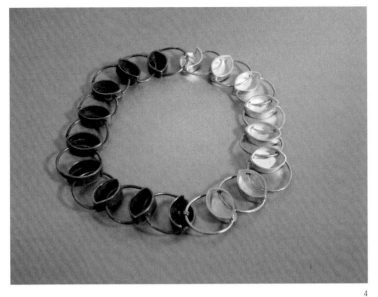

4

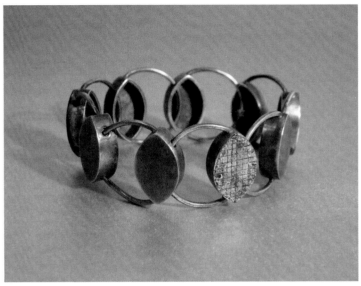

5

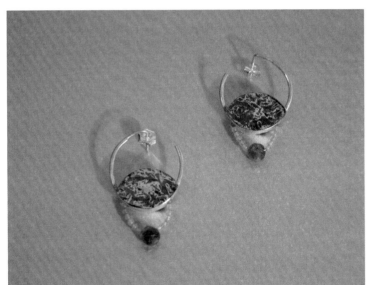

6

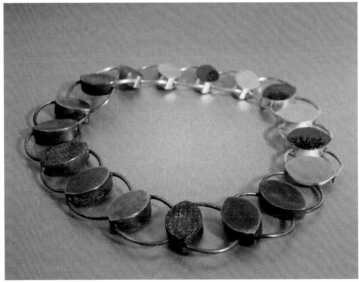

7

4. *Eclipse* necklace

Silver 925, mokumegane,
Japanese lacquer, stones,
pearls, and piano wire,
constructed, lacquered in
layers, threaded

5. *Eclipse* bracelet

Silver 925, Japanese lacquer,
and goldleaf, constructed,
hand engraved, lacquered in
layers, oxidized

6. *Borders* earrings

Silver 925, Japanese lacquer,
goldleaf, recycled faceted
glass, and steel wire, eaten
into by acid, lacquered
in layer

7. *Eclipse* necklace (back)

Silver 925, Japanese lacquer,
and goldleaf, constructed,
lacquered in layers

Jürgen Bräuer

juergen_braeuer@web.de

1

2

The German jeweler Jürgen Bräuer began his career in 1987 with a three-year period of practical training in gold and silversmithing. He then enrolled in Pforzheim University and graduated in 1996 with a diploma in jewelry design. The following year, Bräuer opened his own studio. His pieces have been shown in many exhibitions in Europe as well as in New Zealand. Jürgen's pieces, which often involve a small series of rings made of different metals, is highly architectural, focusing on space and volume. He uses his own technique to smelt one metal into another, and also experiments with porcelain and synthetic materials. In addition to his own line of jewelry, he has designed ornaments for many other companies, including the *Performance* ring for the jewelry maker Niessing.

If you didn't specialize in jewelry, what would you be?
An architect, or a doctor matching the right diagnosis to a proper cure.

If you could work with only one metal, what would it be?
Pure gold, despite all the social and environmental problems involved in extracting it.

3

4

1. Ring
Steel and gold

2. Ring
Steel and gold

3. Ring
Steel

4. Ring
Steel

1

2

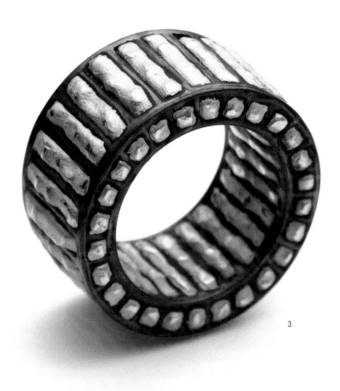

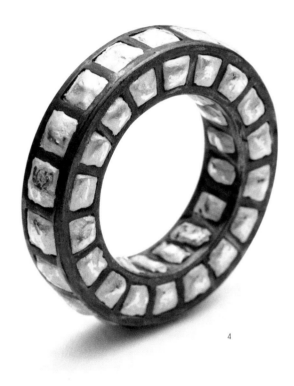

3

4

1. Earrings
Porcelain, gold, and oxidized iron

2. Earrings
Porcelain and gold

3. Ring
Steel and silver

4. Ring
Steel and silver

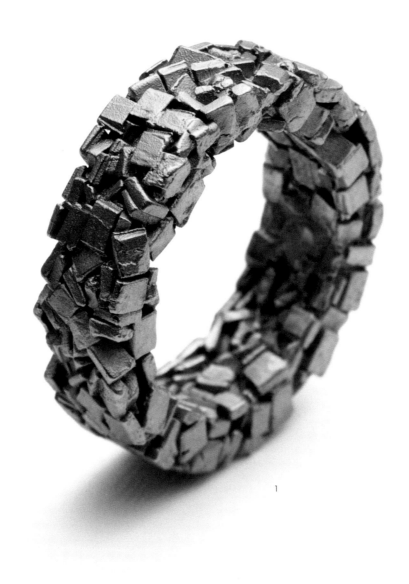

1

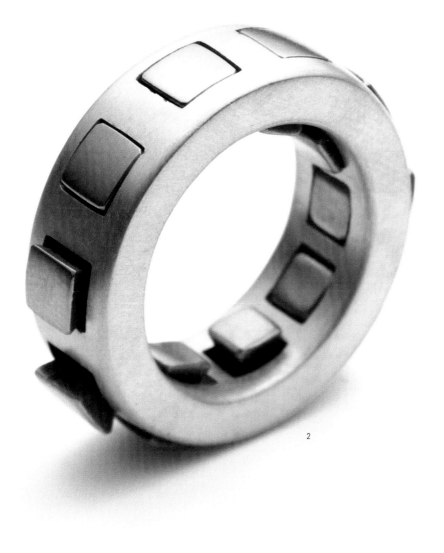

2

1. Ring
Steel

2. Ring
Steel and silver

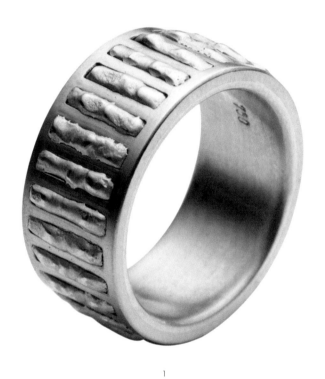
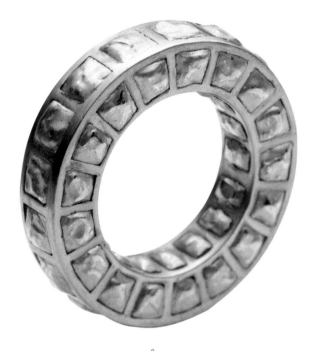

1 2

3

4

1-4. Rings

Steel and gold

Katie Rowland

www.katie-rowland.com

1

2

Katie Rowland trained in graphic design at Kingston University in London before discovering her passion for jewelry. After the success of her initial unisex collections, Katie Rowland has become an award-winning brand of high-end, extravagant pieces. Her background in graphic design has allowed her to make extraordinary use of typography, shape, clean lines, colors, and attention to detail. Her many important collaborations include working on a jewelry collection for the lingerie firm Agent Provocateur. In 2009 alone, she won the Coutts New Designer Award, the Sonama-Cutrer Design Award, and the Lonmin Design Innovation Award for Platinum. In the United Kingdom, she made the list of 2010 New Designers of the Year and the 2010 Catwalk Jewels of the Year.

If you didn't specialize in jewelry, what would you be?
I would love to work as an anthropologist or plastic artist, expressing and exploring human culture.

Describe your work space in three words.
White, intricate, and inspiring.

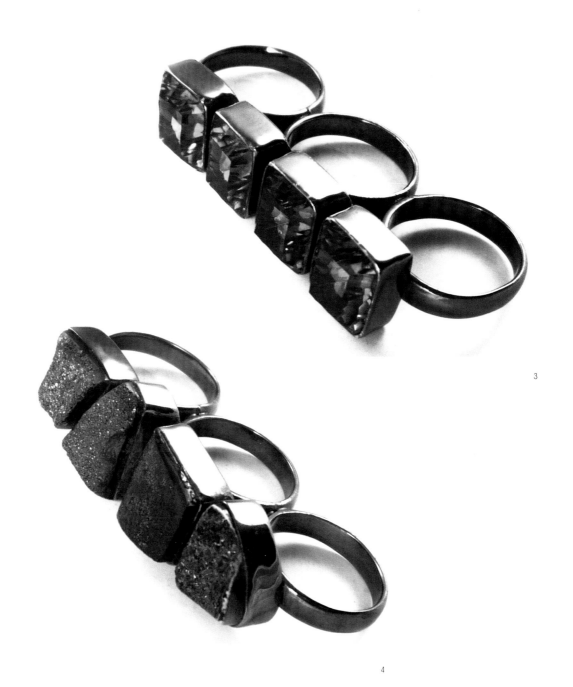

3

4

1. *Lilith Fang* ring
18-karat yellow gold

2. *Lilith Fang* ring
Silver

3. *Triple St. Tropez rainbow* ring
Black rhodium and set of rainbow
druze

4. *Triple St. Tropez* ring
Black rhodium with mystic topaz
stones

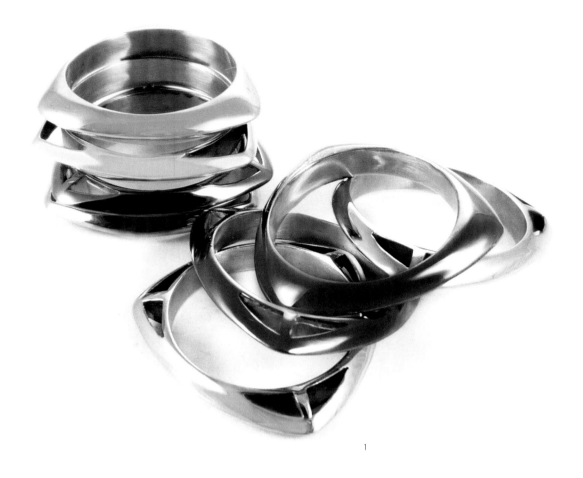

1

2

3

1-3. *Lilith tri stacker* rings
Yellow gold, red gold, and
black rhodium in different
combinations

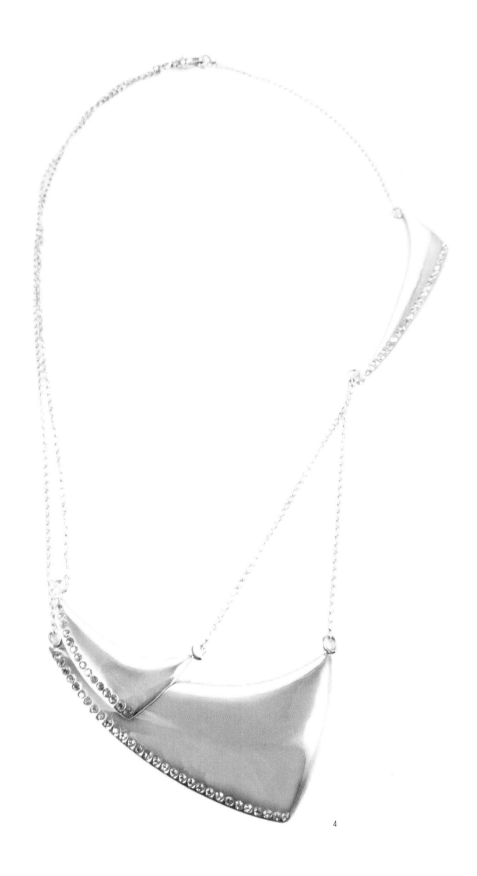

4

4. *Lilith multi-Fang* **necklace**
Red and yellow gold fangs
with incrusted crystals

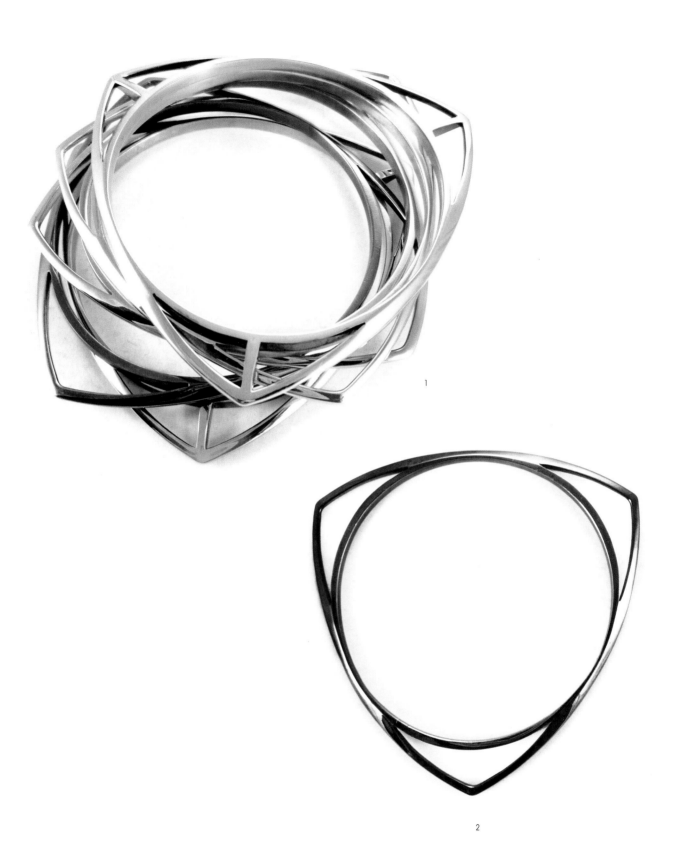

1. *Lilith* bangles
Yellow gold, red gold, and black
rhodium

2. *Lilith* bangle
Black rhodium

3. *Lilith tri-2 window* earrings
with chains
18-karat red gold

4. *Lilith tri-2 window* earrings
18-karat red gold with black
vertex finish

1

2

3

1. *Lilith long Fang* bangle
18-karat red gold incrusted
with crystals

2-3. *Small Fang* earrings
Yellow gold and black
rhodium incrusted with
crystals

Laura Martínez

naturalezasartificiales.blogspot.com

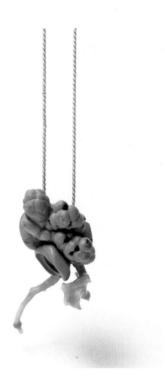

1

Laura Martínez was born in in Barcelona. She has degrees in both artistic jewelry and arts and design from the Escola Massana. A fellowship from the school allowed her to continue work on several projects, which have been featured in various group and solo exhibitions. She also works in close collaboration with her friend Berta Riera at their joint venture, Manguitos, selling their pieces in France, Germany, Spain, and the United States.

If you didn't work in jewelry, what would you like to do?
I would have liked to have been an architect, because I love building things.

If you could work with only one material, what would it be?
Silver, because of its versatility.

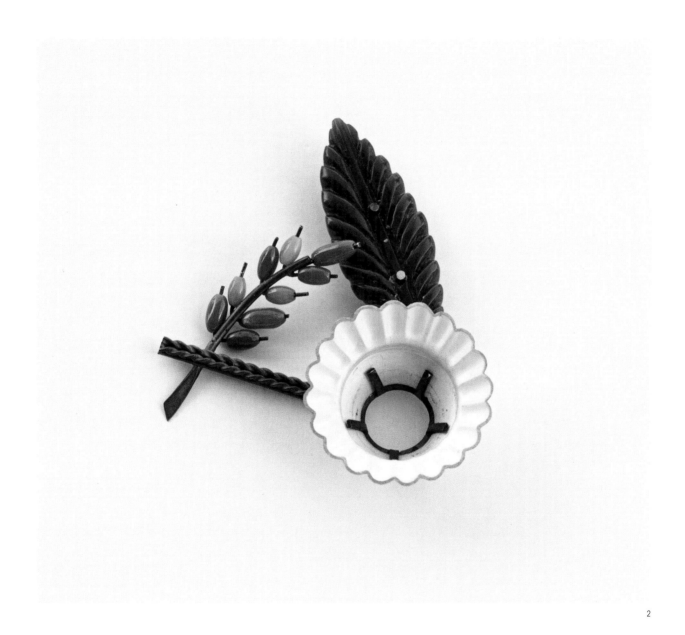

1. *Espécimen* necklace
Silver, coral, silk, acrylic, and
enamel

2. *Flor* brooch
Silver, resin, and coral

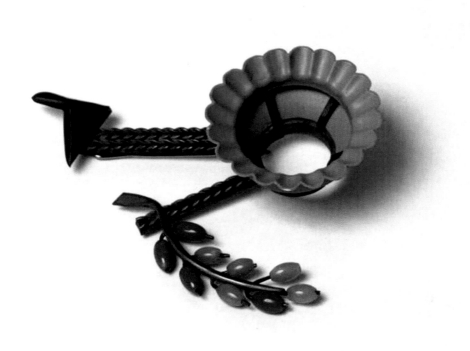

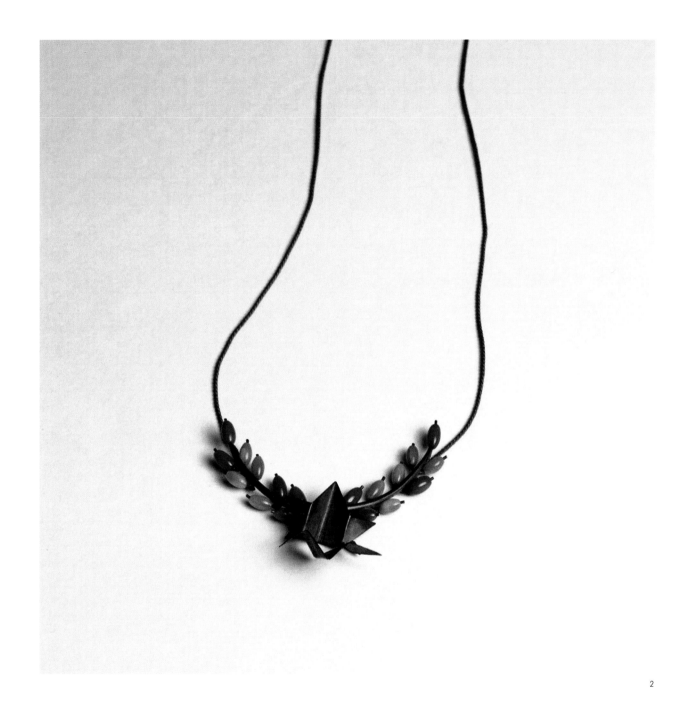

1. *Onda* brooch
Silver, coral, and acrylic
enamel

2. *Lo efímero y lo duradero*
collection necklace
Silver, coral, and silk

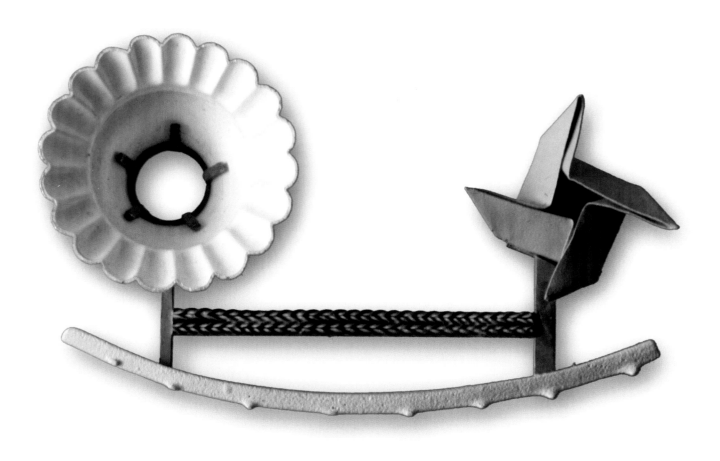

1. *Aire* **brooch**
Silver, enamel, and acrylic

2. *Escalera* **brooch**
Silver, enamel, and acrylic

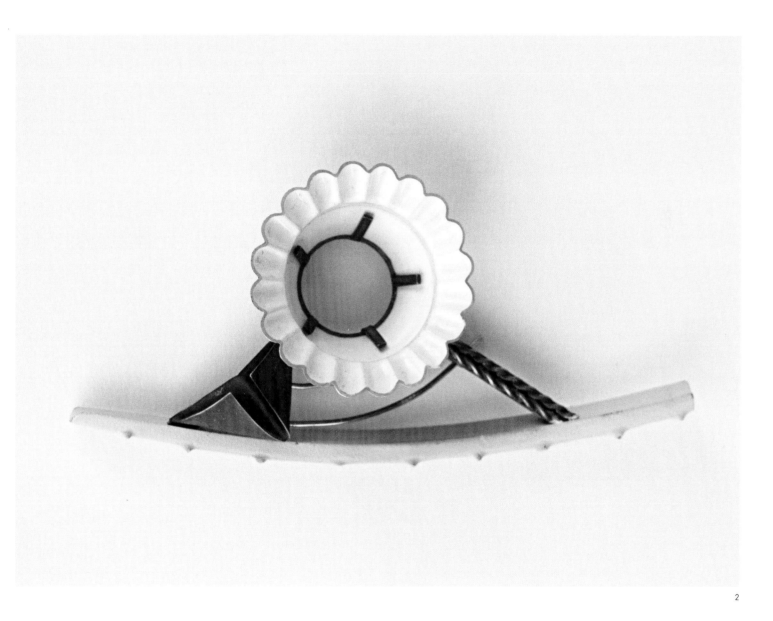

2

1. *Pájaro* necklace
Silver, resin, silk, and acrylic
enamel

2. *Primera especie* brooch
Silver, resin, and acrylic
enamel

Leonor Bolívar

www.leonorbolivar.blogspot.com

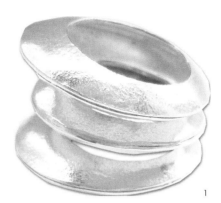

1

Although Leonor Bolívar's studied at the Universidad Jorge Tadeo Lozano in Bogotá focused on industrial design, she ultimately completed her training as a jeweler. Her work has been shown both nationally and internationally, which has enabled her to establish a presence in the European and Asian markets. In her home city of Ibagué, Colombia, she teaches her craft at the Tolima School of Arts and Crafts. She also has been an active participant in Colombia's National Jewelry Program, where she has worked with communities of craftspeople to introduce them to new techniques and technologies.

If you didn't specialize in jewelry, what would you be?
I love working with, and for, people, so I would definitely be doing some kind of craftwork with various communities. I would search for our cultural identity in new design projects and promote the commercial viability of community products.

If you could work with only one material, what would it be?
I have come to love metal and all of its malleability.

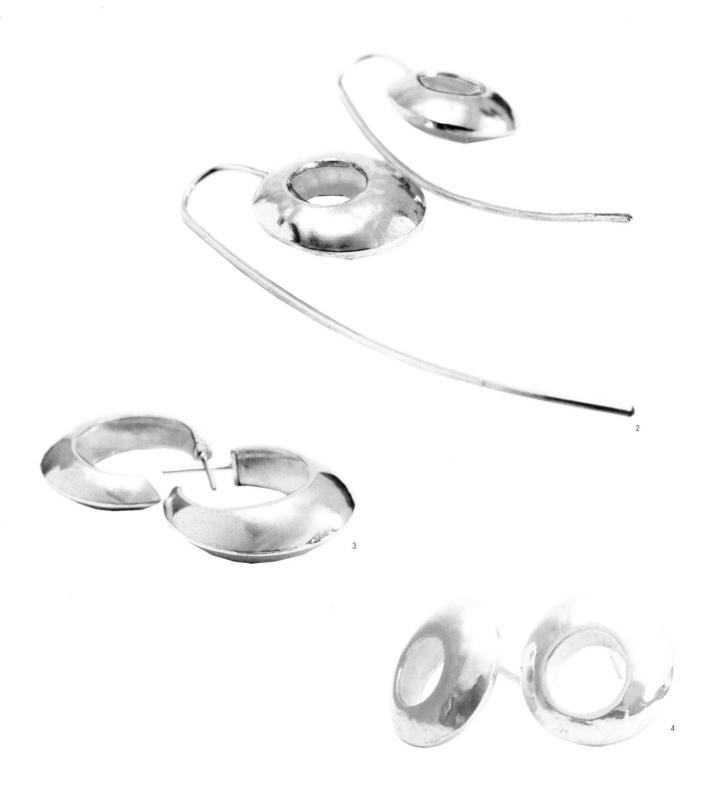

1. *Cíclope* rings
Silver 925 and 24-karat gold plating, chiseling and Japanese lacquer techniques

2. *Cíclope* ring earrings
Silver 925 and 24-karat gold plating, chiseling and Japanese lacquer techniques

3. *Cíclope* long earrings
Silver 925 and 24-karat gold plating, chiseling and Japanese lacquer techniques

4. *Cíclope* earrings
Silver 925 and 24-karat gold plating, chiseling and Japanese lacquer techniques

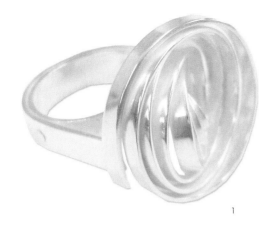

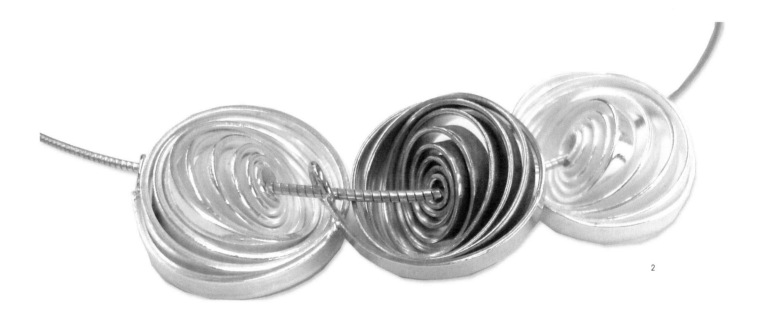

1. *Sinfín* ring
Silver 925

2. *Sinfín* choker
Silver 925 reinforced with
24-karat gold plating

3. *Amores pasados* necklace
Silver 925 and miyuki glass

4. *Amores pasados* earrings
Silver 925

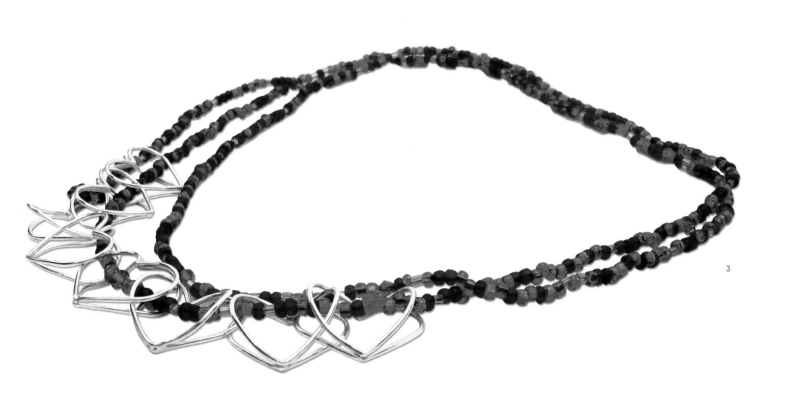

3

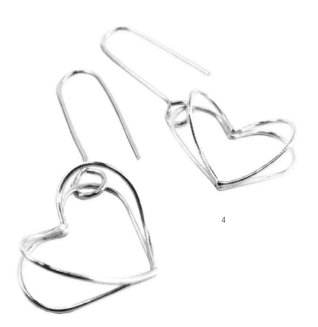

4

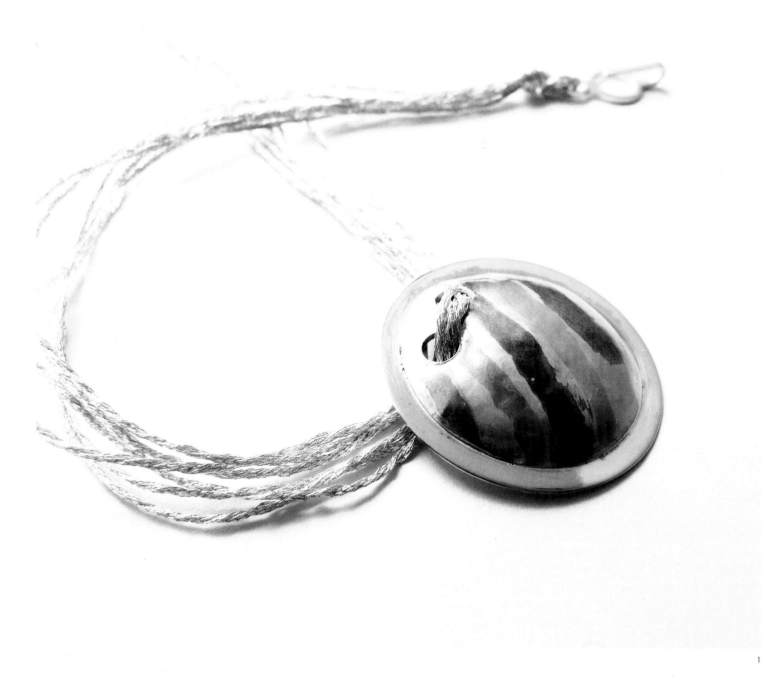

1

1. *Round Gestreept* **pendant**
Silver 925, gold, and copper

2. *Magma* **choker**
Reinforced with 24-karat gold
plating and magma stone

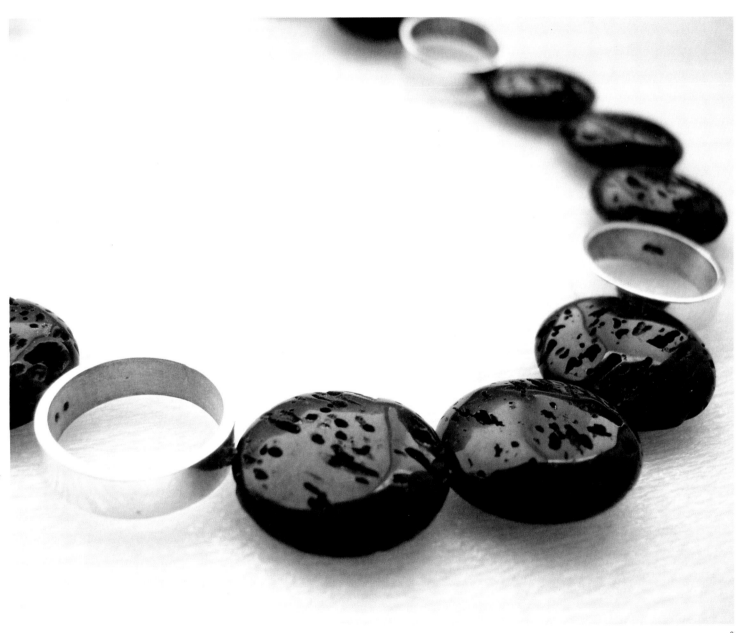

Luis Acosta

www.luisacosta.nl

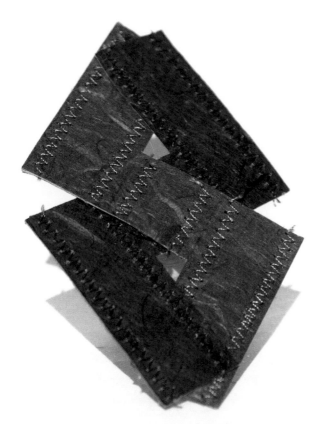

Luis Acosta was born in 1952 in Córdoba, Argentina, but now lives and works in the Netherlands. Although he began by studying economics in Buenos Aires, he also learned weaving and basketwork techniques. Acosta then moved to the Netherlands, where he graduated in 1988 from the Gerrit Rietveld Academy of Fine Arts in Amsterdam, and broadened his studies in Italy, attending the Academie Polimoda in Prato. He now designs fashion accessories and jewelry from paper, creates tapestries, and teaches textile design. In additon to participating in many solo and group exhibitions, his work is displayed in museum collections including the Museum of Arts and Design in New York, the National Museum of the History of Clothing in Buenos Aires, and the Fine Arts Center in Utrecht. Acosta has also curated international exhibitions for institutions including the Cervantes Institute, and he is a curator and member of the Founders' Circle of the Latin American Art Museum of the Netherlands.

If your work involved contemporary music, what style of music would it be?
Minimalist.

Describe your work space in three words.
Simple, clean, tidy.

1

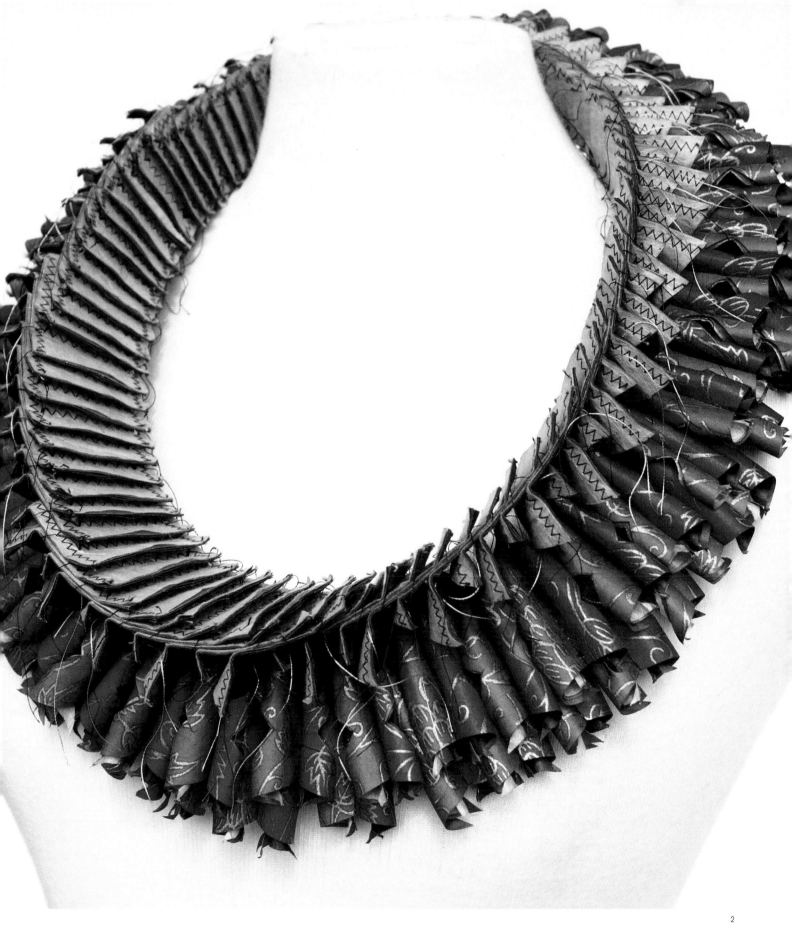

1. Brooch

Six layers of paper sewn by
machine

2. *Choker* **necklace**

Six layers of paper sewn by
machine

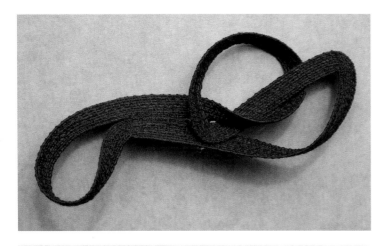
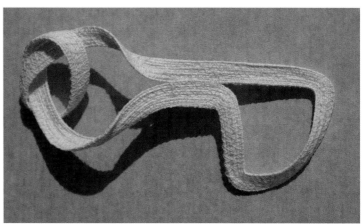
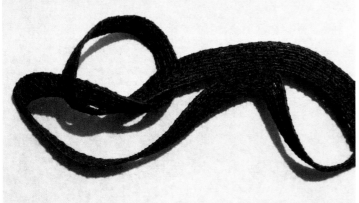
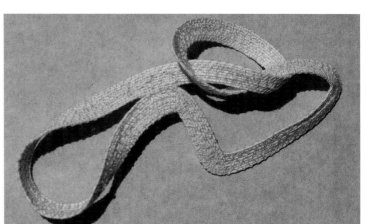
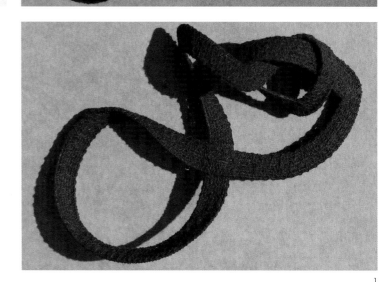

1

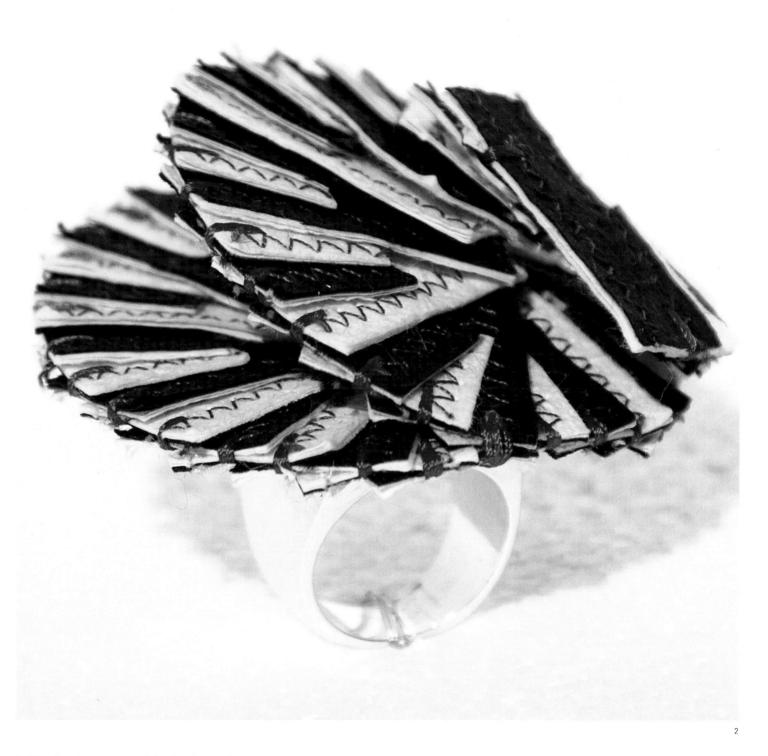

1. *Quipus* brooches

Paper yarn sewn by machine

2. *Escalera de caracol* ring

Six layers of paper sewn by
machine

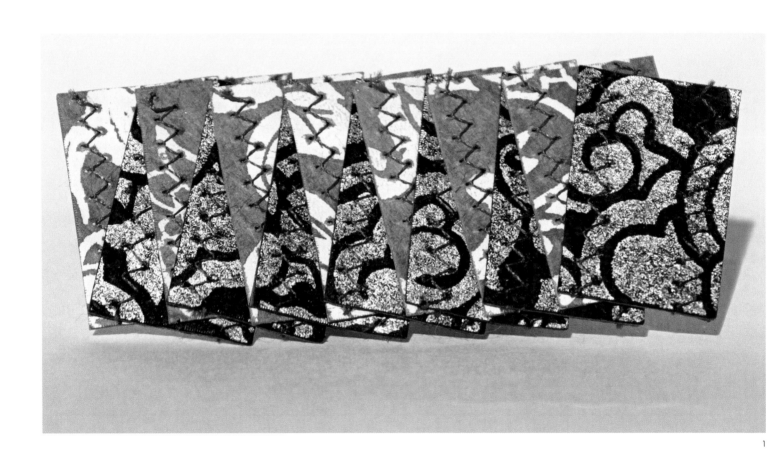

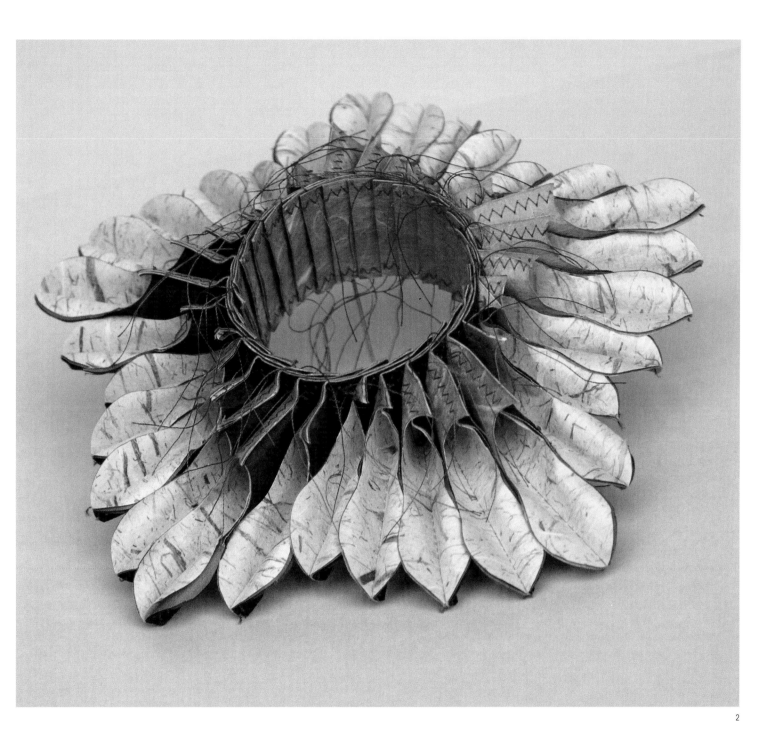

1. Brooch
Six layers of paper sewn by machine

2. Bracelet
Six layers of paper sewn by machine

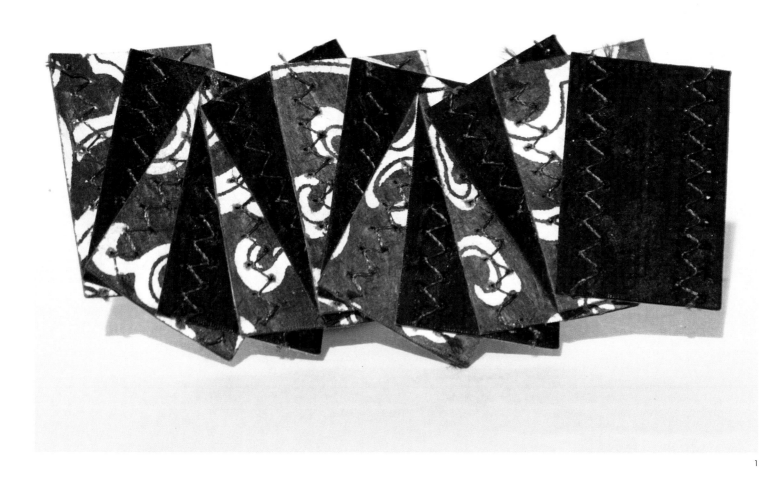

1

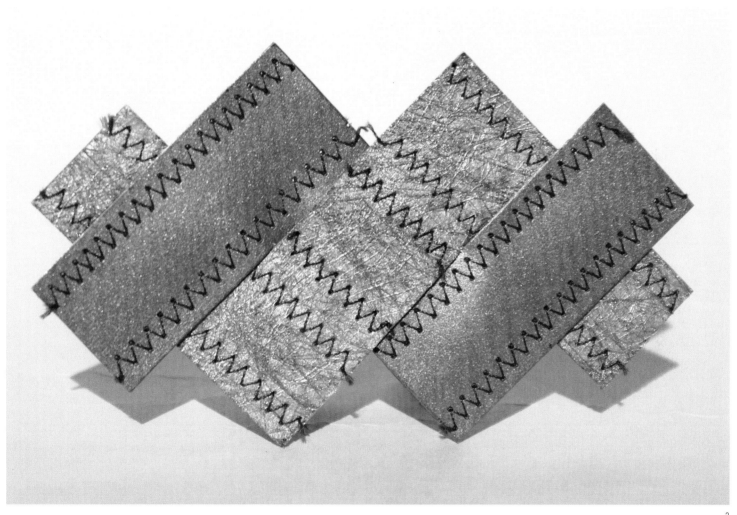

1. Brooch
Six layers of paper sewn by
machine

2. Brooch
Six layers of paper sewn by
machine

Luisa Bruni

www.luisabruni.com

At the State Institute of Art Rome 2, Luisa Bruni studied both gold and silversmithing, and textile and fashion design. She then studied painting at the Accademy of Fine Arts in Rome from where she graduated with honors in 1994. Bruni's work has received several important prizes, including that of the Nobil Collegio di S. Eligio in Rome (University of Goldsmiths, Jewellers and Silversmiths)—which led her to begin work with some of Rome's laboratories on developing the wax modeling techniques she uses today. Bruni has also taught textile art at numerous institutions.

If you didn't specialize in jewelry, what would you like to do?
Be a sculptor! But maybe I would just be doing what I'm doing now.

If you could work with only one material, what would it be?
Wax, for sure.

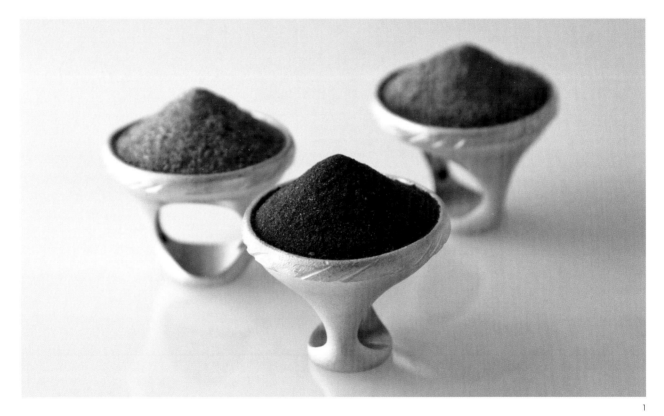

1

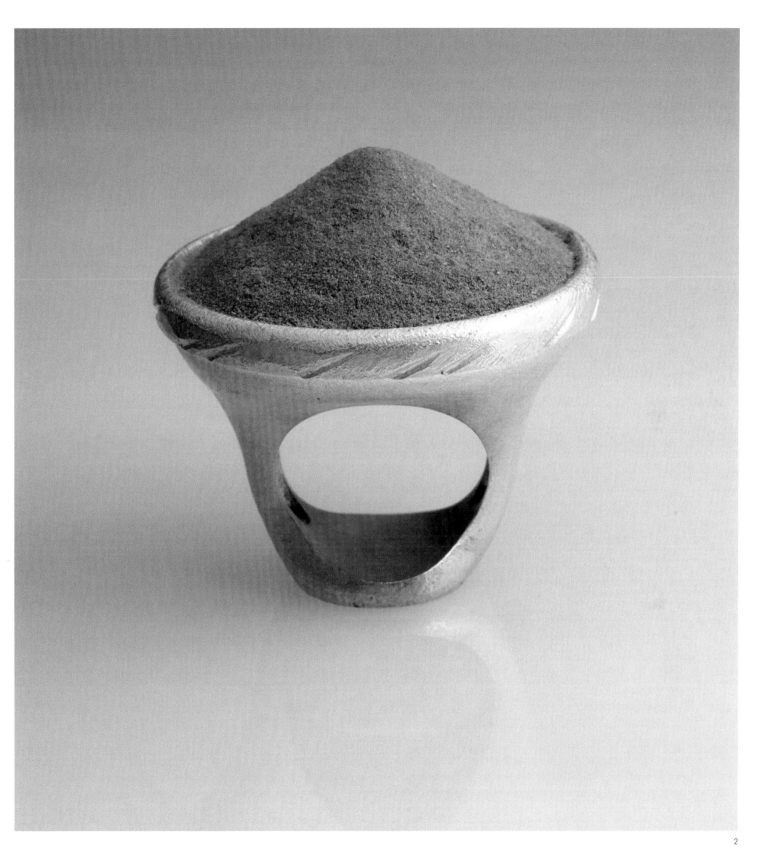

1. *E non è più occidente*
collection rings
Silver, sand, resin, and spices

2. *Curry* ring
Silver, sand, resin, and curry

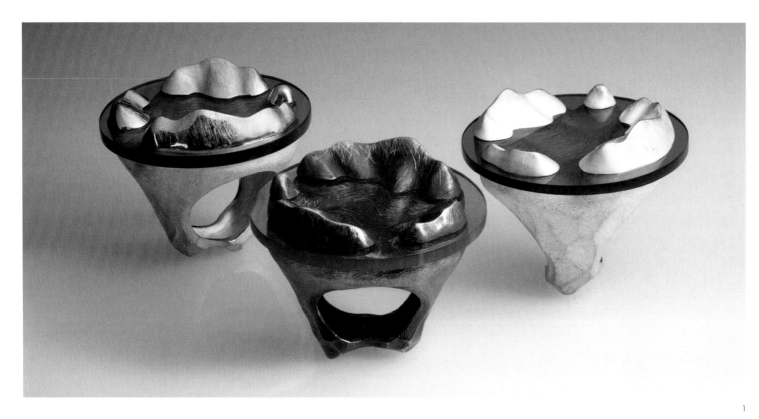

1

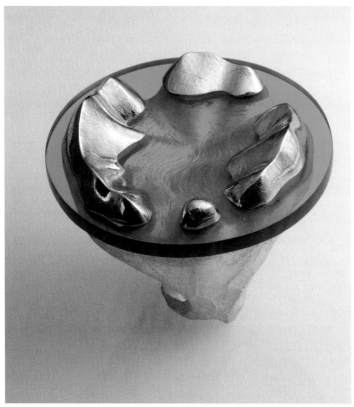

2

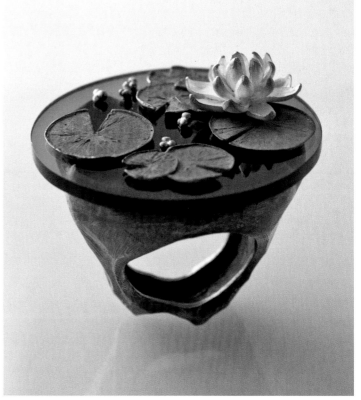

3

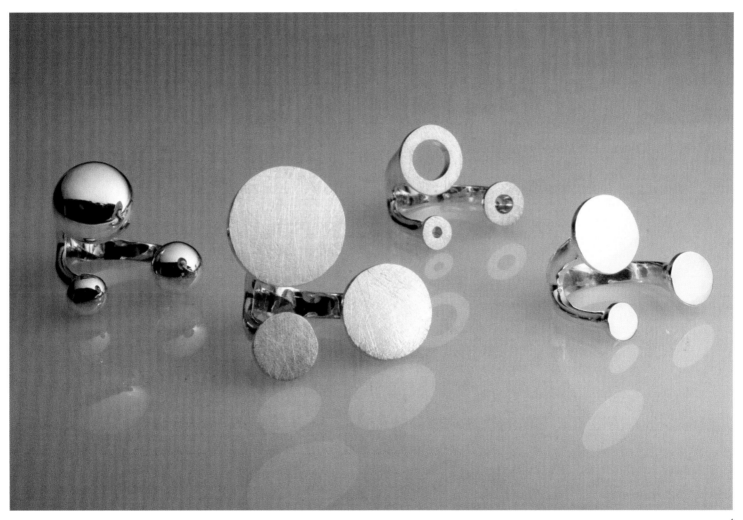

4

1. *Atollon* rings
Gold, silver, bronze, and resin

2. *I (also) have a dream* ring
Silver, gold, and resin

3. *Cra…cra…* ring
Silver, gold, bronze, and resin

4. *Sospensione* collection rings
Silver

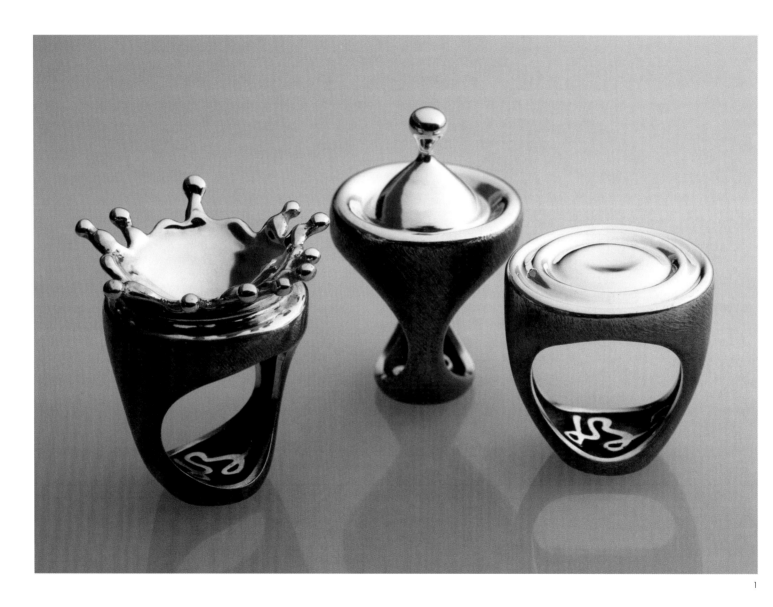

1. *Miniplink!* **collection rings**
Silver and plexiglass

2. *Plink!* **collection rings**
Silver

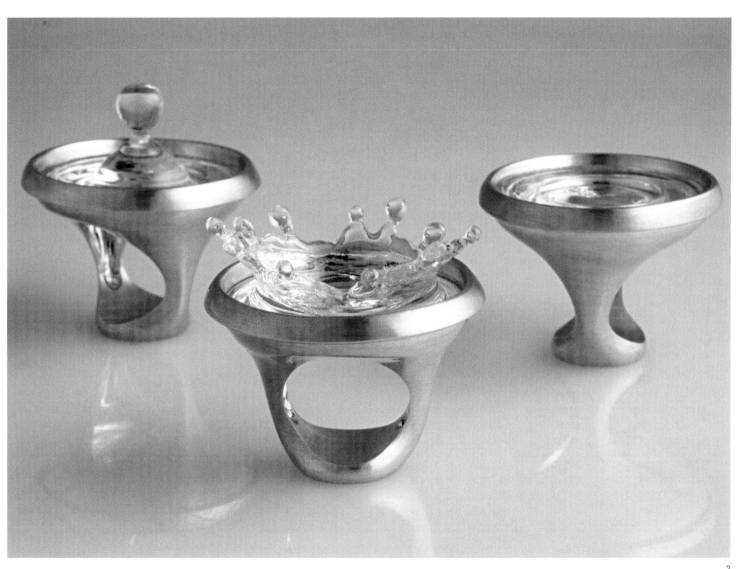

Majoral

www.majoral.com

Enric Majoral was born in Barcelona in 1949. He attended the Arts and Crafts School and the Polytechnic University of Catalonia, where he studied draftsmanship and technical architecture. In 1972, he moved to Formentera, an island off the eastern coast of Spain, and began working as a self-taught jeweler, developing his own innovative style outside the artistic mainstream. Since the early days of his career, he has always been responsible for designing, producing, and marketing his jewelry and sculptures, which are sold both in his own chain of eight shops and in galleries and other establishments in Europe and the United States. He has been honored with the Lifetime Achievement Award by the Association of Catalan Jewelers and the National Crafts Award by the Catalan Ministry of Industry in 2007. In 2008, two pieces from his series *Joies* *de sorra* ("sand jewelry") were added to the permanent collection of the Museum of Arts and Design in New York.

If you didn't specialize in jewelry, what would you be?
I work with jewelry because I don't know how to do anything else, but I could imagine myself doing something connected with the sea and nature. I could also see being a clown.

If you could work with only one material, what would it be?
Gold, because of its historic and symbolic value.

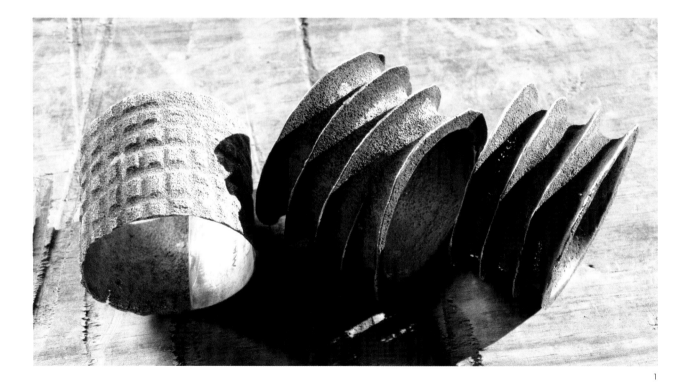

1

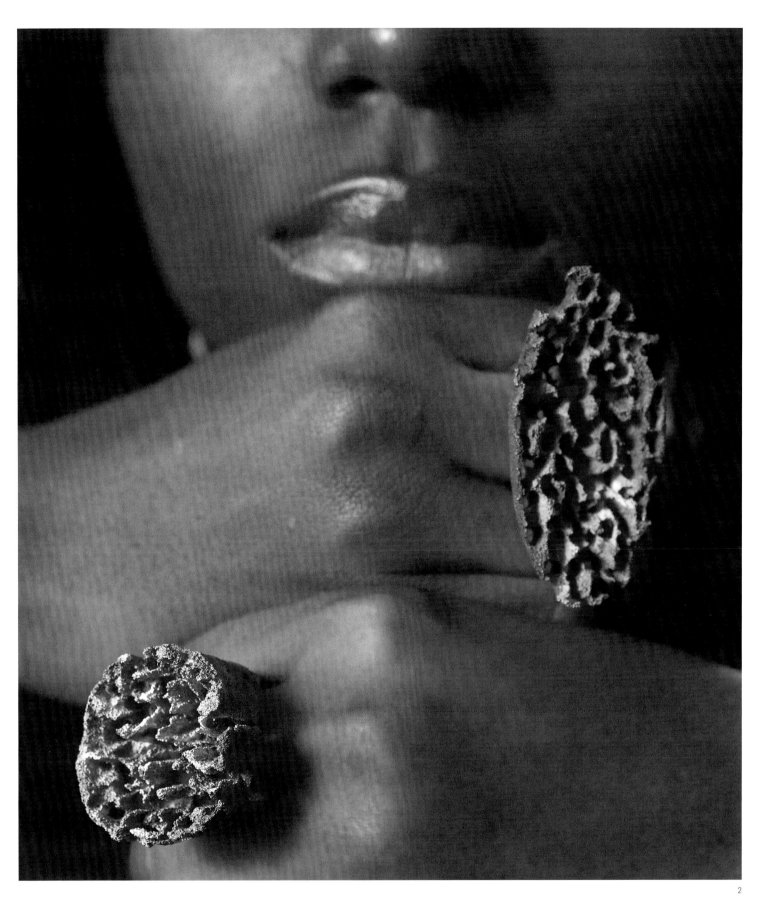

1. *Joies de sorra* bracelets
Silver painted

2. *Joies de sorra* rings
Silver painted

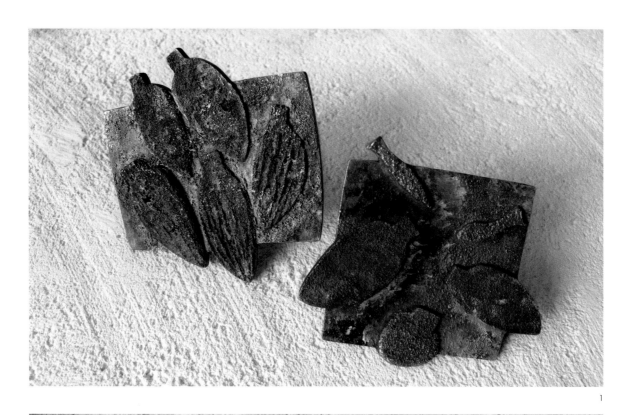

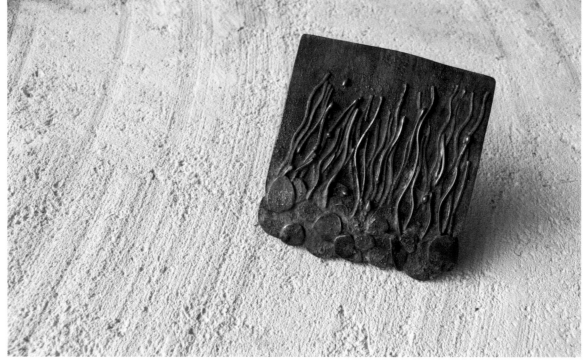

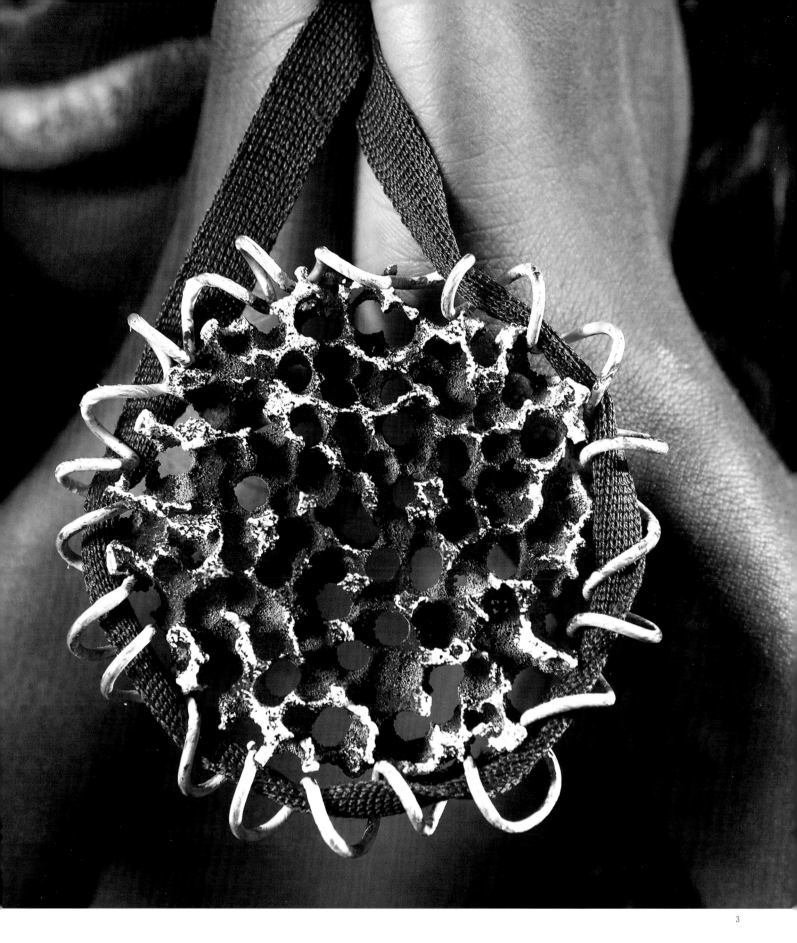

3

1-2. Retorn a Formentera pendants
Silver and gold painted

3. Joies de sorra pendants Silver
painted

323

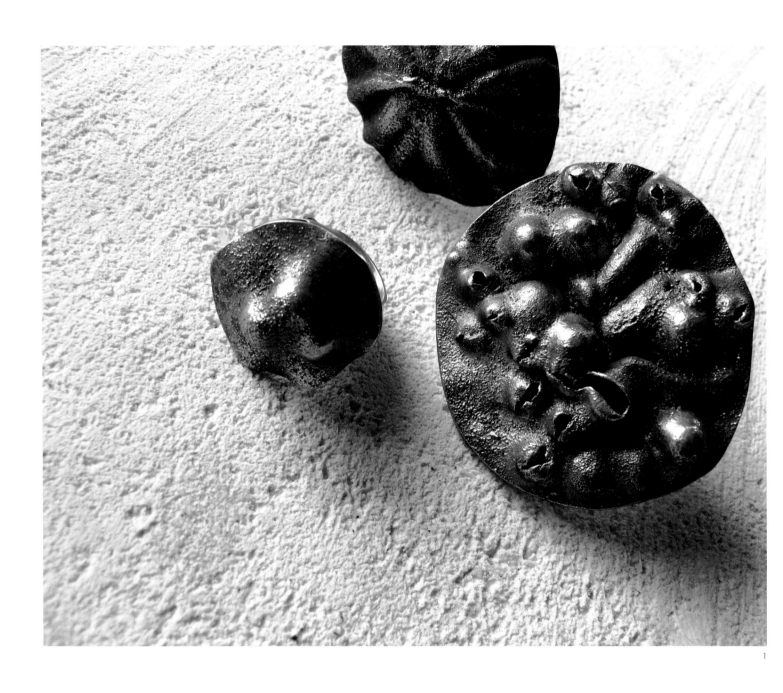

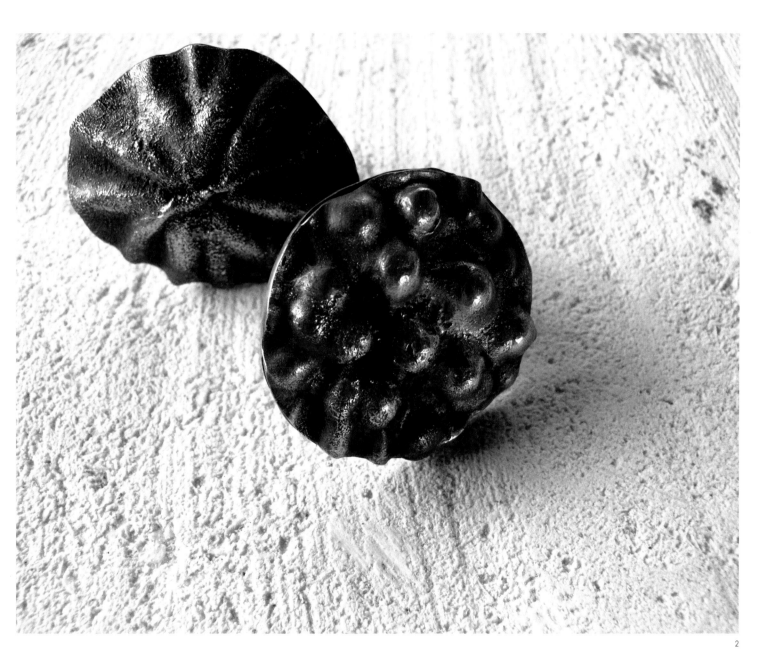

1-2. *Natures mortes* rings
Silver and gold painted

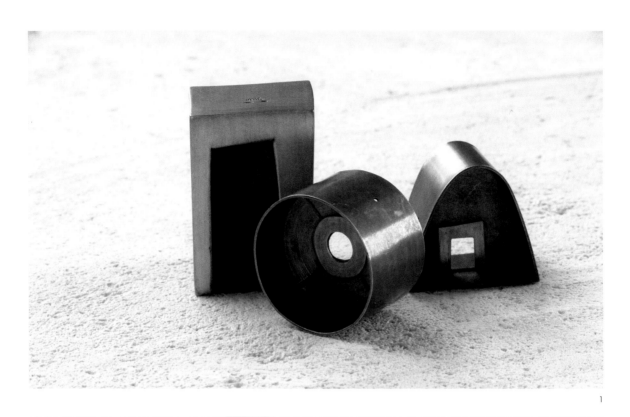

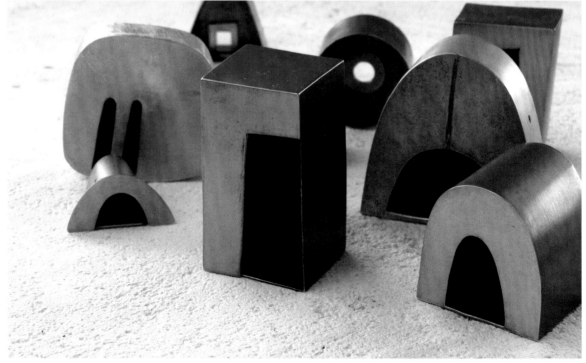

3

4

1-2. *Capelletes* pendants
Silver and gold

3-4. *Trossos de Formentera* pendants
Silver and gold painted

Maki Kawawa

www.kawawamaki.com

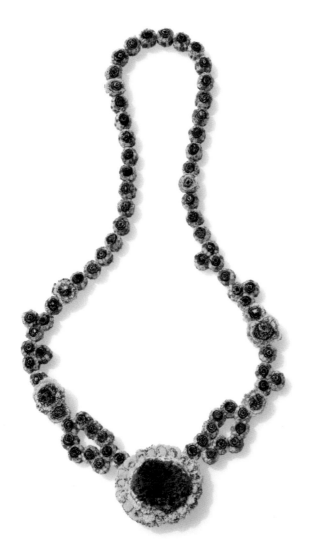

1

Handmade jewelry designer Maki Kawawa was born in Tokyo. She studied jewelry design at Tokyo's Hiko Mizune College of Jewelry from 2005 to 2009. Even before graduating, her jewelry began to be shown in group and solo exhibitions around the world. The young designer has already received a number of awards, including Germany's Bavarian Crafts Council Prize, and she has been named an assistant professor at her alma mater. Kawawa designs pieces to "*give people pleasure,*" and her jewelry is simple and very dynamic. Her necklaces, for example, include detailed work in textiles and are timeless, colorful, and rich with ethnic accents. Her work is to be enjoyed, and is an invitation to gaze at the finer side of life.

If you didn't specialize in jewelry, what would you do?
I would be baking bread, because I really adore bread!

If you could work with only one material, what would it be?
Textiles, for sure.

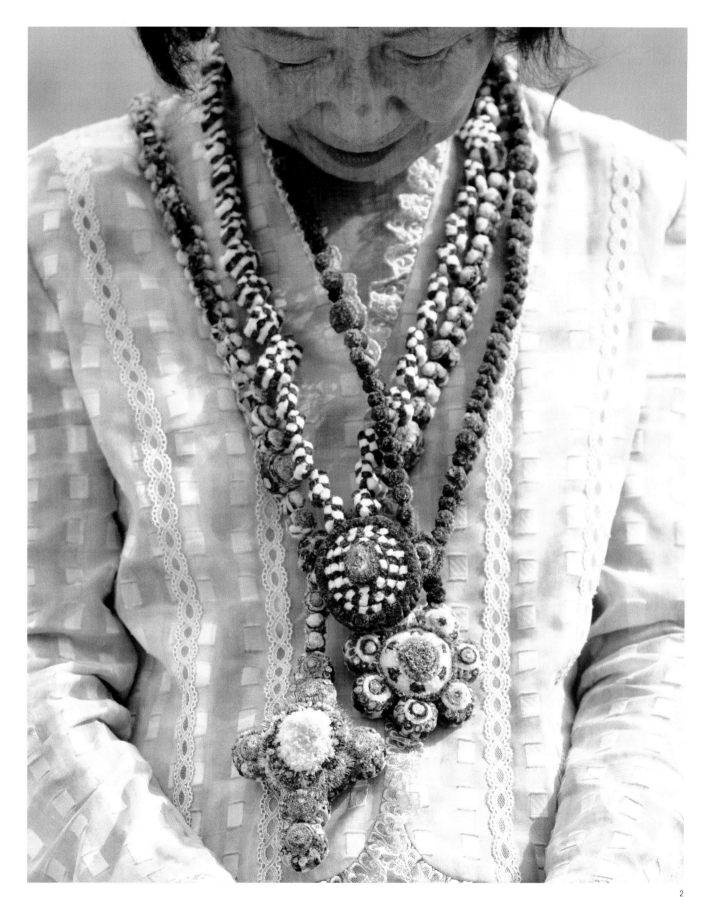

2

1. Necklace
Handmade with textiles

2. Necklace
Handmade with textiles

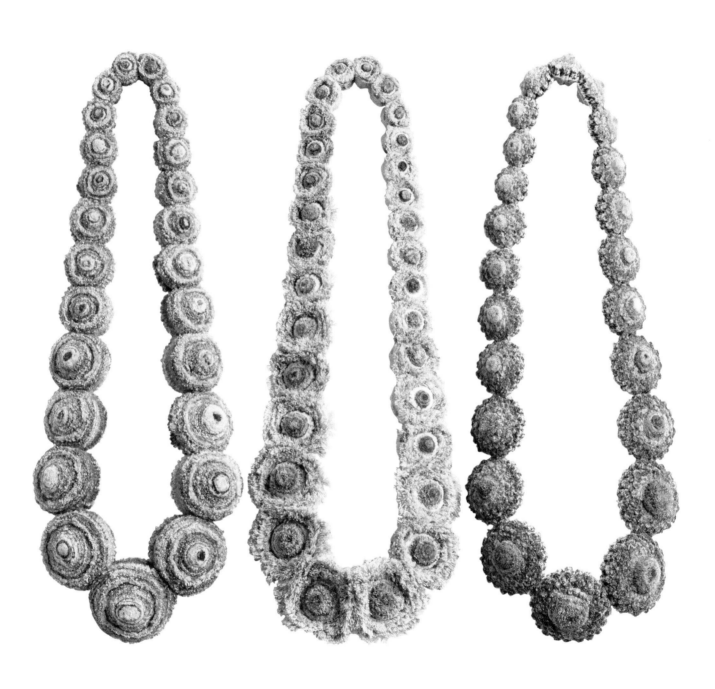

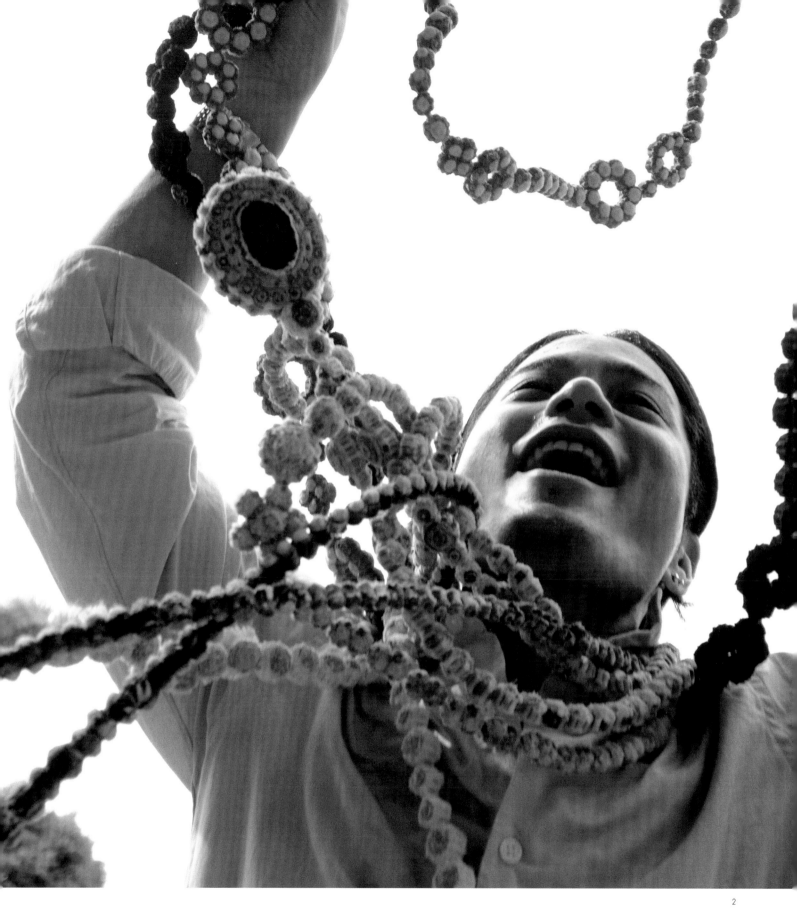

1. Necklaces
Handmade with textiles in
pastel shades

2. Necklaces
Handmade with textiles

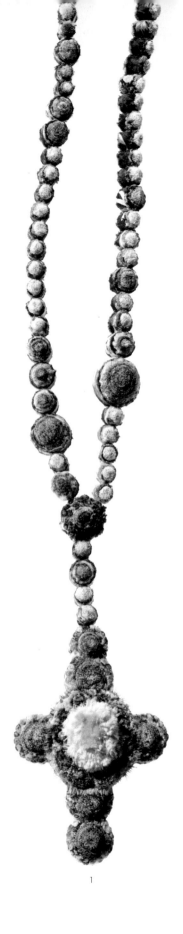

1

1. Necklace
Handmade with textiles

2. Necklace
Handmade with textiles

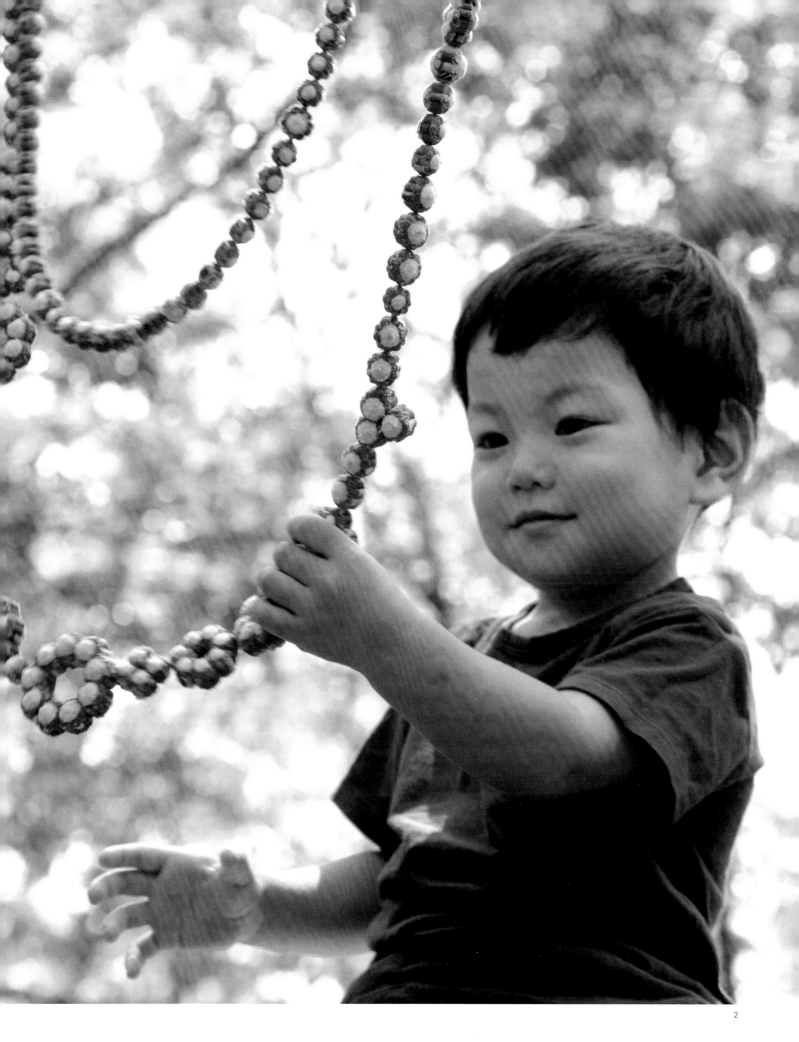

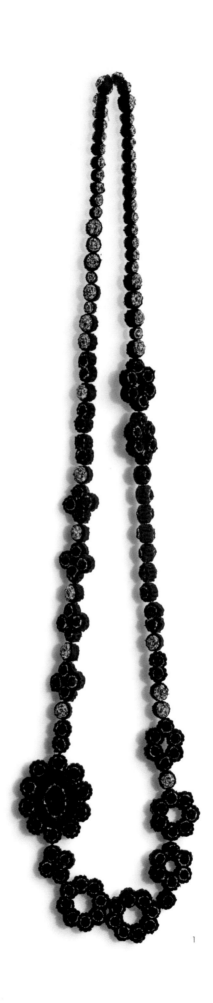

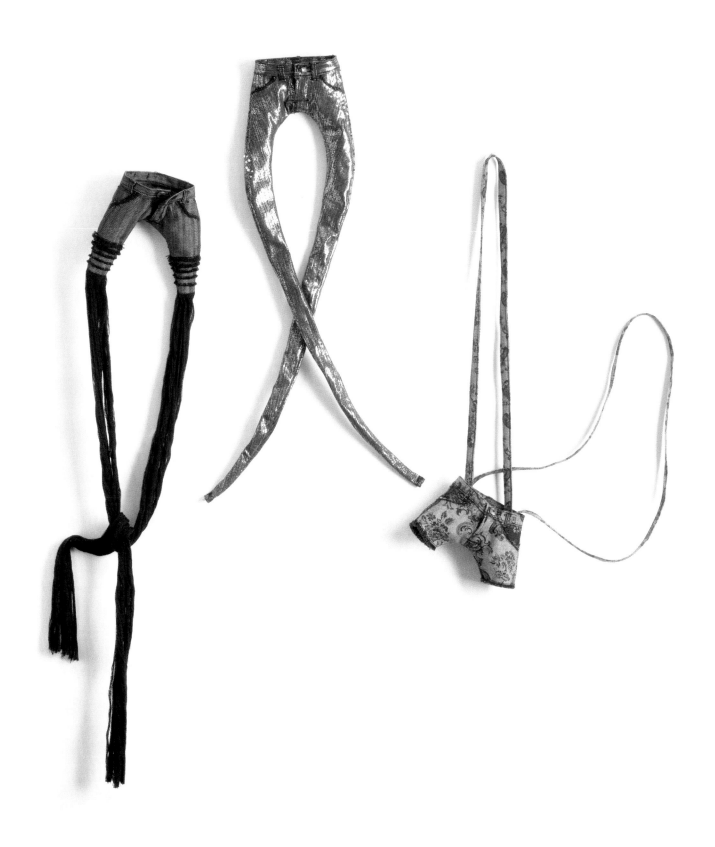

1. Necklace
Handmade with textiles

2. Necklace
Handmade with textiles

Manuela Gandini-Manuganda

www.manuganda.it

1

Born in Alessandria, Italy, in 1962, Manuela Gandini has been living and working in Milan since 1982. She began her career not in art but in information technology, having graduated from The University of Milan with a degree in computer science in 1988. Since her graduation she was working in IT companies, until she started her studies of jewellery making techniques, jewellery design, wax modelling, and 3D design techniques, in 2000. Then she established Manuganda, her signed collection, and she was first included in exhibitions featuring both Italian and international designers the following year. Her work highlights the aesthetic rigor of form, and places special emphasis on combinations of materials, colors, and finishes. Gandini aims to create pieces of contemporary jewelry that can live in harmony with the wearer without being influenced by the dictates of fashion.

If you didn't specialize in jewelry, what would you be?
An architect or interior decorator.

Describe your work space in three words.
Warm, peaceful, and white.

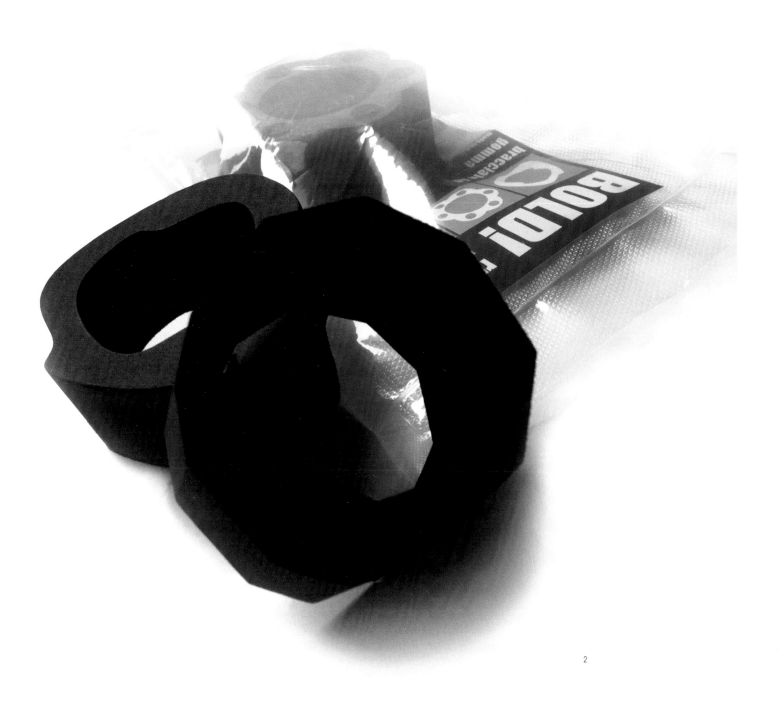

2

1-2. *Bold!* **bracelet**
Anallergic, recyclable, black
rubber

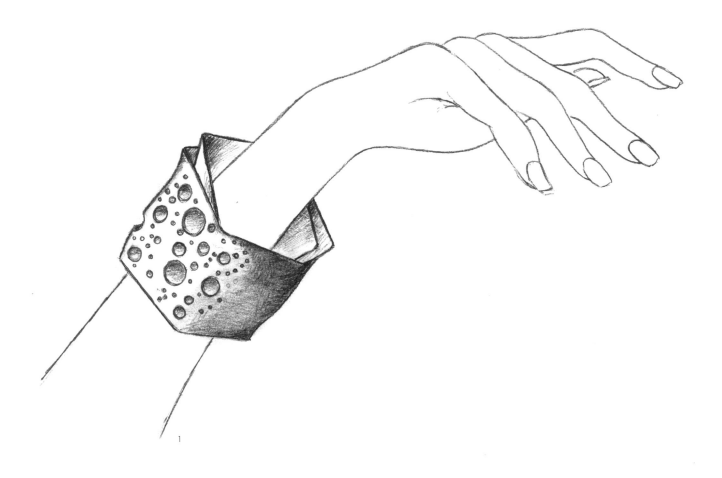

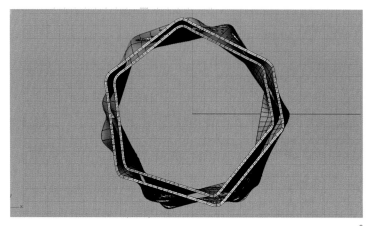

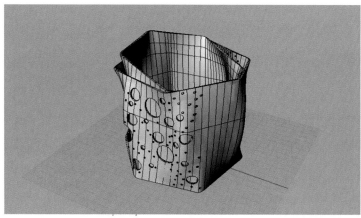

1-3. *Berlino* bracelet sketch
and 3D designs
Designed for the Precious
Titanium jewelry exhibition
(Milan Trienale, 2010)

4-5. *Berlino* bracelets
Titanium

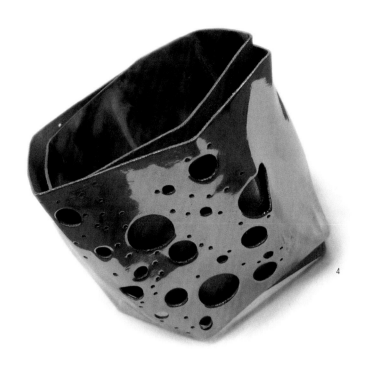

4

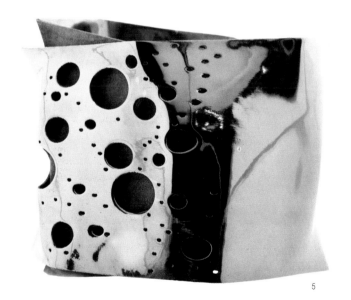

5

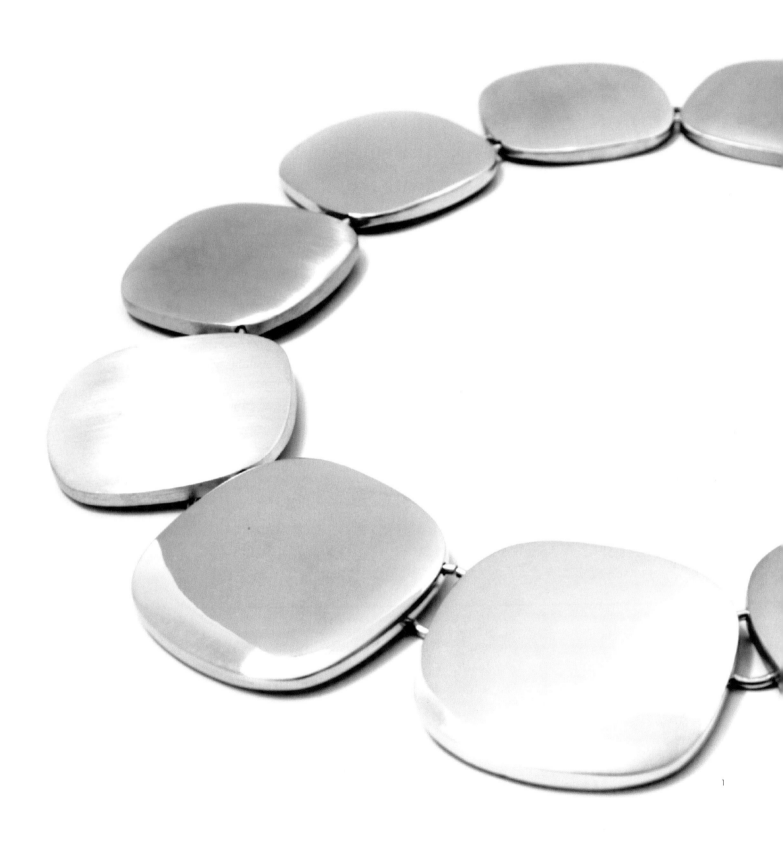

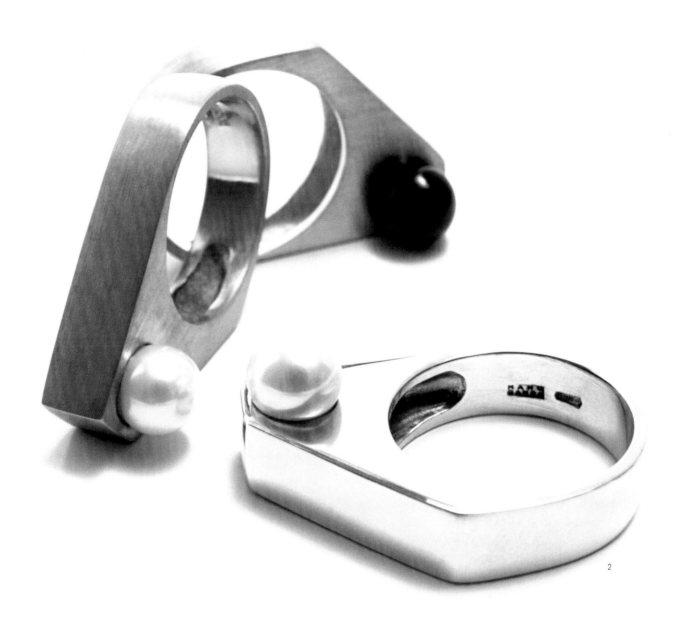

1. *Cialde* **necklace**
Silver and bronze with
different finishes

2. *Casa* **rings**
Silver/red gold with onyx and
freshwater pearls

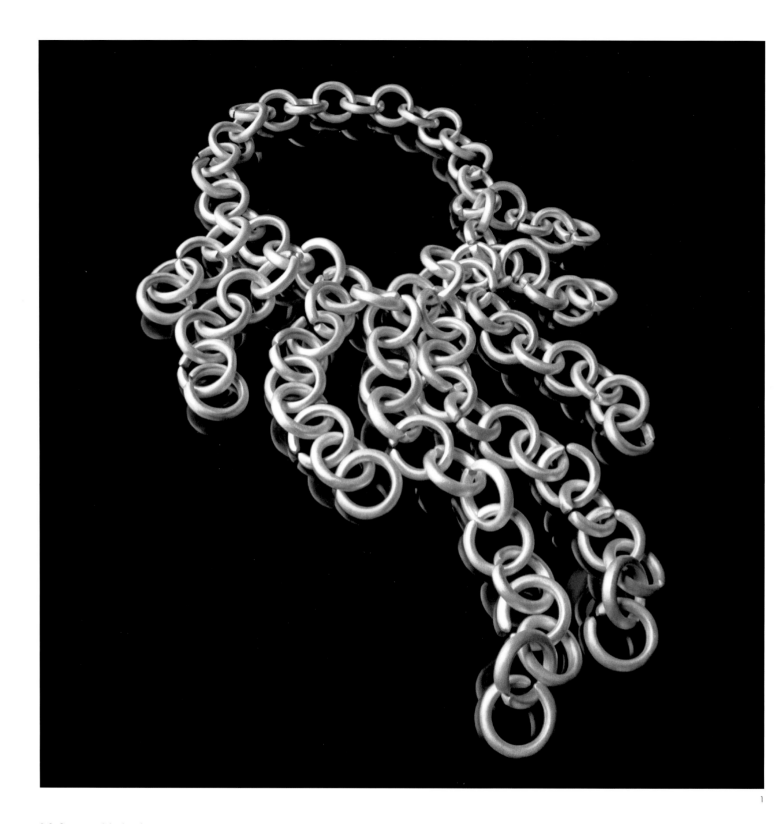

1-2. *Compo* modular jewelry
Anodyzed aluminum, metal injection
molding, and anodyzation

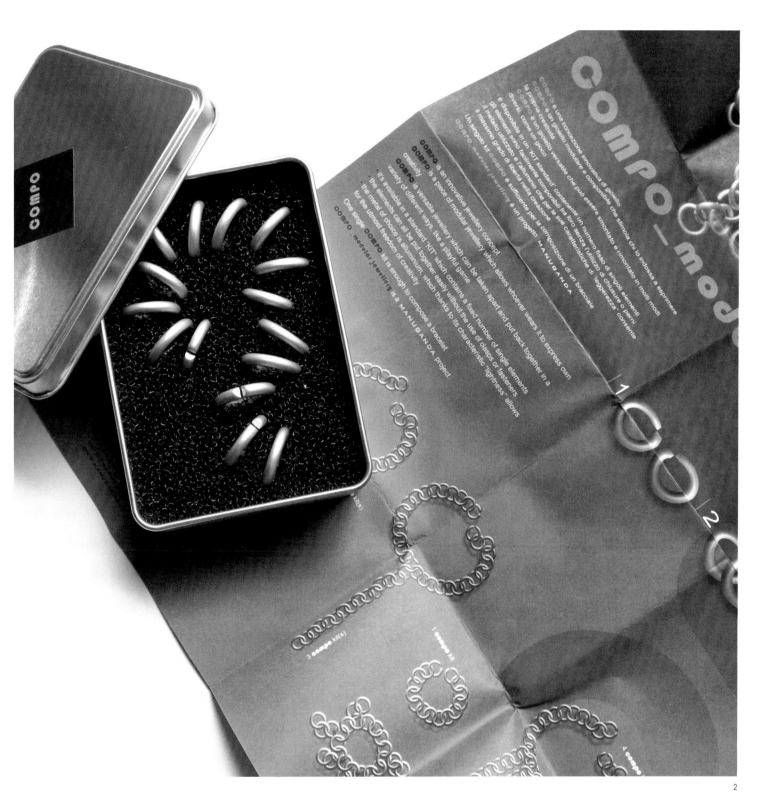

COMPO è una concezione innovativa di gioiello.
COMPO è un gioiello modulare e componibile che simbolo chi lo indossa a esprimere
la propria creatività.
COMPO è un gioiello versatile che può essere smontato e rimontato in molti modi
diversi. Come in un "KIT" standard contenente un numero fisso di singoli elementi
e disponibile in un "KIT" standard contenente un numero fisso di singoli elementi
gli elementi sono facilmente componibili fra loro senza l'utilizzo di chiusure o perni.
e massimo grado di libertà nella creazione per la sue caratteristiche di leggerezza. Consente
Un singolo kit COMPO è sufficiente per la composizione di un bracciale
COMPO_essentia / jewellery è un progetto MANUGANDA.

COMPO is an innovative jewellery concept.
COMPO is a piece of modular jewellery which allows whoever wears it to express own
creativity.
COMPO is versatile jewellery which can be taken apart and put back together in a
variety of different ways, like a playful game.
it's available in a standard "KIT" which contains a fixed number of single elements
the elements can all be put together easily without the use of clasps or fasteners
for the metal of choice is aluminium, which thanks to its characteristic "lightness" allows
free utmost freedom of creativity.
One single COMPO kit is enough to compose a bracelet
COMPO_essentia / jewellery is a MANUGANDA project.

Marc Monzó

www.marcmonzo.net

Jewelry designer Marc Monzó was born in Barcelona in 1973 and trained at the Escola Massana. Throughout his career, he has created pieces that are idiosyncratic and conceptual, but at the same time draw their inspiration from everyday life. Monzó starts with conventional materials and techniques, then disguises, manipulates, and reinterprets them to create simple pieces with a very sleek style. His honors include the 2006 Design Prize awarded by the Association of Jewelers in Catalonia. Monzó's jewelry has been featured in many galleries and included in museum collections such as those of the Museum of Decorative Arts in Barcelona, and the Stedelijk Museum 's-Hertogenbosch (the modern art museum of 's-Hertogenbosch, the Netherlands) and the Françoise van den Bosch Foundation in the Netherlands.

If you didn't specialize in jewelry, what would you be?
A musician.

Describe your work space in three words.
Tidy, dynamic, geometric.

1

1. *Two lines* rings
18-karat gold

2. Bracelet
Silver

1. *Eclipse color* brooch
Aluminum, steel, and enamel

2. *Fire* brooch
18-karat gold

1

1. *Sollitaire* ring
18-karat white gold and
zirconite

2. *Black star* brooch
Oxidized silver and steel

Mari Ishikawa

www.mari-ishikawa.de

Mari Ishikawa was born in Kyoto, Japan, in 1964. In 1986, she graduated with a degree in art from Japan's University of Education. Mari spent three years working as a high school art teacher and then a graphic designer at Aim Creates, an advertising agency in Tokyo. During that time, she took a course in jewelry at the Hiko Mizuno College of Jewelry, which prompted her to study jewelry at the Academy of Fine Arts in Munich. Ishikawa has lived in Munich since, and has her own workshop where she produces pieces known for their subtlety. She has been the recipient of many prizes, including the 2010 Bayerischer Staatpreis Award in the International Handicraft Fair Award in Munich, the 2007 Tahitian Pearl Trophy (second prize), the 2000 Herbert Hofmann Award, and first prize in Munich's Böhmler Art Awards. Her work has been included in solo and group exhibitions around the world, as well as in museum collections such as those of the Dallas Museum of Art, the Museum of Arts and Design in New York, the Jewelry Museum in Pforzheim, Germany, the Hiko Mizuno Collection in Tokyo, and the Espace Solidor in Cagnes-sur-Mer, France.

If your work involved contemporary music, what style of music would it be?
My work would not be a very modern style of contemporary music. It might be jazz, perhaps.

Describe your work space in three words.
My parallel world!

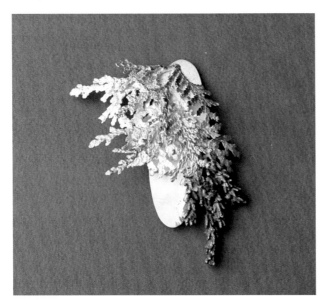

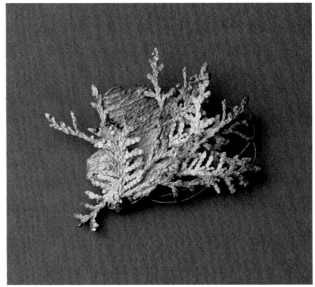

1

2

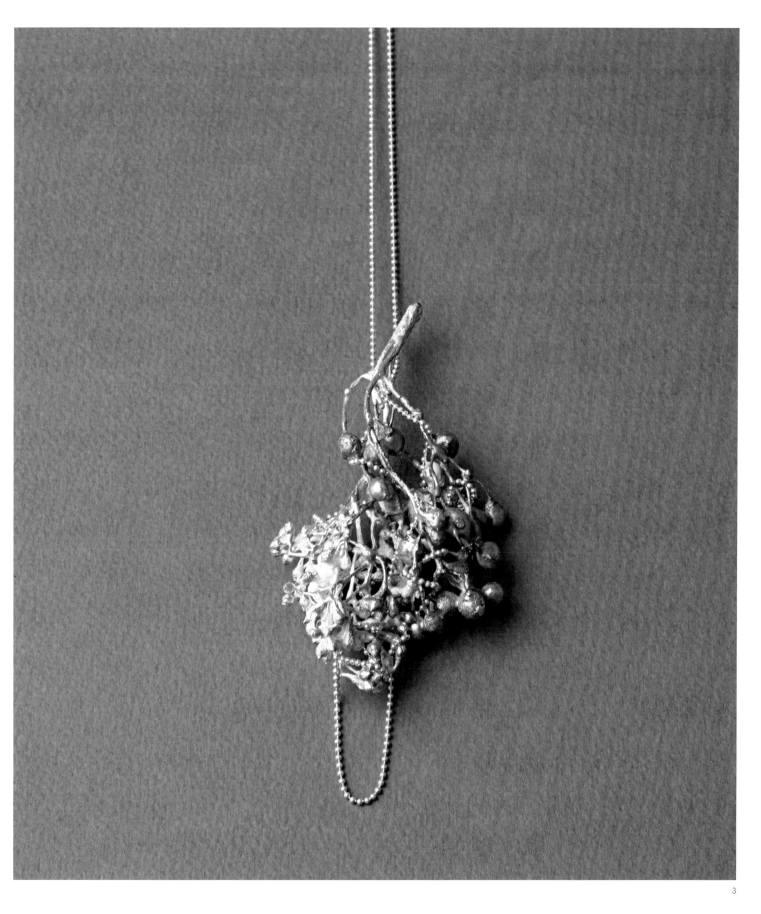

1. Brooch
Silver 925

2. Brooch
Silver 925 and black
diamond

3. Necklace
Silver 925

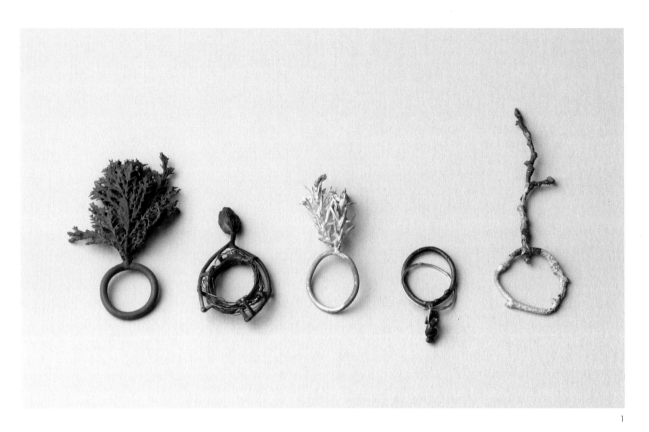

1

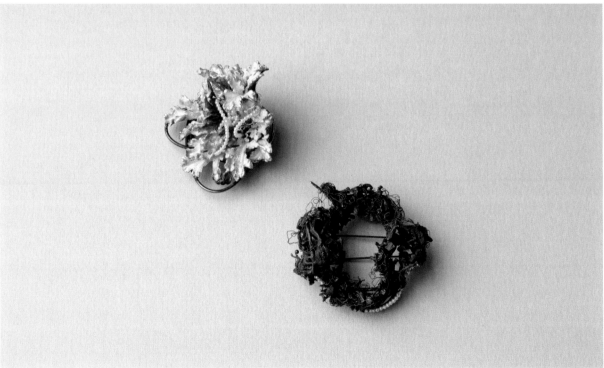

2

1. Rings
Gold 750 and silver 925

2. Top: Brooch
Silver 925 and pearls
Bottom: brooch
Silver 925, pearls, and coal

3. Necklace
Silver 925 and diamonds

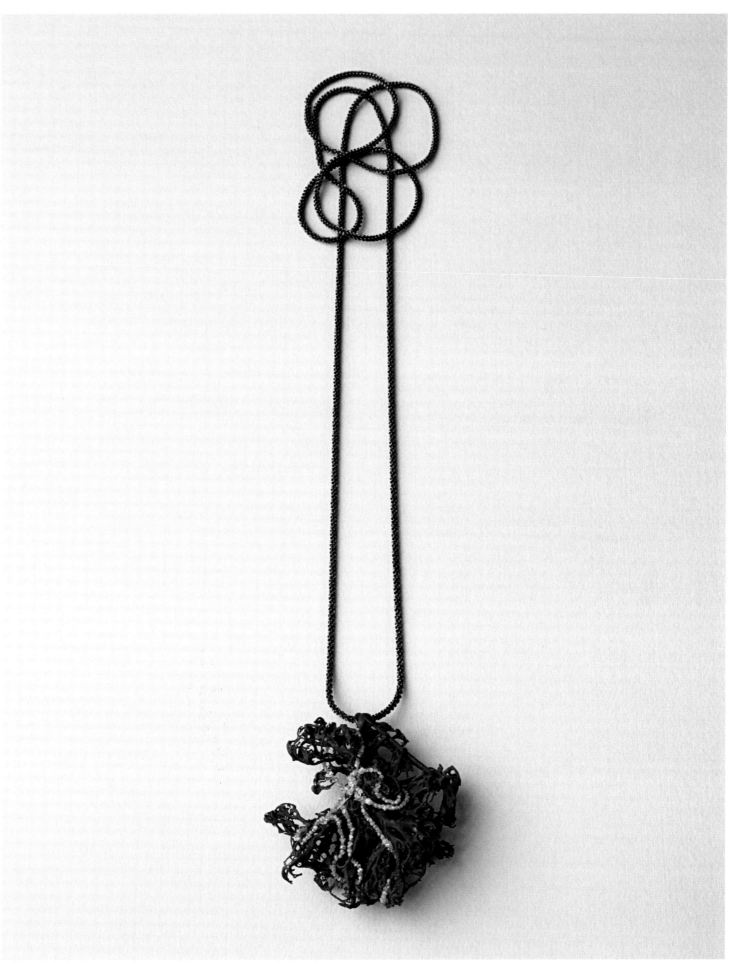

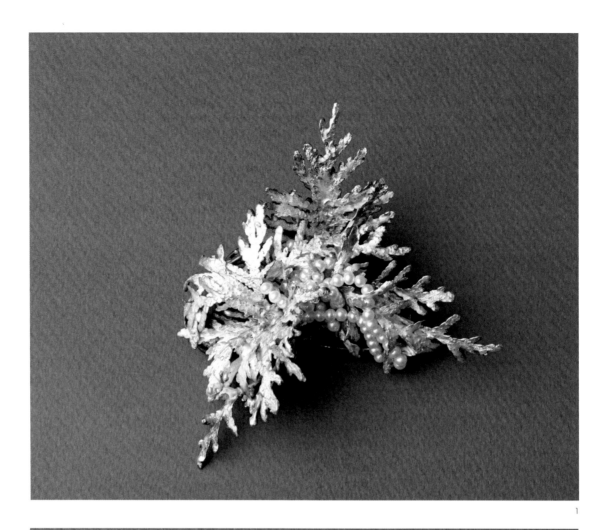

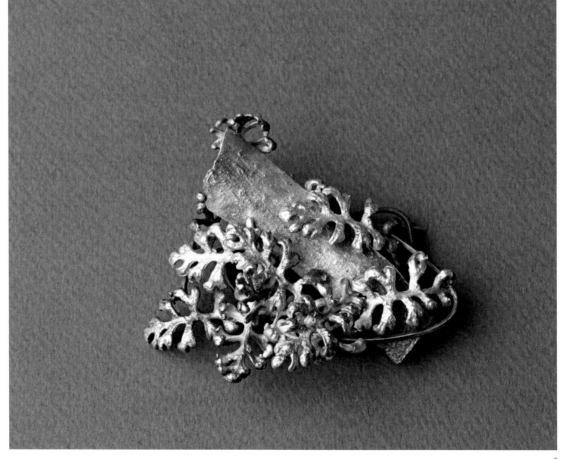

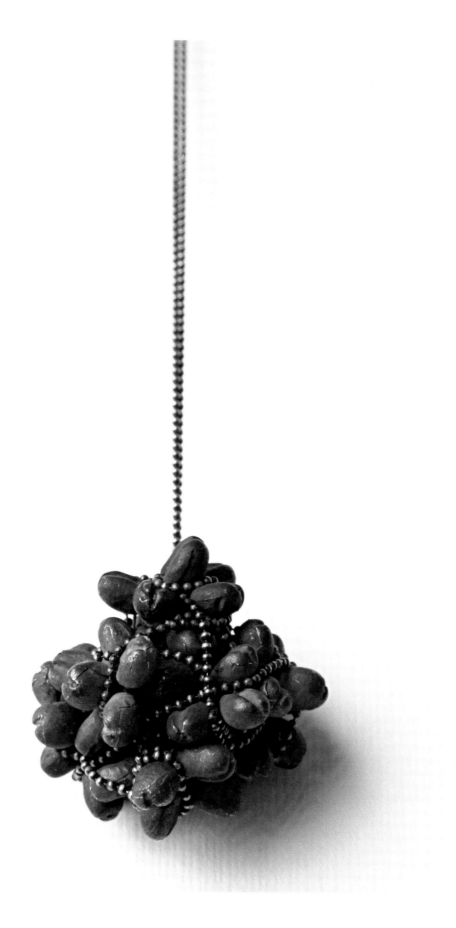

3

1. Brooch
Silver 925 and pearls

2. Brooch
Silver 925

3. Necklace
Silver 925 and silk

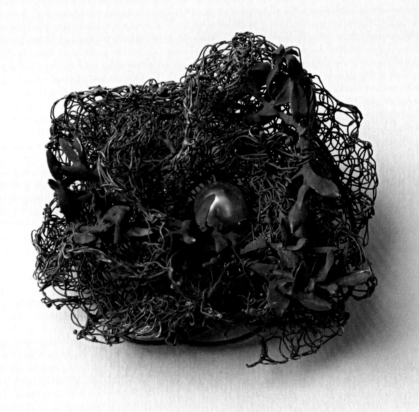

1

1. Brooch
Silver 925 and Tahitian pearl

2. Brooch
Silver 925

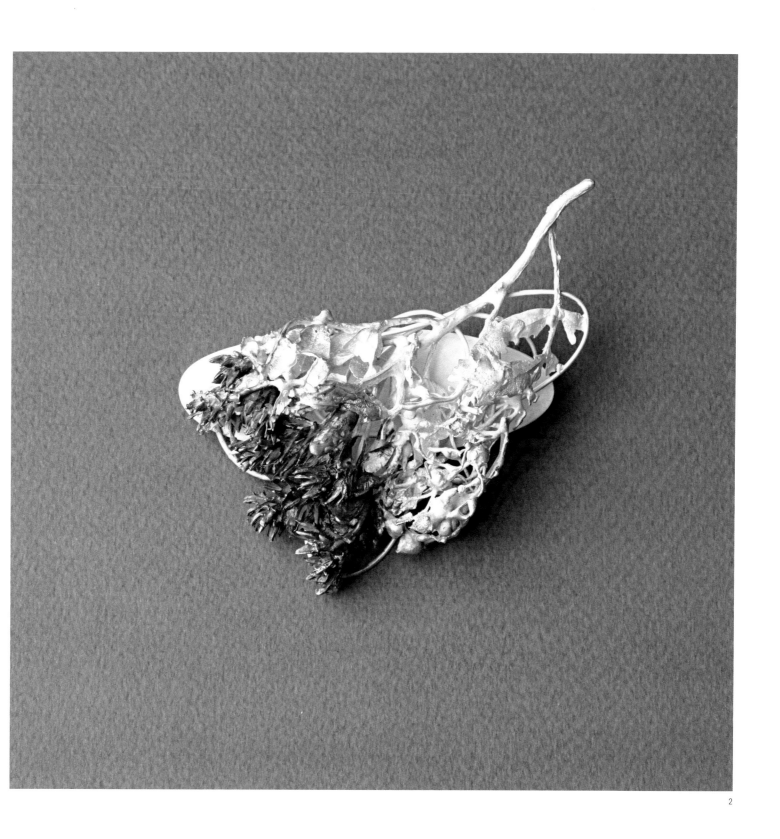

Marie Niel

www.marieniel.com

1

Marie Niel has been drawn to jewerly since she was a child. She started out as a jewelry salesperson, dreaming of the day she would have her own line. Niel studied jewelry design and arts and crafts at Lycée Jean Guéhenno in Saint-Amand-Montrond, France. She enrolled in workshops given by the great master, André Cabourdin and with the draftsman, Véronique Duffale of the Duhem company, both in Paris. After graduating, she worked for Van Cleef & Arpels and Louis Vuitton. She later moved to the French West Indies and worked with the jeweler Samba Kone for the store Tropic Or, where she learned the traditional jewelry-making techniques of Martinique. Niel has since settled in Barcelona, where her own studio carries several lines of jewelry. Her piece *Nuit Lumineuse* ("luminous night") was recently selected for the prestigious HRD Awards in Antwerp.

If your work involved music, what style of contemporary music would you classify it as?
That depends. On the one hand, it would be something simple: a flower between your teeth and an accordion, guitar, friends, and good wine, like you were in a Parisian café. But it might also be some trance music that travels into the depths of the subconscious, to arouse my inner spirit, my body, and my soul!

Describe your work space in three words.
Poetic, creative, dramatic

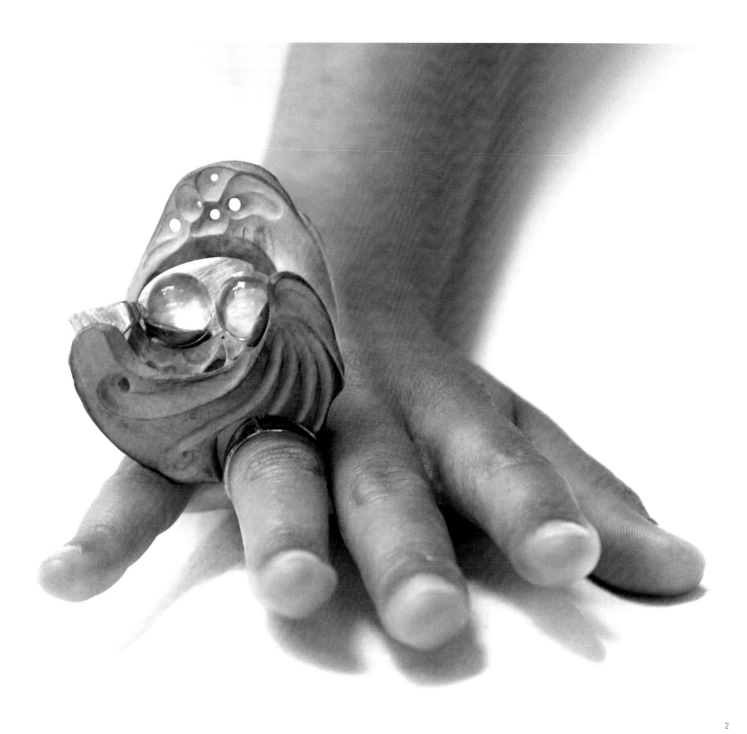

2

1. *A night at the opera* sketch
Presented at the 2007 HRD
Awards

2. *Abysse* ring
Brass, boxwood,
and plexiglass

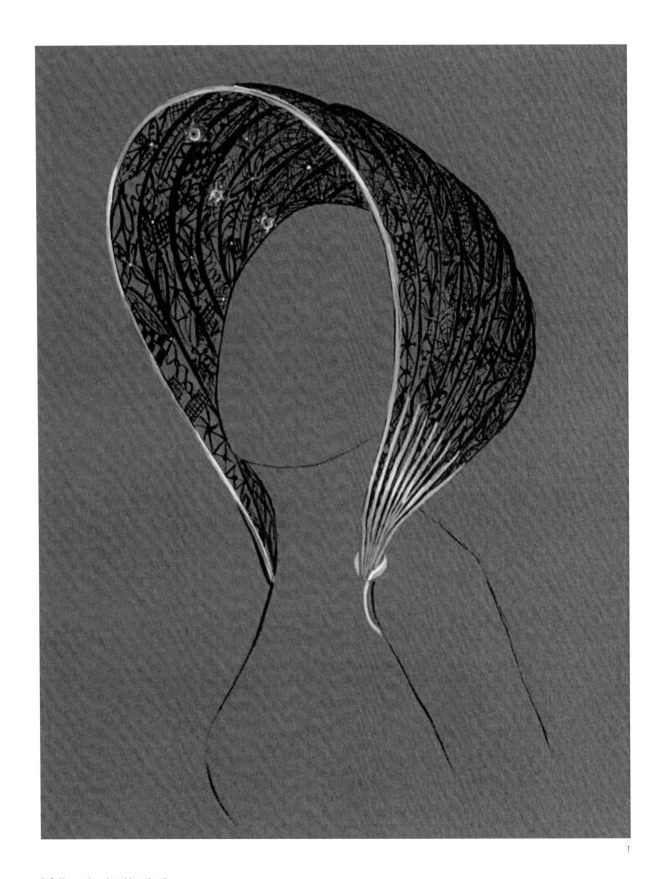

1-2. *You and me* jewel-hat sketches
On the left in open position, closed
on the right

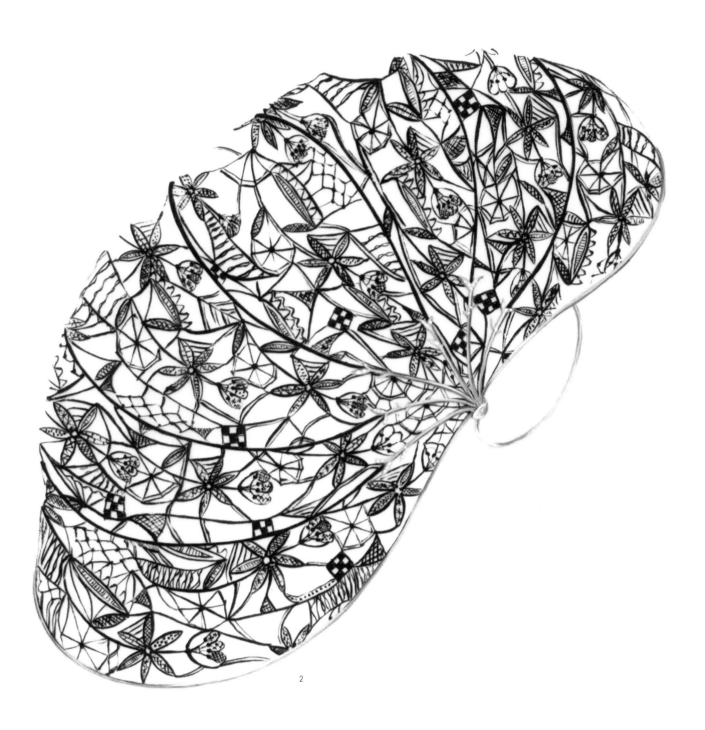

2

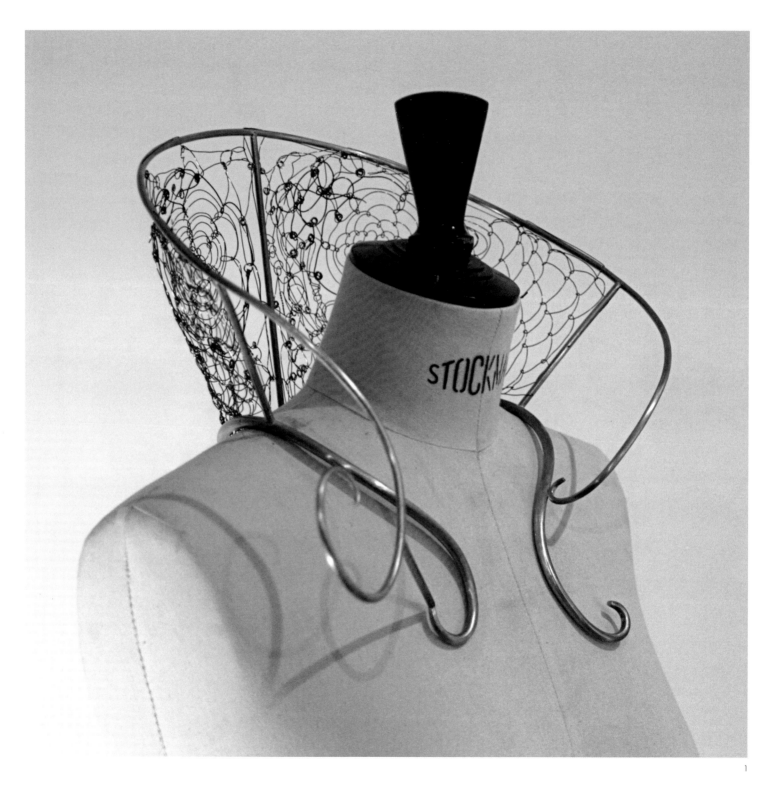

1

1. *Fée Tuss* necklace
Brass and copper

2. *Achta* necklace
Brass

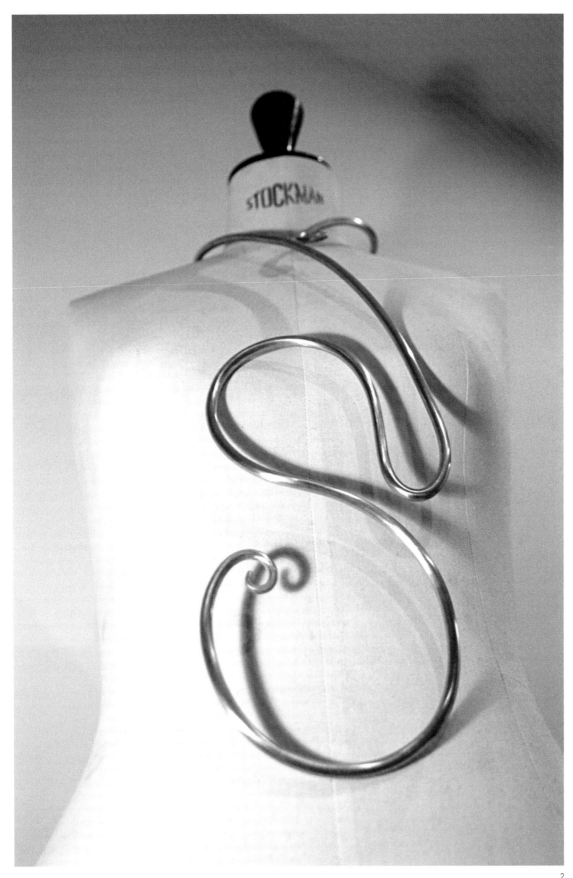

Marijke de Goey

www.marijkedegoey.com

Marijke de Goey was born in 1947 in Utrecht, the Netherlands. Since studying at the Gerrit Rietveld Academy in Amsterdam, she has worked around the world on innovative jewelry, scuptures, and large-scale sculptural and architectural projects. Her many accolades include the 1984 Art Award of the city of Gouda, the 1985 Francoise van den Bosch Prize, and first prize in the 2002 Polish Biennial. In 2001, she was honoured with the Royal Knight of the Order of the Dutch Lion. She lectures and conducts workshops in the Netherlands, the rest of Europe, and Asia.

If your work involved contemporary music, what style of music would it be?
My work might be associated with jazz, with its rhythmic repetitions of the same theme laced with explosive solos and improvisations.

If you could work with only one material, what would it be?
I would choose steel, on both a small and large scale, for its resistance.

1

1. *Scissors* rings
Gold and anodyzed titanium

2. *Cube* necklace
14-karat gold

1. *Beatrix* brooch
Gold and meteorite

2. *Collapsed square* brooch
Stainless steel

2

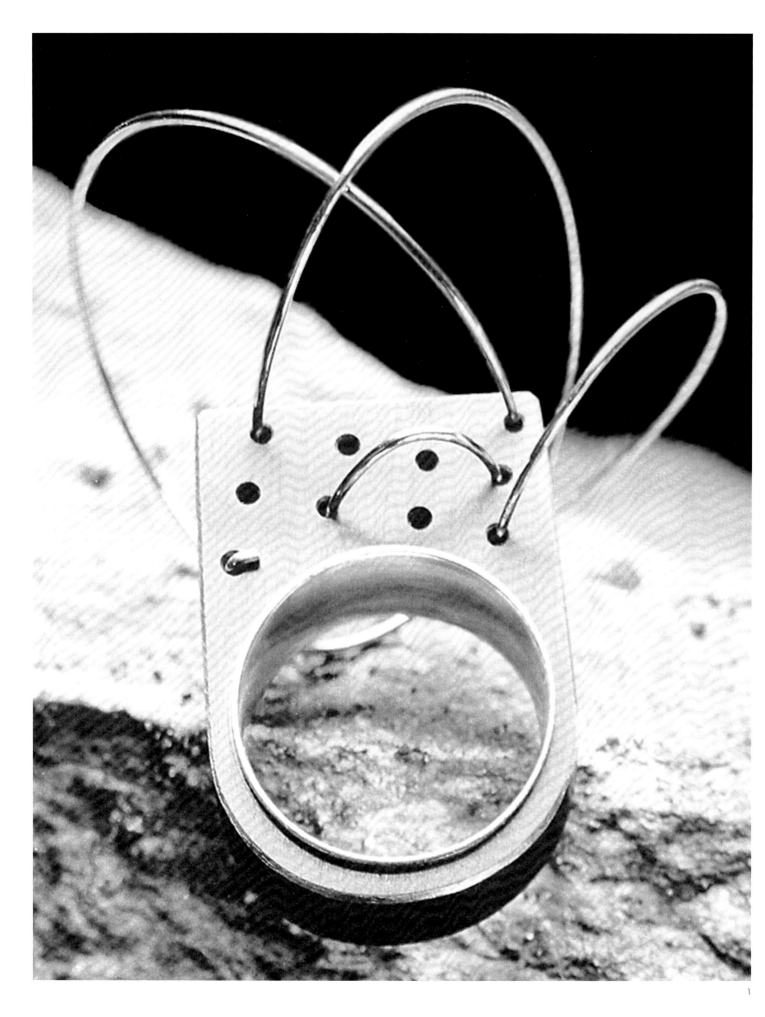

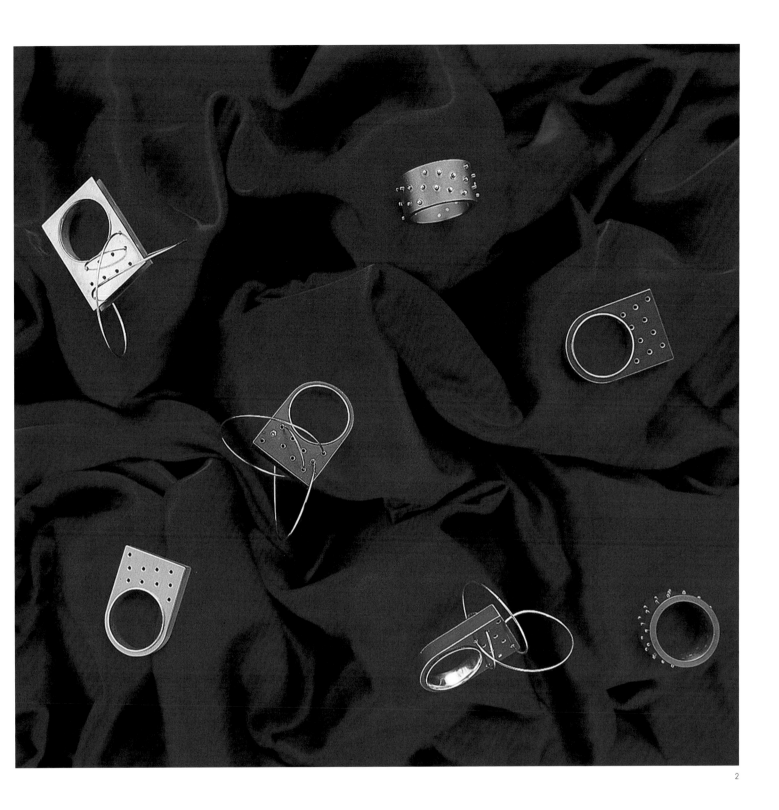

1. *Curly burly* **ring**
Silver and anodyzed titanium

2. *Knobbles, Horizon* **and**
Curly burly **rings**
Gold, silver, and anodyzed
titanium

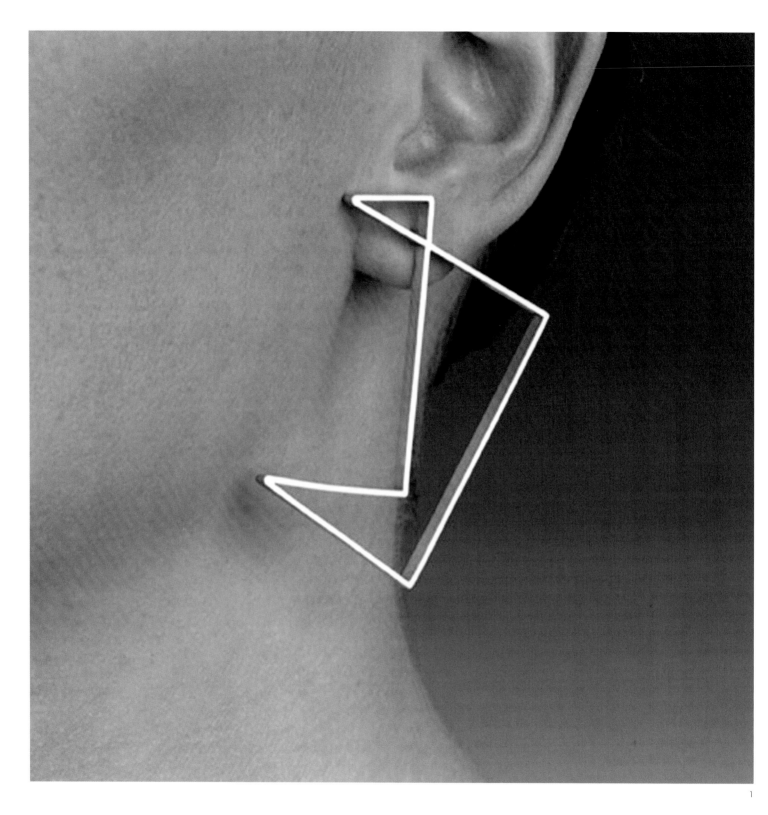

1. *Dancing square* earrings
14-karat gold

2. *Mass & illusion* necklace
14-karat gold

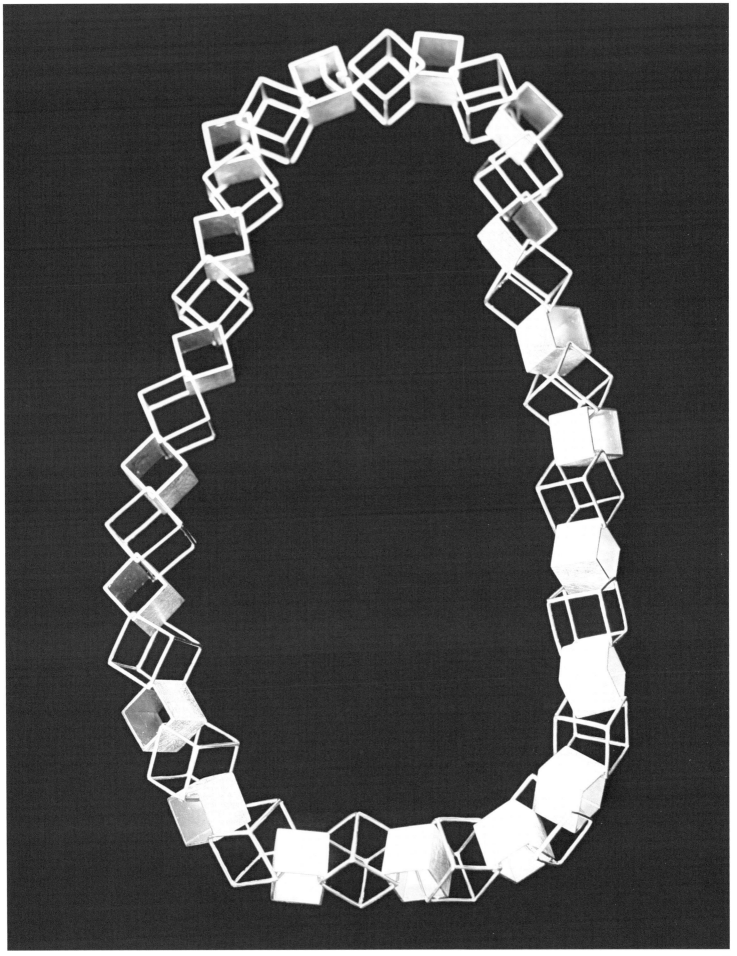

Marina Massone

www.marinamassone.com

Marina Massone was born in Buenos Aires, Argentina, in 1972. She graduated as an industrial designer from the School of Architecture, Design and Urban Development at the University of Buenos Aires. In 1994, she opened her own industrial design studio but since 2000 has concentrated solely on designing and producing contemporary jewelry. Her work has been included in numerous design exhibitions, museums, and galleries in Argentina and around the world. In addition to teaching courses in industrial design at her alma mater, she also teaches courses in conteporary jewlery at her studio. Massone's recent honors include a first prize at the 2010 National Competition for Contemporary Jewelry, held on the occasion of Argentina's bicentennial.

If your work involved music, what style of contemporary music would you classify it as?
Brit pop, and soul.

Describe your work space in three words.
Experimentation, transformation, and materialization of my ideas.

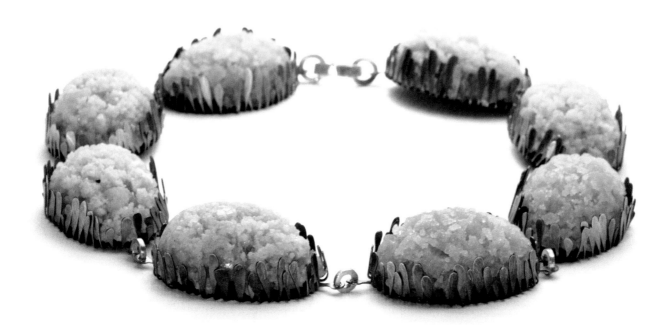

1

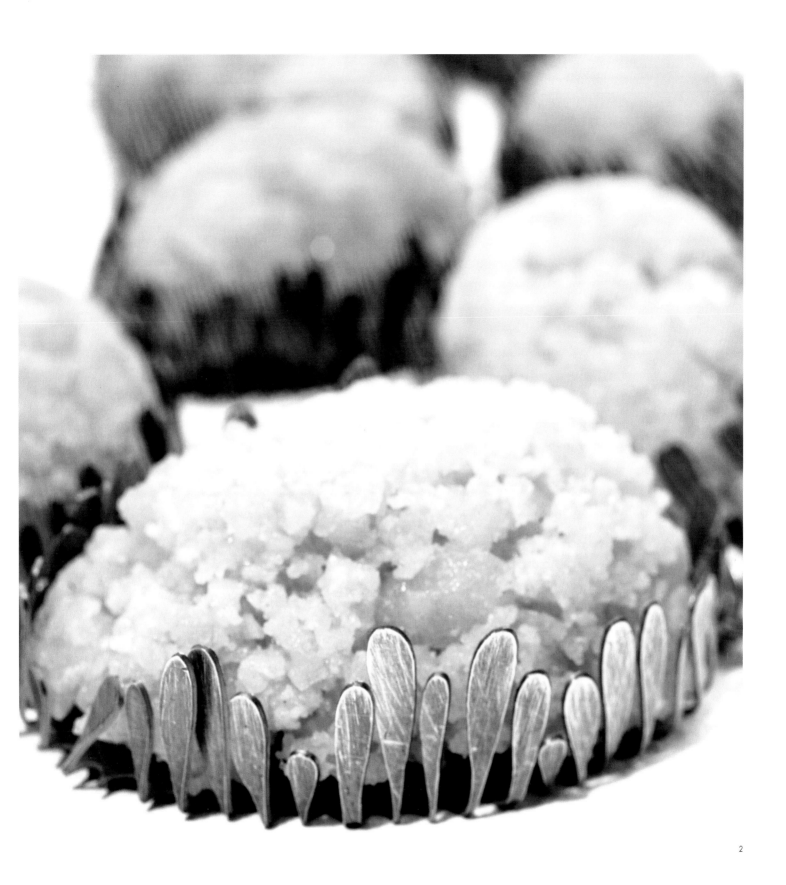

1-2. *Sand* necklace
Resin and silver

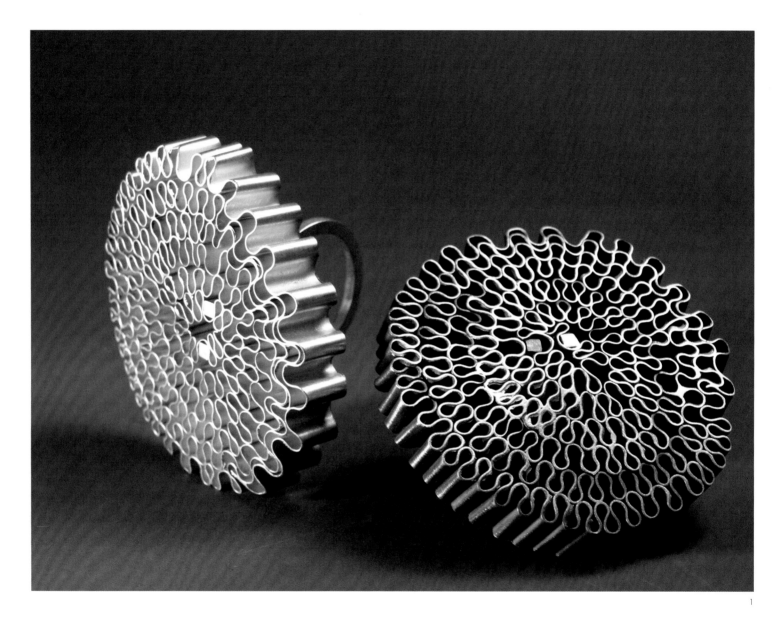

1

1. *Beehive* ring
Silver

2. *Beehive* brooch
Silver

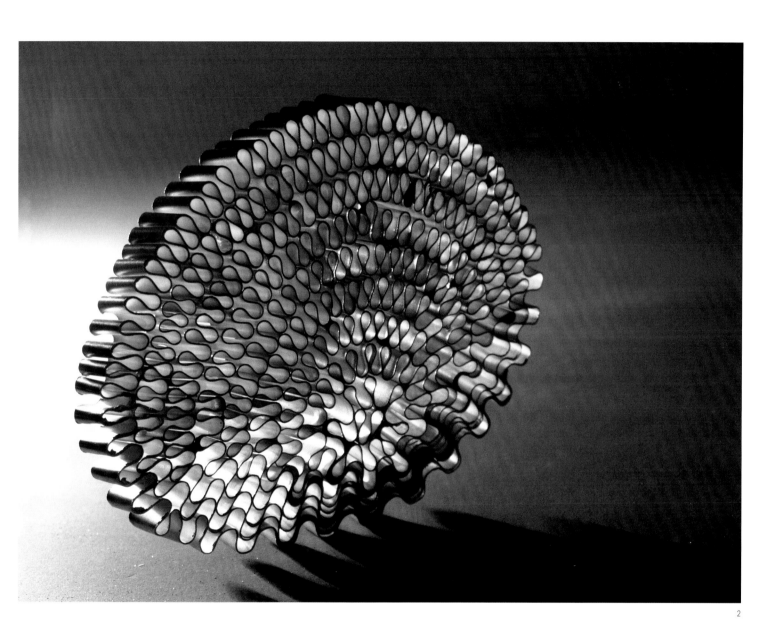

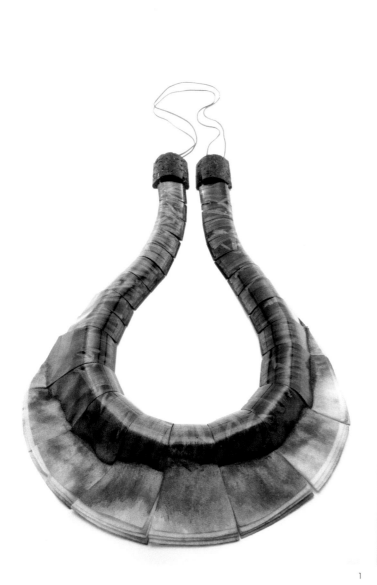

1

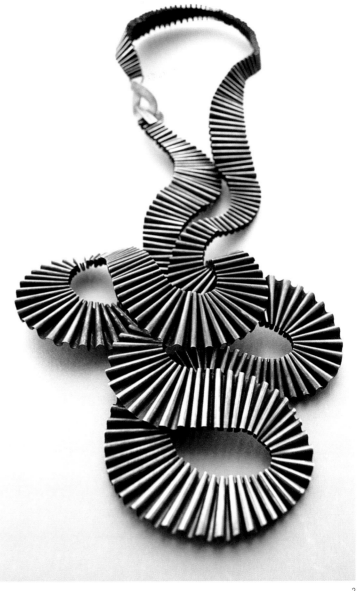

2

1. *Island* brooch
Resin, paper, and acrylic

2. *Beehive* necklace
Oxydized bronze

3. *Beehive* necklace
Bronze

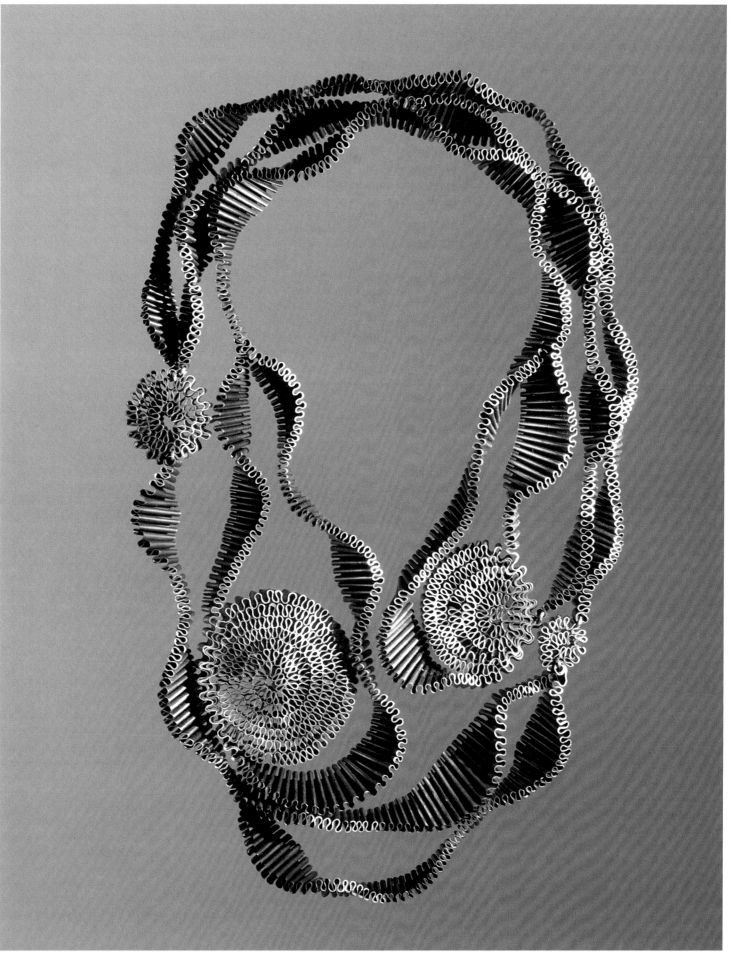

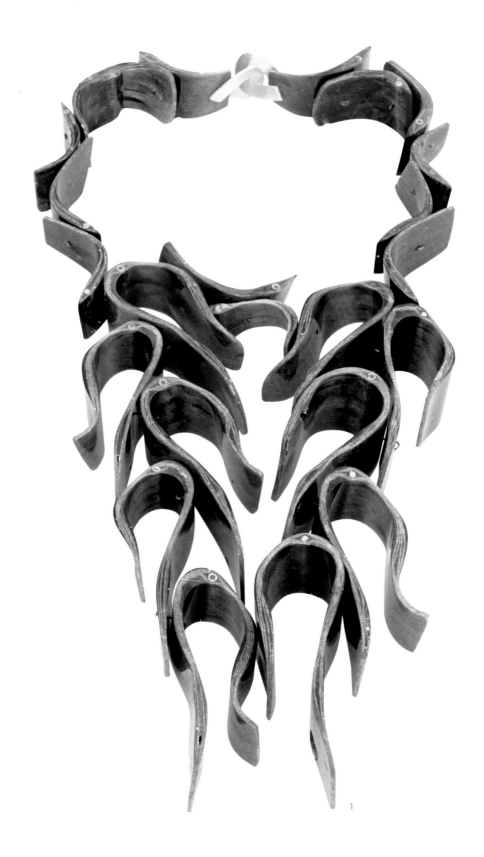

1. *Seaweed* necklace
Resin

2. *Garland* necklace
Bronze

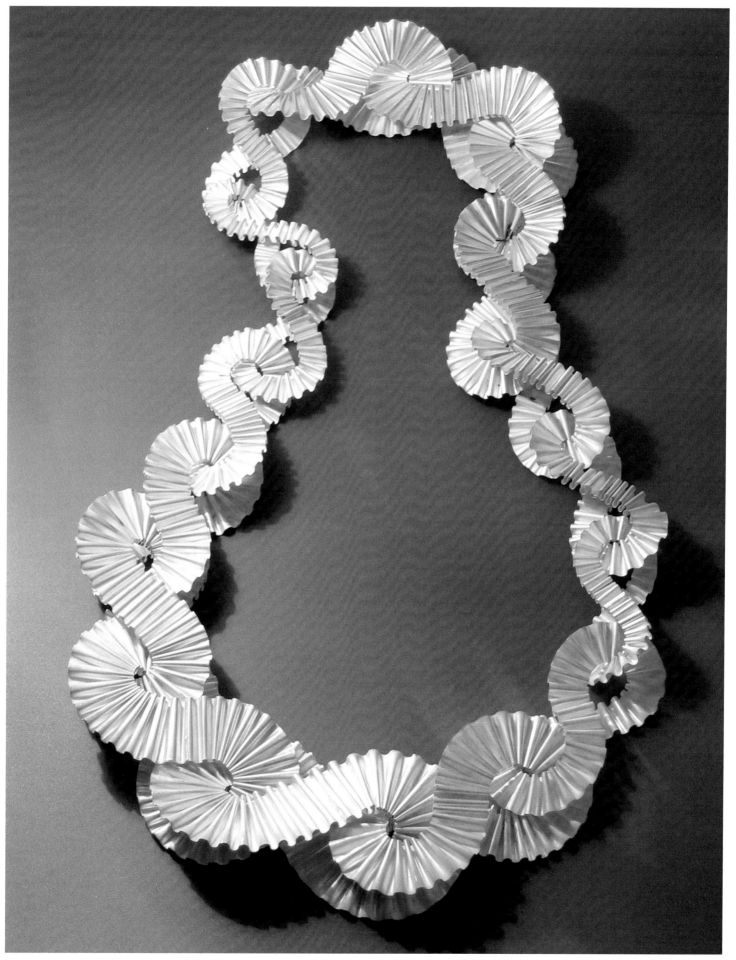

Marta Boan

www.martaboan.com

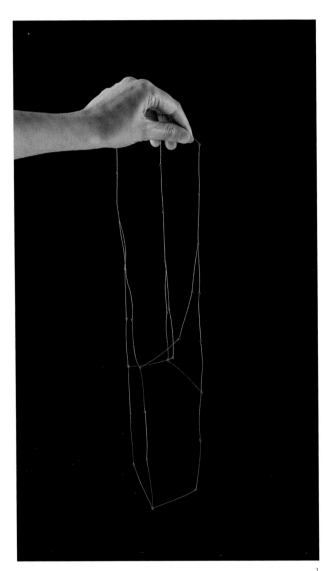

1

Marta Boan was born in Barcelona in 1976. In 2000, she recieved a degree in fine art, majoring in sculptural behavior at the University of Barcelona. While there, she won a scholarship to study sculpture at the New Academy of Fine Arts in Milan. Her postgraduate work includes a course in artistic jewelry at the Escola Massana and time studying artistic jewelry at the Estonian Academy of Arts. Marta has taken part in many solo and group exhibitions in Europe and Japan. She has been the recipient of a number of grants, including the Research and Creation grant awarded by the Catalan National Council of Culture and the Arts for her *Polimin* project, and a grant for artists traveling abroad from the Ramon Llull Institute in Barcelona. Her awards include the Enjoia't and the Bcn in 2007 and the Tallinn Applied Art Triennial Prize in 2009.

If you didn't specialize in jewelry, what would you be?
It has always been clear in my mind that I wanted to spend my time creating, and that is what I have done through various disciplines before discovering jewelry. Otherwise, I might have become a psychologist.

Describe your own workspace in three words.
Small, light, peaceful.

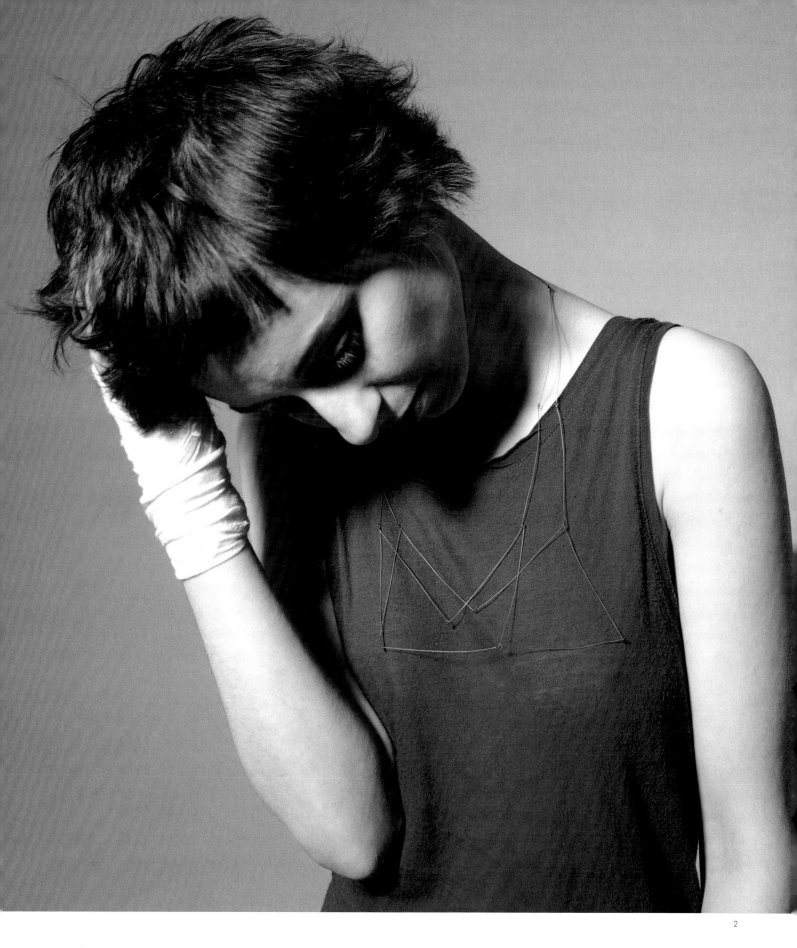

1. *Cub regular 1/3* necklace
Anodyzed titanium

2. *Cub regular 1/2* necklace
Anodyzed titanium

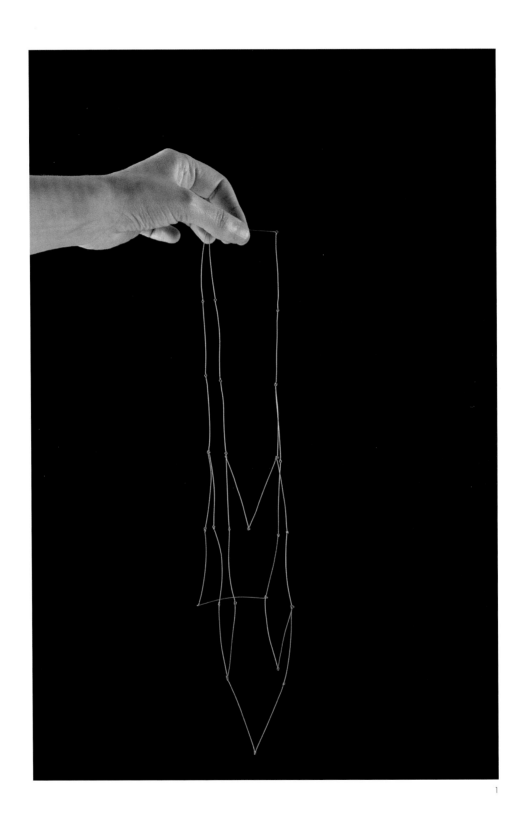

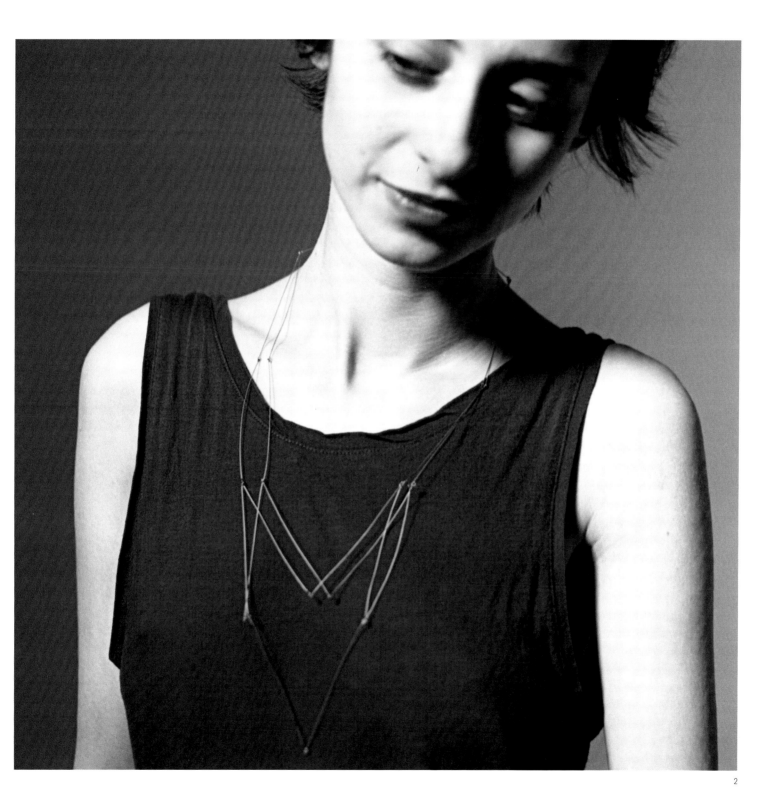

1-2. *Cub irregular 1/3* necklace
Anodyzed titanium

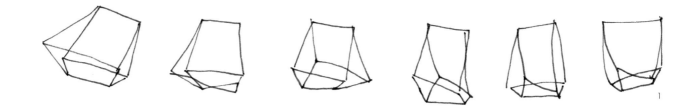

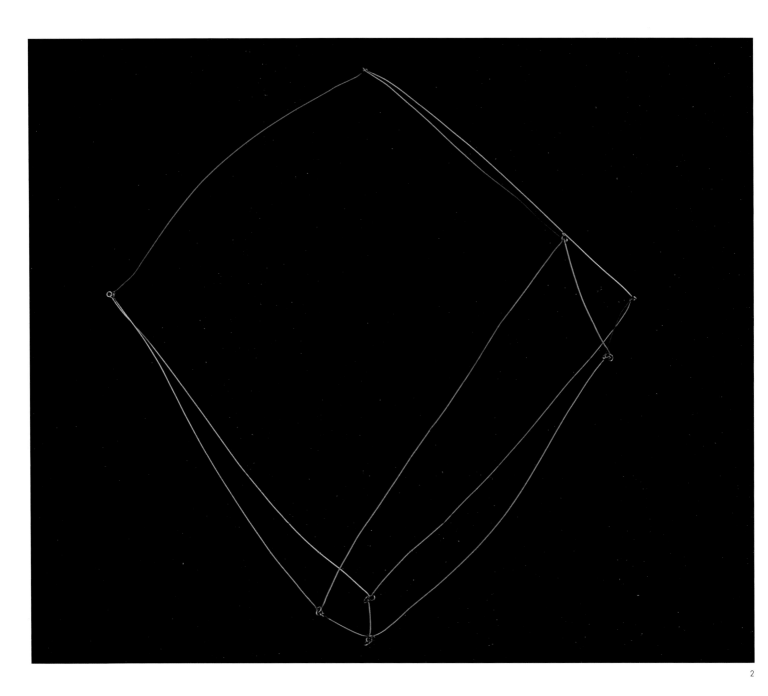

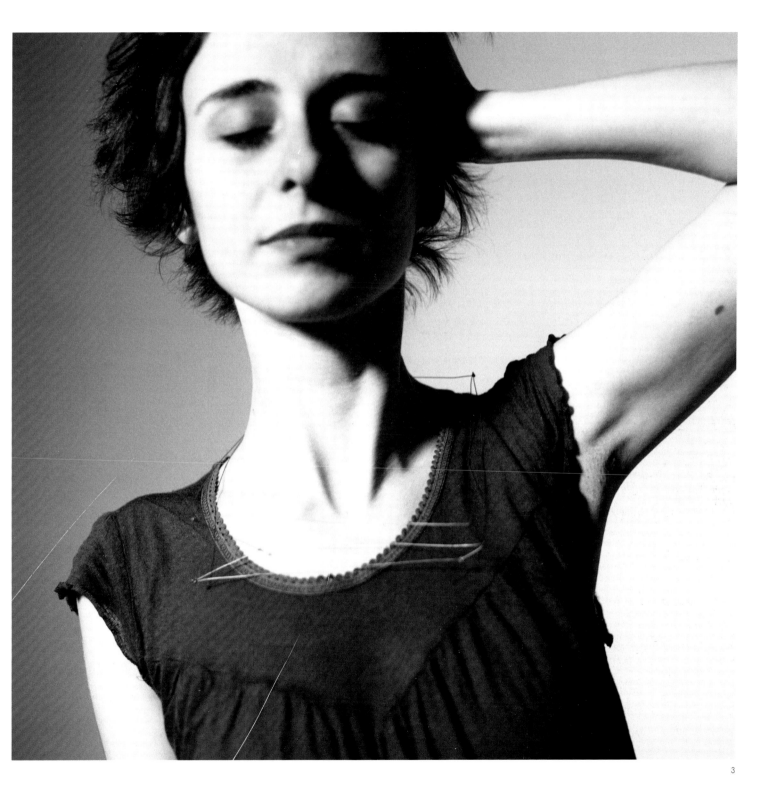

3

1. Sketchbook drawings

2-3. *Cub irregular 1* necklace
Anodyzed titanium

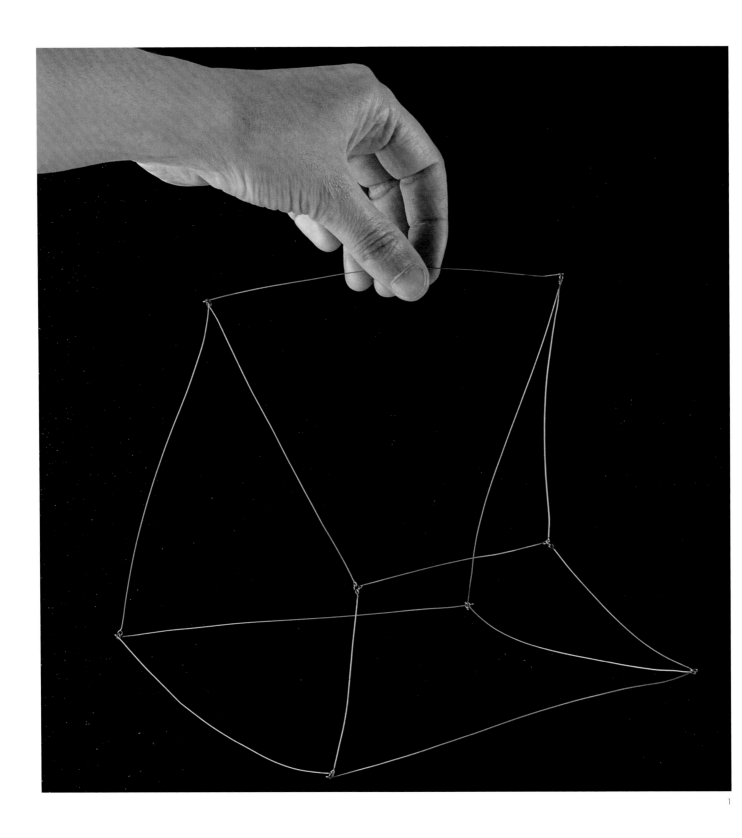

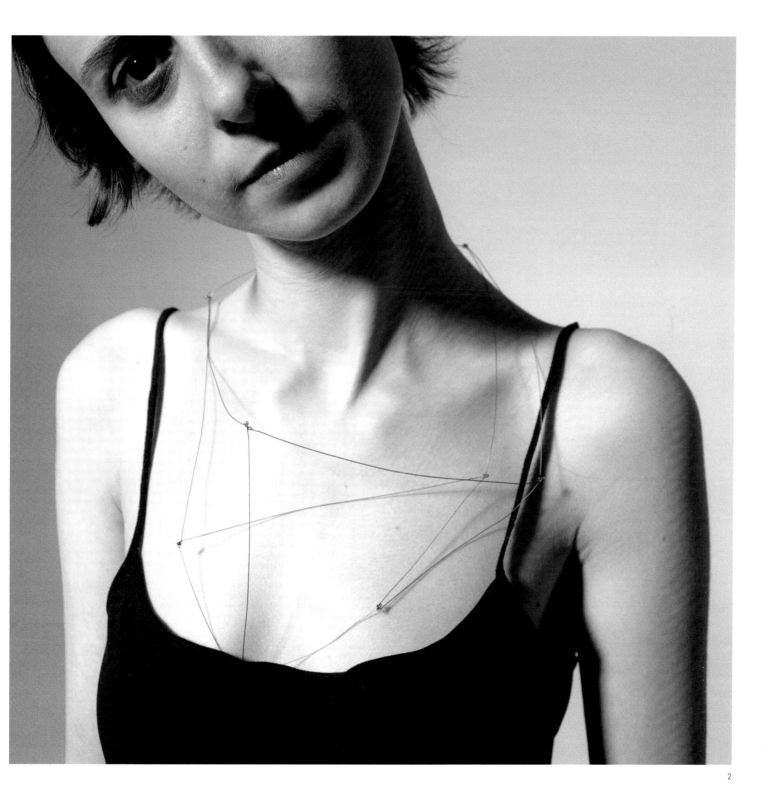

1-2. *Cub irregular 1*
necklace
Anodyzed titanium

Marina Molinelli

www.metalisteria.com.ar

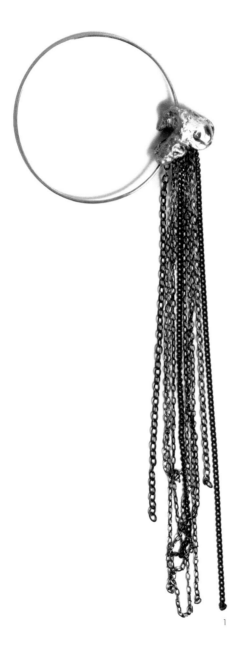

1

Marina Molinelli was born in Buenos Aires in 1972. She studied jewelry with the designer Jorge Castañón at his studio, La Nave, while studying for industrial design at the School of Architecture, Design and Urban Planning at the University of Buenos Aires. She graduated in 1999 and worked as a teacher until 2006. She is continually expanding her range of materials and techniques, experimenting with sepia, sand casting, enameling, and wax modeling. Molinelli has developed jewelry for various brands and designers, curated selections of jewelry, and has taken part in important workshops and key symposia, including *First Encounter between Europe and Latin America of Contemporary Jewelry*, organized by the Otro Diseño Foundation for Cultural Cooperation and Development in Mexico in 2010. Since 2004, she has partnered with Francisca Kweitel to coordinate Metalisteria, an online gallery for contemporary jewelry.

If you could work with only one material, what would it be?
Metal.

Describe your work space in three words.
Light, open, colorful.

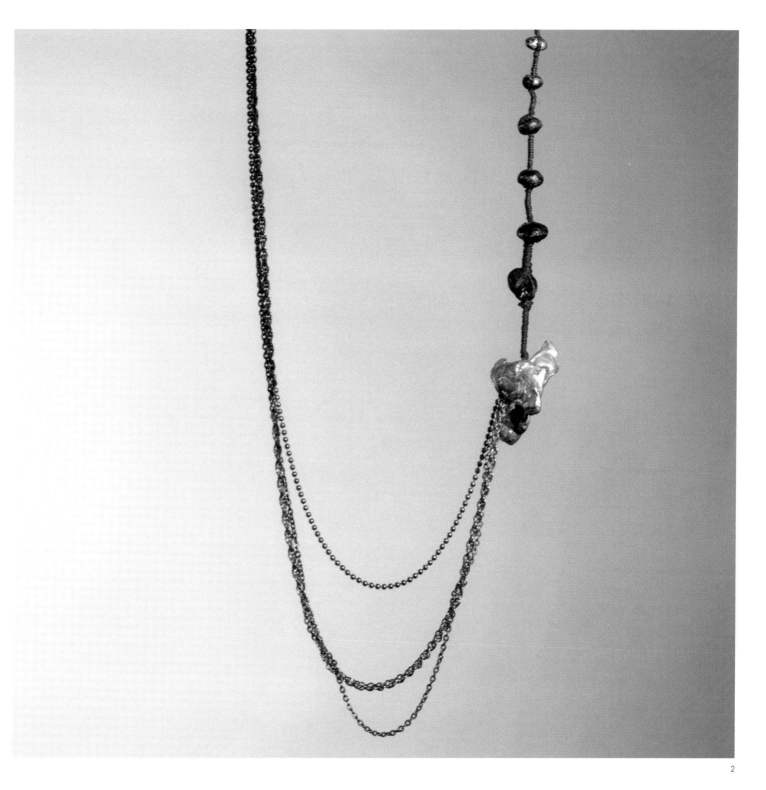

2

1. *Ciclos* brooch
Silver 900 and pure silver

2. *Transformación* necklace
Pure silver, silver chains, and
silk thread

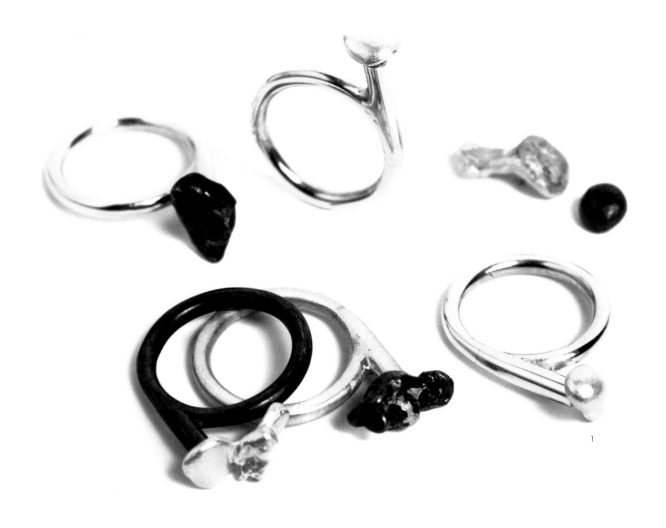

1. *Iguales/diferentes* rings
Silver with interchangeable
pieces that pops together

2. *Pura vida* necklace
Freshwater pearls, silver, and
silk thread

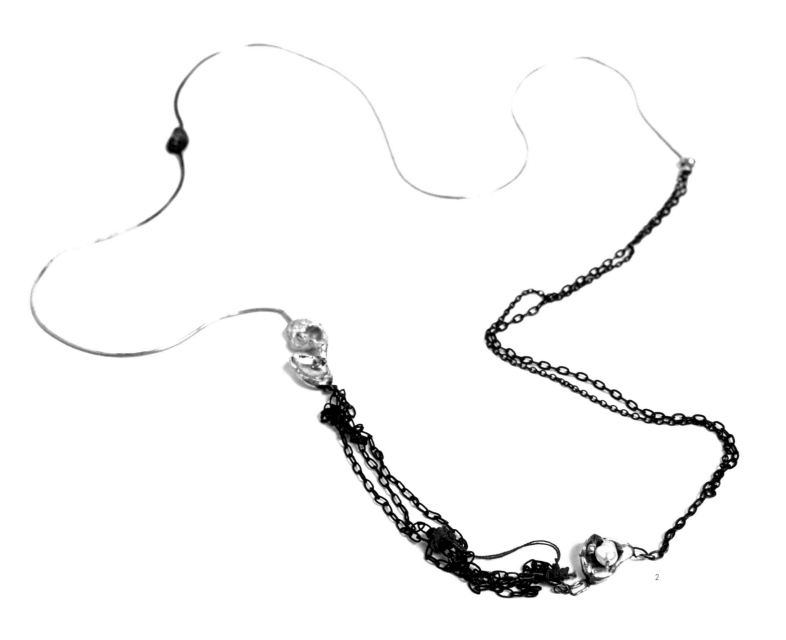

2

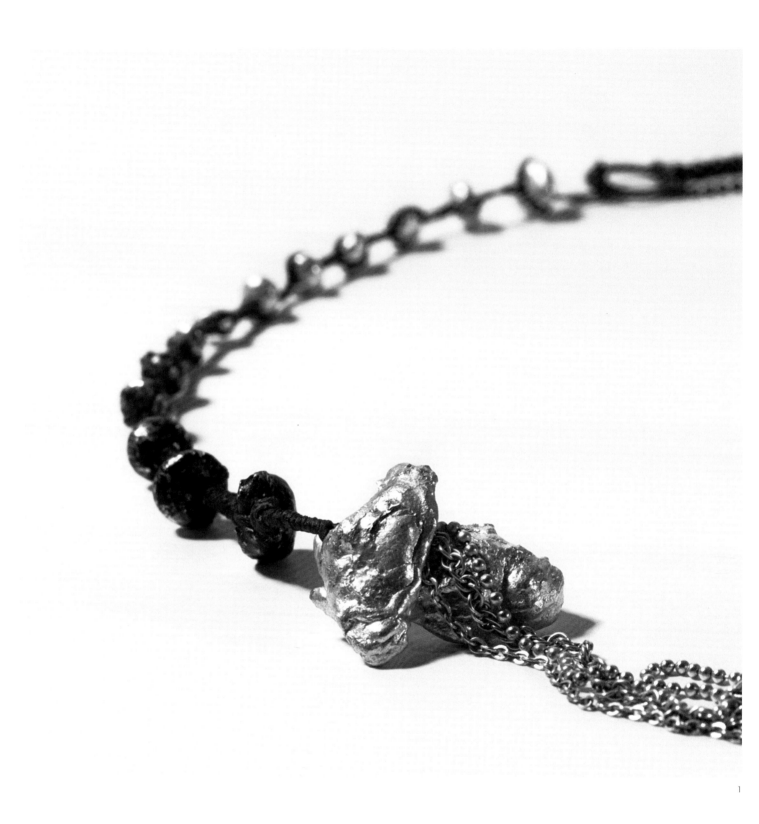

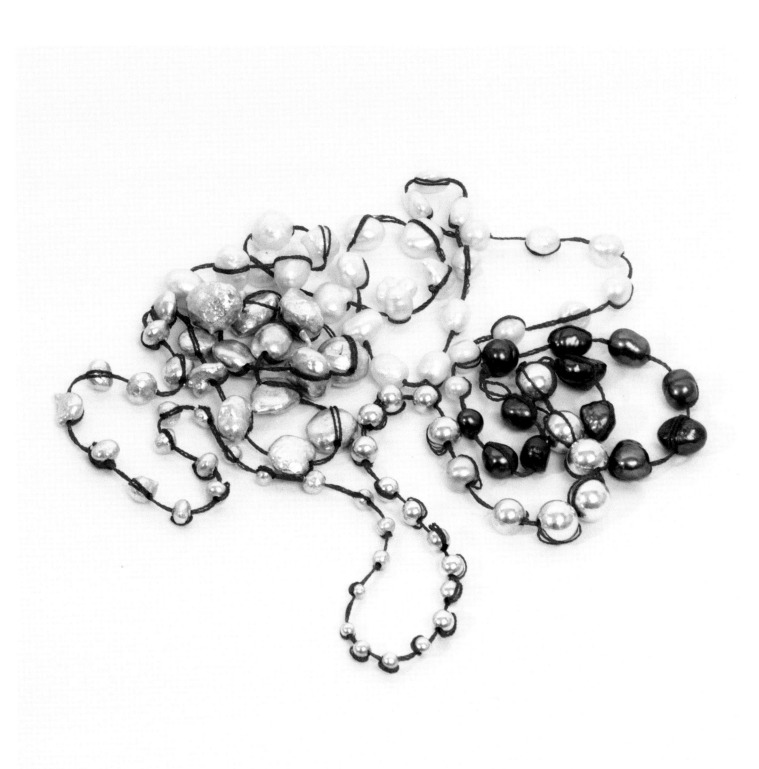

1. *Transformación* necklace

Pure silver, silver chains, and
silk thread

2. *Pura* necklace

Freshwater pearls, silver, and
silk thread

Mimi Scholer

www.mimischoler.com

Mimi Scholer was born in Stuttgart, Germany. She began her career by training as a silversmith in Neugablonz, before going on to study art at institute tk in Frankfurt. In 1997 she graduated in product design from institution tk in Vienna. She worked as an independent designer in New York, Buenos Aires, and Munich, where she spent two years designing fashion accessories for Escada. She then traveled to London and then to Barcelona, where she has lived since 2004. A year after arriving, she opened her shop in the city's historic center. Her pieces have their own logic, reflecting the perfection and imperfection found in the world, and an inspired proportion between colors and materials.

If you didn't specialize in jewelry, what would you be?
A writer.

If your work involved music, what style of contemporary music would you classify it as?
Bossa nova.

1

2

1. Earrings
Silk fringe and brass

2. Pendants
Glass ball, Swarovski stones,
and handpainted seahorse

3. Earrings
Sterling silver and Swarovski
stones

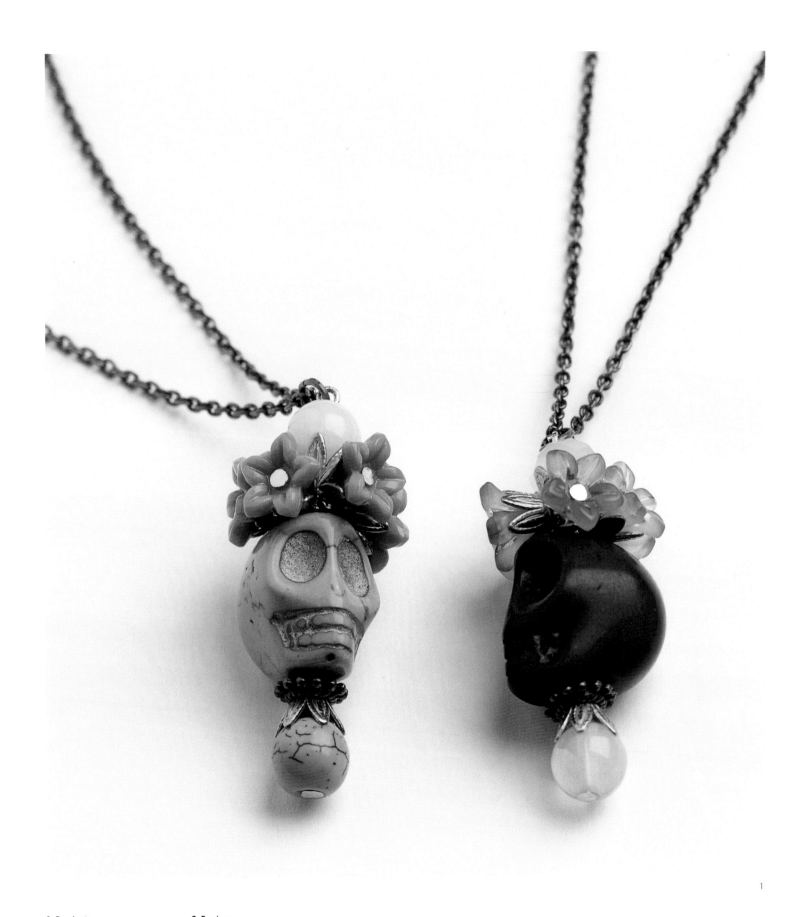

1. Pendants

Stone skull, resin, mineral
stones, and brass

2. Earrings

Brass, glass, mineral stones,
resin, and Swarovski pearls

1

1. Necklace
African feathers and brass

2. Necklace
Wood, glass, and resin

398

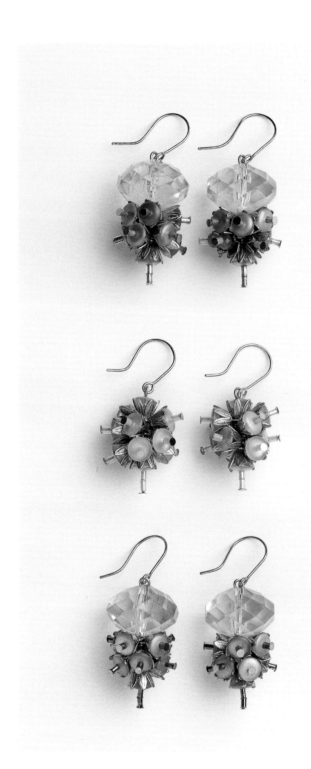

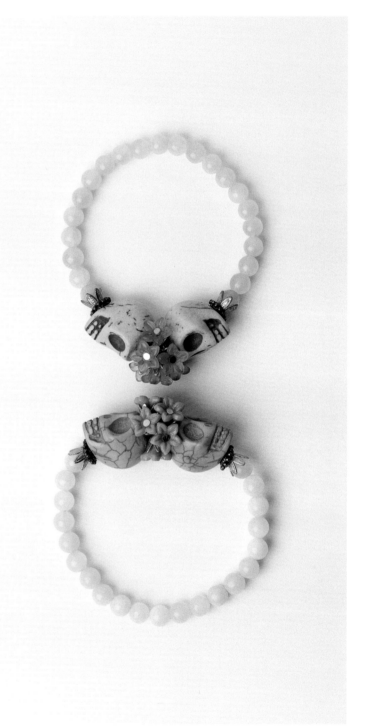

1

2

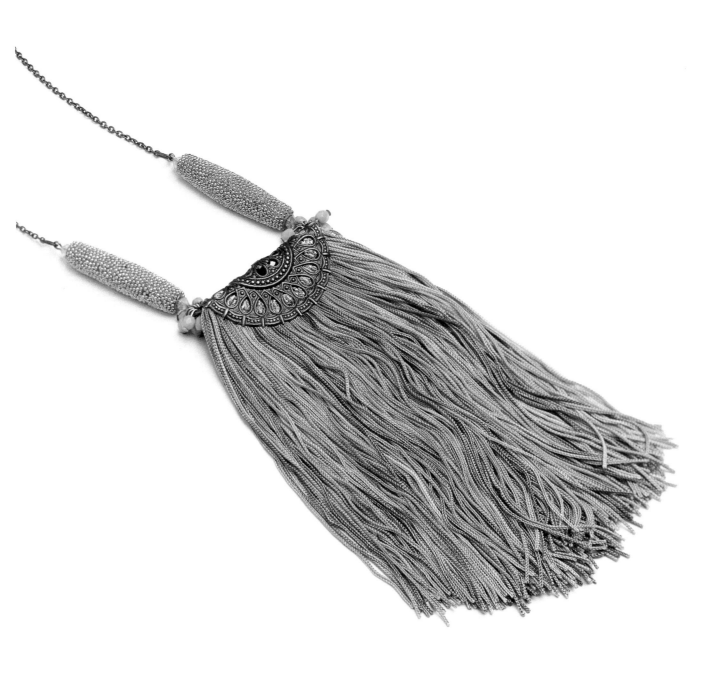

1. Earrings

Glass, resin, and brass

2. Bangles

Mineral stones, glass, resin, and brass

3. Pendant

Silk fringe, brass, and mineral stones

Molmaculan

www.molmaculan.com.br

1

2

Molmaculan Design was founded in 2002 by the architect Fernando Maculan and jewelry designer Adriano Mol with the goal of designing conceptual jewelry. Maculan trained in architecture and urban planning, and Mol majored in jewelry design at School of Architecture at the Federal University. Mol then went on to receive a master's degree in materials engineering, from Redemat (Thematic Network on Materials Engineering), Brazil. The Brazilian duo is known for the quality of their designs and their strong commitment to innovation. Their awards include first prize at the 2003 HRD Awards (Diamond Jewellery Competition) in Belgium, first prize at the 2006 International Jewellery Design Excellence Award in Japan (in the Innovation and Uniqueness in Design category), and third prize at the 13th Brazilian Gems and Precious Metals Institute Awards.

If you could work with only one material, what would it be?
Air.

If your work involved contemporary music, what style of music would it be?
We're a mix—the equivalent of hitting *shuffle* on your music player.

Describe your work space in three words.
A constantly changing space.

1-3. *DAF* Jacket
Jacket with fluor diamonds

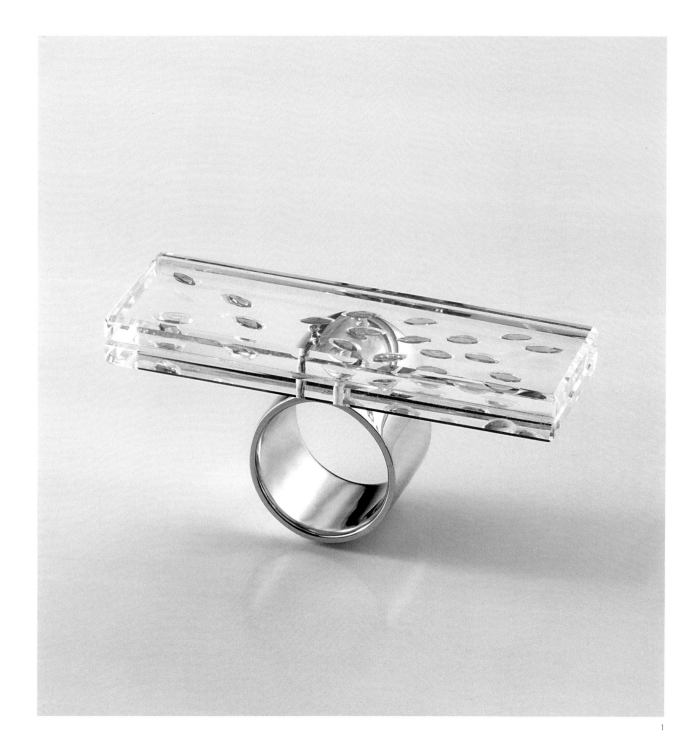

1. *Bonito* ring
Rock crystal, andalusite, and
18-karat white gold

2-3. *Cambury* ring
Aluminum and injected
polymer

2

3

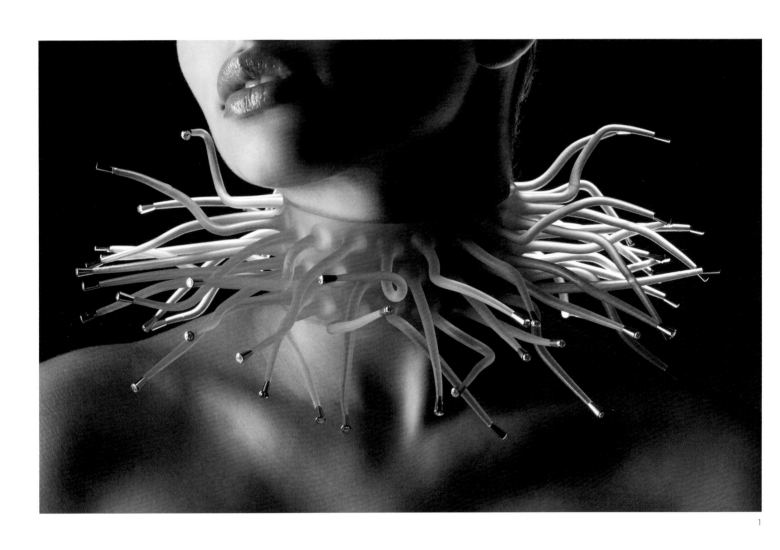

1

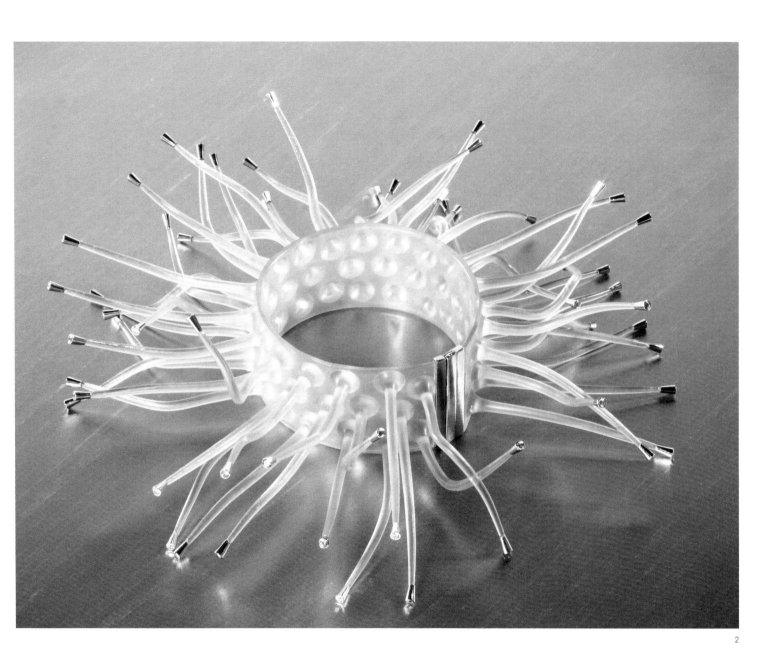

2

1-2. *Hidra* necklace
Polymers, 18-karat white
gold, and diamonds

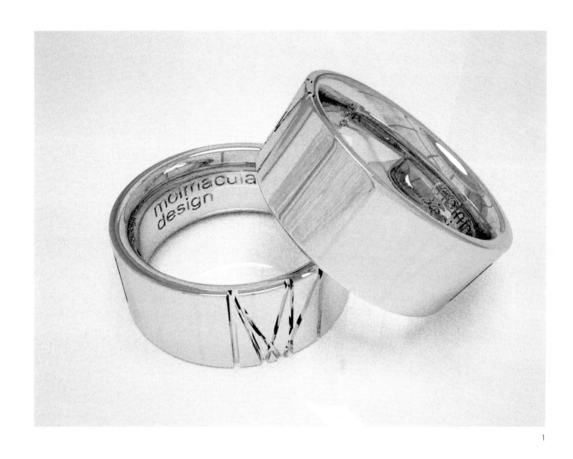

1

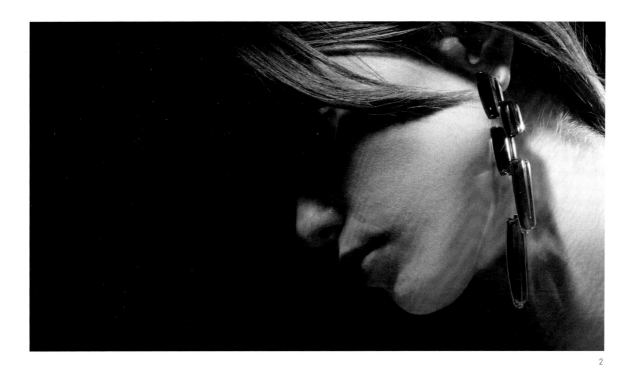

2

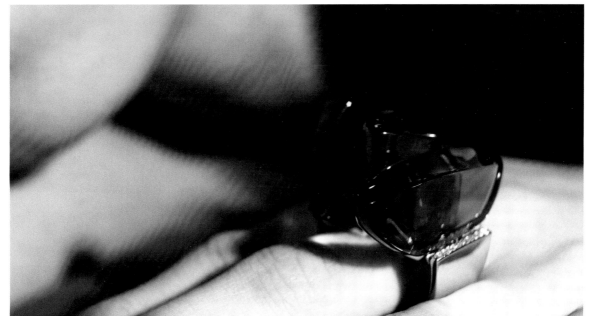

3

1. *Mech* collection
Aluminum

2-3. *Kemushi* and *Chou-
Chou* ring and earrings
Amethyst and 18-karat white
gold

Nancy Aillery

www.aillery.be

Belgian designer Nancy Aillery has been working in the jewelry sector for more than twenty-five years, since training in jewelry and metalwork design at St. Lucas Art College in Antwerp. Her work has garnered several major prizes, including the De Beers National Award in 1987, 1989, and 1991. She is a member of the board of the Belgian High Council of Jewelry and Watches and one of the founders of the Belgian Circle of Jewelry, Art, and Craft Design. Aillery has a keen artistic sensibility and draws her inspiration from humanity, architecture, and the beauty of nature that she finds in her everyday life. Her collections feature beautiful solitaire rings, characterized by their clean, modern lines reflecting the philosophy "*less is more.*"

If you didn't specialize in jewelry, what would you be?
I would be an interior decorator.

If your work involved contemporary music, what style of music would it be?
Easy listening or world music.

1

2

1. *Upside down* rings
Gold, amethyst, and onyx

2. *Piep* ring
Yellow gold

412

2

1. *Big Flintstone* ring
Gold and diamonds

2. *Daisy* ring
Gold and diamonds

1

2

3

1. *Samaria* ring
Yellow gold and diamond
solitaire

2. *Prison* ring
Yellow gold with smoky
quartz

3. *Elegance* ring
White gold and diamond
solitaire

Nane Adam

www.naneadam.de

1

Nane Adam was born in Weimar, Germany, in 1970. She studied jewelry design at the University of Applied Science in Heiligendamm, and took a postgraduate degree at the University of Wismar. Adam's career then quickly took off, and she was invited to participate in exhibitions both in Germany and abroad. In 2007, she opened her own studio workshop in Weimar. Her work is characterizied by bold experimentation with techniques and materials. Inspired by the spectacular bridges of Spanish architect Santiago Calatrava, for example, she produced a system of flexible rings, combining metals with nylon to create different tensions inside the ring and allowing the ring to accomodate many finger sizes. She also uses mokumegane, a Japanese technique dating from the late sixteenth century, which consists of building up several layers of different metals, such as silver, gold, or copper, to create an organic, wood-like effect.

If you didn't specialize in jewelry, what would you be?
I would be an archaeologist.

If your work involved contemporary music, what style would it be?
I identify my work with jazz.

1-2. *Flexible* ring
Silver and nylon

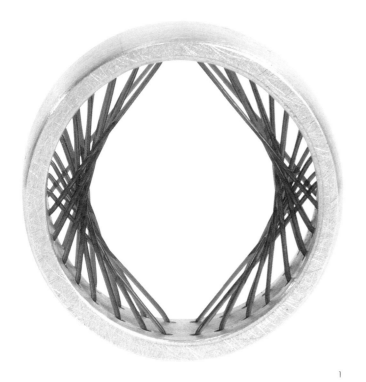

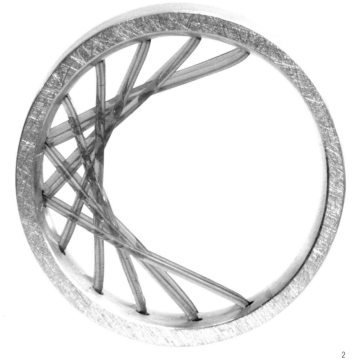

1

2

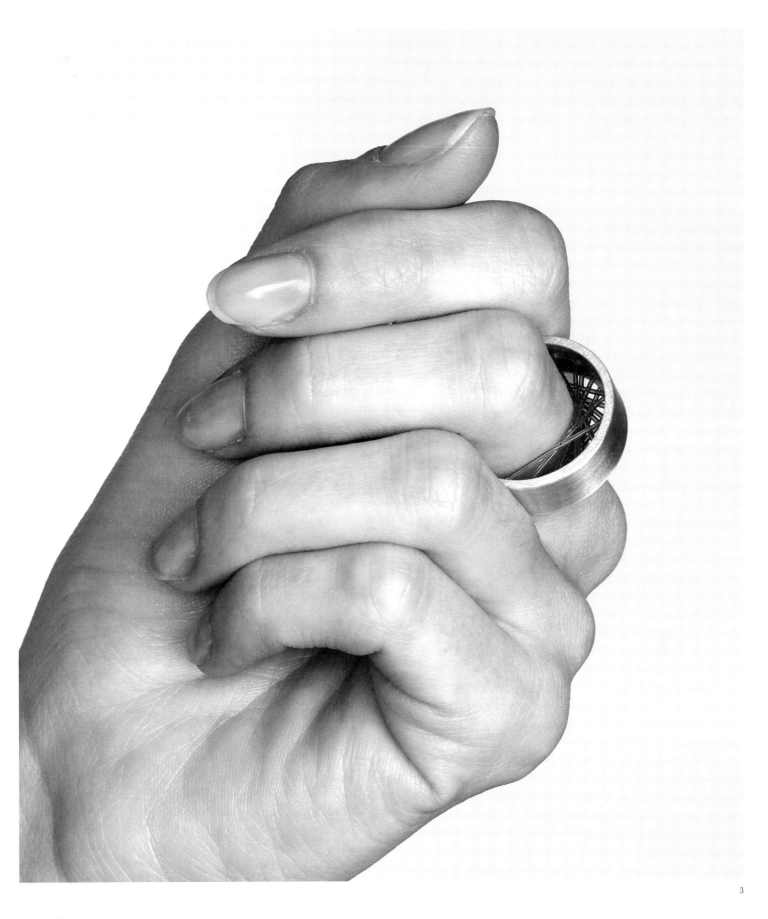

1-3. *Flexible* ring
Silver and nylon

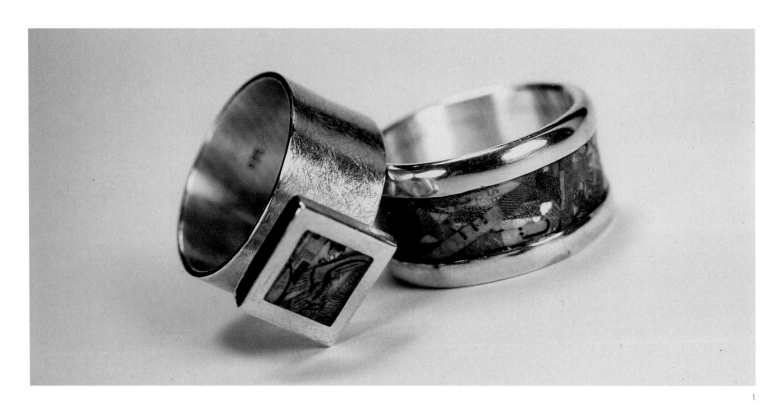

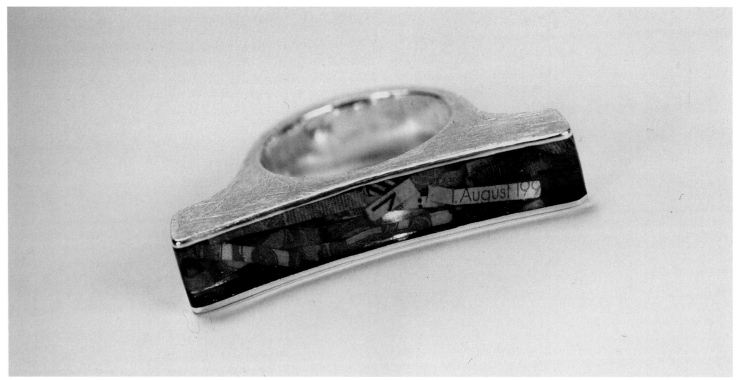

1-2. *Money* rings

Silver and collage of tickets

3. *Flexible* earrings

Silver and nylon

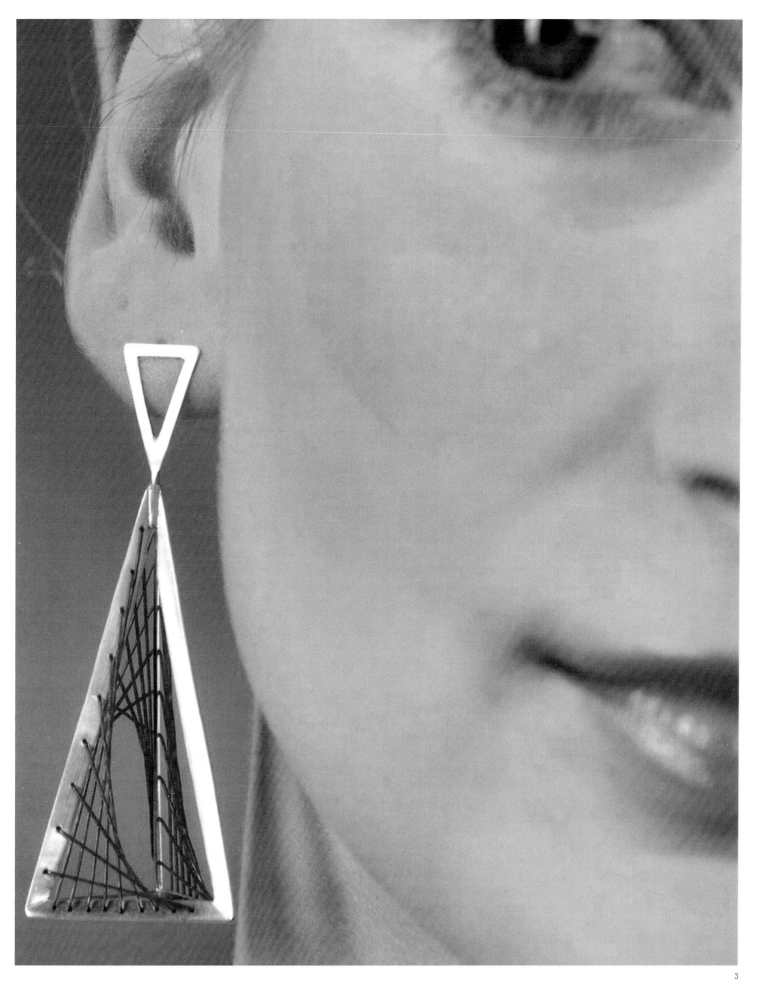

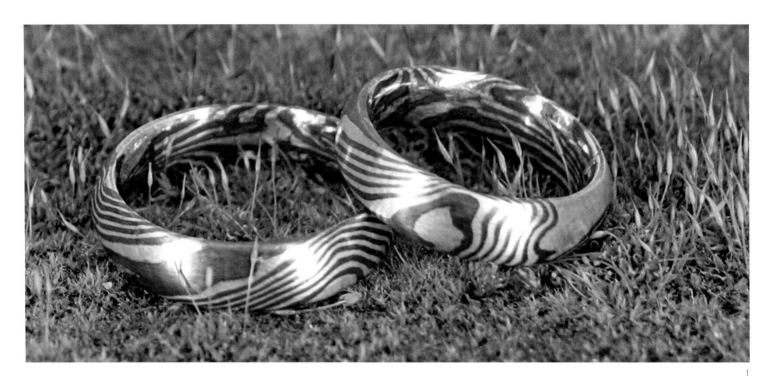

1

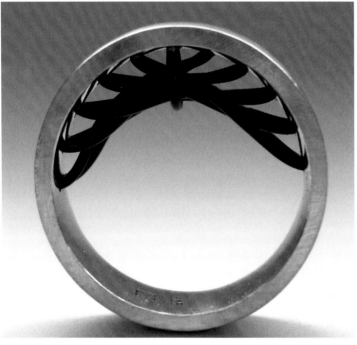

2

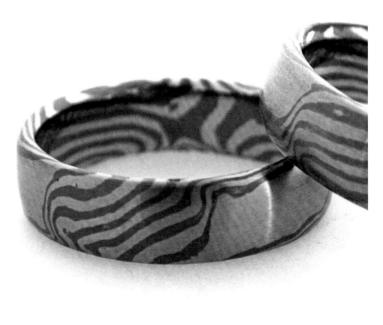

3

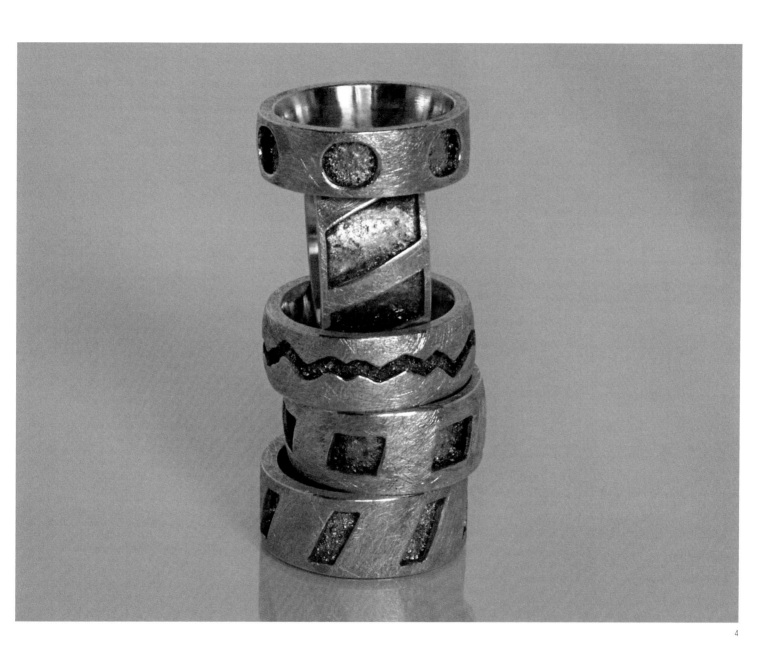

4

1. *Mokume-gane* ring
Silver and red gold

2. *Flexible* ring
Gold and nylon

3. *Mokume-gane* ring
Silver and palladium

4. *Golden* ring
Silver and goldleaf

Natalia Saldías

www.nataliasaldias.com

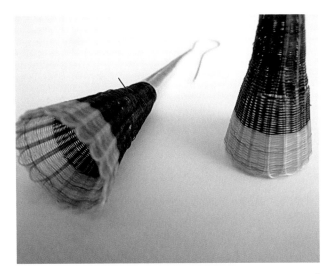

1

Chilean designer Natalia Saldías graduated with a degree in design from the University of Valparaíso in Chile, and has an advanced technical degree in arts with a specialization in artistic jewelry from the Valencia School of Art and College of Design in Spain. Saldías's interest in ornamentation began at an early age; she is continually experimenting with new techniques and materials to create unique pieces that carry her personal hallmark. She has been included in jewelry exhibitions and fairs throughout Spain. Her project *Difusión de la cultura Rapa Nui a través de la técnica del mosaico* ("dissemination of the Rapa Nui culture using the mosaic technique") won the first prize from Chile's National Fund for Regional Development.

If your work involved contemporary music, what style of music would it be?
Bossa nova.

Describe your work space in three words.
My imaginary workshop.

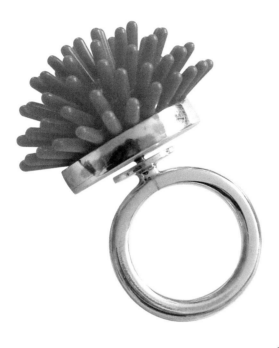

2

3

1. *Mi sombra* earrings
Silver and horsehair

2-3. *Textures* ring
Silver, felt, beads, and found
object

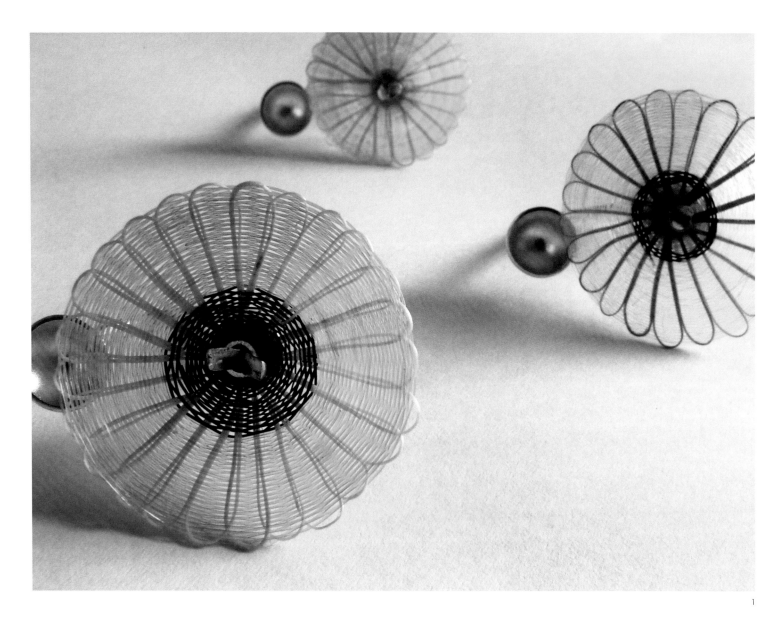

1. *Primavera* ring
Silver and horsehair

2. *Circus–contorsionist* rings
Silver and rubber

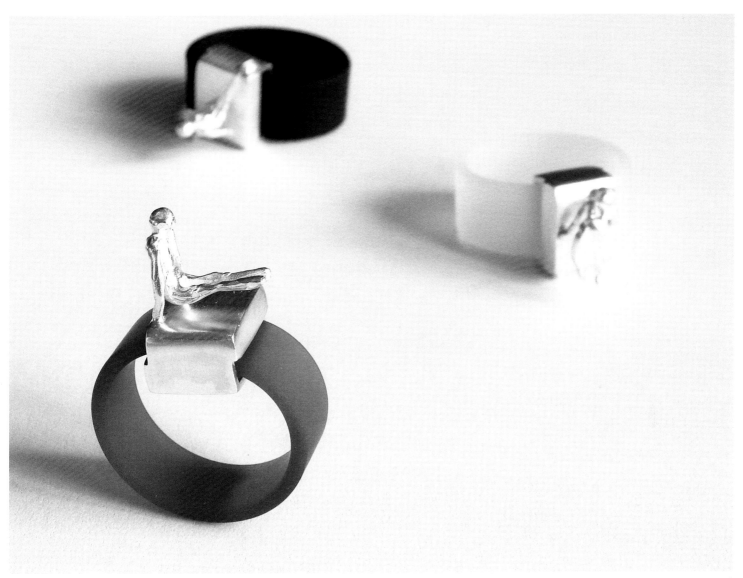

2

427

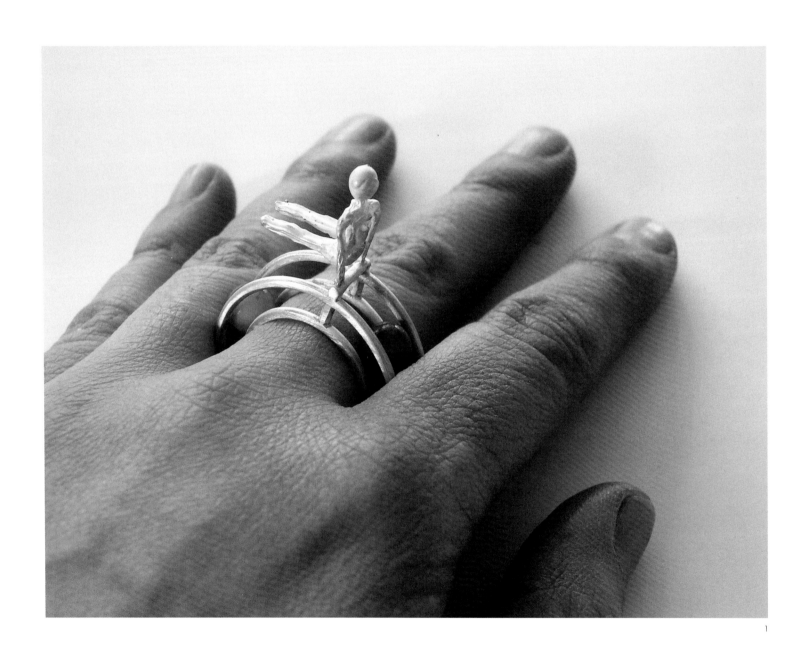

1

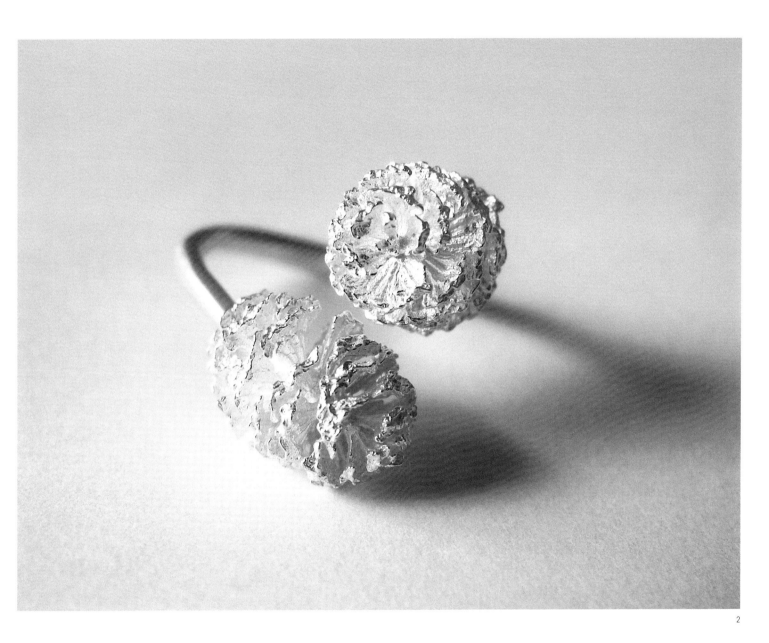

1. *Circus* ring
Silver and polymers

2. *Natura* ring
Silver

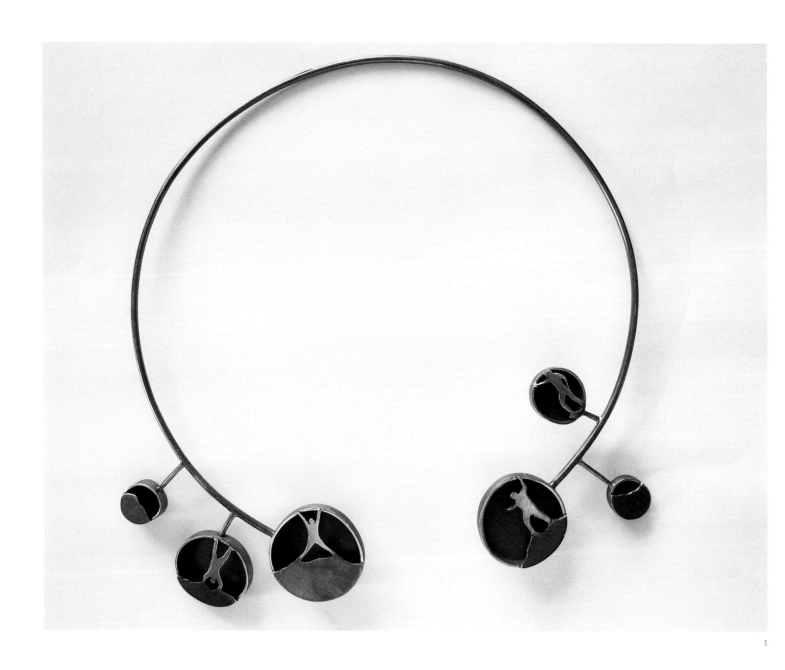

1

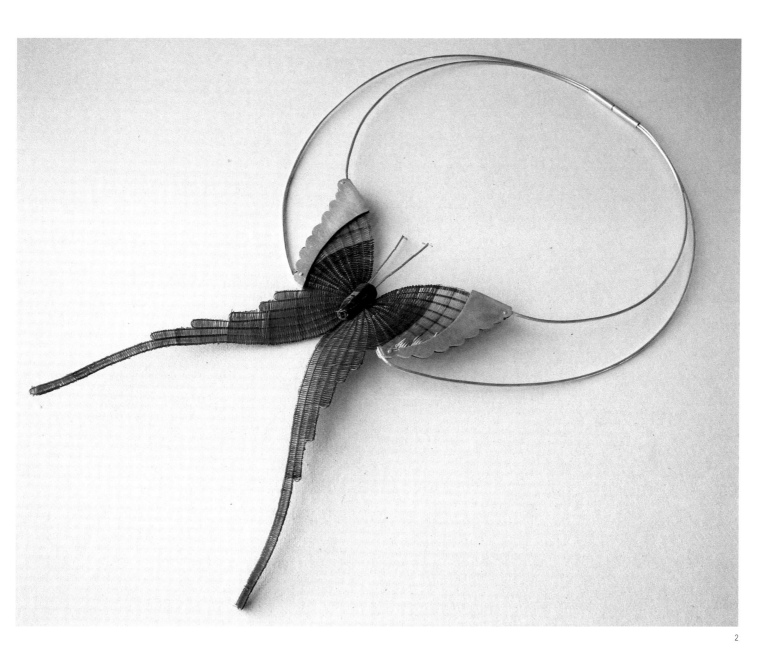

1. *Aventuras* ring
Oxidized silver and enamel

2. *Vuelo* necklace
Silver and horsehair

Nicolás Estrada

www.amarillojoyas.com

Colombian artist Nicolás Estrada was born in Medellín in 1972, and currently lives and works in Barcelona. He studied artistic jewelry at the Escola Massana, where he learned a wide range of techniques, including wax modeling, traditional Berber jewelry, and traditional Colombian filigree. Estrada's deep-rooted and meaningful work combines a subtle irony with a deep sense of reflection. His many awards and nominations include first prize at the 2003 Midora fair in Denmark, finalist for the 2003 Swarovski Award in Spain, and nominee in 2007 for the Netherland's New Traditional Jewelry Award. Estrada's pieces have been shown at galleries throughout Europe and the Americas.

If your work involved contemporary music, what style of music would it be?
Heavy metal.

Describe your work space in three words.
Peaceful, light, and tidy

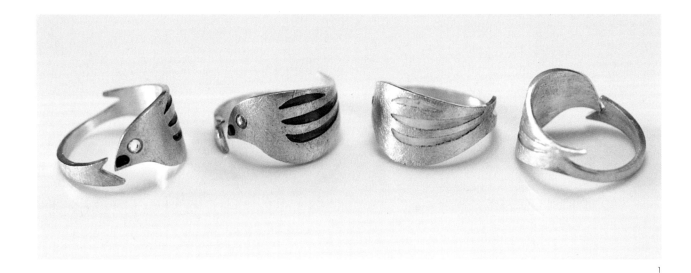

1

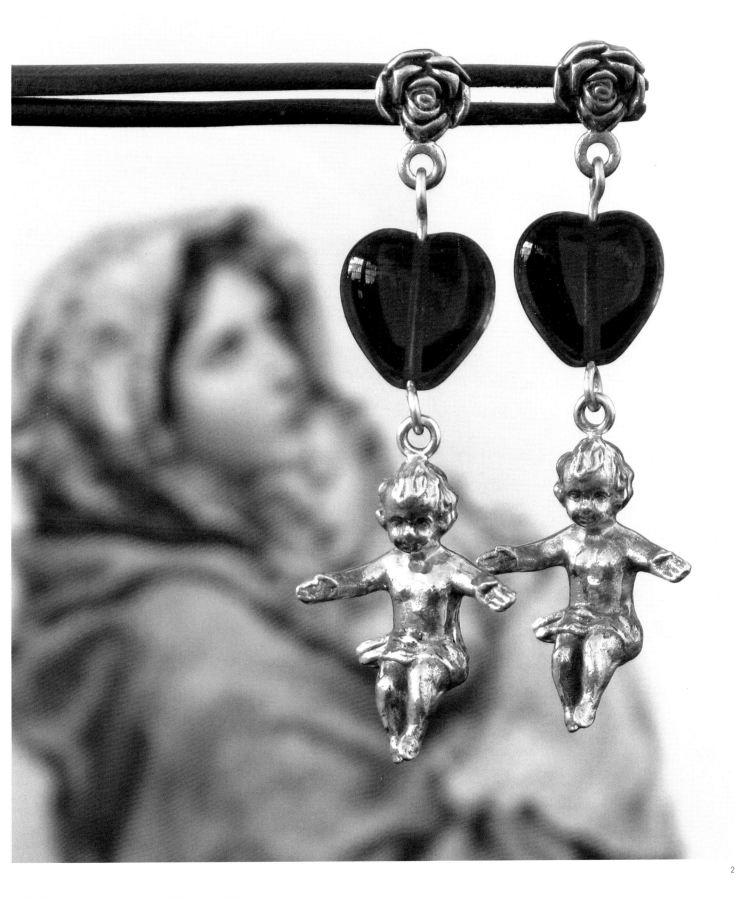

1. *Pajarito* rings

Silver, enamel, and glass

2. *Niño Jesús* earrings

Silver and glass

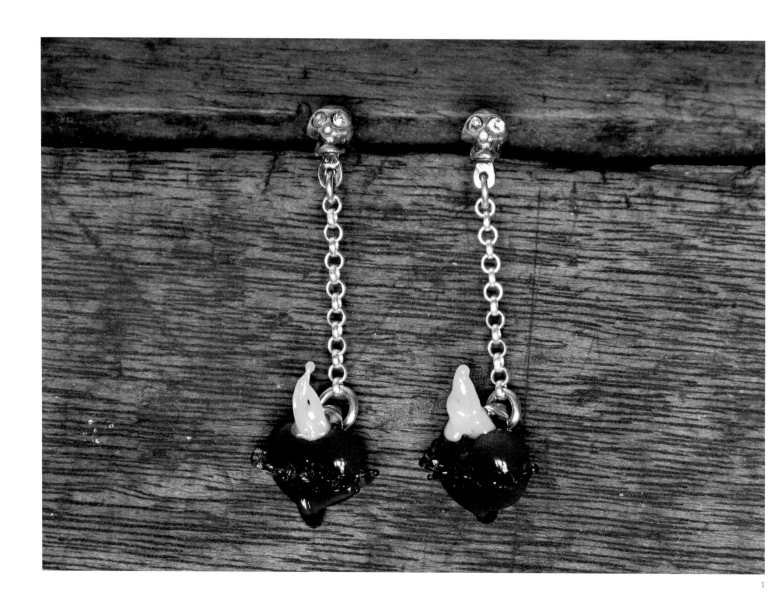

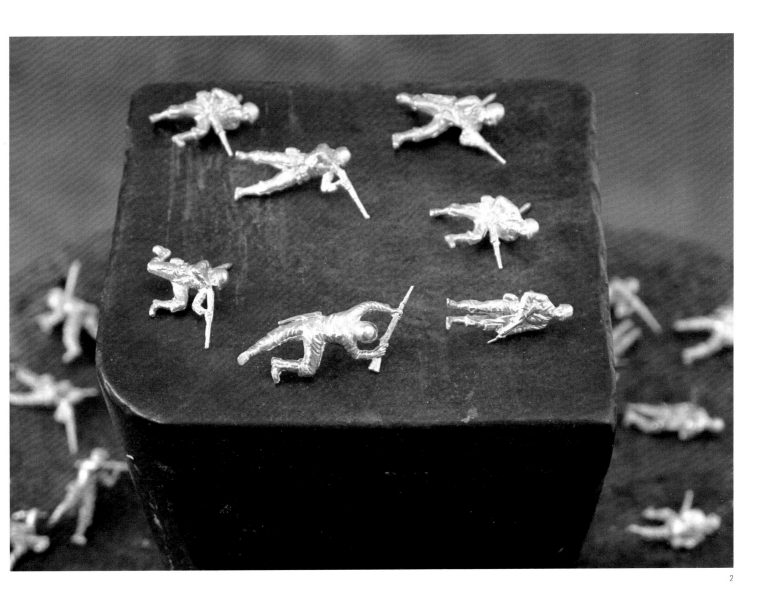

1. *Calaveritas + corazones* earrings
Silver and glass

2. *Soldados* pin
Silver

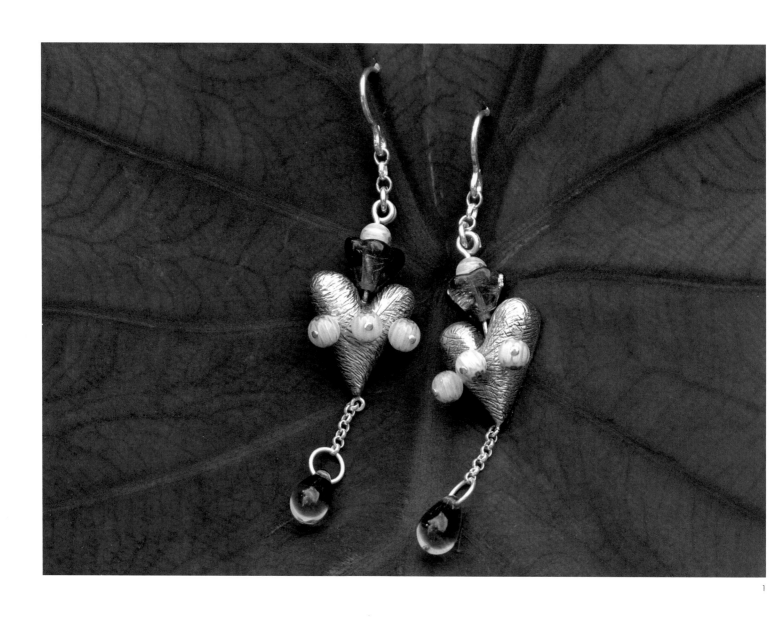

1

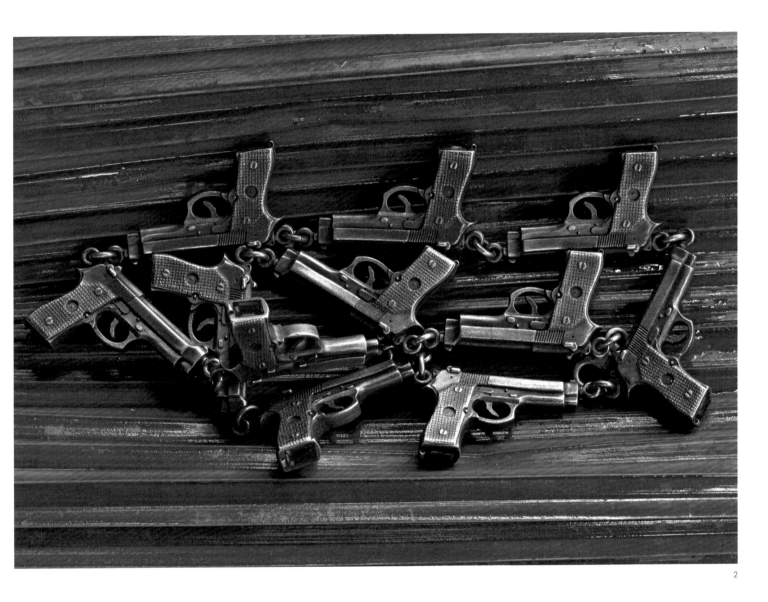

1. *Corazones* earrings
Silver, amethyst, and glass

2. *Manos sucias* necklace
Silver and glass

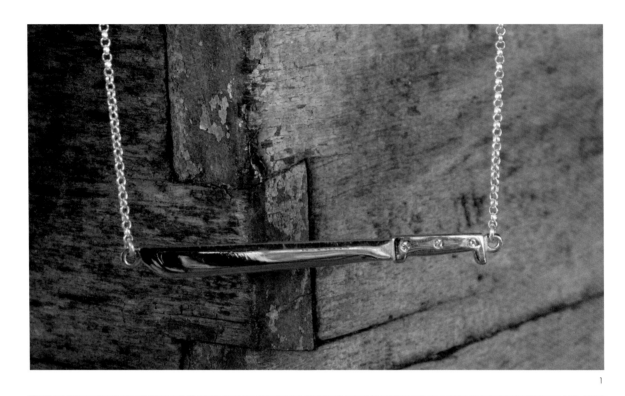

1

2

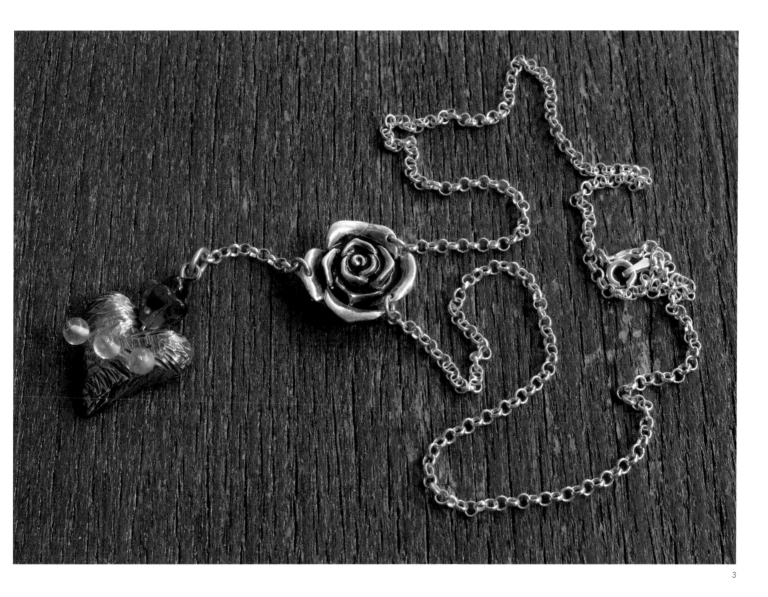

3

1. *Machete* necklace
Silver, gold-plated silver, and
glass

2. *Divorcio* ring
22-karat yellow gold and
18-karat yellow gold

3. *Corazón + rosa* necklace
Silver, opal, onyx, glass, and
enamel

Ortiz-Gadler

www.ortiz-gadler.com

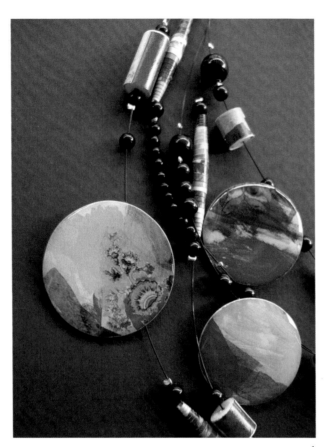

1

Ortiz-Gadler emerged in Siena in 2004 as a jewelry workshop and gallery when Ethel Ortiz and Dolores Gadler decided to fuse their passion for art and handmade crafts. The main element in their creations is recycled paper, which is painted, decorated, and hand-dyed after being mixed with other materials like resin and pigments. This process gives their pieces a contemporary, urban look.

If you could work with only one material, what would it be?
We would surely go for paper. We love this material because it is poor and perishable. Besides, paper can be seen in two ways: it conveys great delicacy, but it also conceals an element of real firmness, determination, and character. It is also extremely versatile.

Describe your workspace in three words.
The workplace must be inviting, stimulating, and experimental. Our workshop provides a space for reflection and is full of things that inspire us and hold special memories that have been with us for years. It is a refuge where we can give rein to our creativity and experiment at will.

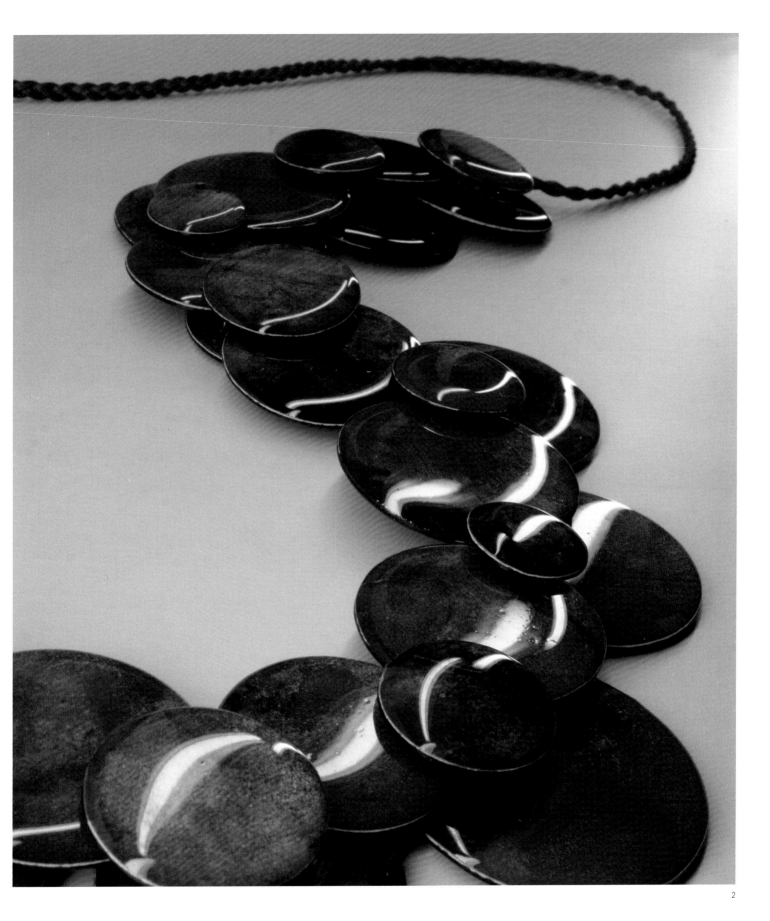

1. *Lola* necklace
Glass, paper beads, and resin

2. *Layers* necklace
Handpainted paper, silk
thread, resin, and pigments

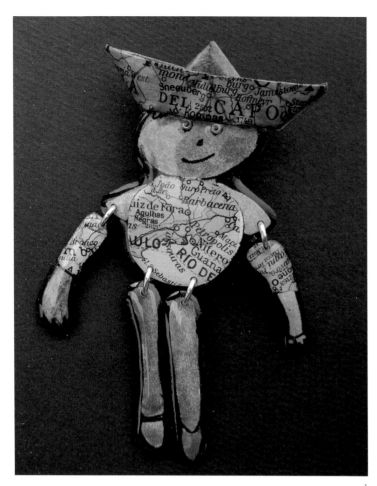

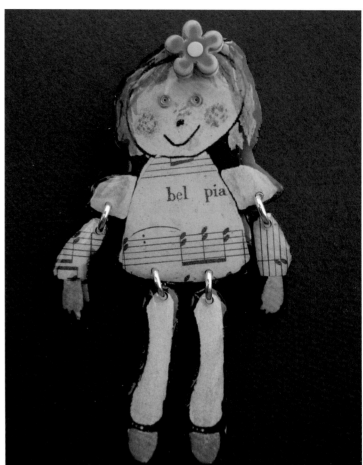

1-3. *Bambi* broochs
Handpainted enamelled
paper, wood, silver, and
others

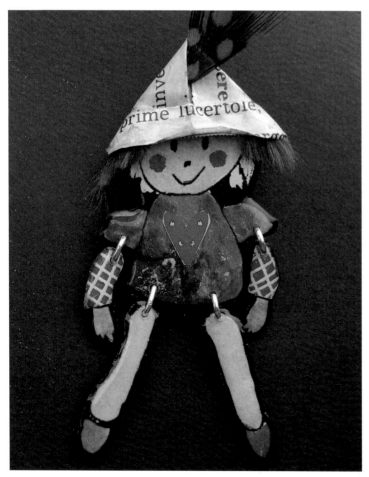

1

2

3

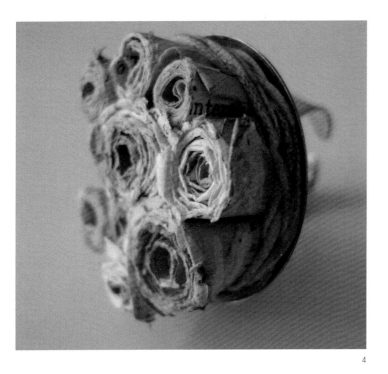

4

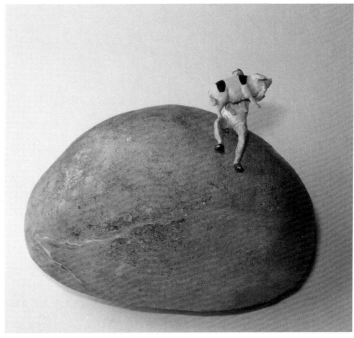

5

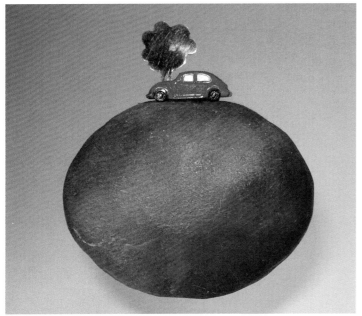

6

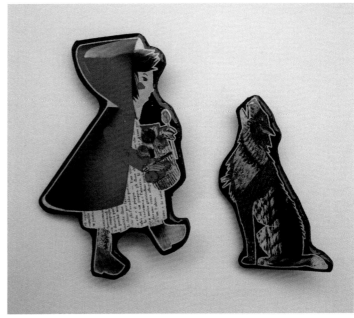

7

4. *Charta* ring
Paper, silver, and linen cord

5-6. *Stone* broochs
Handpainted papier maché, silver, Swarovski crystals, and plastic

7. *C'era una volta-Little Red Riding Hood* brooch
Wood, silver, and resin

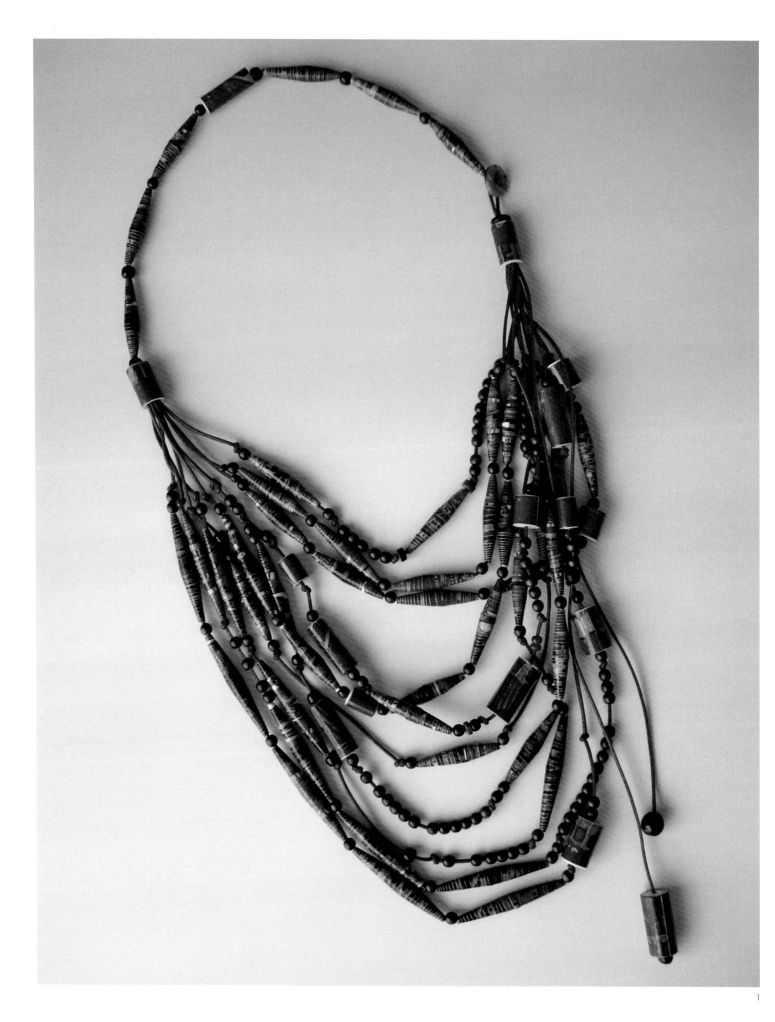

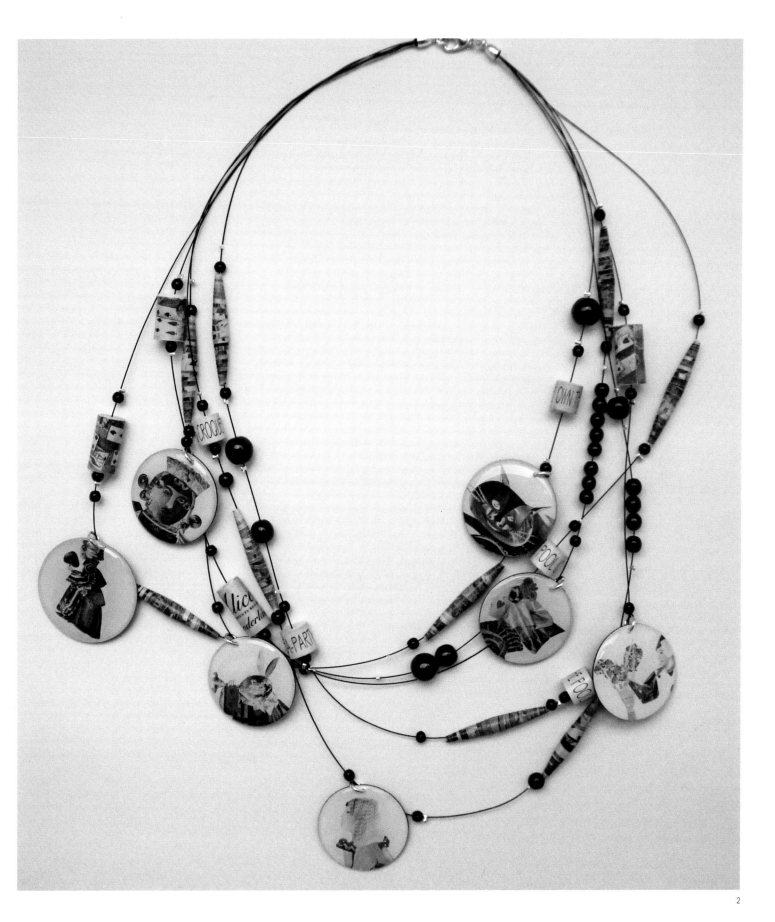

1. *Amazzonia* necklace
Paper beads, glass beads, silver, nylon, and stainless steel

2. *C'era una volta* necklace
Newsprint, wood, silver, Swarovski crystals, and resin

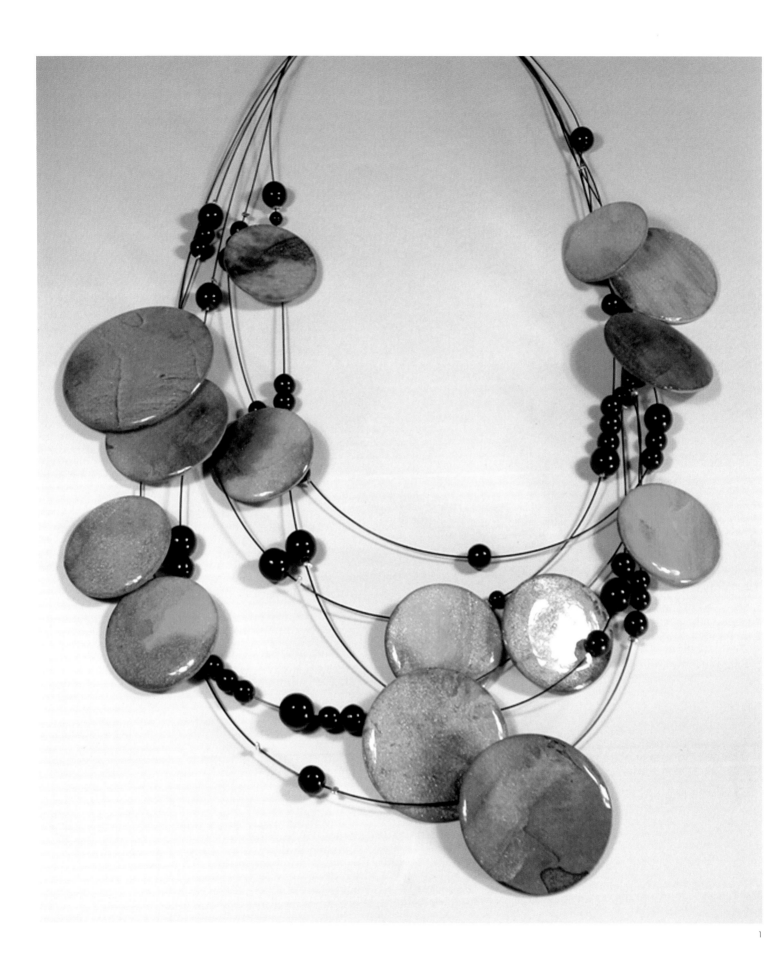

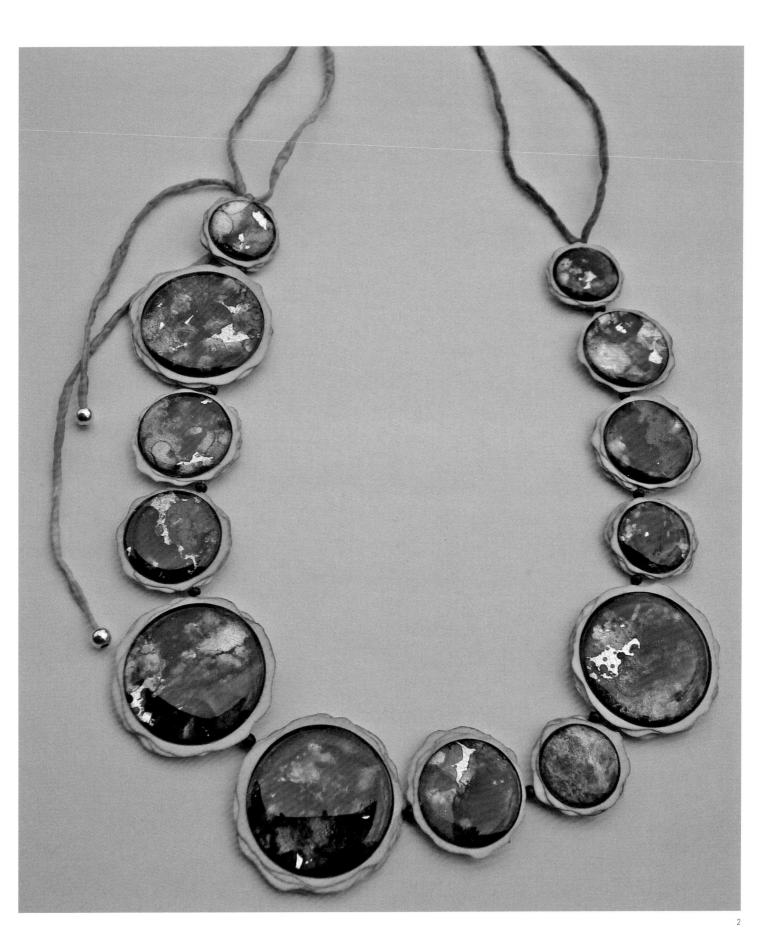

1. *Ethel* **necklace**
Handpainted paper, silver,
glass, nylon, stainless steel,
and pigments

2. *Moon* **necklace**
Handpainted paper,
handpainted silk thread, and
pigments

Oscar Abba

www.oscarabba.com

Oscar Abba is an Italian jewelry designer living and work-
ing in Barcelona. He studied psychology at the Sapienza
University of Rome. Subsequently, he moved to Barcelona,
where he studied artistic jewelry design at the Escola
Massana. His creations in gold and silver have their own
language, based on geometric and numerical explora-
tion through their material properties, form, and folds. His
pieces have been shown in many solo and group exhibi-
tions and are on display in international museums and
important design stores throughout Europe and the Unit-
ed States.

If you didn't specialize in jewelry, what would you be?
I would experiment with film.

**If you could work with only one material, what would
it be?**
Iron and steel.

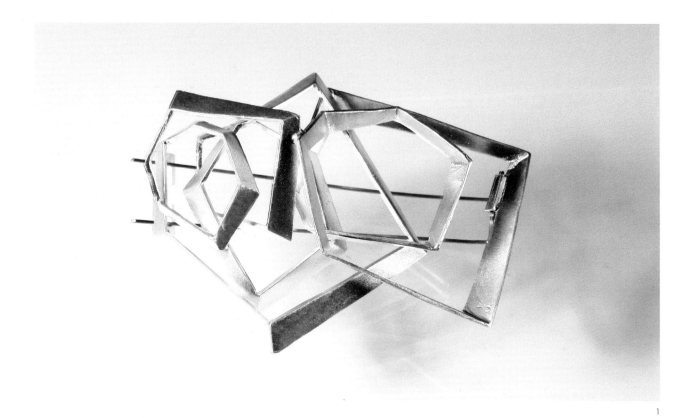

1

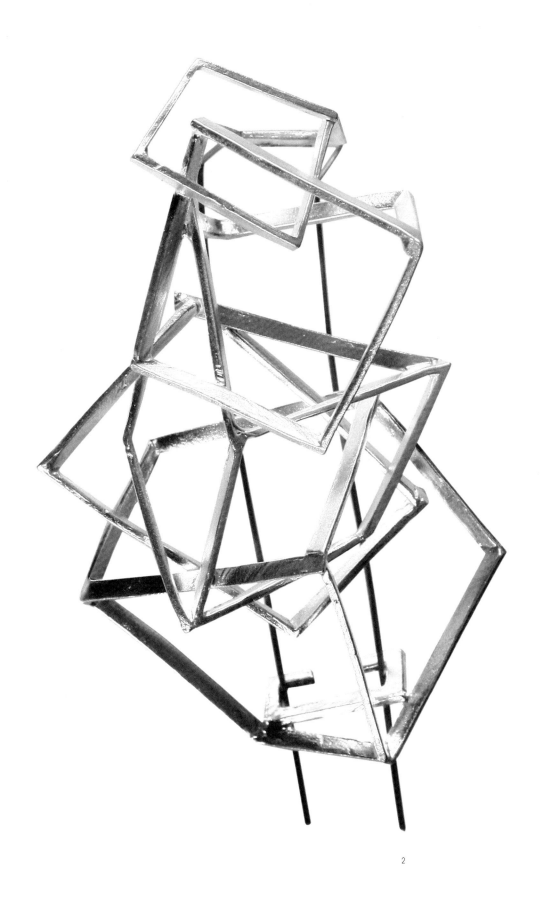

2

1. *Circlings* brooch
Yellow gold

2. *Boucle* brooch
Yellow gold

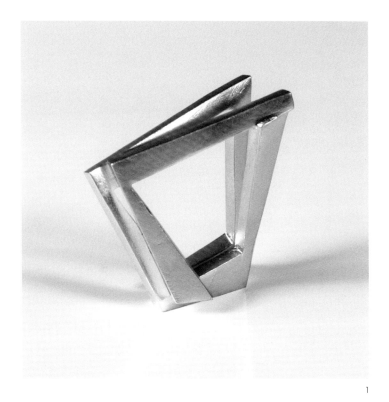

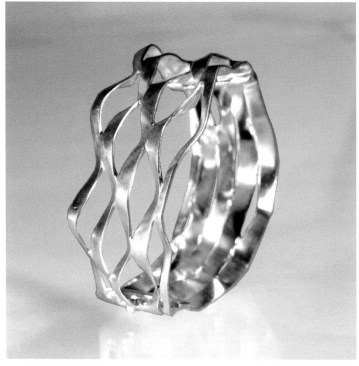

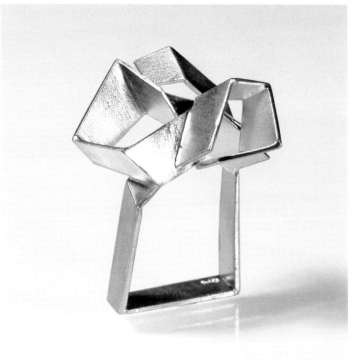

1

2

3

1. *Arquitectura espacial* ring
Silver

2. *Artic* ring
Silver

3. *Leaves* bangle
Silver

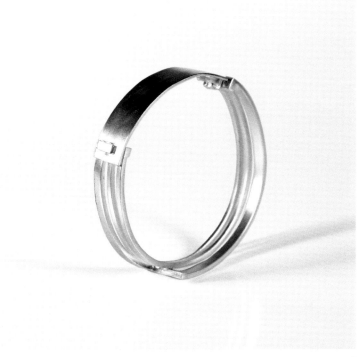

4

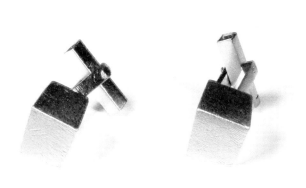

5

4. Man's bracelet
Silver

5. *Polyhedral* cufflinks
Silver

6. Silver piece
Soldering process

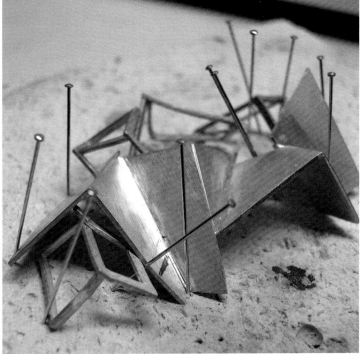

6

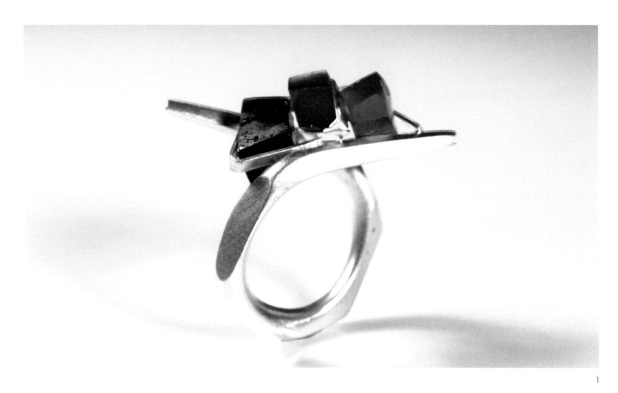

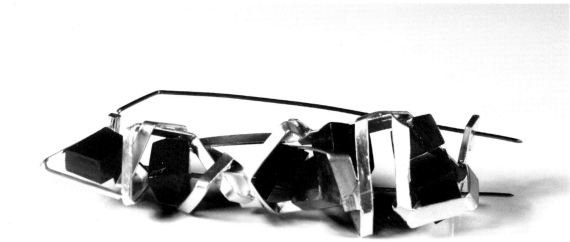

1. *Crystal* ring
Silver and resin

2. *Crystal* brooch
Silver and resin

3. *Crystal* necklace
Silver and resin

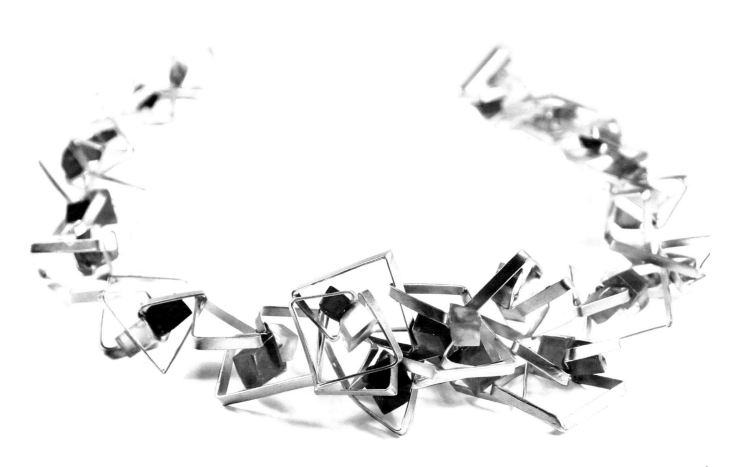

3

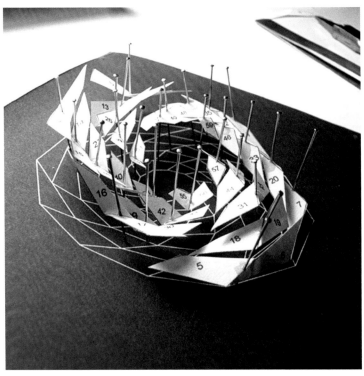

1

2

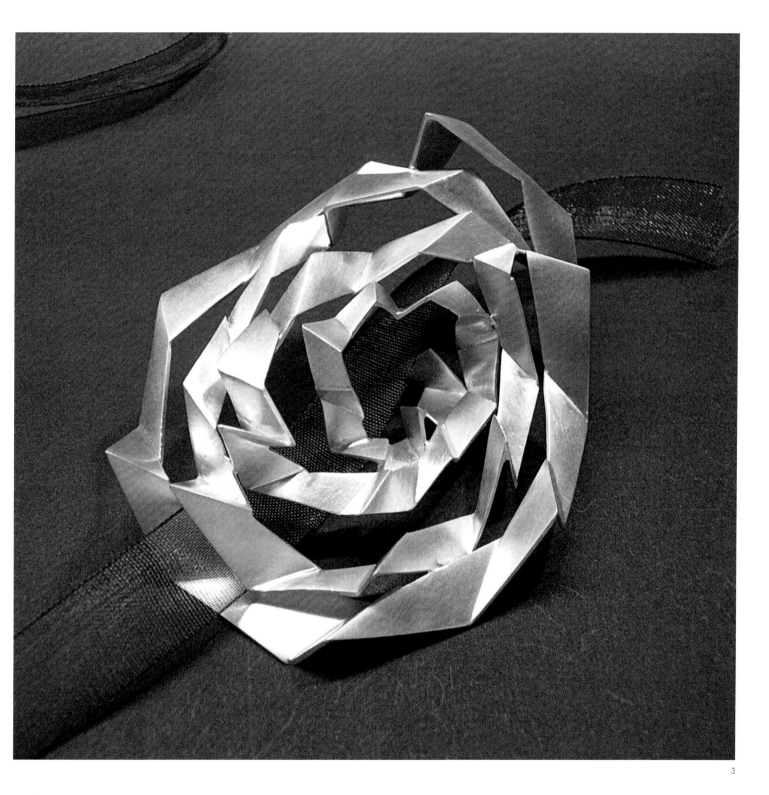

1-2. *Campidoglio* pendant **3.** *Campidoglio* pendant
Sketch and model Gold

Petr Dvorak

www.dvorakart.com

Petr Dvorak was born in Czechoslovakia in 1954. In 1969, he enrolled at a vocational college to study metal engraving. He continued his training at the Arts and Crafts School in Turnov, Czech Republic, where he majored in jewelry design. After working as a jewelry designer in Prague, he opened his own workshop in Vienna. Dvorak's work is characterized by its use of function, form, and color, and the balance he strikes between design and functionality. He has been included in exhibitions in Asia, Europe, and the United States.

If you didn't specialize in jewelry, what would you be?
I would like to think of myself being creative regardless of what I do. My goal is to create according to the vision that I have, regardless of the material. There are any number of possibilities, but it would probably be something to do with craft.

Describe your work space in three words.
Function, form, and color.

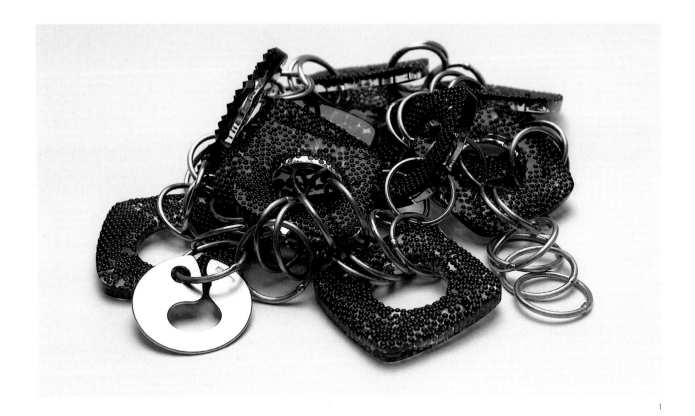

1

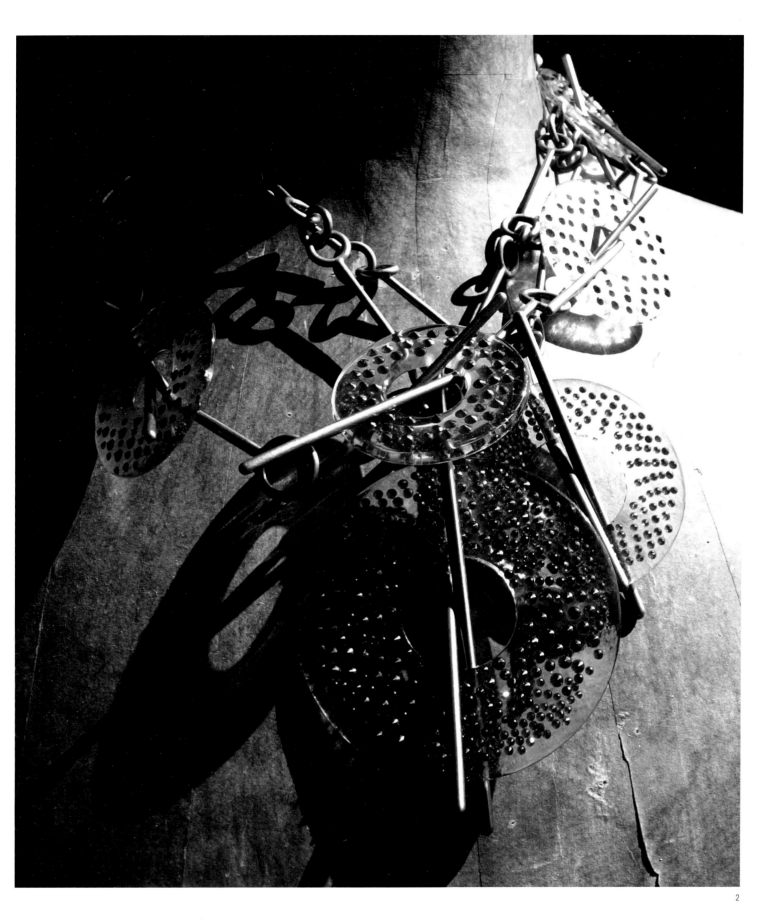

1. Necklace
Molten glass with Czech
garnets and gold

2. *Discus* **necklace**
Molten glass, garnets,
and titanium

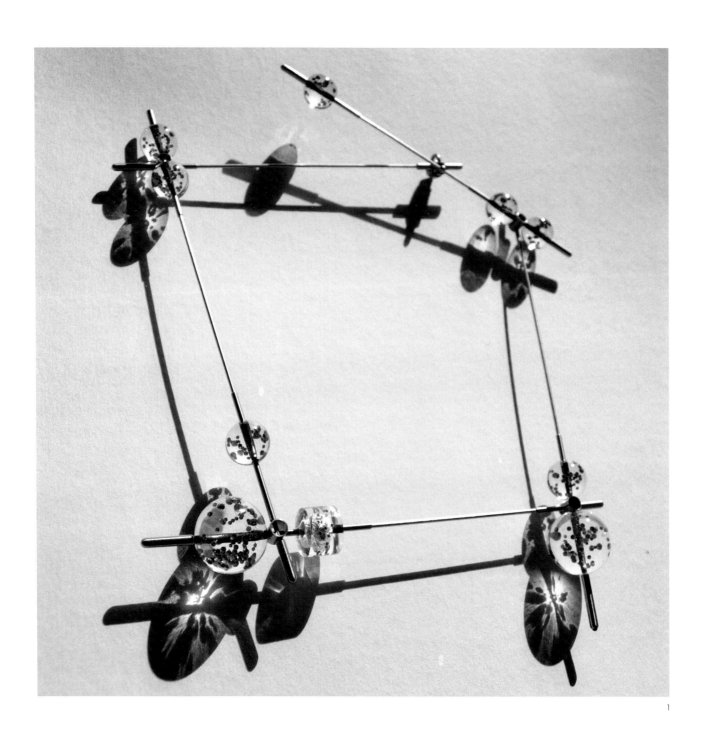

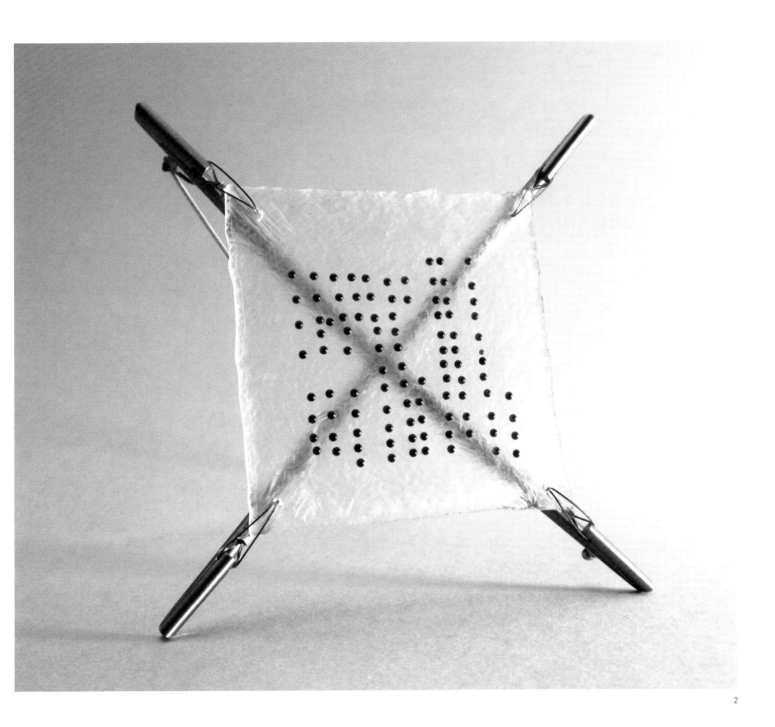

2

1. Necklace
Glass balls, uranium
glass ball with Czech
garnets, steel, and titanium

2. *Cross IV* brooch
Fused glass plate with Czech
garnets and titanium, steel,
and silver structure

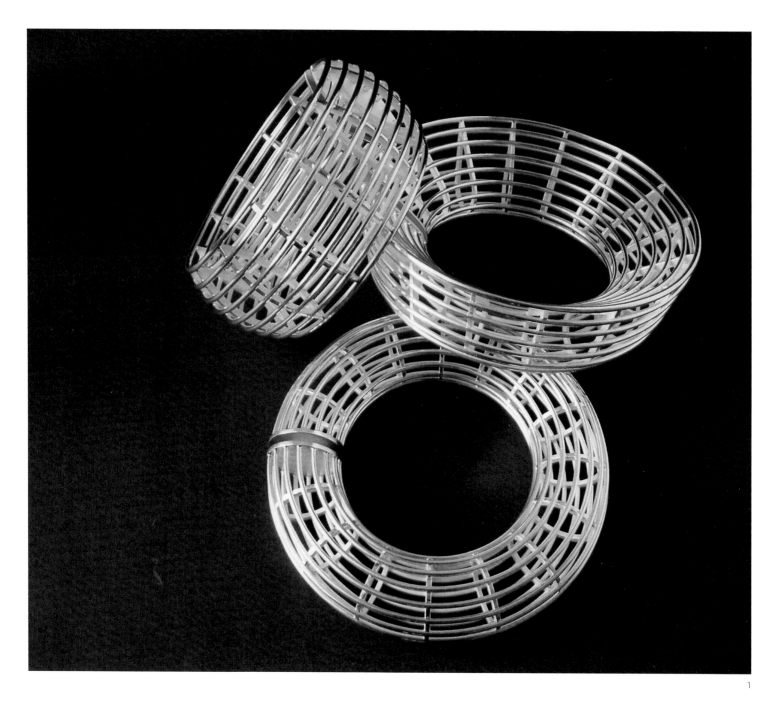

1. Bracelets
Silver

2. *Round* necklace
Silver with glass stones

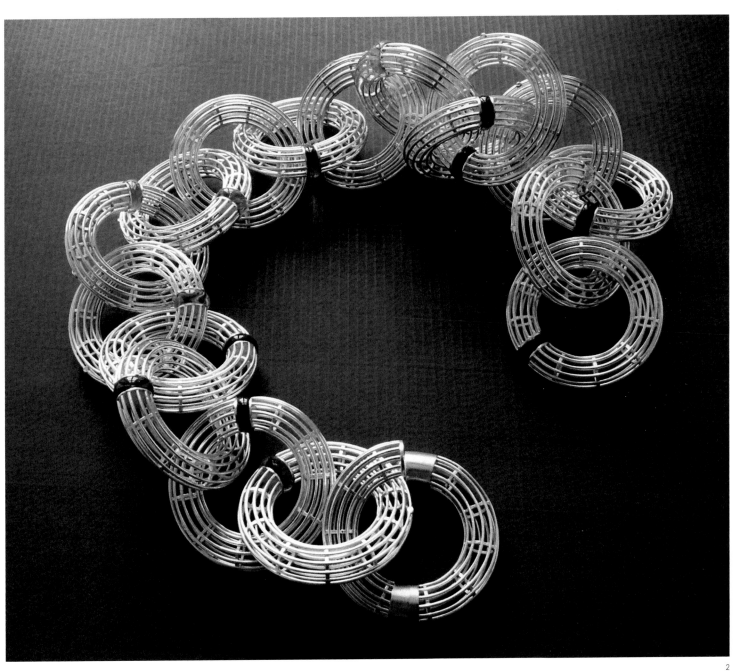

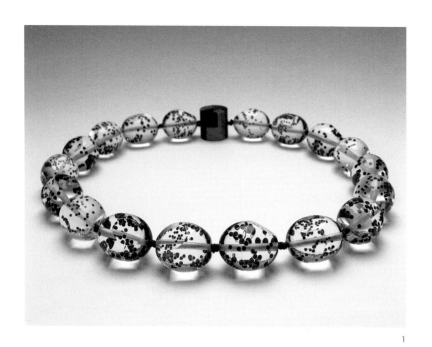

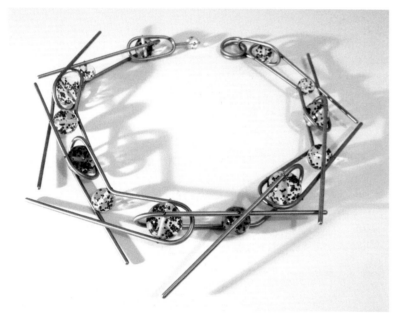

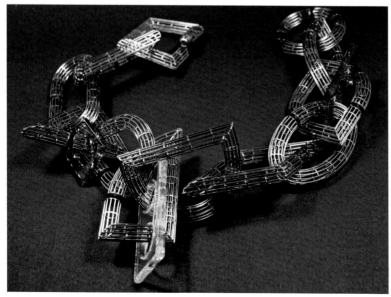

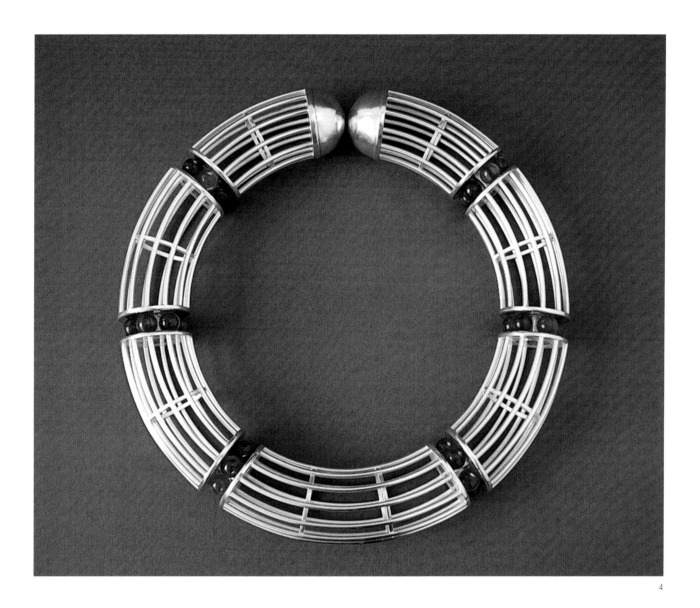

4

1. Necklace
Glass beads, uranium glass bead with garnets, titanium, and magnetic acrylic clasp

2. *Espinas* necklace
Transparent and colored glass beads with Czech garnets, and titanium.

3. *Great construction wire* necklace
Yellow and white gold with synthetic stones, synthetic blue quartz, yellow yttrium aluminum garnet, and synthetic pink ruby

4. Necklace
Silver with synthetic ruby beads; all pieces rotate 360°

Emanuela Deyanova Ramjuly

www.ramjuly.com

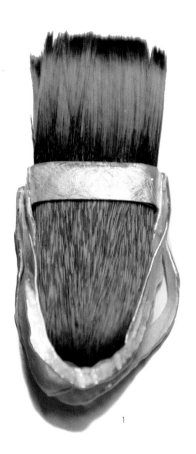

1

Emanuela Deyanova was born in Sofia, Bulgaria, in 1979. She studied metalwork design at the School of Visual and Decorative Arts in her hometown. She subsequently specialized in glass and ceramics at Bulgaria's National Academy of Fine Arts, and in 2006 moved to Barcelona to study jewelry design at the Escola Massana. She is currently living in Amsterdam, where she maintains her own studio. Awards for which she has been nominated include the N'joiat Best Collection at the Barcelona Contemporary Jewelry Week, and Best Stand Design at Woonbeurs in Amsterdam. Porvocative conceptual work such as her *How to wear a famous painter* collection and *My secret daily tea ritual* have been shown in galleries in, Germany, the Netherlands, Portugal, and Spain.

If you didn't specialize in jewelry, what would you be?
An inventor. A discoverer. An educator teaching people about fair trade in the gold and diamond mining sectors.

Describe your work space in three words.
A wild spaceship!

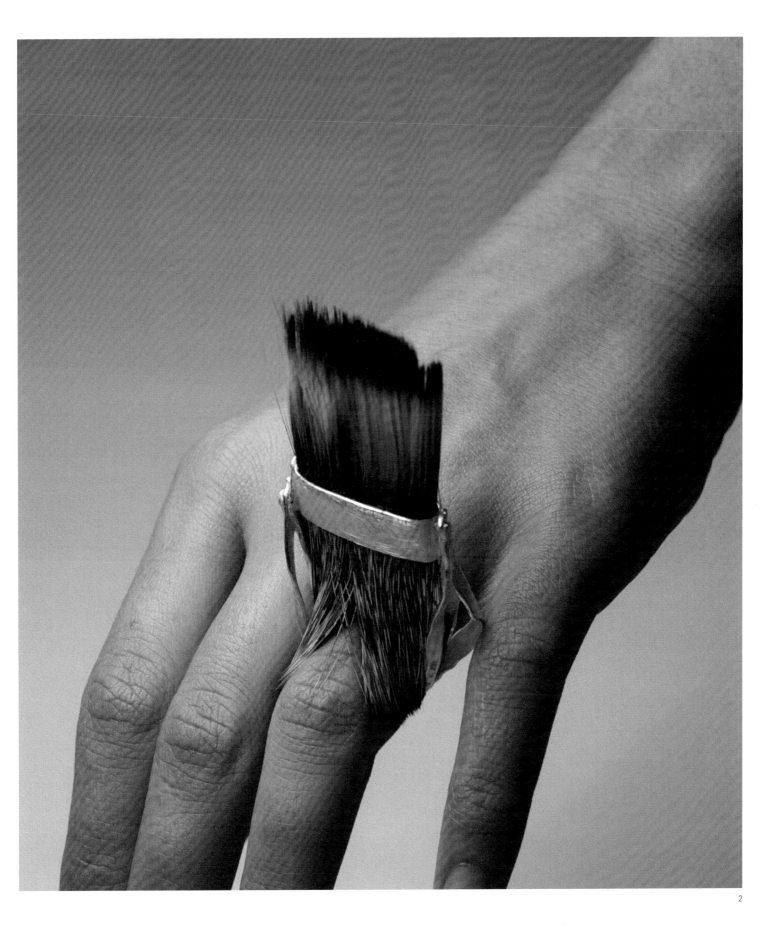

1-2. *Koala diamond brush* ring
Natural koala fur, aluminium, silver,
and 24-karat gold

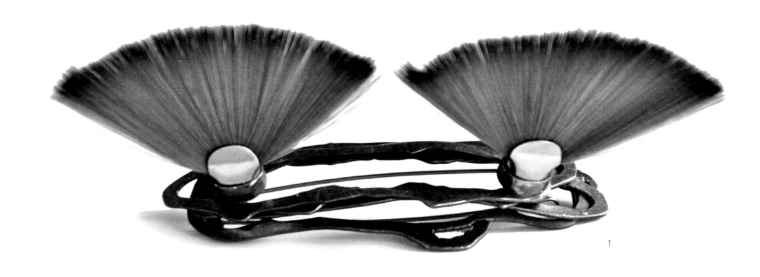

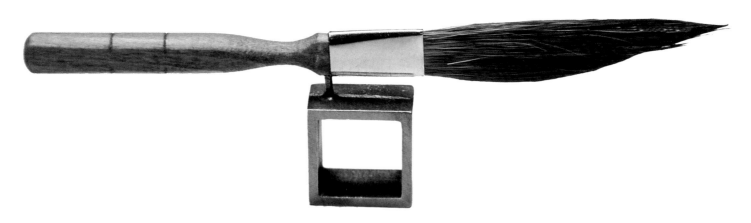

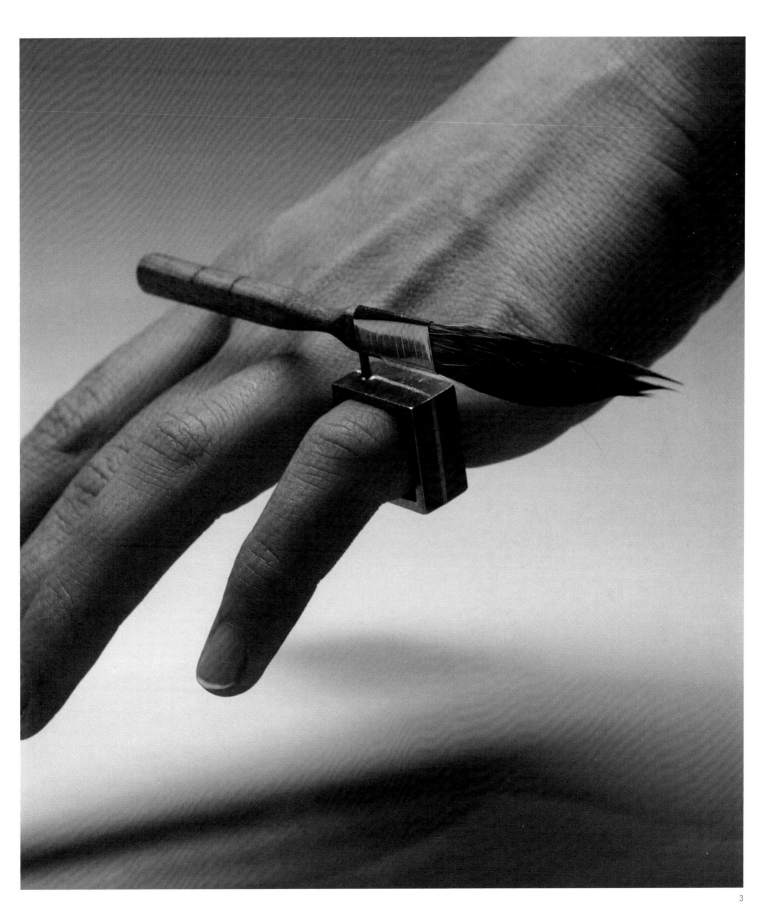

1. *2 Abanico* brooch

Silver, aluminium, and natural fur

2-3. *Hold hieroglif string* ring

Natural fur, wood, aluminium, silver, and 24-karat gold

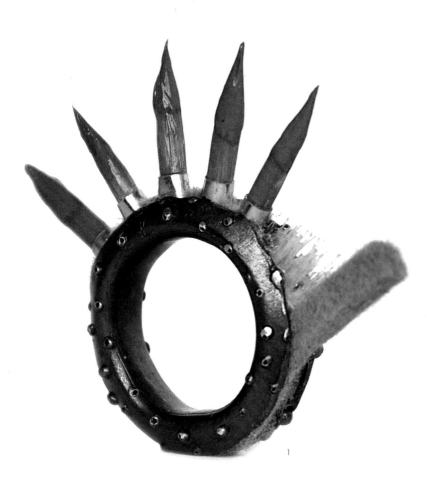

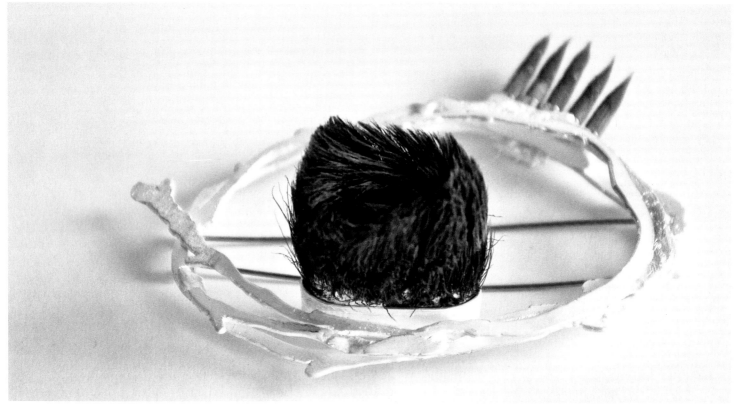

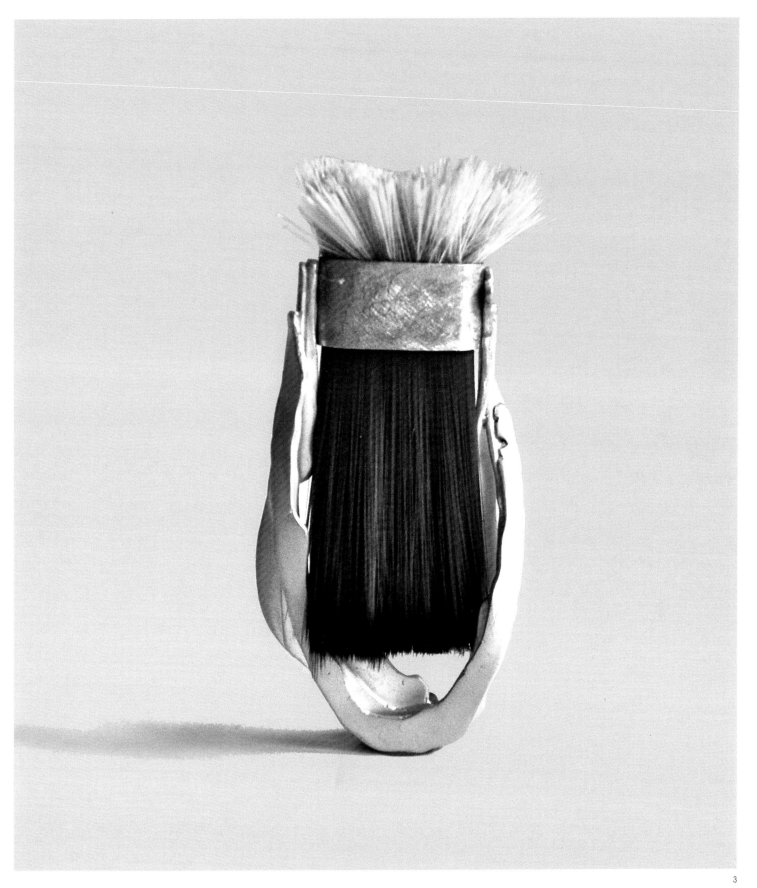

1. *5 ways to paint in red* ring
Natural fur, aluminium, paint, fibre,
and silver

2. *5 ways to paint in red* brooch
Natural fur, aluminium, paint, fibre,
and silver

3. *Brush my finger* ring
Natural fur, artificial fur, and silver

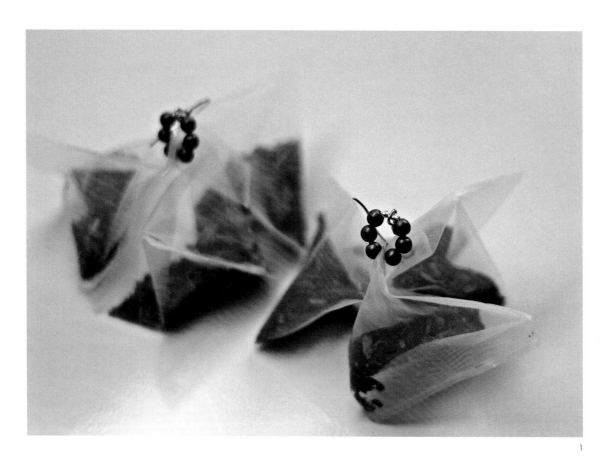

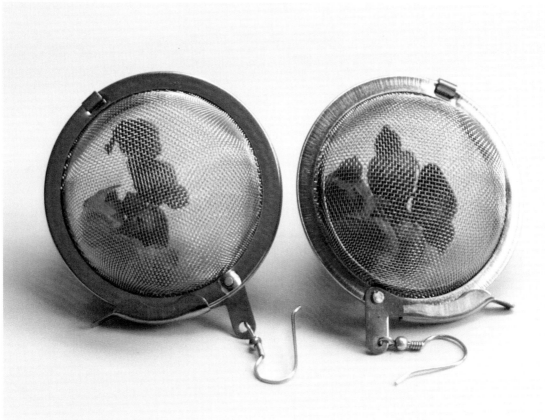

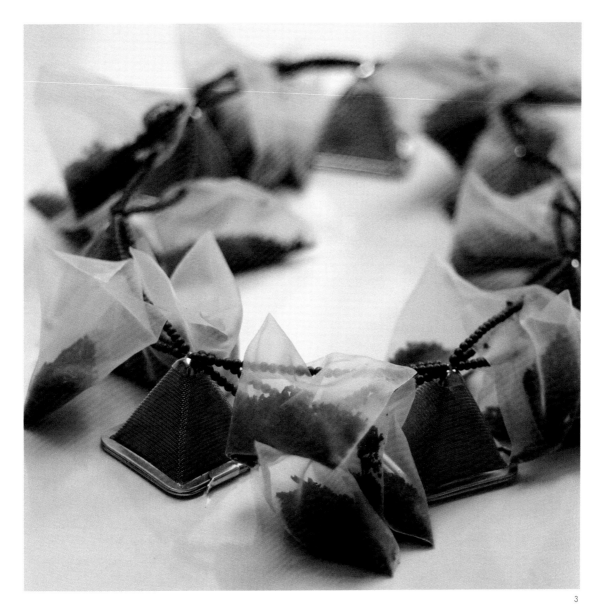

3

4

1. Indonesian chai earrings
Silver, silk, hematite, and tea

2. Rose-tea earrings
Silver, aluminium, and rose petals

3-4. Rose pyramide necklace
Aluminium, silk, matte onyx,
rose petals, and tea

Rosa Nogués

rosareus@hotmail.com

Rosa Nogués Freixas was born in Reus, Spain, and studied contemporary jewelry at the Escola Massana in Barcelona. An exchange with the Jewelry College of South Karelia Polytechnic in Lappeenranta, Finland, enabled her to expand her views on design. Freixas has taken part in group exhibitions throughout Europe. In 2009, she was awarded the European Prize for Applied Arts by the World Crafts Council-Europe.

If you could work with only one material, what would it be?
If I could work with only one material, I wouldn't be as enthusiastic about my work as I am. The reason I am drawn to contemporary jewelry in the first place is because there are no limits regarding materials, shape, or technique. Having said that, I have always worked with porcelain. I'm tied to it because I can recreate it, shape it, and create a discourse based on how I do so. It then takes on new strength and other sensations, opening up new avenues of expression.

Describe your work space in three words.
Microuniversal, silent, intimate.

3

1-2. *Densitats* **necklace**
Wood, porcelain, silver, and
textile yarn

3. *Densitats* **necklace**
Wood, porcelain, enamel,
silver, and textile yarn

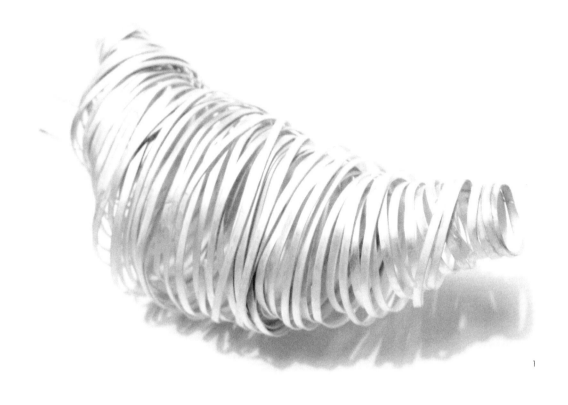

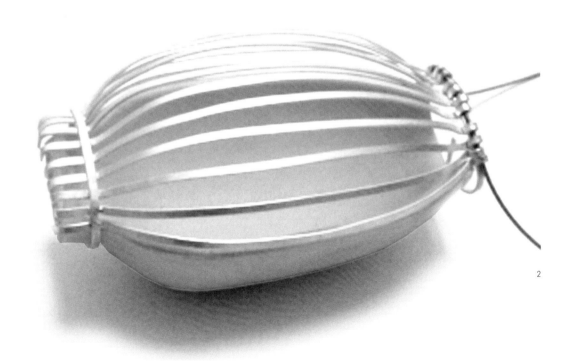

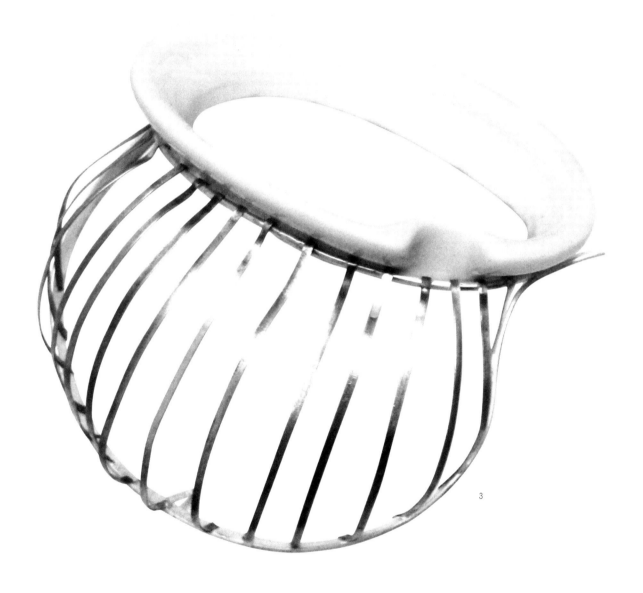

3

1. *Halos* brooch
Silver and steel

2. *Lo efímero y lo que permanece* necklace
Porcelain, silver, and steel

3. *Lo efímero y lo que permanece* brooch
Porcelain, silver, and steel

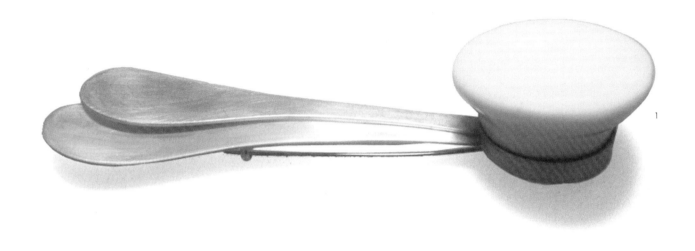

1

2

3

4

1. *Once upon a time* brooch
Porcelain, silver, and steel

2. *Form is emptiness* brooch
Porcelain, silver, and steel

3. *Inside the emptiness* brooch
Porcelain, silver, and steel

4. *Beat* necklace
Leather, porcelain, silver, polymer, and textile yarn

1

1. *Taking off* brooch
Leather, porcelain, silver,
and steel

2. *Hidden* necklace
Leather, porcelain, enamel,
silver, and textile yarn

3. *Alive* brooch
Leather, porcelain, silver,
enamel, and steel

2

3

Sabine Lang

www.sabinelang.info

1

Contemporary jewelry designer Sabine Lan was born in Neheim-Hüsten, Germany, in 1976. She studied gold and silversmithing at the Art School in Hanau, graduating in the year 2000. Subsequently, she went to the University of Düsseldorf to obtain her diploma in jewelry design. She then worked as a designer for contemporary jewelry firms in Germany and the United Kingdom until 2005, when she established her own studio. Her work, which includes eye-catching bubbles of various sizes and shapes, has gained her prizes suchs as the first place in the 2006 New Traditional Jewelry competition in Amsterdam.

If you didn't specialize in jewelry, what would you be?
An ice cream designer.

If you had to describe your workspace in three words, what would they be?
An inspirational, creative chaos.

2

1. *Freestyle bubbles* earrings
PETG plastic, nylon, and silver

2. *Freestyle bubbles* necklace
PETG plastic and nylon

1

2

3

4

1. *Butterfly bubbles* necklace
PETG plastic and nylon

2. *Freestyle bubbles* necklace
PETG plastic and nylon

3. *Big bubbles* necklace
PETG plastic and nylon

4. *Five row bubbles* necklace
PETG plastic and nylon

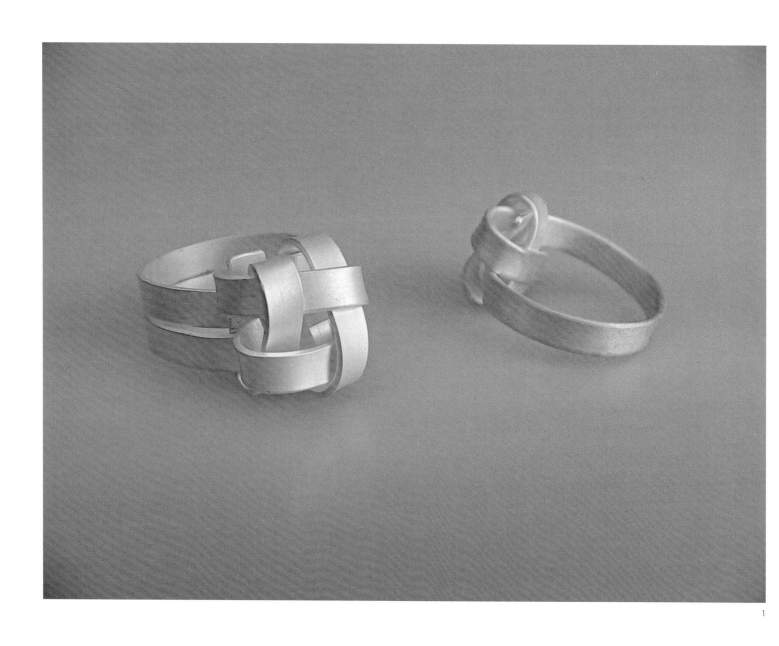

1

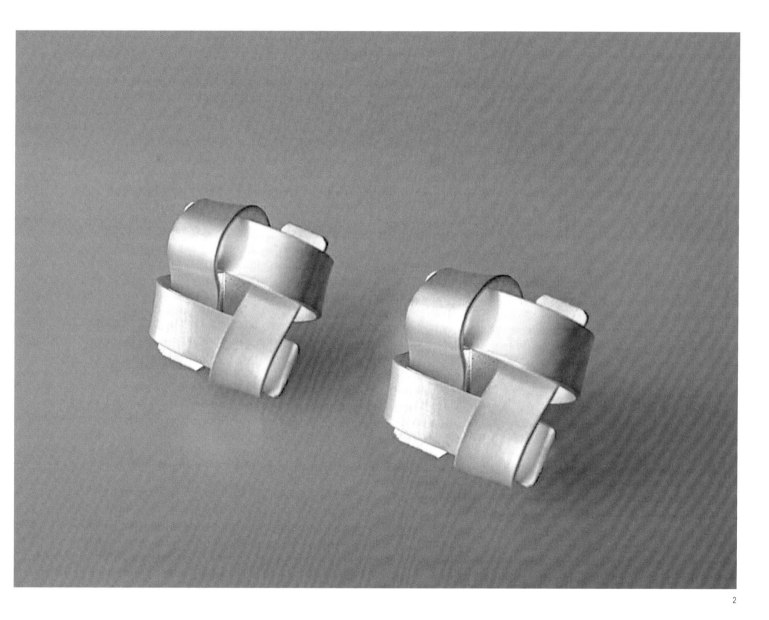

1. *Knots* rings
Silver

2. *Knots* earrings
Silver

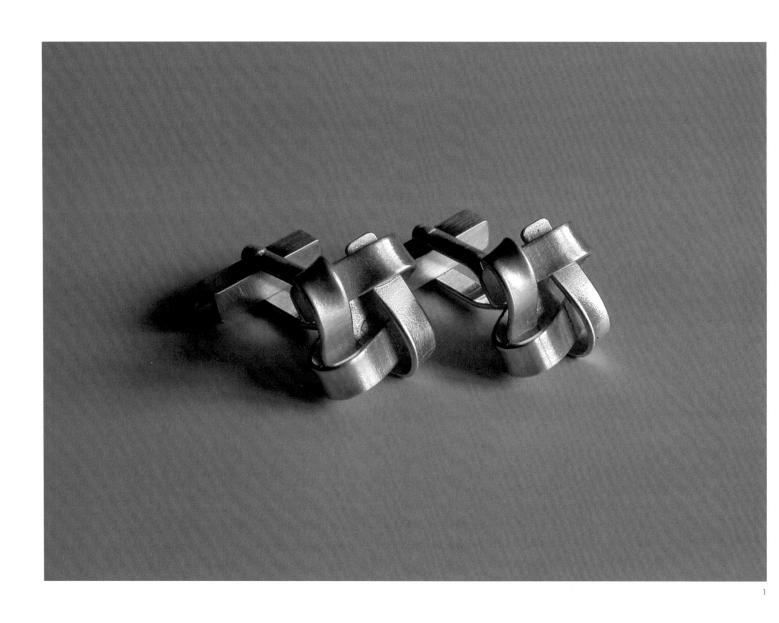

1. *Knots* cufflinks

Silver

2. *Freestyle bubbles* necklace

PETG plastic and nylon

Sara Engberg

www.saraengberg.se

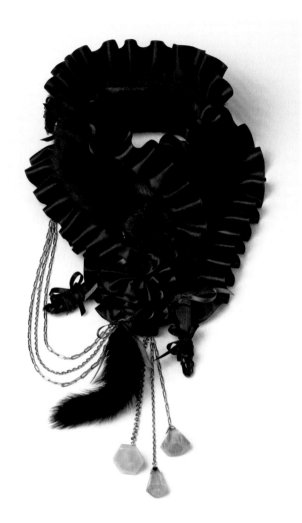

1

Sara Engberg lives and works in Stockholm. In 1998, she recieved her master's degree in metal design from the University College of Arts, Crafts and Design in Stockholm. She has taken part in a number of exhibitions across Europe and has won numerous prizes, including the Enjoia't Award at the 2010 Barcelona Contemporary Jewelry Week. Her jewelry, with its use of language and word play, tells stories about hopes, expectations, and disappointments.

If you didn't specialize in jewelry, what would you be?
A novelist.

If your work involved music, what style of music would it be?
I would like to think of my jewelry as dream pop or dark, dreamy, alternative pop/rock, like Beach House, a fantastic band from Baltimore.

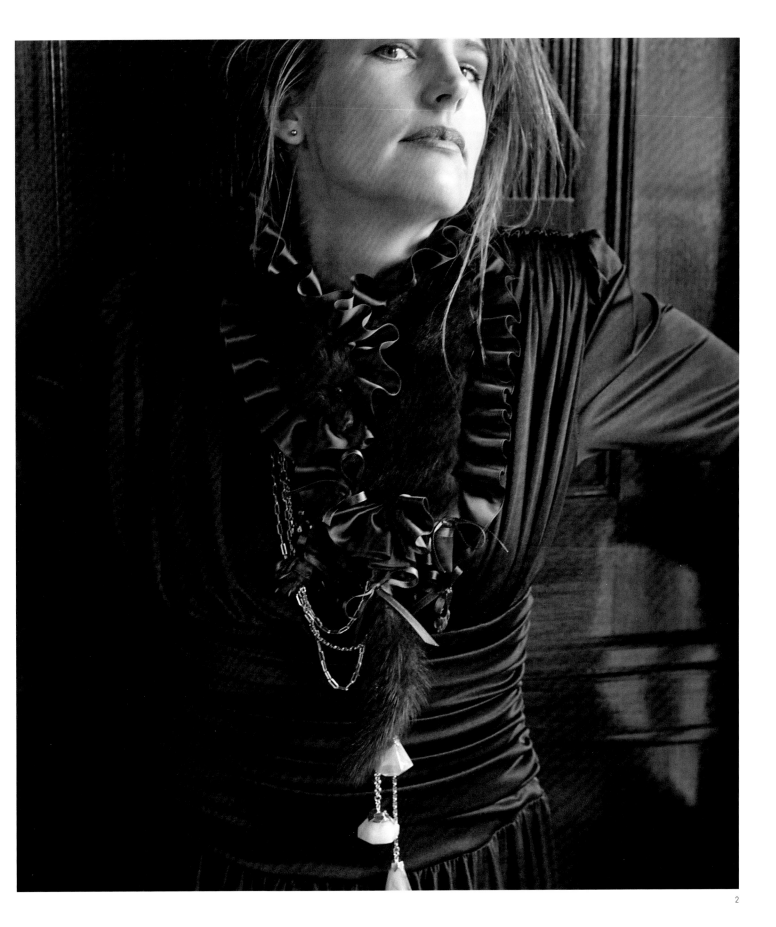

1-2. *Amber makeover* necklace
Mink boa, satin ribbons,
gold-plated silver,
and faceted amber

1. *I did it all for you* brooch
Painted porcelain, silver, and
fabric

2. *Armour* crown
Prozac antidepressant tablets

491

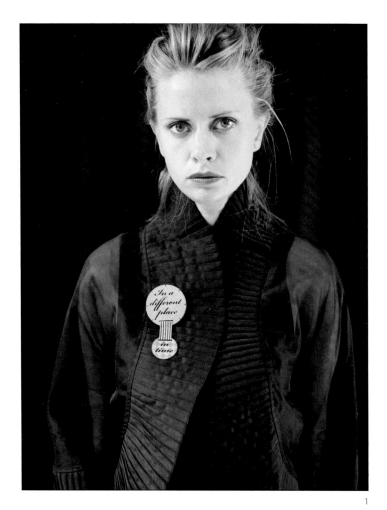

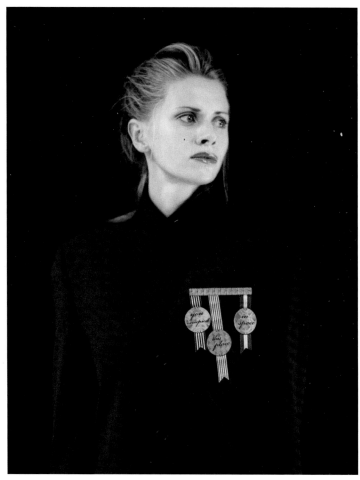

1

2

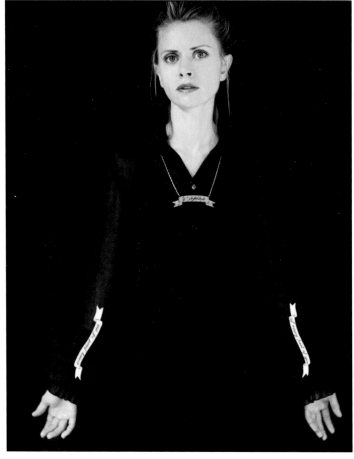

3

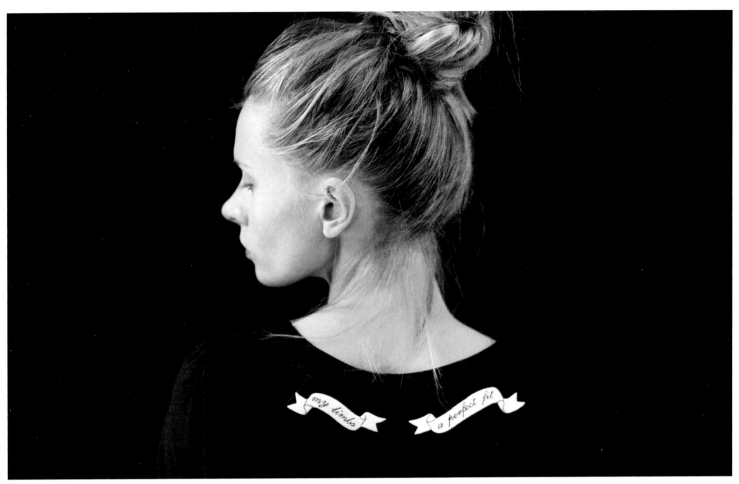

4

1-5. *In a different place in time* collection
Based on the poem *In a different place in time*

1. *In a different place in time*
2. *You occupied this place in space*
3. *Every part of me: a replica of every part of you*
4. *My limbs: a perfect fit*
5. *For the void you left behind*

5

1. *I tried so hard* **brooch**
Four brass plates and fabrics

2. *You lost me* **brooch**
Printed silk and felt, with
details in silver and silk cord

Standing behind that thin bamboo door,
squeezed between those two big, dripping darknesses
right on that thin line of light
torn between why and why not and whatnot

I was unlocking the door to the sea
or to that dodgy hotel room of the mind

I followed the ghost of the white sands
and for thirteen hours of glorious darkness
I was trapped under a mosquito net

gleaming with sweat and golden cup balm
I was struggling to break free

tangled up in a blackness sprinkled with light
enveloped in a billowing, starry sky

I think you lost me there
gazing at the stars in my microcosm of captivity,
allowing the ocean to fill my head with nameless symphonies

gradually becoming aware
of something deeply disturbing:
the surprising pleasure in being overpowered

you lost me, and I woke up to discover
the world bulging in through my window
like a giant, blue satin cushion

spilling over onto my desk, my chair, my floor, my everything

you lost me

my everything
until then
was you

2

495

Satya Jewelry

www.satyajewelry.com

The founders of Satya Jewelry, Satya Scainetti and Beth Torstrick Ward, create pieces that both arouse the emotions and convey a sense of tranquility and hope. Semi-precious stones long associated with healing properties, are combined with sacred symbols made of solid 18-karat gold, and plated with 24-karat gold and sterling silver. Their pendants are made with the traditional technique of lost wax in Thailand. The complete line is found in their chain of four boutiques in the United States and a fifth in Covent Garden, London. Their creations are worn by numerous celebrities and have appeared in movies and popular television shows. In 2005, Satya was named Best Everyday Jewelry by *New York* magazine.

If you could work with only one material, what would it be?
I would like to work with precious stones. They are colorful, energizing, and fascinating to look at!

Describe your work space in three words.
Creative, exciting, and challenging.

1

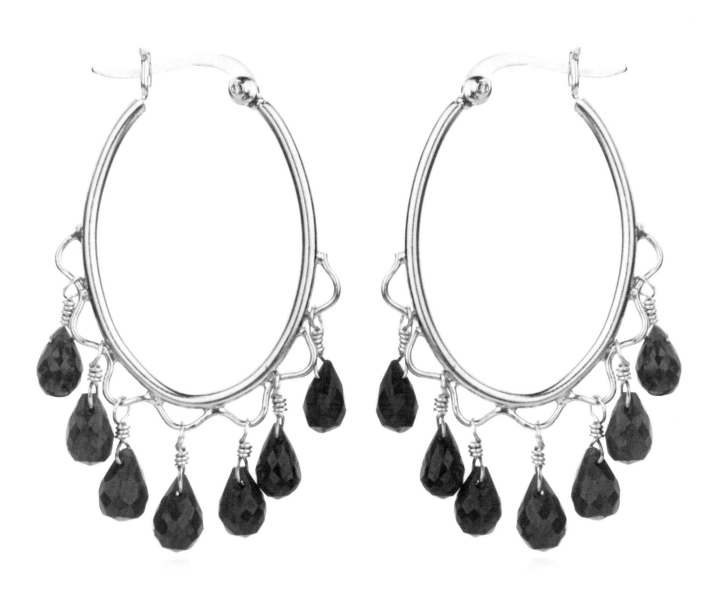

1. Bracelet
18-karat solid gold and rubies

2. Earrings
Gold-plated sterling silver and rubies

2

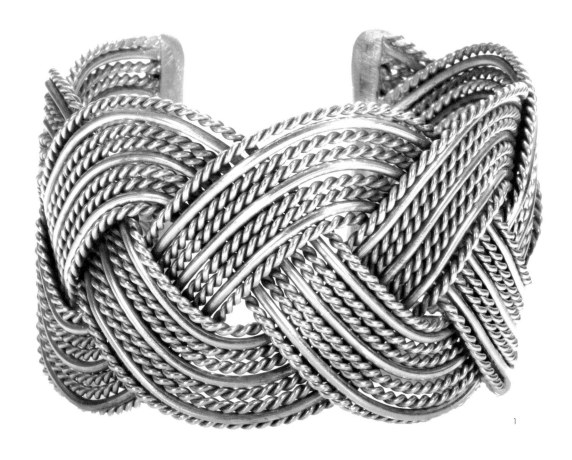

1

1. Bracelet
24-karat gold-plated sterling
silver

2. Earrings
24-karat gold-plated sterling
silver with green onyx

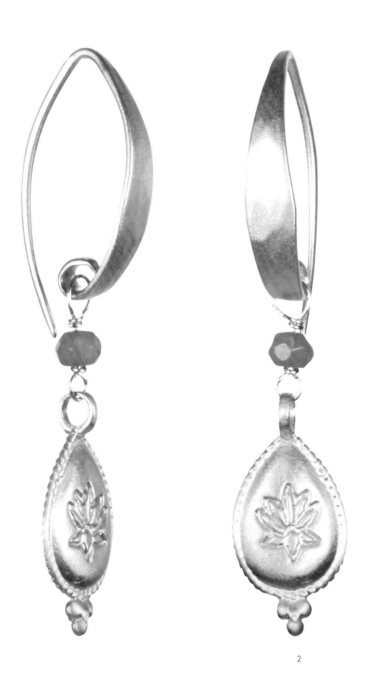

2

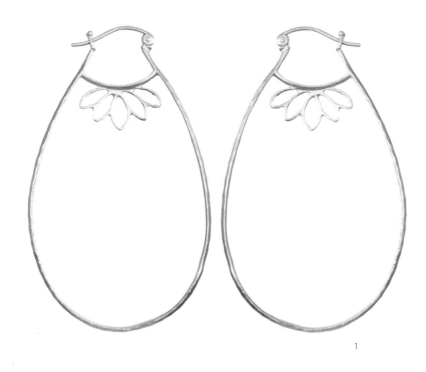

1

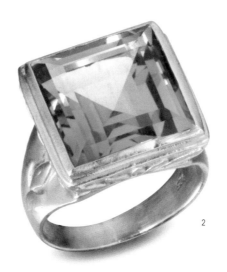

2

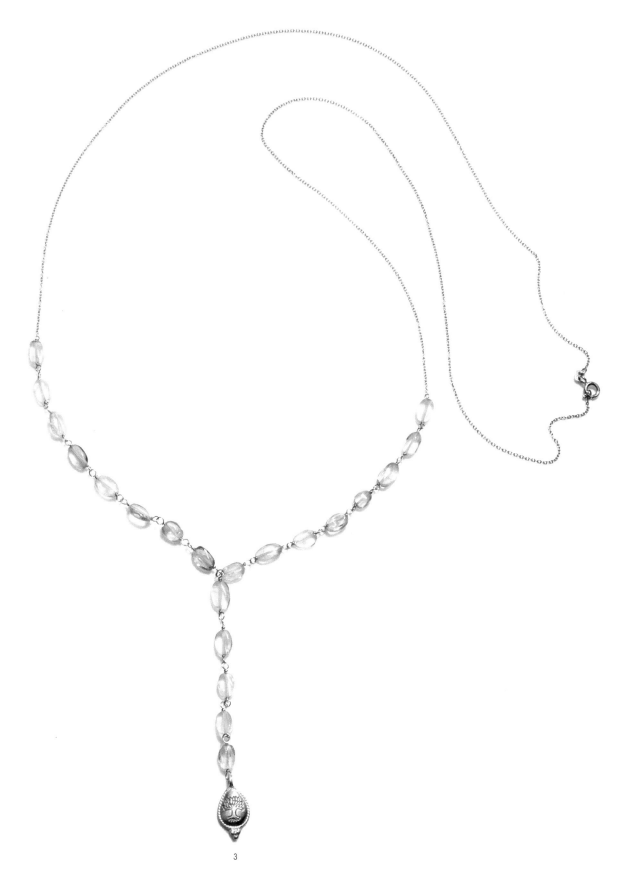

3

1. Earrings
Gold-plated sterling silver

2. Ring
24-karat gold-plated sterling
silver with blue topaz

3. Necklace
24-karat gold-plated sterling
silver with citrine

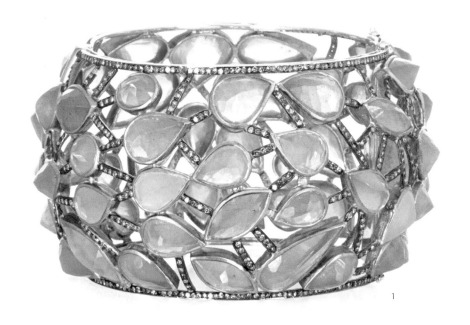

1

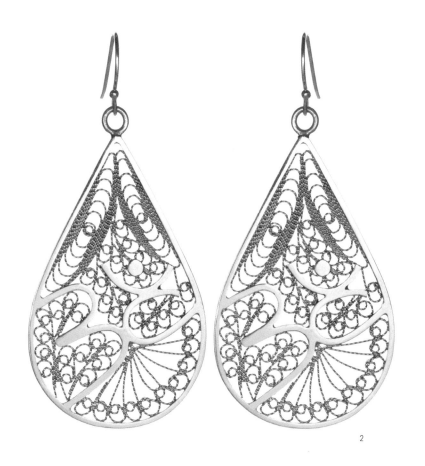

2

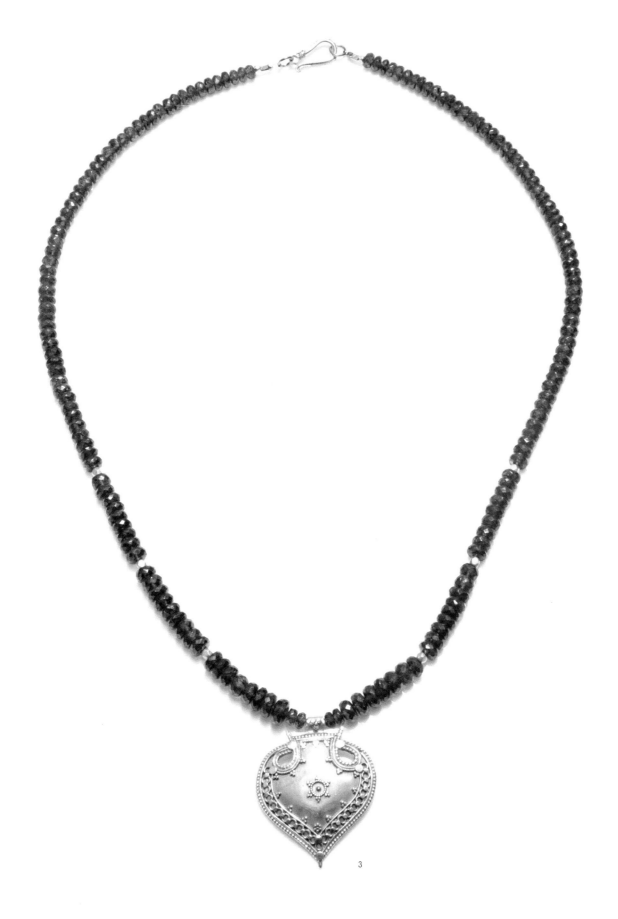

3

1. Bracelet
18-karat gold with
aquamarines and diamonds

2. Earrings
18-karat gold

3. Necklace
8-karat gold with handcut
garnets

Şenay Akın

www.senayakin.com

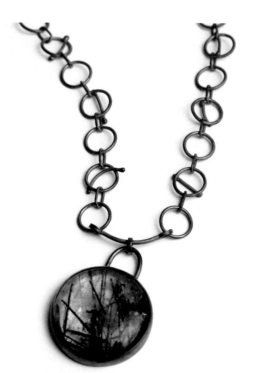

Şenay Akın was born in Bulgaria and currently lives in Istanbul. She graduated with a degree in photography from Mimar Sinan Fine Arts University in Istanbul in 1998, and then went on to study jewelry design, gemology, and settings at the Scool of Arts and Crafts in Vicenza, Italy. In 2005, she began working as an apprentice under Alberta Vita in her studio in Padua. In 2008, Akin set up her own jeweler's workshop in Istanbul, where she also holds classes. Her pieces—whether commissioned or part of a design collection—are completely handmade. She considers herself a storyteller, creating three-dimensional narratives that invoke the feeling of being told a fairy tale.

If you didn't specialize in jewelry, what would you be?
I would like to be a photographer, interpreting and forming the connection between different worlds. I would like to be able to speak as many languages as possible.

Describe your work space in three words.
Light, feminine, and friendly.

1

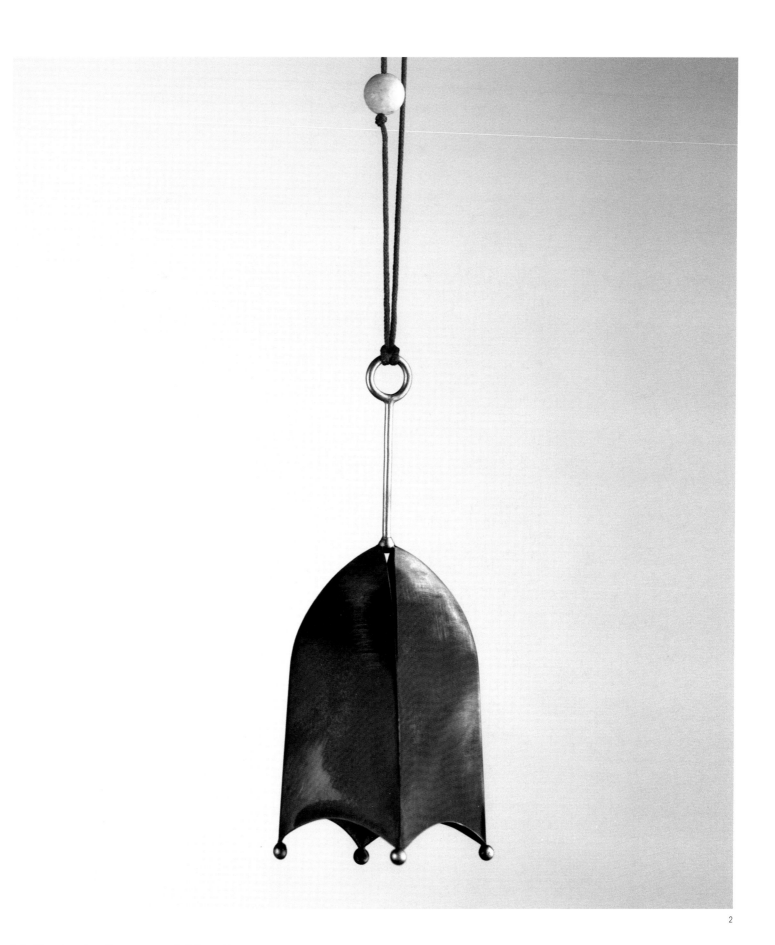

2

1. *Spellbound woods* necklace
Rutilated quartz and silver

2. *Flying* necklace
Silver, white onyx, and red cord

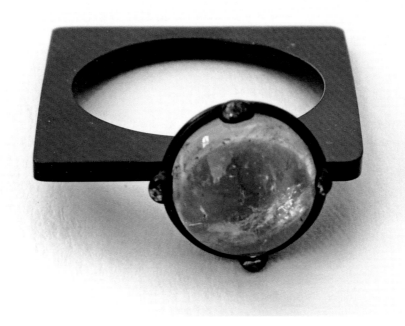

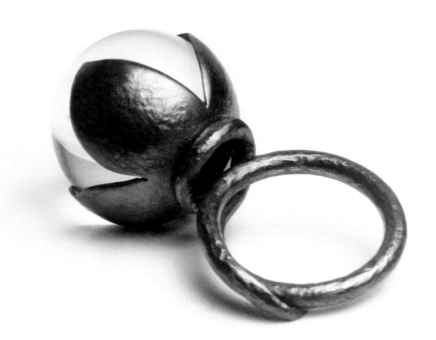

1

2

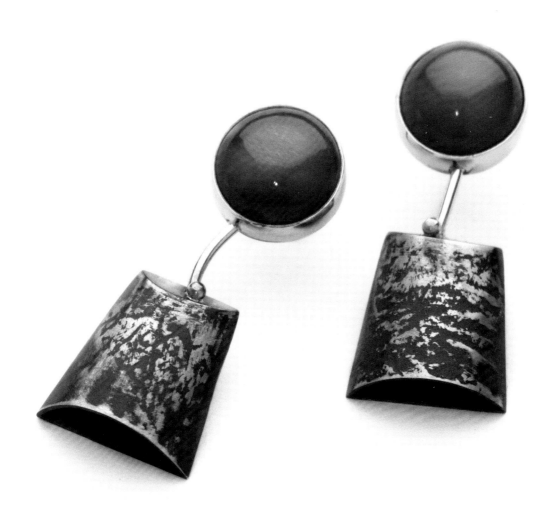

3

1. *Square prince* ring
Aquamarine and silver

2. *Iron rose* ring
Quartz and silver

3. *Forest trolls* earrings
Moonstone, 18-karat gold,
and silver

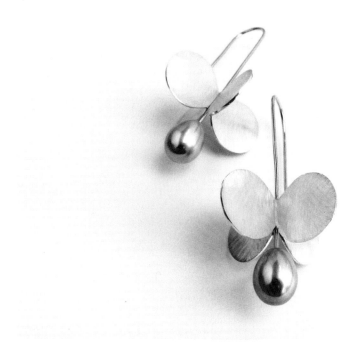

1

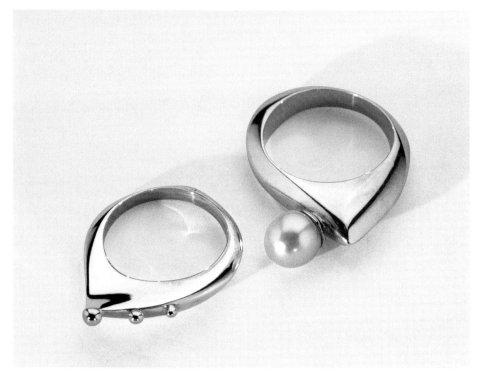

2

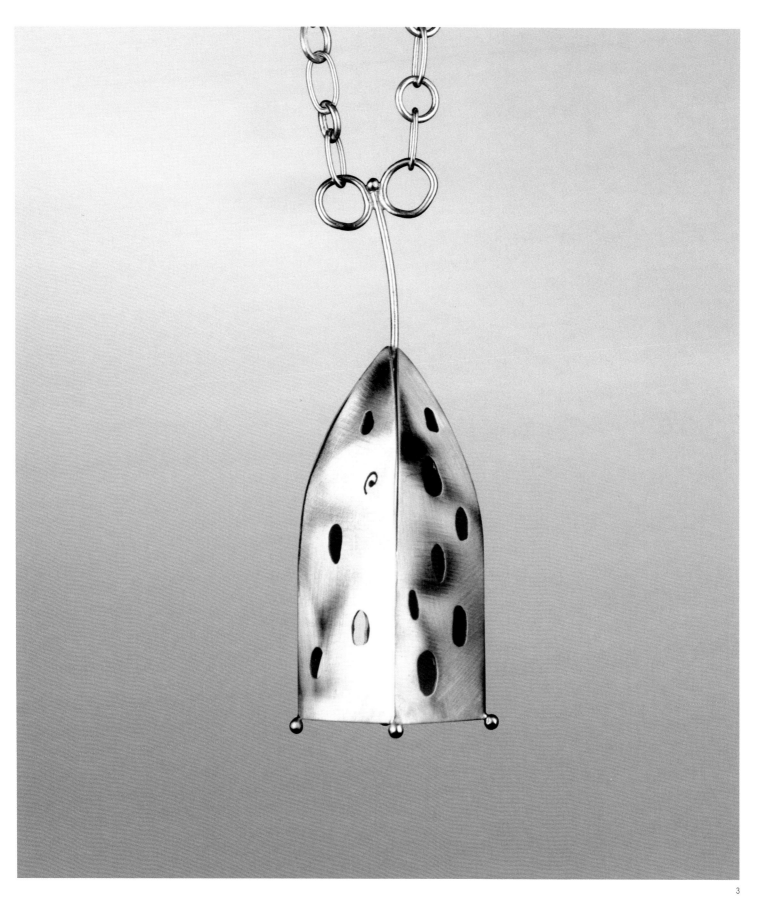

1. *Butterfly* **earrings**
Freshwater pearls, 18-karat gold,
and silver

2. *Princess & Harlequin* **rings**
Freshwater pearls, 18-karat gold,
and silver

3. *Tower* **pendant**
18-karat gold and silver

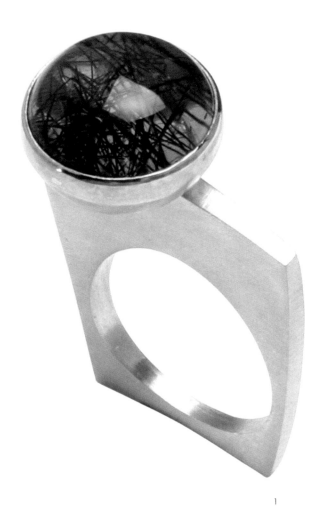

1

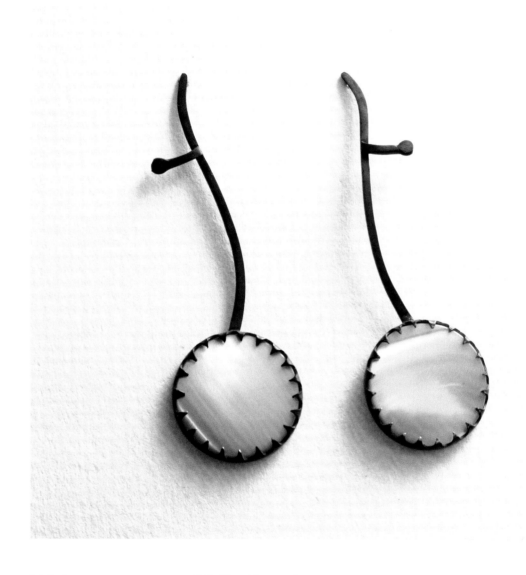

1. *Lake* ring
Rutilated quartz and silver

2. *Spellbound flower* earrings
Mother of pearl and silver

Silvia Walz

www.silviawalz.tk

Silvia Walz was born in Gelsenkirchen, Germany, in 1965, but she has lived and worked in Spain for more than twenty years. She studied metal design at Hildesheim Technical College Germany, before continuing her studies at the Escola Massana in Barcelona, where she has held a professorship since 1994. Her work, which is characterized by symbology, emotion, and mastery of technique, has been featured in numerous group exhibitions throughout Europe. Walz's honors include the Frombork 2007 Biennial International Amber Prize. In 2008, she began the *Sensational Jewelry* project at the Taller Perill in Barcelona, where she trains and inspires the next generation in contemporary jewelry.

If you didn't specialize in jewelry, what would you be?
An astronaut!

Describe your work space in three words.
A controlled mess.

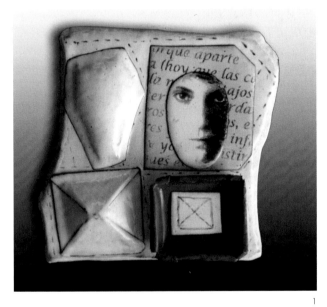

1

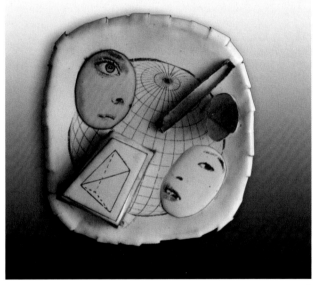

2

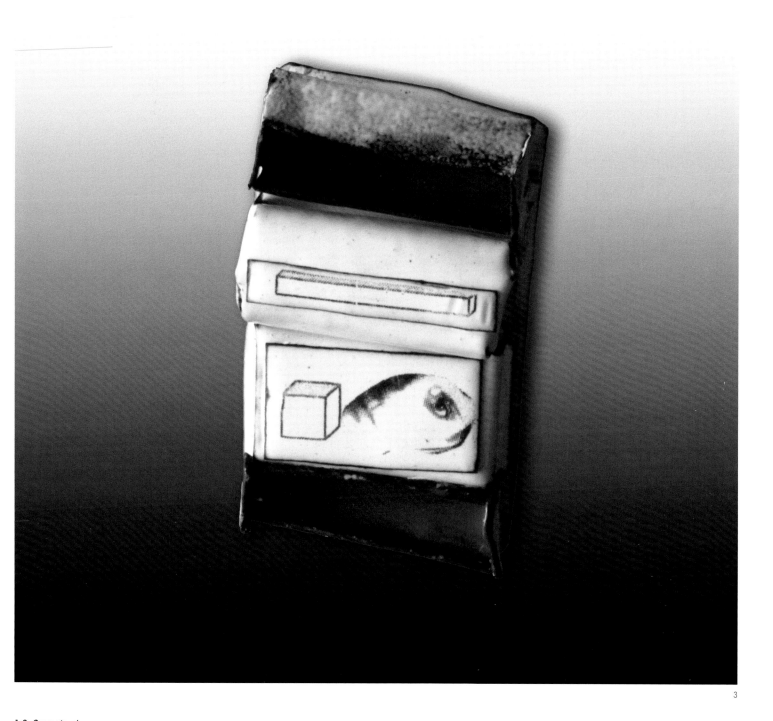

1-3. *Geometry* pieces
Copper and enamel

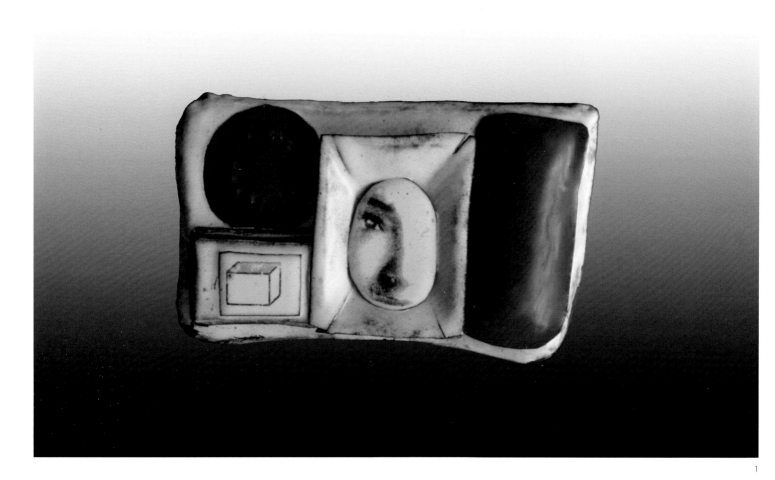

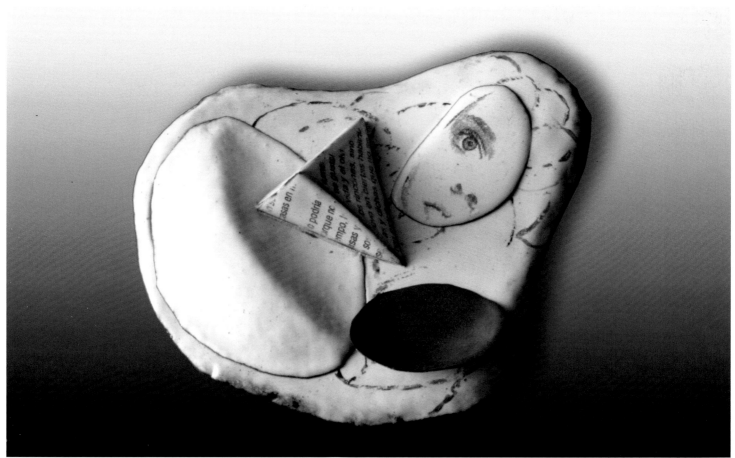

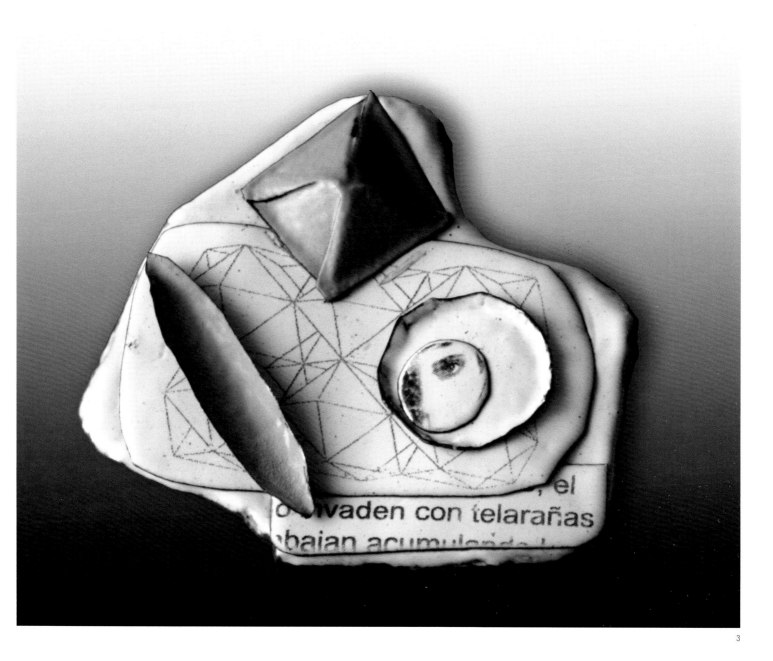

1-3. Geometry pieces
Copper and enamel

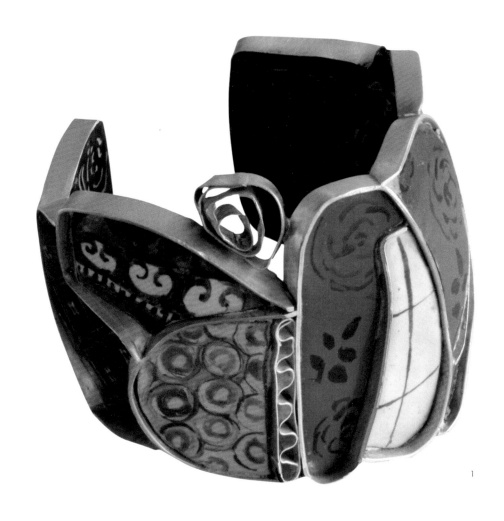

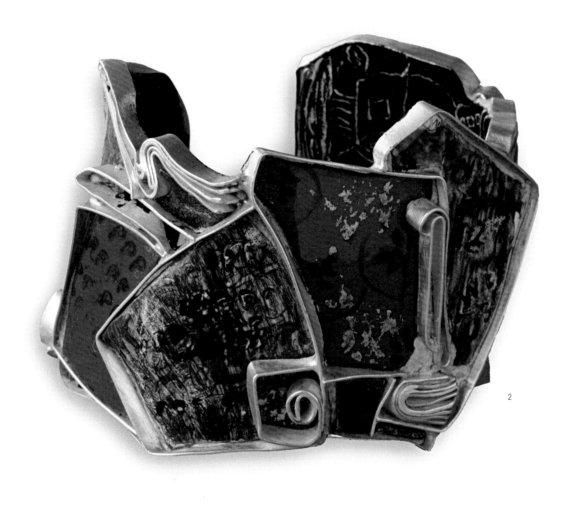

2

1. *La casa de Josef* bracelet
Silver, copper, enamel, and
resin

2. *La casa de Elvira* bracelet
Silver, copper, enamel, and
resin

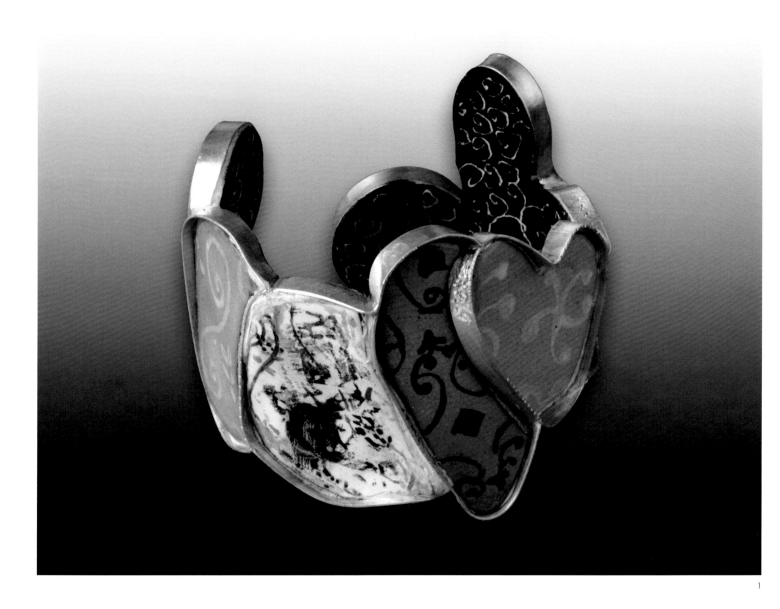

1. *La casa de Marta* bracelet
Silver, copper, enamel, and resin

2. *La casa de Magdalena* bracelet
Silver, copper, enamel, and resin

2

Stefania Lucchetta

www.stefanialucchetta.com

Italian designer Stefania Lucchetta lives and works in Bassano del Grappa. Her career in arts and design began when she entered the Academy of Fine Art in Venice; she later graduated in humanities from the Ca'Foscari University of Venice. While she was enrolled in some postgraduate courses, she began working in her family's jewelry business as a designer and obtained her master's degree in industrial design from Padua's Italian School of Design. Her work has been featured in a number of shows and exhibitions, and she has been nominated for several prestigious prizes, including Best Young Designer of Italian Jewelry at the 2009 Italian Jewelry Awards.

If you didn't specialize in jewelry, what would you be?
An architect or interior decorator.

If you could work with only one material, what would it be?
At this stage of my life, I would choose titanium.

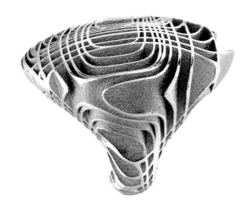

1

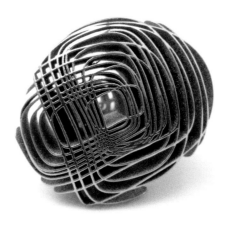

2

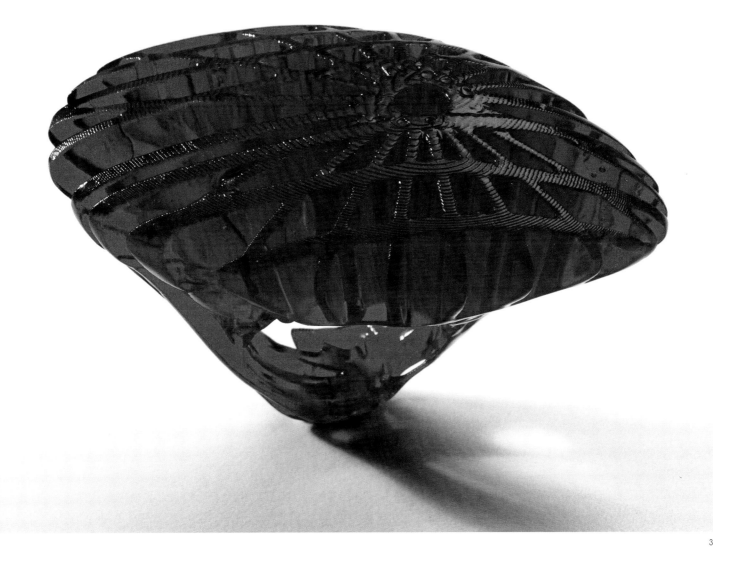

3

1-2. *Digital* ring
Titanium

3. *Crystal 11* ring
Biocompatible resin

521

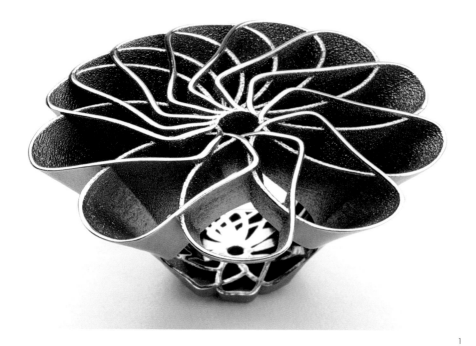

1

2

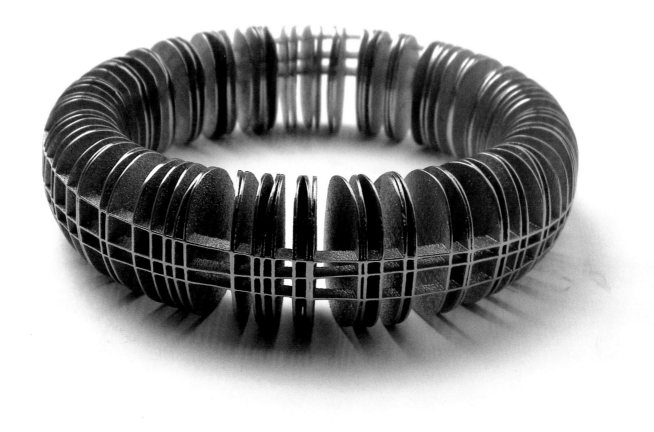

1. *Sponge 76* ring
Stellite

2. *Silk 12* ring bracelet
Titanium

3. *Silk 51* bracelet
Titanium

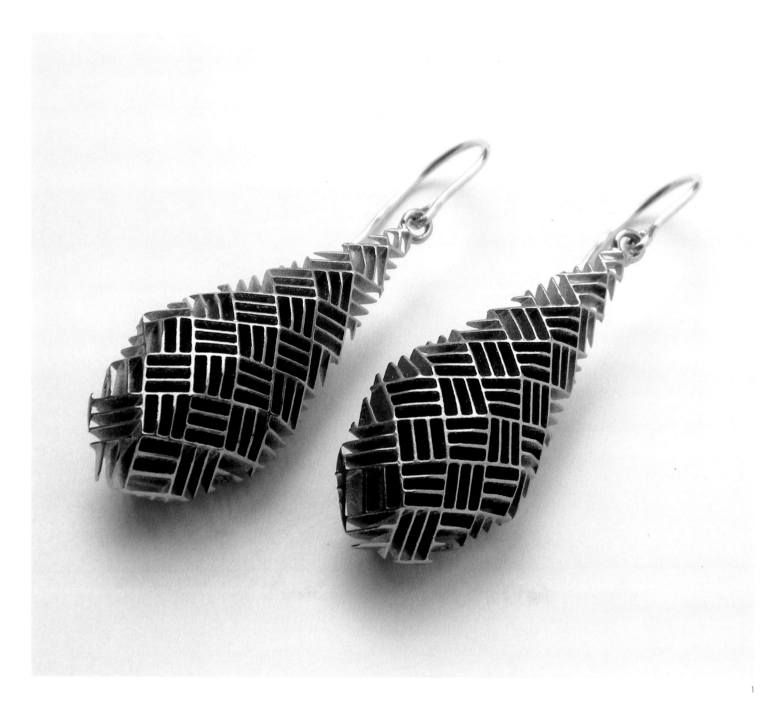

1. *Diamond* earrings
Anodyzed titanium

2. *Diamond* ring
Anodyzed titanium

3. *Crystal 76* ring
Stellite

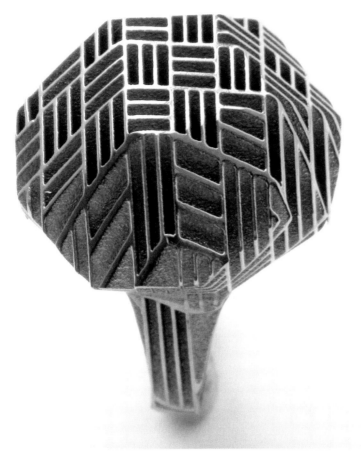

1

2

3

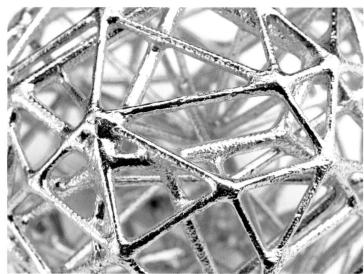

4

1. *Ottagonale* necklace
Silver

2. *Trapezium* necklace
Silver

3-4. *Crystal* brooch
Silver and gold

5. *Sponge 25* ring
Biocompatible resin
and diamonds

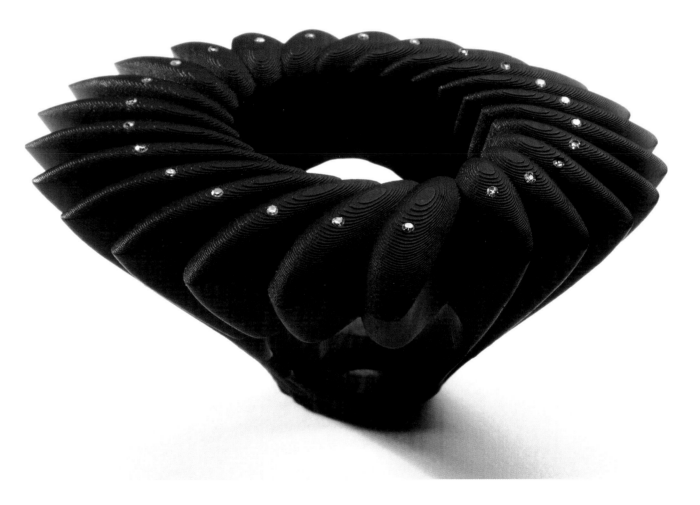

Stéphanie Barbié

stephaniebarbie-joyas.blogspot.com

Stéphanie Barbié was born in France in 1972, and has been living and working in Barcelona since 2004. She lived in Réunion, the French island outpost off Madagascar, for three years, where she studied anthropology and started to sell handcrafted items at local markets. After traveling in Australia, she returned to France and spent a few years creating decorative objects in resin. She then moved to Barcelona, where she studied jewelry at the Escola Massana. Since 2008, she has taken part in the *Sensational Jewelry* project coordinated by Silvia Walz. She currently gives classes on resin at various workshops in Barcelona and at the Escola Massana. Barbié's work as a jeweler en-ables her to continue her anthropological research from another angle; her pieces focus on relationships between people, with the environment, and with material, driven by a desire to understand the world around her

If you didn't specialize in jewelry, what would you do?
If I weren't interested in jewelry, I would like to be in theater.

Describe your work space in three words.
Refuge, exile, indoors.

1

2

1. Brooch
Resin and German silver

2. *Lo olvidado* necklace
Amber, silver, and resin

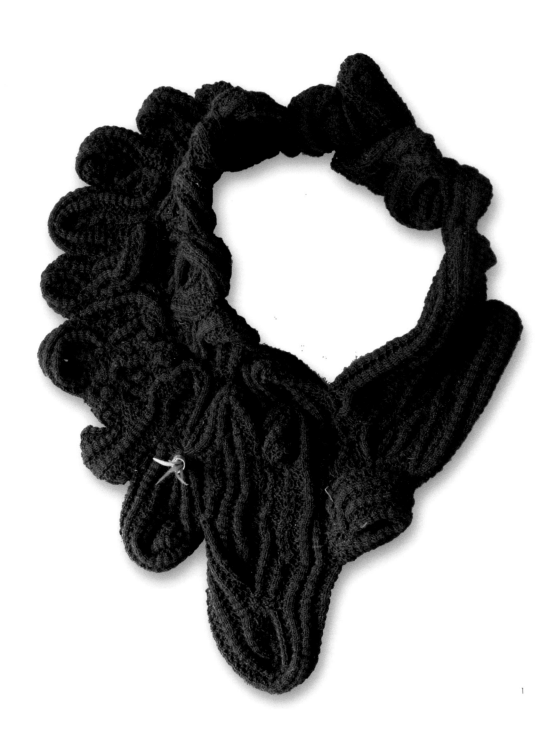

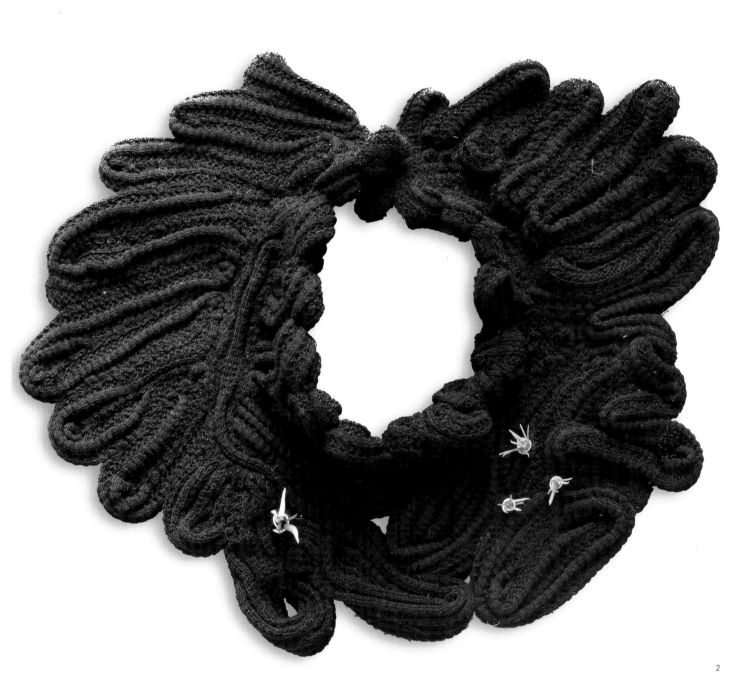

2

1. Necklace
Recycled cloth, plastic, and
silver

2. Necklace
Recycled cloth, plastic, and
silver

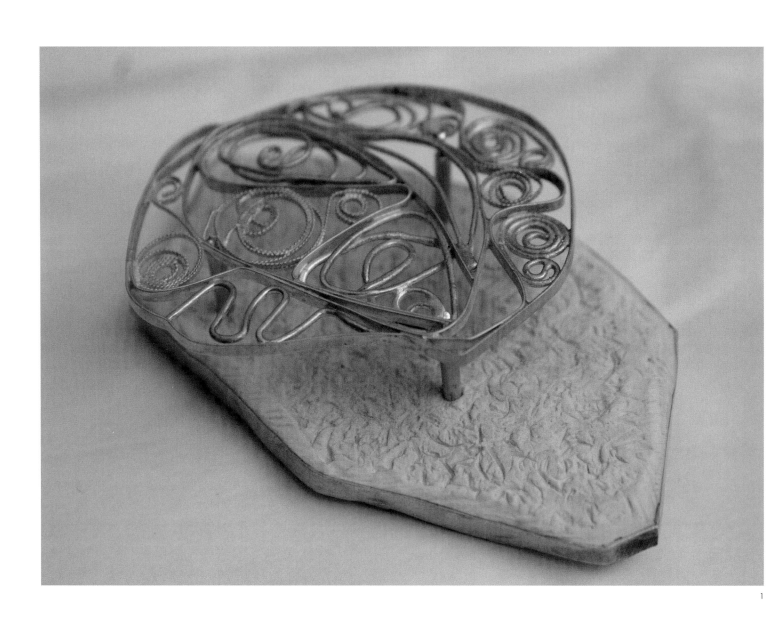

1

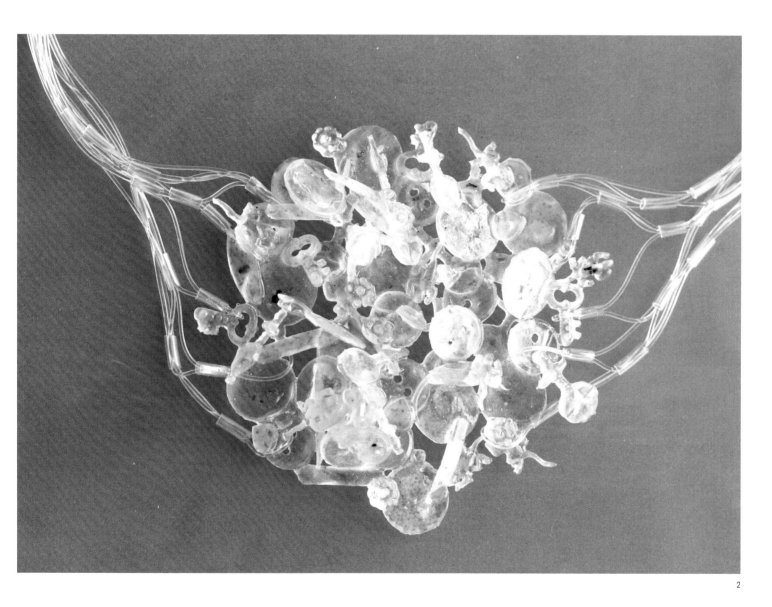

2

1. Brooch
Ecological resin and silver

2. Necklace
Resin, amber, and silicone

533

Susanna Loew

www.design-loew.de

Susanna Loew was born in 1966 in Idar-Oberstein, Germany. Her studies at the University of Applied Science in Pforzheim, Germany, and at the Royal College of Art in London provided her with a solid background in both jewelry and art. For her creations, she works with layers of gold, silver, or platinum, which she works until they are as fine as paper and as soft and fluid as cloth. This enables her to manipulate metals as if they were foil to obtain unique shapes and structures. Her work has won major awards including the Inhorgenta Innovation Award in Munich, Germany, in 2006, and the Inhorgenta Special Platinum Award in 2008. Her pieces have also been featured in many galleries and public and private collections in Europe and the United States.

If your work involved music, what style of contemporary music would you classify it as?
A mix of free jazz and world music.

If you had to describe your workplace in three words, what would they be?
Head, heart, and hands—which is to say that I can work anywhere, so long as I have a minimum number of tools and a thin layer of silver.

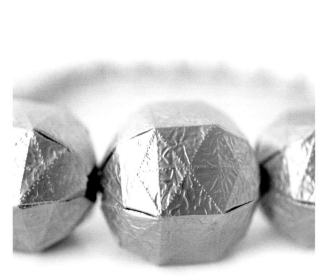

1

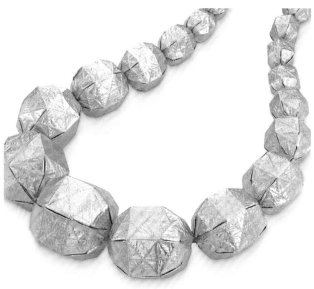

2

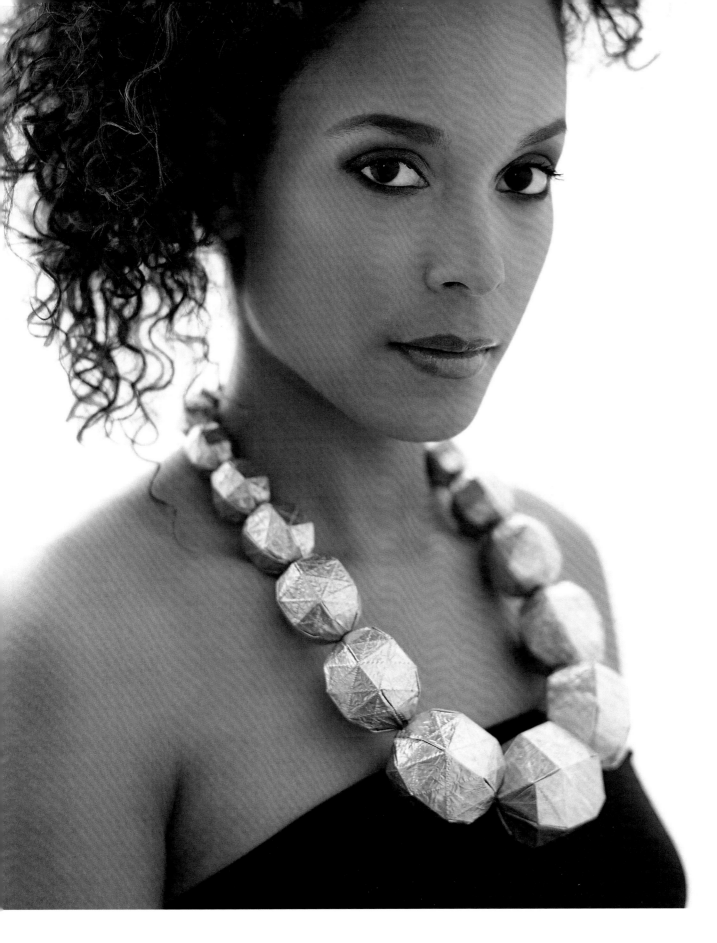

1-3. *Stella* **necklace**
Thin layers of folded
platinum

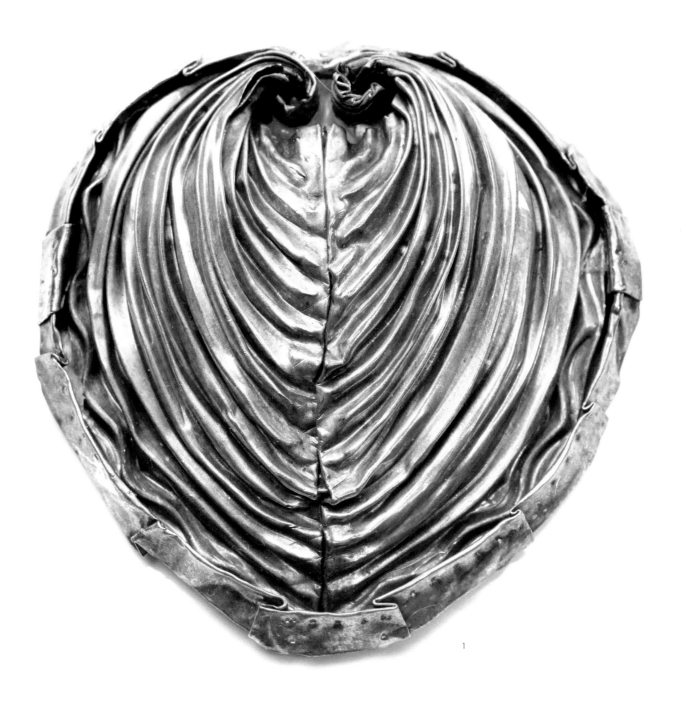

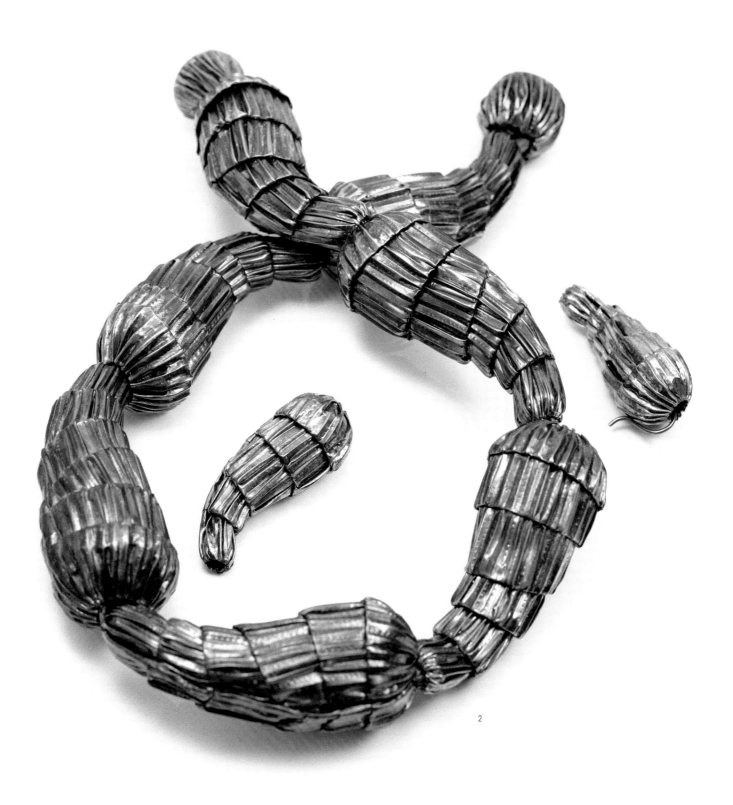

2

1. *Heartshell* brooch
Silver 999 and 935

2. *Coral* large necklace
Silver 999 and 935, silk, and
magnet

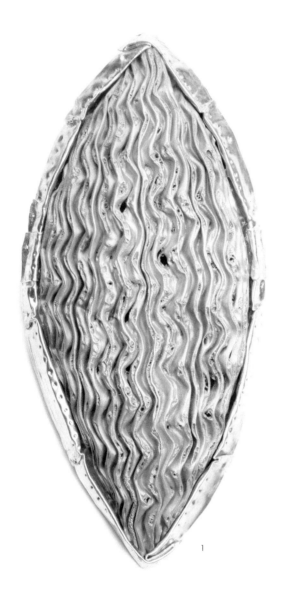

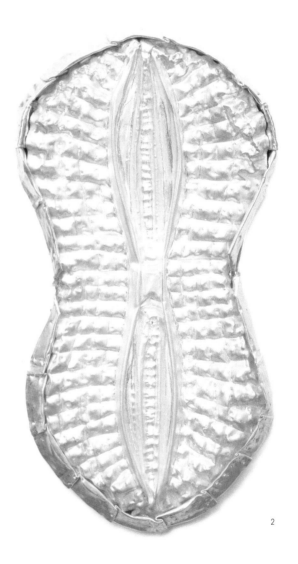

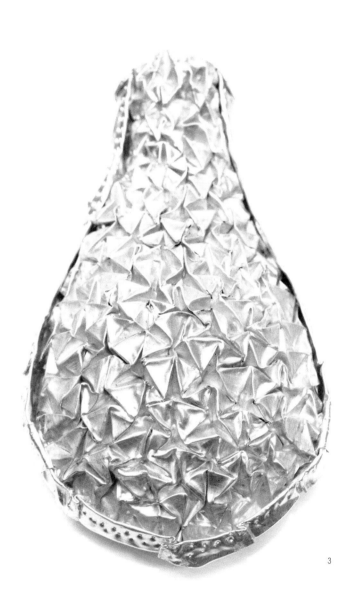

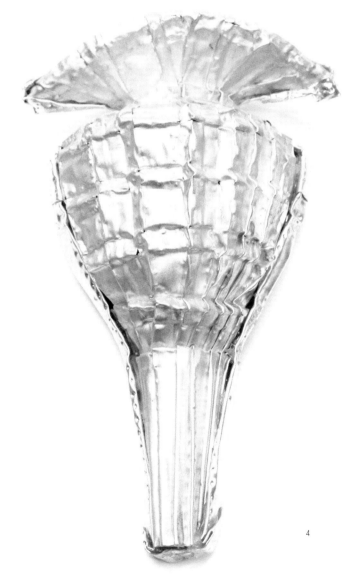

3

4

1. *Wave* brooch
Silver 999 and steel

2. *Diatomeea* brooch
Silver 999 and steel

3. *Sponge* brooch
Silver 999 and steel

4. *Poppy* brooch
Silver 999 and steel

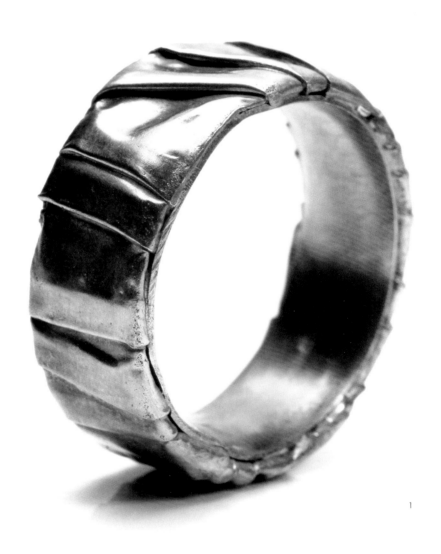

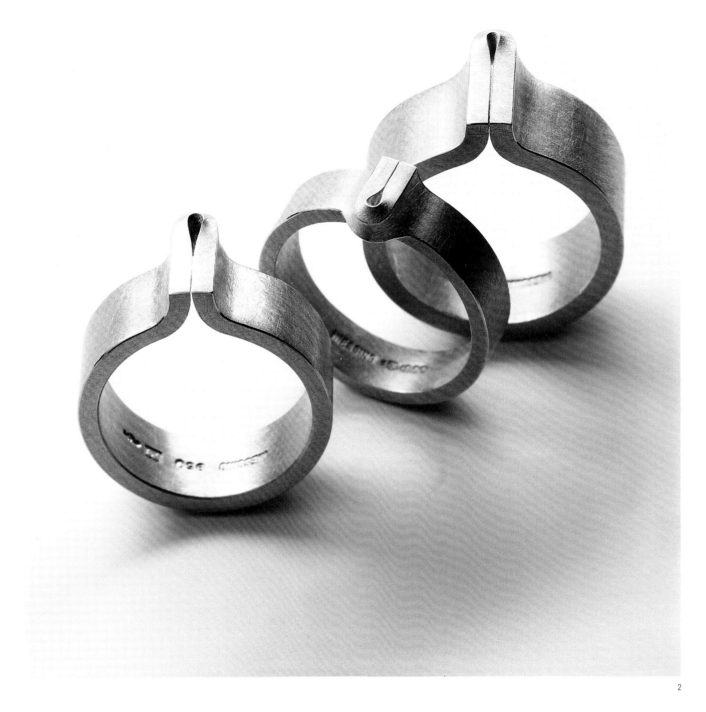

1. *Loew* ring
White gold and yellow gold

2. *Loew u-turn* rings
White gold and yellow gold

Taisuke Nakada

nakada-jewelry.qee.jp

1

Japan's Taisuke Nakada graduated in 2004 from the Hiko Mizuno College of Jewelry in Tokyo. For several years he worked repairing jewelry and watches, while continuing his training at Le Arte Orafe jewelry school in Florence. His individualistic designs have won him a place in international fairs including the Barcelona Contemporary Jewelry Week and Munich's Inhorgenta, where he won the Innovation Award in 2009. Taisuke aims to confer power with his pieces. With his *Syo-jin* ("accumulation") Collection, for example, he sets out to convey the importance of continual practice and effort to the achievement of success.

If you didn't specialize in jewelry, what would you be?
I would like to be a farmer because I really love working outside in the country.

If you could work with only one material, what would it be?
I would choose iron because while it looks as if it is very simple, it is in fact very powerful and has a great many facets. It is not the most glamorous of materials, but it helps many people in their everyday life. I feel an incredible power from iron, and that's why I like it so much.

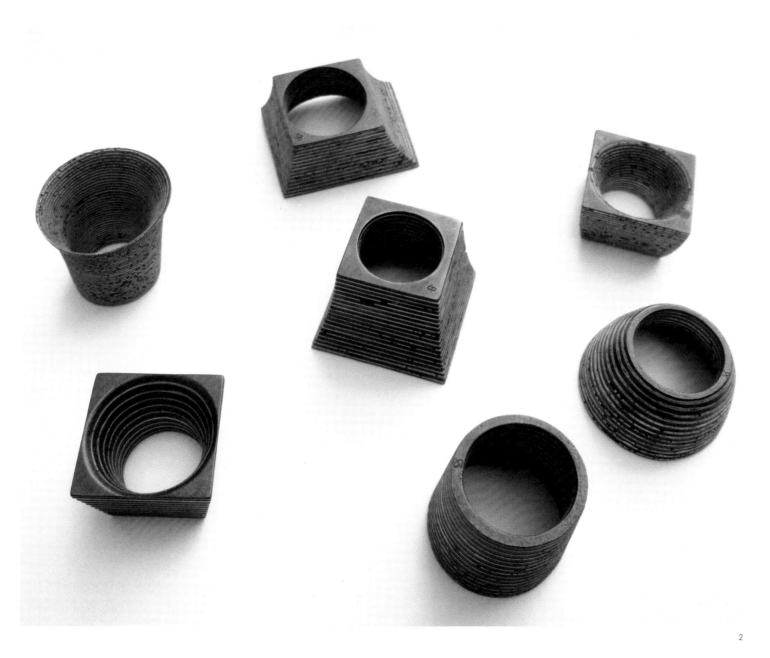

1. *Syo-Jin* ring
Iron and silver solder

2. *Syo-Jin* rings
Iron and silver solder

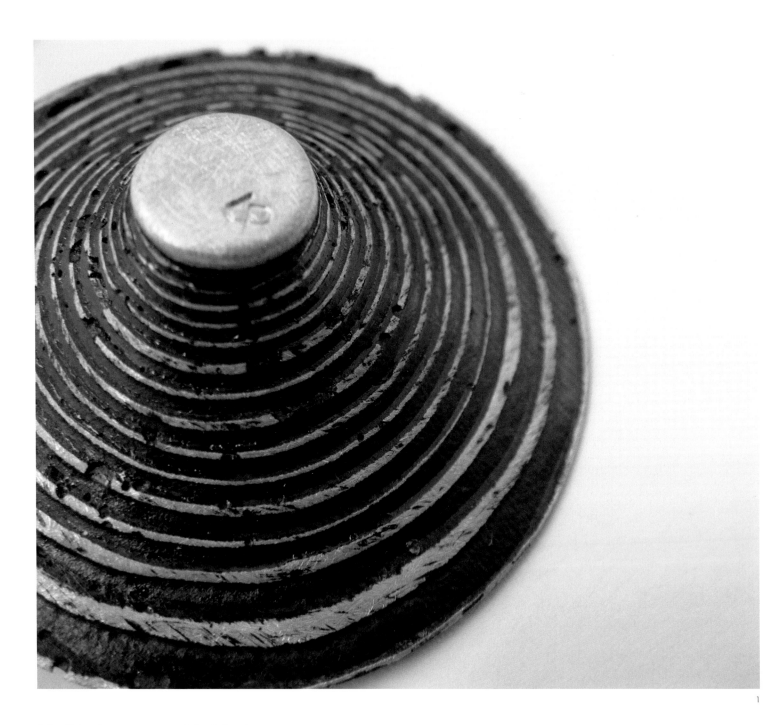

1. *Syo-Jin* brooch
Iron, silver solder, 18-karat
yellow gold, and silver 950

2. *Syo-Jin* brooch
Iron, silver solder, 18-karat
yellow gold, and silver 950

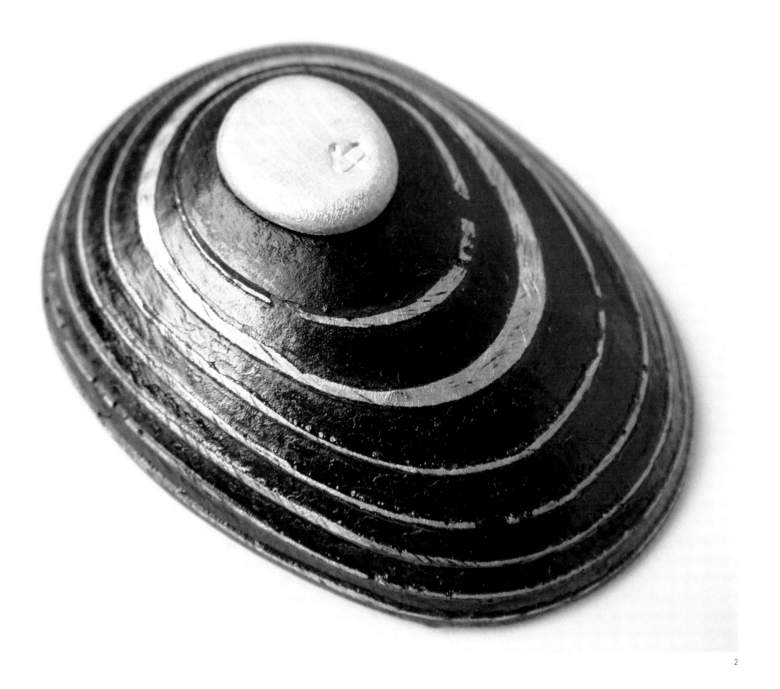

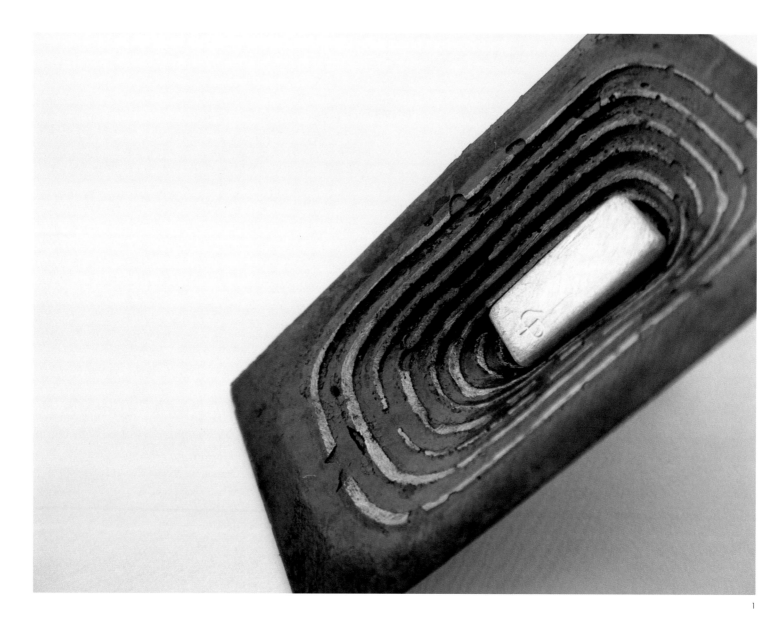

1

1. *Syo-Jin* brooch
Iron, silver solder, 18-karat
yellow gold, and silver 950

2. *Syo-Jin* ring
Iron and silver solder

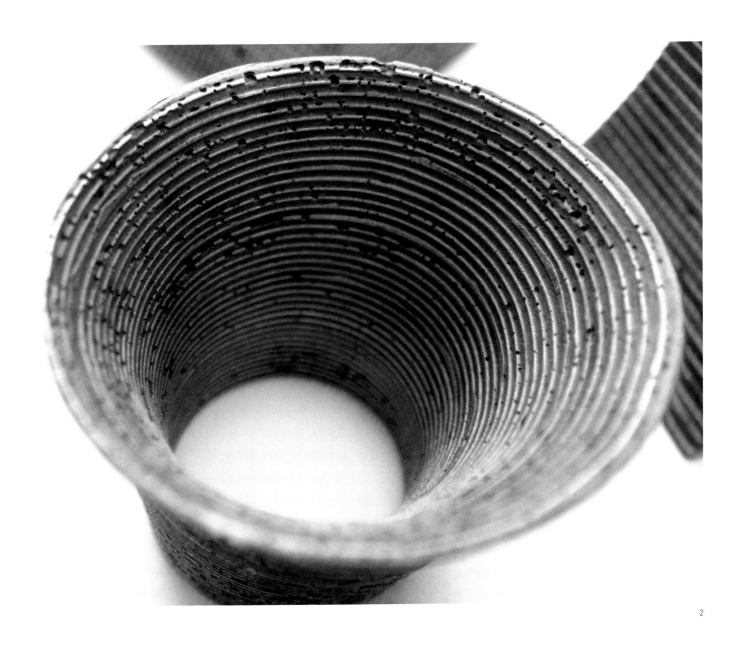

Tass Joies

www.tassjoies.com

Gloria and Gemma Miralles are the heart and soul of Tass Joies, and Sants is the district in Barcelona that has nurtured their creations over the past fifteen years. Gloria is the creator of the pieces, and trained at the School of Arts and Trades of Barcelona. Winner of the first Young Designer Award given by the Spanish Fashion Jewellery Manufacturers' Association, she has participated in several exhibitions and worked with various publications as well as on projects with a number of artisan jewelers. Tass enjoys experimenting with textures and finishes. Their work often features fired enamel, or silver and gold in contrast.

If you didn't specialize in jewelry, what would you be?
We think Tass has an inner world brimming with creativity

that we could only have developed experimenting in the world of fine art. Because of this, we might have worked in any number of media. We love to carry out projects with artists and professionals from other disciplines, create new synergies, and work together on new artistic proposals.

If you had to describe your workplace in three words, what would they be?
A small world teeming with ideas, with sketches, unfinished pieces, excitement, and love for craftwork.

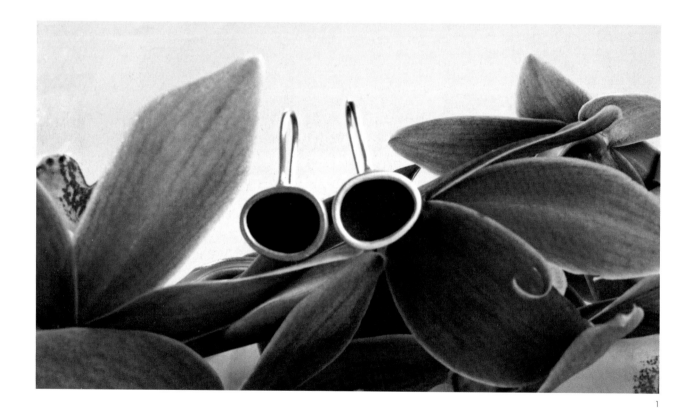

1

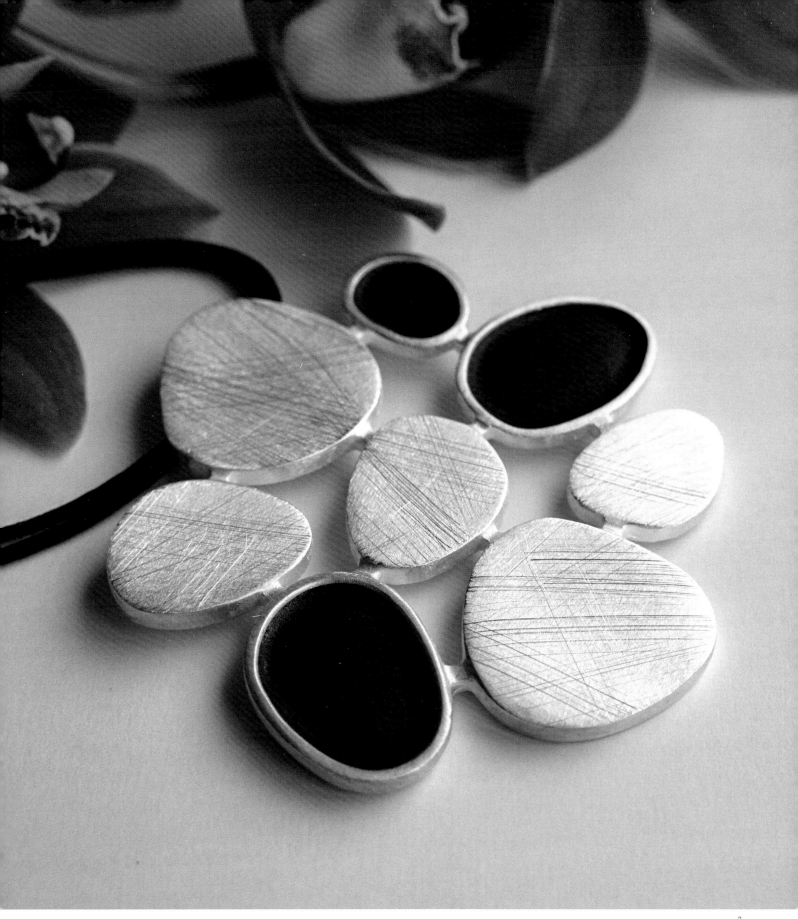

1-2. *Rocks* **earrings and pendant**
Diamond plated silver and black
matte enamel

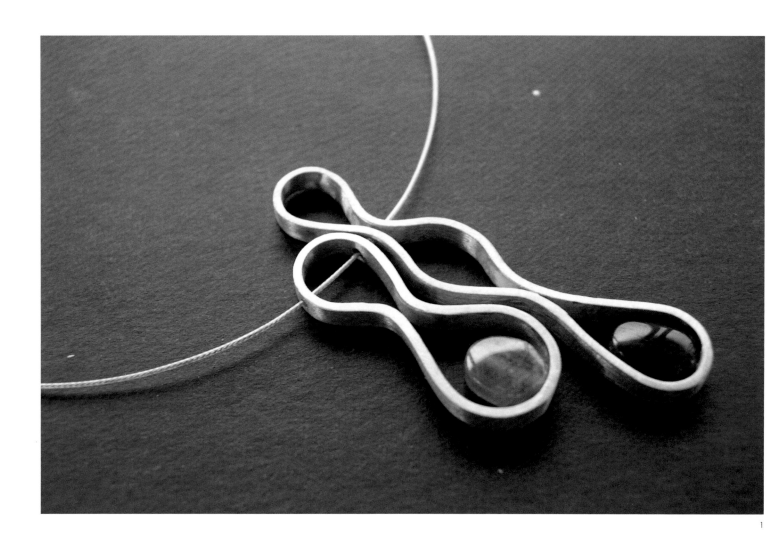

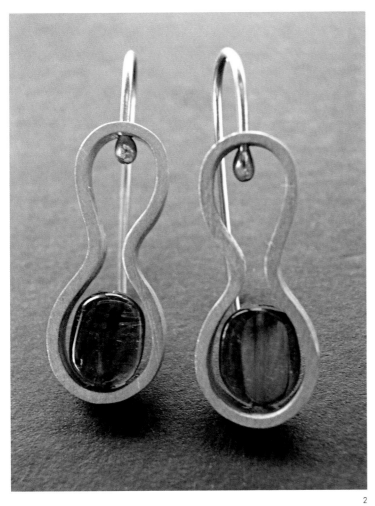

2

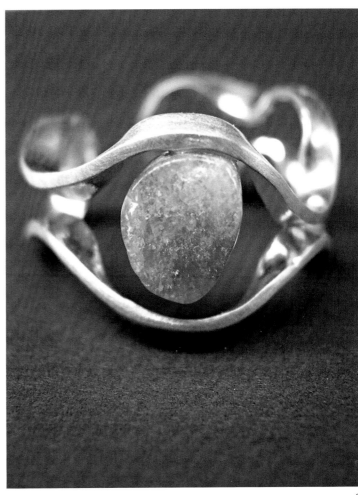

3

1-3. *Infinit* **pendant,
earrings, and ring**
Spirals in gold, flanked and
decorated with pink and
green tourmalines

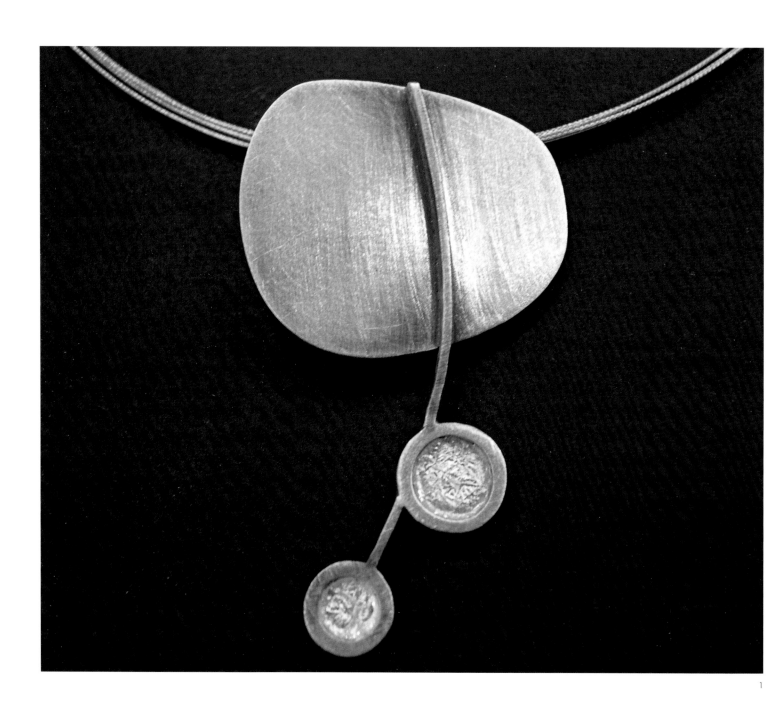

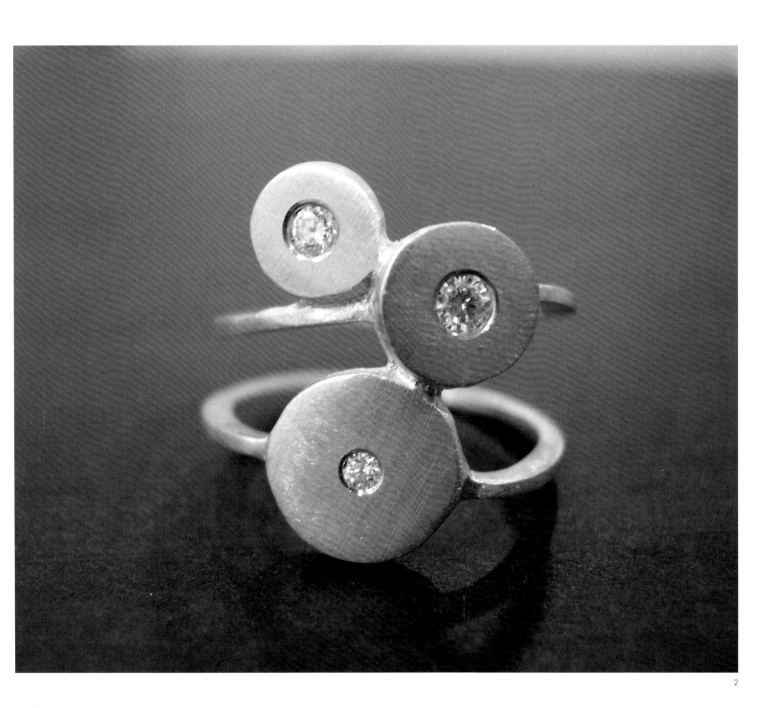

1-2. *Ra* pendant and ring
Tinged silver and goldleaf

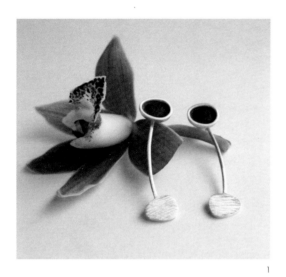

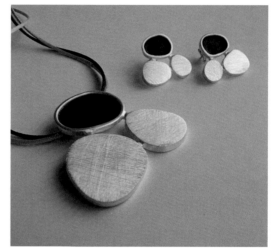

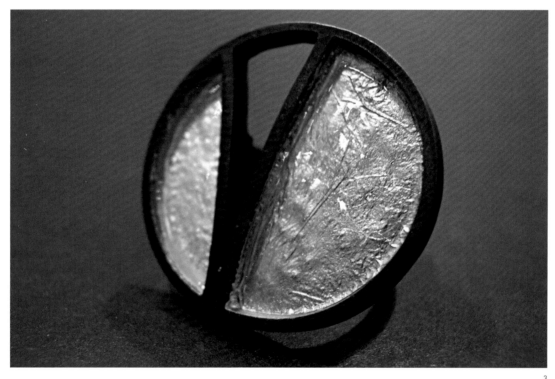

1. *Rocks* **earrings**
Diamond plate and black matte
enamel

2. *Rocks* **earrings and pendant**
Pieces of diamond plated silver
and black matte enamel

3. *Geometric* **ring**
Oxidized silver, goldleaf,
and enamel

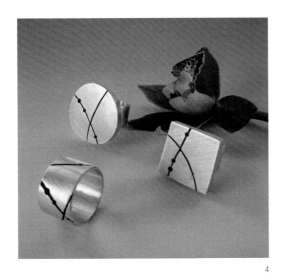

4

5

6

4. *Links* rings
Matte and oxidized silver

5. *Links* pendant
Matte and oxidized silver

6. *Lia* pendants
Oxidized silver

Teresa Estapé

www.teresaestape.es

Teresa Estapé studied fine art at the University of Barcelona and jewelry at the Escola Massana. Since 1997 she has devoted her energies to small-scale sculpture and contemporary jewelry. In 2001, she moved to Madrid and spent five years working with Helena Rohner, a designer of objets d'art and jewelry. In 2006, she returned to Barcelona and began to include engraving and collage techniques in her projects. Today, her soulful, creative objects are winning growing acclaim from those drawn to the animistic fantasy world she invokes. Her work is a spontaneous dialog between space, chance, and the artist, reinterpreting the past as a celebration of the continuous return to life.

If you weren't involved in jewelry, what would you like to be?
If I wasn't interested in jewelry, I would like to be an industrial engineer.

If your work involved music, what style of contemporary music would you classify it as?
It would be blues.

1

1. *Delicado bestiario* necklace
Brass, cornelian, and silver

2. *Cazatiempos* pendants
Gold, silver, coral, and watch pieces

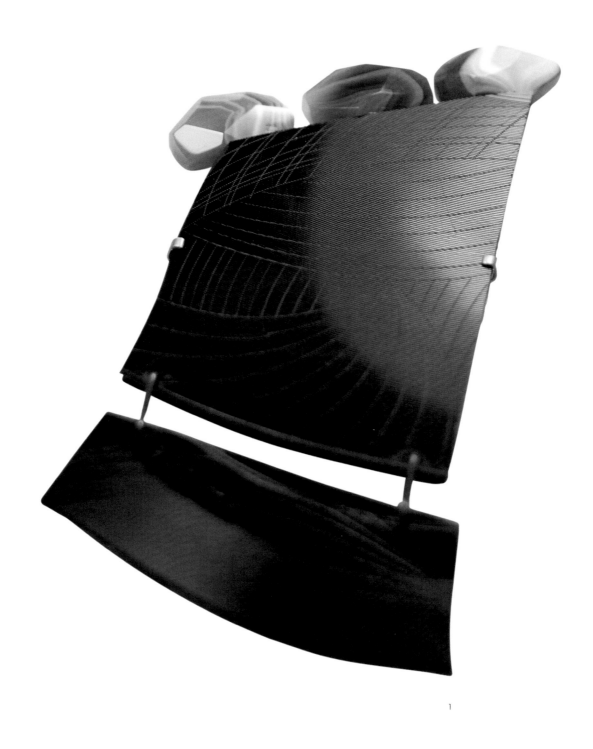

1

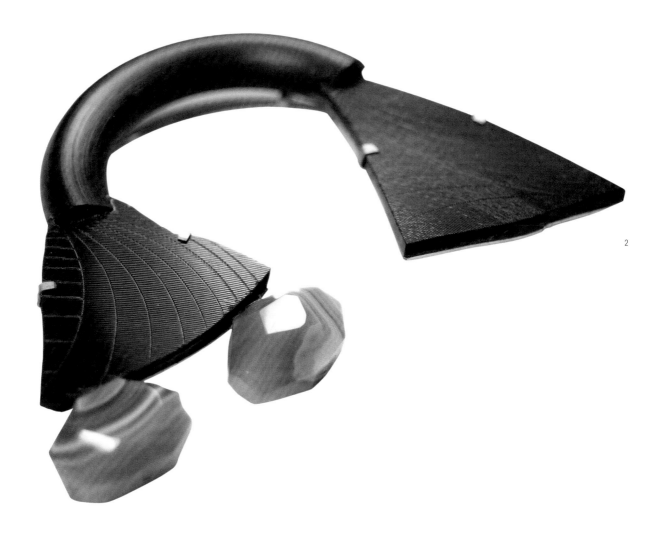

2

1-2. *Viaje* **brooches**
Bakelite, silver, German silver,
agate, and ebony

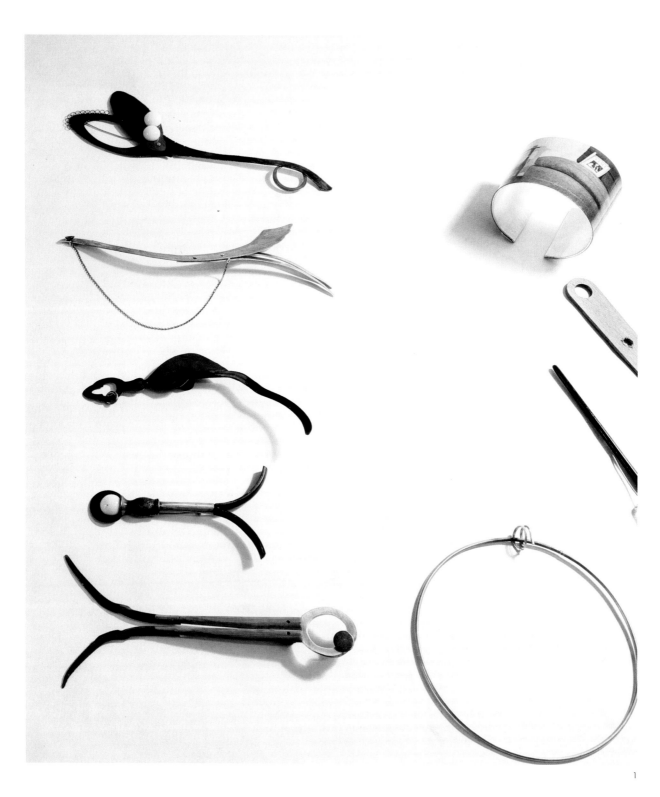

1-3. *Animalario* pieces
Brass, silver, bone, and wood

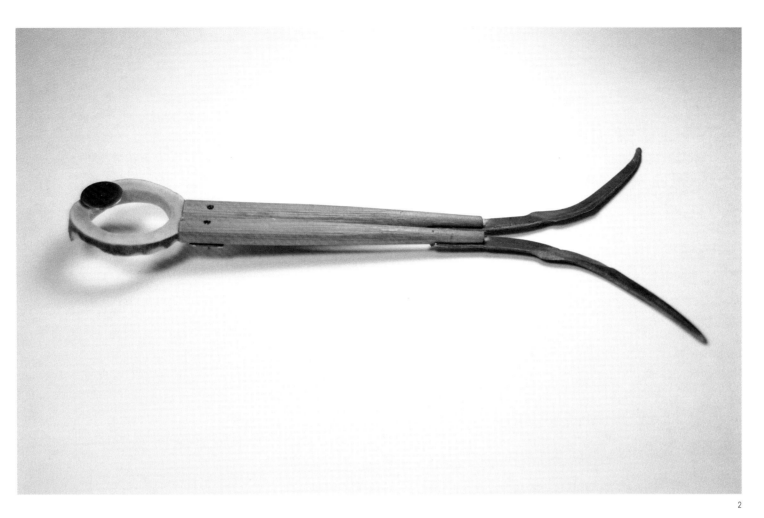

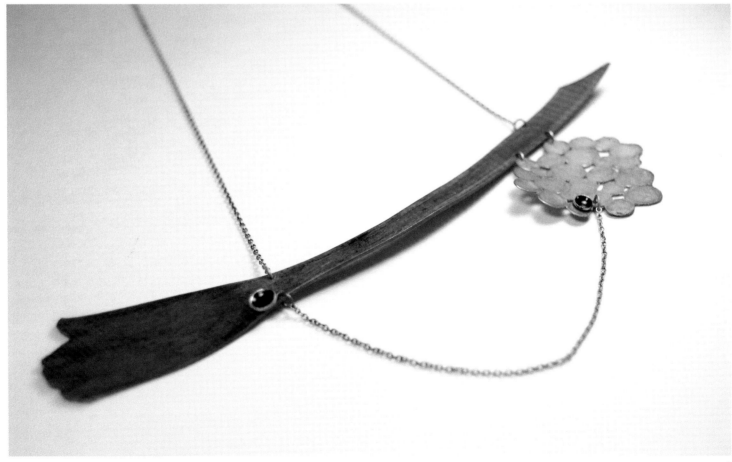

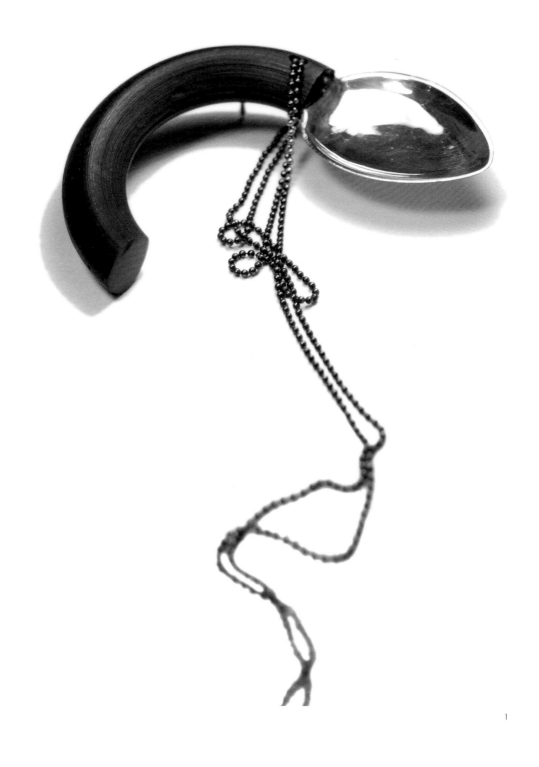

1

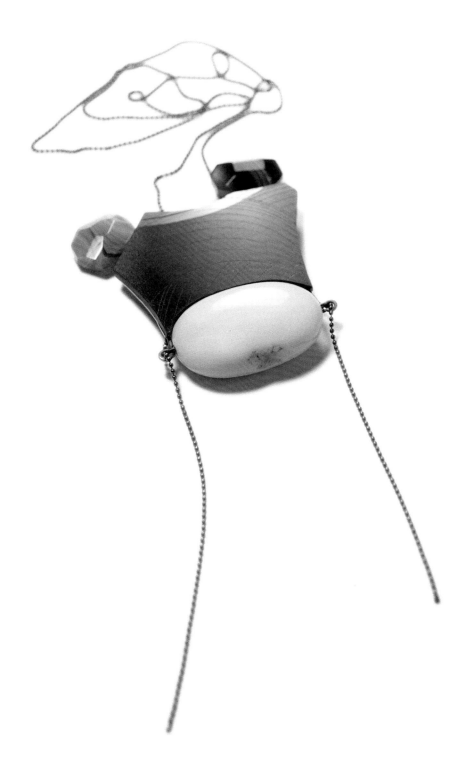

1-2. *Viaje* **pendants**
Bakelite, silver, German silver,
agate, and ebony

Ulla + Martin Kaufmann

www.ulla-martin-kaufmann.de

Siblings Ulla and Martin Kaufmann were born in 1942 in Hildesheim, Germany, and have been working together since 1961. Between 1958 and 1962 they trained as goldsmiths with Theodor Blume in Hildesheim and Carl Van Dornick in Wohldenberg. After working in Norway and France, they returned to Hildesheim and set up a goldsmiths' workshop on their parents' farm. Soon afterward, their work began to be featured at major jewelry fairs throughout Germany. As a result, they were asked to develop a cutlery line for Wilkens & Söhne, a silverware company in Bremen. The line they created, *Palladio*, has won numerous prizes and their partnership with the firm continues to this day. Both their jewelry and cutlery lines balance aesthetic vision with the requirements of mass production. Their pieces are notable for their large volumes and formal rigor.

If you could work with only one material, what would it be?
We are fascinated with gold. This inspired us to develop our own pieces from bands of gold, which was the conceptual starting point for everything that has followed.

1

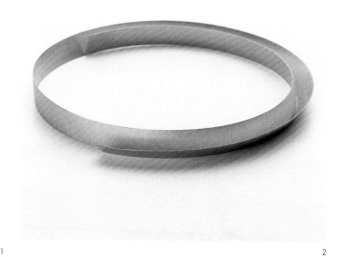

2

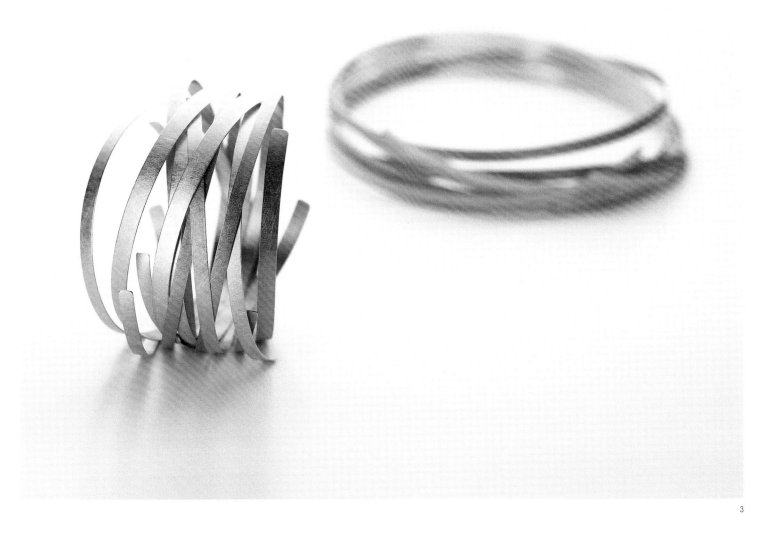

3

1. *Band* bracelet
Yellow gold 750

2. *Gespielgelt* necklace
Yellow gold 750

3. *Nest* bracelet and necklace
Yellow gold 750 and gray gold

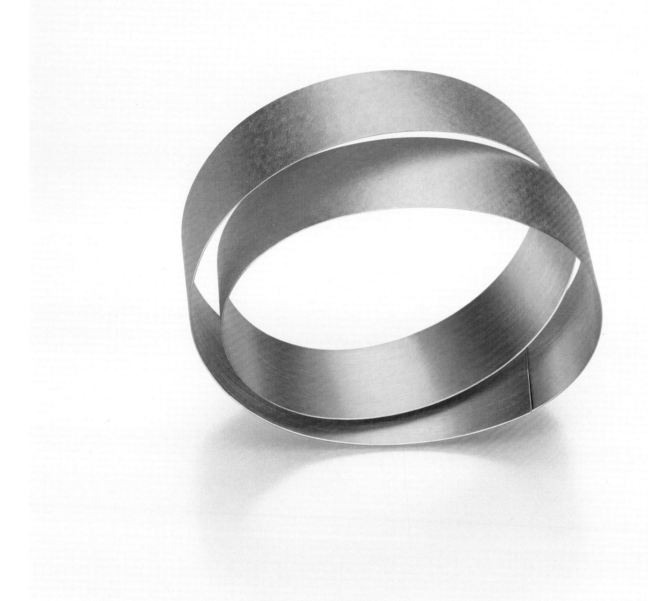

1. *Band* bracelet
Yellow gold 750

2. *Gewickelt* rings
Yellow gold 750 and gray
gold

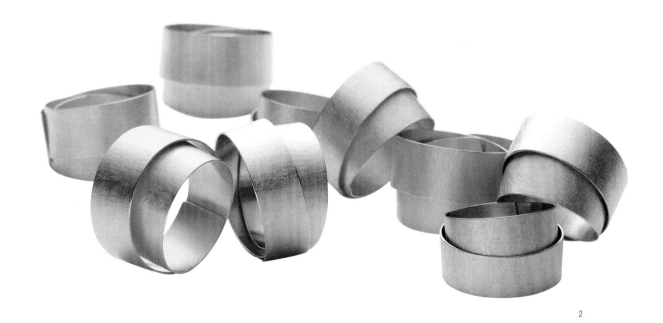

2

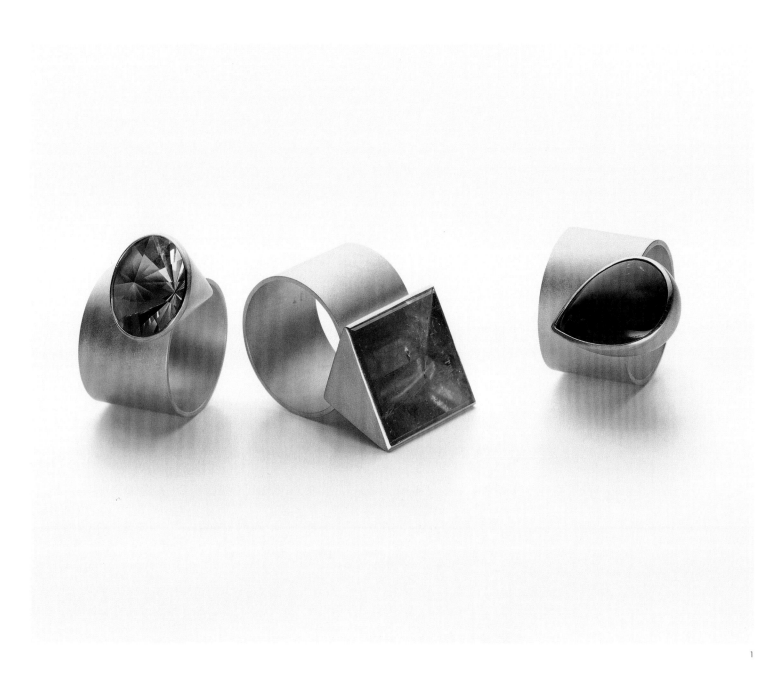

1. *Architektur* rings
Yellow gold 750, with citrine
quartz and tourmaline stones

2. *Gespiegelt* bracelet
Yellow gold 750

1. *Spirale* bracelet
Yellow gold 750

2. *Welle* bracelet
Yellow gold 750

Verdeagua Alhajas

www.verdeagua-alhajas.com

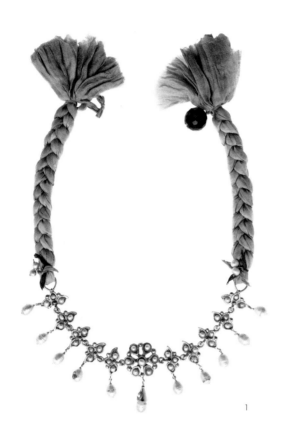

1

Spanish designer Virginia Abascal has always been fascinated by other cultures. After studying business administration in Spain and the United Kingdom and getting a master's degree in international relations in Amsterdam, she began her professional career in the diplomatic world. She nurtured a dream of working in jewelry, however, and opened her jewelry company in 2007. Her collections draw their inspiration from other cultures and are completely handmade following traditional methods. Her works makes great use of 24-carat gold-plated brass and semi-precious stones like amethyst, turquoise, jade, tourmaline, cultured pearls, and coral.

If you didn't specialize in jewelry, what would you be?
If I wasn't interested in jewelry, I would like to be a contemporary dancer. I have always liked moving to music and feeling as if my whole body has fused with its rhythms.

If you had to describe your workspace in three words, what would you say?
My workspace is eclectic, peaceful, and inspiring.

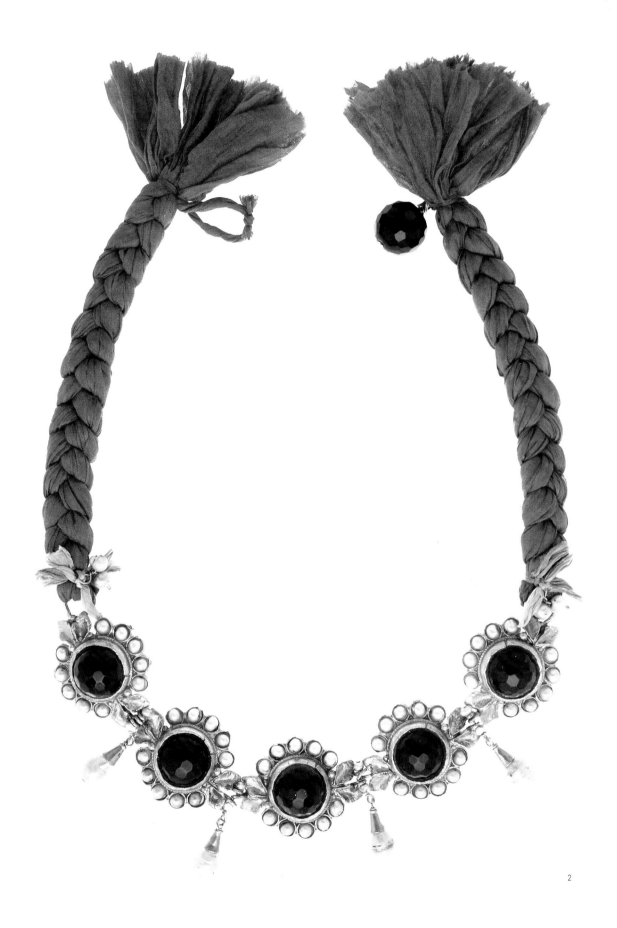

2

1. *Mandala* necklace
24-karat gold-plated brass,
pearls, jade, and natural silk

2. *Black camellia* necklace
24-karat gold-plated brass,
pearls, jade, and natural silk

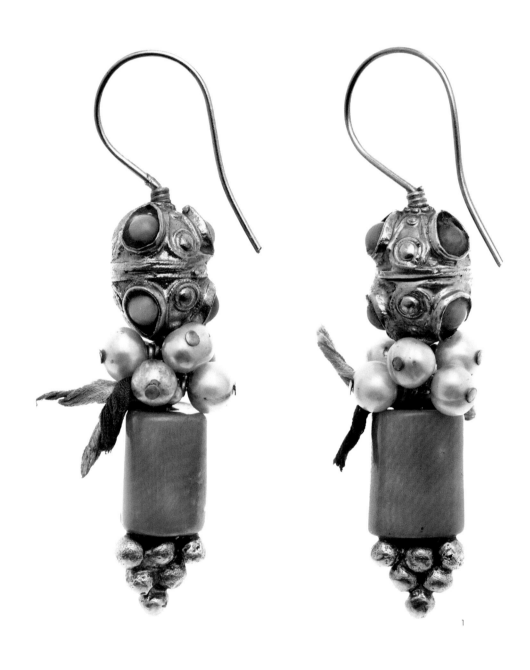

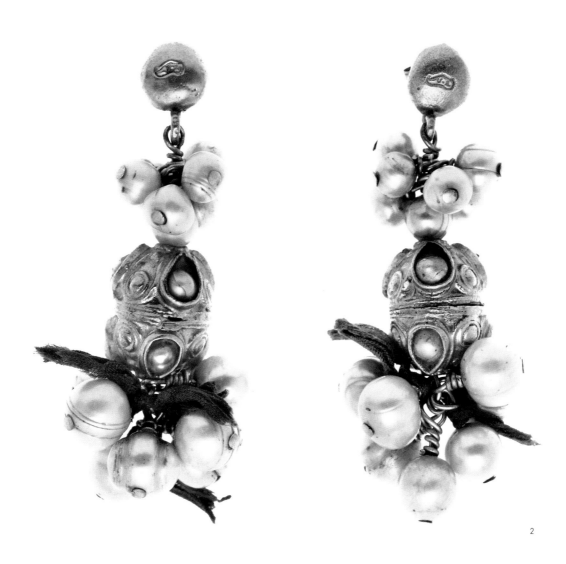

2

1. *Kerala* earrings
24-karat gold-plated brass
with coral and cultured
pearls

2. *Manila* earrings
24-karat gold-plated brass
with cultured pearls and silk
details

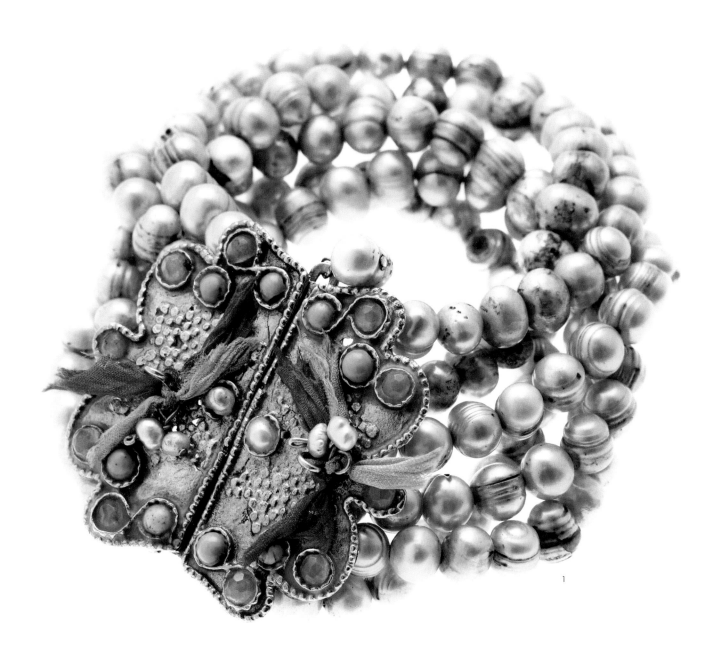

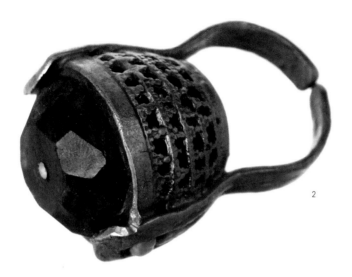

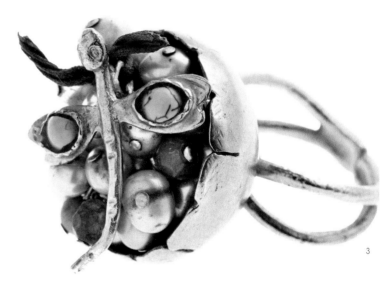

1. *Rome* bracelet
Five rows of cultured pearls,
24-karat gold-plated brass
clasp, fuchsia jade, and
turquoise

2. *Smoke* ring
24-karat gold-plated brass
with gray quartz

3. *Nido* ring
24-karat gold-plated brass
with semiprecious stone
details and dragon fly

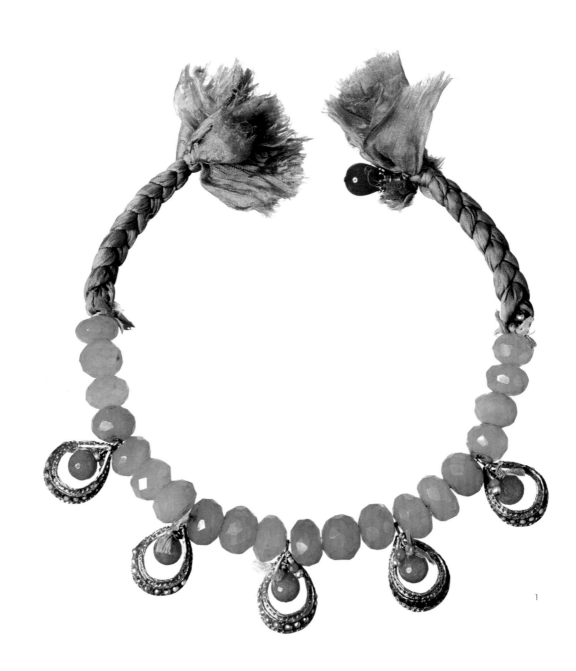

1

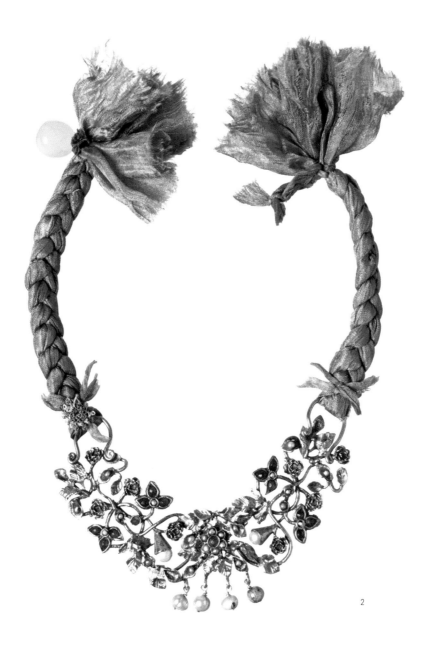

2

1. *Mil y una noches* **necklace**
24-karat gold-plated brass, aqua
quartz, fuchsia jade, and silk

2. *Tiara* **necklace**
24-karat gold-plated brass, cultu-
red pearls, semiprecious stones,
and silk

Viviana Carriquiry

www.vivianacarriquiry.com.ar

1

Viviana Carriquiry was born in Argentina in 1970. Although she initially studied architecture, she eventually enrolled in the Municipal School of Jewelry, where she studied under the wing of Jorge Castañón. In 2003, after perfecting her technique, she and the designer Paula Levy opened a contemporary jewelry studio in Buenos Aires Carriquiry, as well as taken part in solo and group exhibitions in Argentina, China, Mexico, and the United States. She uses design and experimentation to express herself without any stylistic or formal limitations, developing unique pieces and small collections.

If you didn't specialize in jewelry, what would you be?

I would be an architect, because I studied for this degree but set it aside to pursue a career in jewelry. But this is where all my training came from, along with many of my friends.

If you could work with only one material, what would it be?

That's a difficult question, but at this stage in my life I need to work with material that I can really change, so I would probably pick a soft material like cotton or wool.

1. *Mokume* rings
Silver 925 and mokume

2. *C'est la vie* ring
Silver 925, oxidized copper,
and German silver

1-2. *C'est la vie* **earrings**
Chain made of silver 925
and oxidized German silver

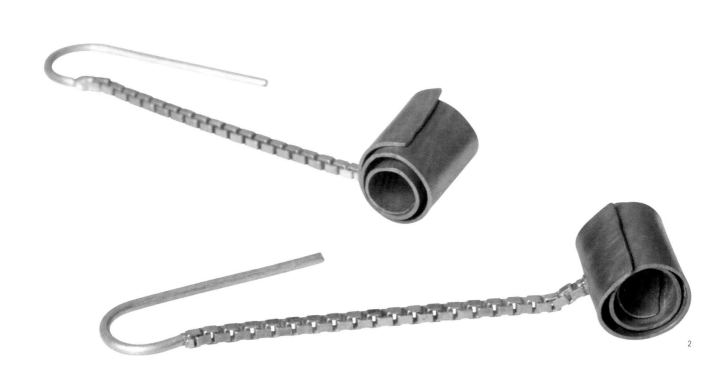

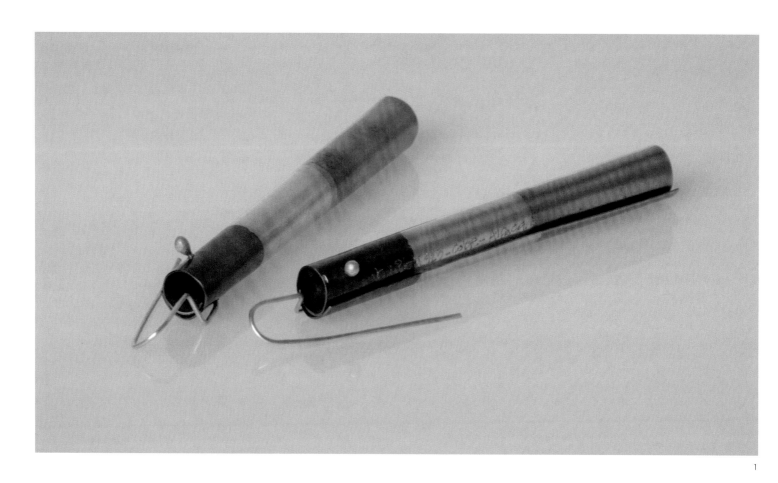

1. *Long c'est la vie* earrings
Silver 925, oxidized copper,
and German silver

2. *C'est la vie* pendant
Silver 925, oxidized copper,
and German silver

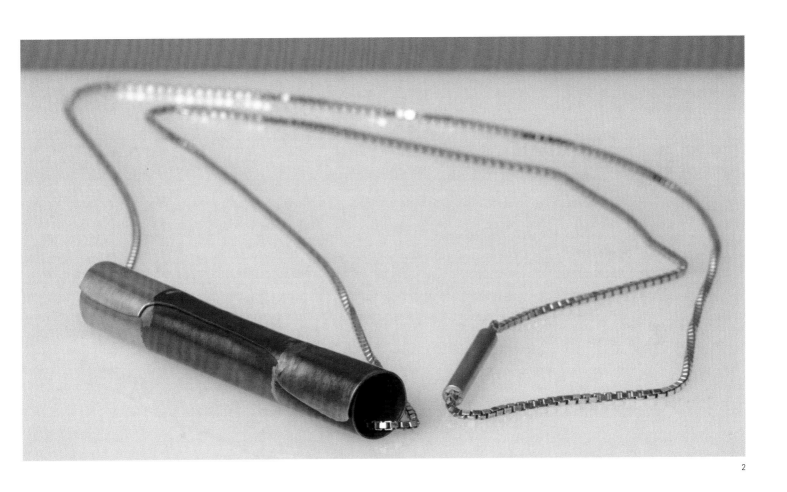

Walter Chen

www.monteazulestudio.com

1

A Taiwanese creator of jewelry and objets d'art, Walter Chen has lived and worked in Barcelona since 1997. He graduated from the Escola Massana, where he majored in artistic and sculpted jewelry, and graduated from the Faculty of Fine Art at the University of Barcelona, where he enrolled for a Ph.D. His use of paper, bamboo, and silk reflect his study of the arts, design, and culture of the East; his work often invokes the evolution and growth of nature and seeks to capture the balance between fullness and void in objects emanating inner light. He has given several lectures on the relationship between thought, art, and lifestyles of the East.

If you didn't specialize in jewelry, what would you be?
I would restore documents and paintings on paper.

If you could work with only one material, what would it be?
Organic material.

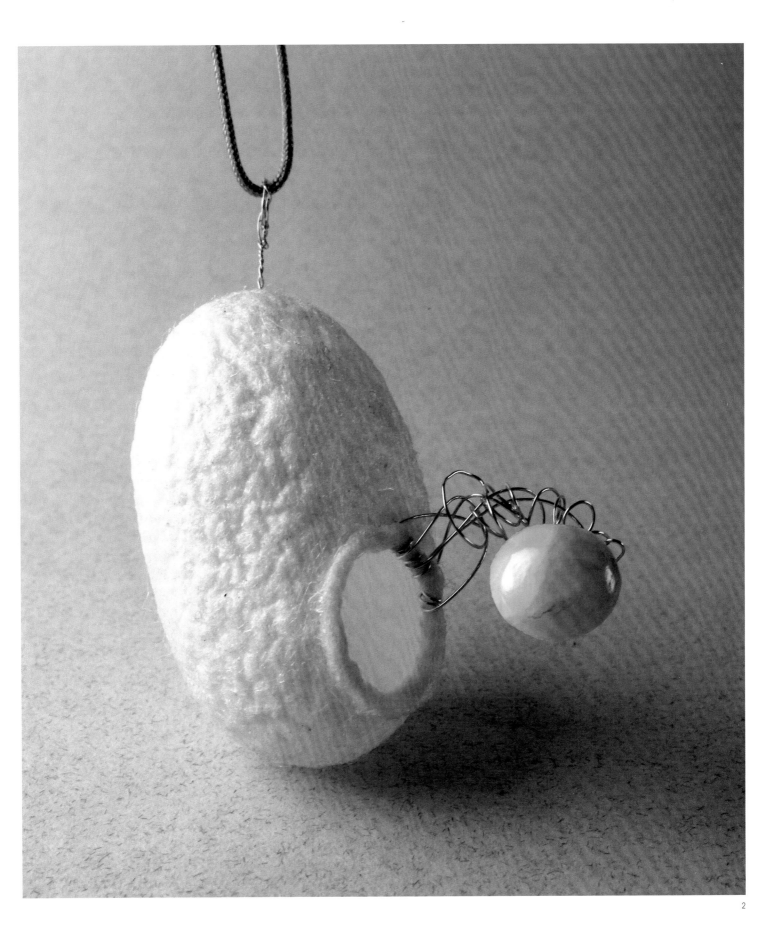

1. *Diálogo del alba* **necklace**
Sterling silver, rough
diamond, and saffron

2. Pendant
Natural silk, gold thread,
jadeite, and silver thread

2

587

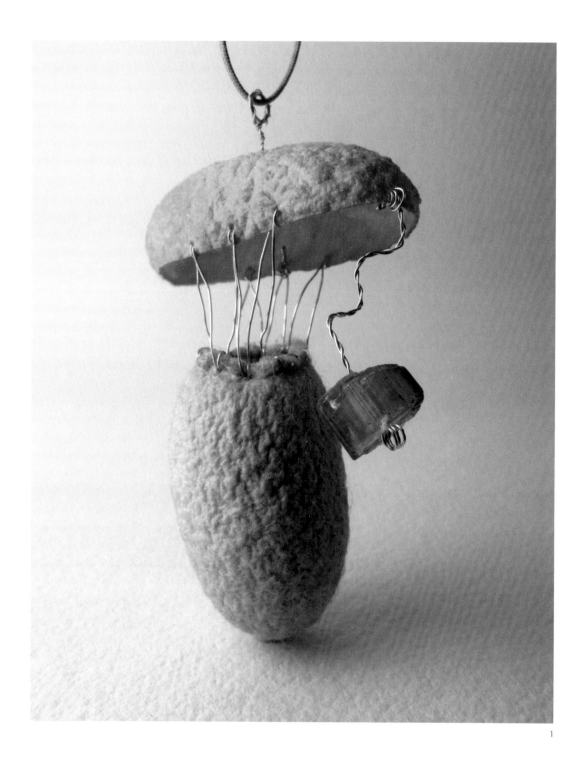

1

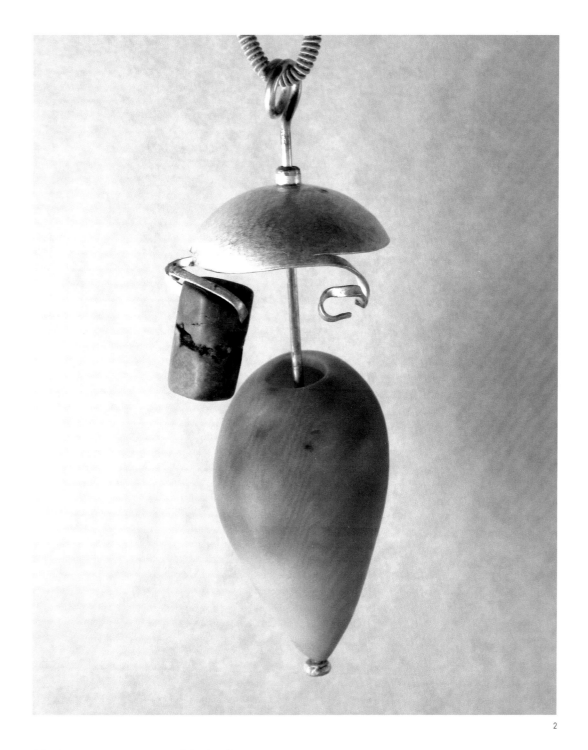

2

1. Pendant
Natural silk, gold thread,
rough tourmaline, silver
thread, natural saffron, and
spinach dye

2. *Laud* pendant
Sterling silver, tourquoise and
Ecuadorean ivory palm seed

589

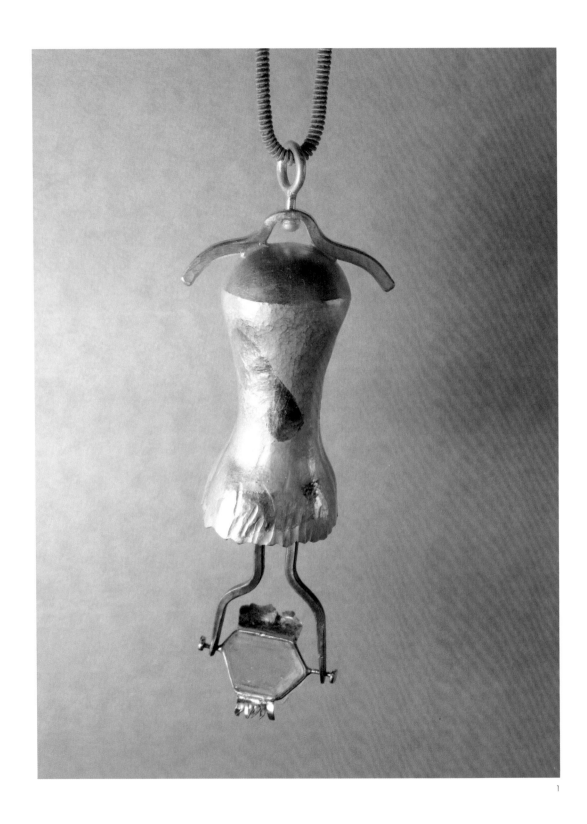

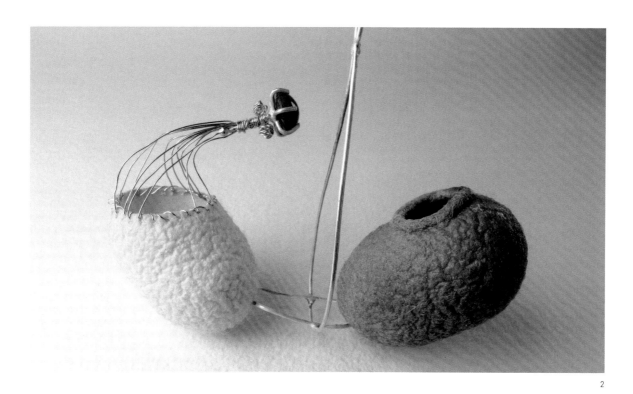

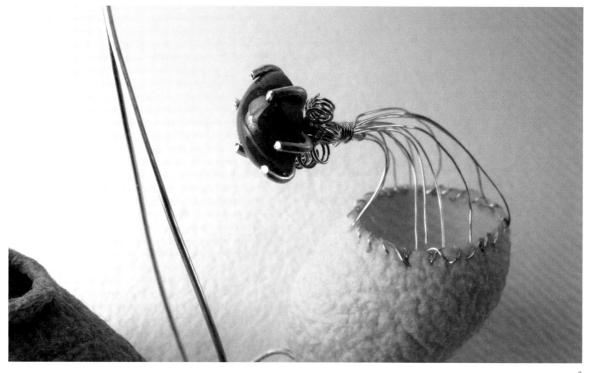

1. *Ten* pendant
Sterling silver, gold, and
aquamarine

2-3. Pendant
Natural silk, gold thread, ruby,
sterling silver, natural saffron,
and red cabbage dye

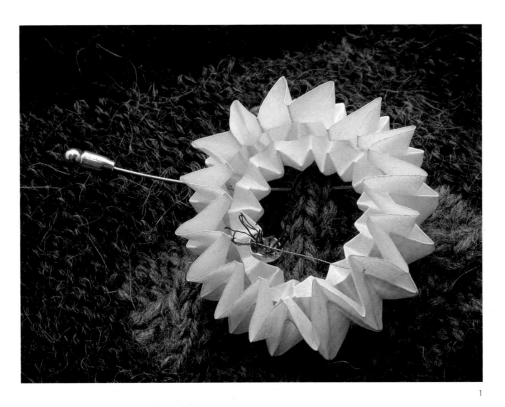

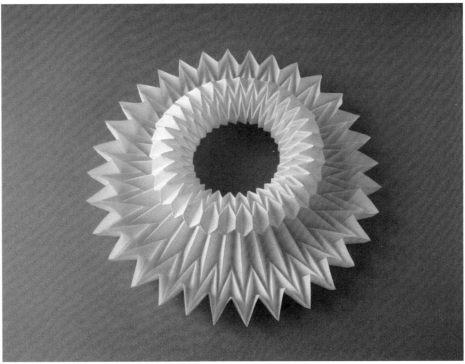

1. Brooch
Card, sterling silver, and
saffron

2. Bracelet
Card

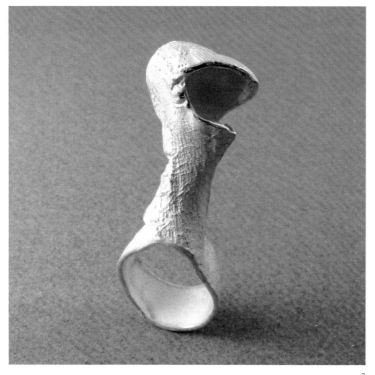

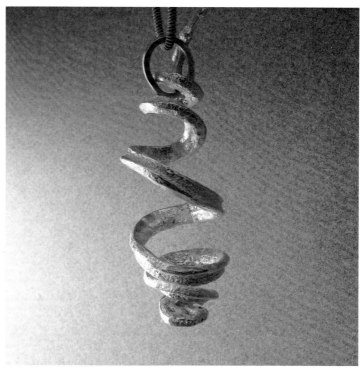

3

4

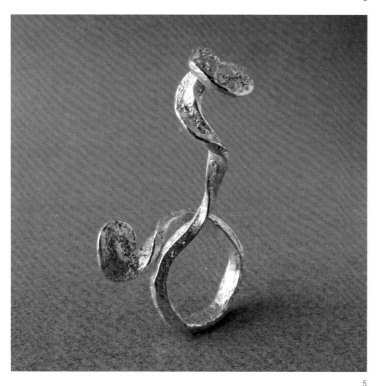

5

6

3. Ring
Sterling silver

4. *Textura naranja* **necklace**
Sterling silver

5. *Textura naranja* **ring**
Sterling silver

6. Pendant
Sterling silver

Yannik Mur

www.yannickmur.fr

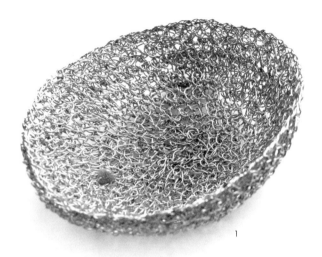

1

Yannick Mur was born in Aix-en-Provence, France, in 1963. For more than a decade she has presented a new collection every year at the Première Classe fair in Paris. Her collections stand out for the way they combine simple lines with precious and rough materials, giving her pieces a style that is simultaneously elegant and casual. Mur has been a recipient of the SEMA award and her pieces are exhibited at the Pompidou Center in Paris, the Museum of Contemporary Art in Chicago, the Museum of Decorative Arts in Paris, and the Takashimaya department store in Osaka, Japan. Her sense of artistic discipline can be seen in more than her jewelry: Mur has also taught classical dancing for more than fifteen years.

If you didn't specialize in jewelry, what would you be?
A perfume creator.

Describe your workspace in three words.
Nature, light, and travel.

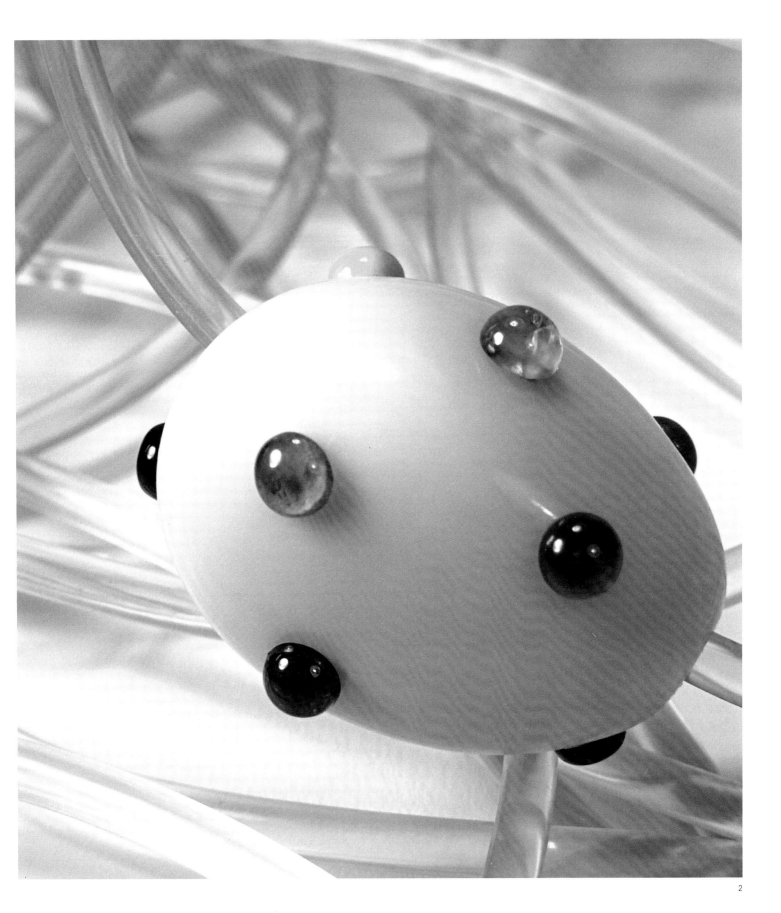

1. *Offrande* medallion
Compressed embroidery
handmade in 18-karat yellow
and white gold thread, with
5-karat rough diamond

2. *Plexivoir* necklace
Vegetable ivory seed in its
original form inlaid with
precious stone (topaz,
tourmaline, amethyst,
coralline, and onyx) and
silicone cord

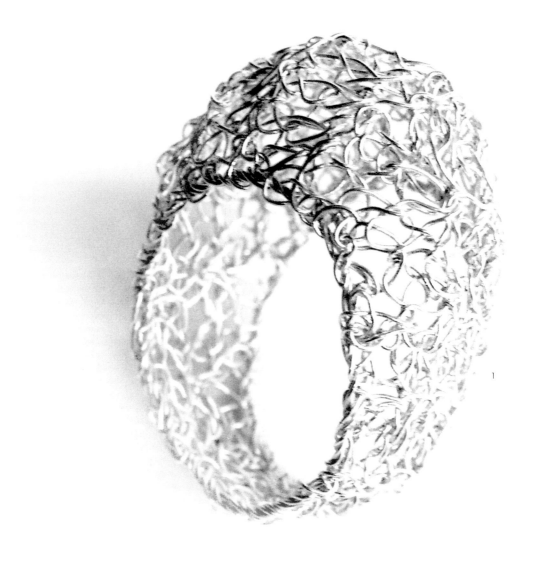

1. *Bulle* ring
Handsewn embroidery with
18-karat white gold thread

2. *Jonc* ring
Compressed embroidery
sewn by hand with 18-karat
white gold thread

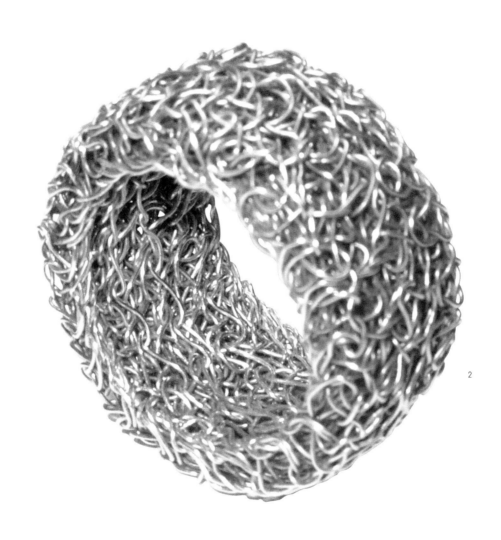

2

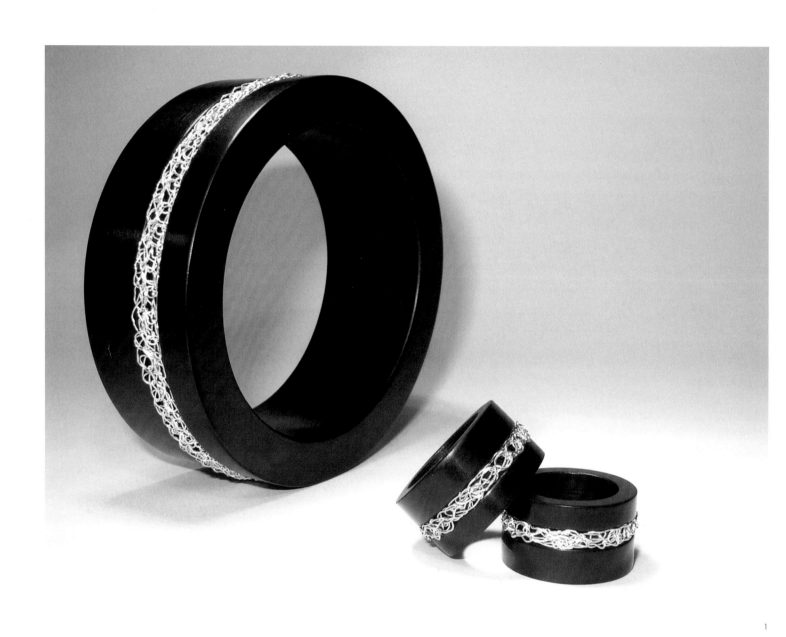

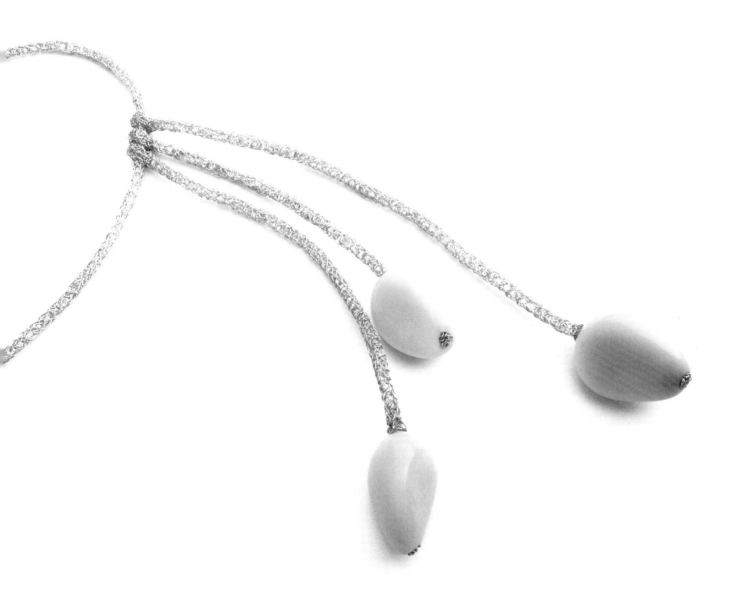

2

1. *Ébène* bracelet and rings
Ebony with embroidery sewn
and 18-karat white gold
thread

2. *Trio de blanc* choker
Compressed embroidery
sewn by hand with 18-karat
white gold thread and three
vegetable ivory seeds in their
original form